A HISTORY OF
MOTION PICTURE
COLOR TECHNOLOGY

A HISTORY OF
MOTION PICTURE
COLOR TECHNOLOGY

Roderick T. Ryan

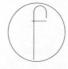

THE FOCAL PRESS
London and New York

First published 1977

Text set in 11/12 pt Photon Times, printed by photolithography, and bound in Great Britain at The Pitman Press, Bath

CONTENTS

6

PREFACE

Man's interest in the use of color for visual presentation goes back in history to his earliest known attempts at pictorial representation. Its use has persisted in his art and architecture, costume and decoration up to the present time. It was only natural that it should be introduced into his entertainment, games, pageant plays and finally motion pictures.

The first attempts to produce color in motion pictures were crude and far from realistic. Many color systems were invented, developed and used only to be abandoned when other systems emerged that were preferable from a technical or commercial standpoint. In the course of slightly more than seventy years the names of over one hundred color processes have appeared in motion picture advertising and on the theatre screens. Not all these were individual processes; some were merely names given by a producing company or laboratory to an existing process and still others were foreign films that utilized a process popular in the country in which they were produced. Elimination of the name only and the foreign processes leaves approximately fifty which originated or were used in America. Each of these systems has contributed to the technological advancement of motion pictures through photographic chemistry or optics.

The original purpose of this study was to compile and present, in some semblance of order, the available technical information concerning the color motion picture processes developed in the United States during the period 1900–1975. This aim was modified somewhat to include processes developed in other countries that had a significant effect on the United States motion picture industry. The processes that fall into this category are: Kinemacolor, the various lenticular processes and Gaspar color in the earlier days—Ferraniacolor, Fujicolor and Gevacolor at the present time. These processes, developed in England, Europe or Asia, achieved acceptance in the United States and contributed to the technology of color motion pictures. To exclude them from the study would have been to present an incomplete picture.

The usual procedure followed in the classification of color processes is to group the processes into two broad categories: Additive and Subtractive. For ease of presentation however the processes described in this study have been divided into sub-groups having one or more common elements. Within each group they are presented chronologically. Separate chapters have been assigned to the additive optical, mechanical and shared area processes, bipack processes, and monopack processes.

RODERICK T. RYAN

9

I A BRIEF EXPLANATION OF COLOR

Color as we speak of it in photography is quite different from the pigments of the painter. Since it is a characteristic of light it is well to begin any study of color by examining the nature of light itself. Some of the properties of light are:

1. It travels in straight lines.
2. It can be bent and focused by means of a lens.
3. It can be dispersed by a prism (Fig. 1).
4. It is made of waves of radiant energy of varying wavelengths (Fig. 2).
5. The wavelengths can be located in the electromagnetic spectrum and identified.
6. It is the physical cause of the sensation of sight.

Because light is important in the lives of everyone its nature and composition have interested man from the very beginning of his scientific inquiries. Progress in arriving at valid answers to the questions concerning light, however, was very slow. The theory that is the basis for the modern theory of light and radiation was suggested only 100 years ago. In 1873 James Maxwell made observations and calculations which showed that the velocity of light waves and the velocity of radio waves were the same. His work further indicated that the only difference between the two types of waves was in their wavelength. Because these waves are

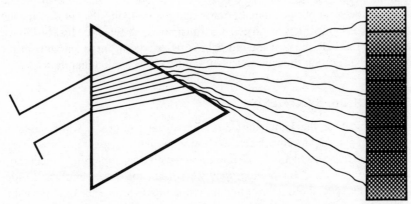

Fig. 1 Forming the spectrum. White light passes through a prism and is separated into its component colors, forming the spectrum, due to the fact that shorter waves are refracted more than longer waves.

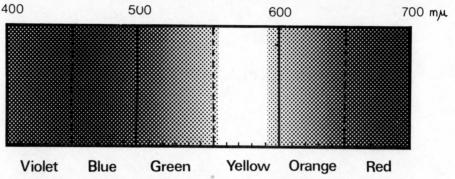

Fig. 2 The visible spectrum. Red light waves are the longer; blue light waves are the shorter.

surrounded by both an electrical and a magnetic field they are called electromagnetic waves, and the Electromagnetic Theory has been evolved to explain their various actions.

The spectrum of electromagnetic radiation extends from extremely short wavelengths of the cosmic and gamma ray radiation through the ultraviolet, infrared and radio wave radiation. Only a small band of wavelengths between 400 and 700 millimicrons affects the eye and enables us to perceive light and color. In Figure 2 the wavelength scale shows the various colors in relation to wavelength. The longest wavelengths appear as red. Shorter ones appear orange, still shorter ones, yellow; down through green, blue-green, blue, to violet, the shortest wavelengths which we can perceive. Each wavelength of light by itself results in a slightly different perception of color, resulting in a very large number of hues which are perceivable by the eye. When light consisting of a mixture of a number of different wavelengths strikes the eye, only one color is perceived, since the eye is not capable of analysing light into its component parts. When several wavelengths are involved, the resulting color of the mixture is less pure or less saturated, and a mixture of all wavelengths in approximately equal amounts gives the sensation of white or no color.

While in the strictest sense color is a property only of light, it is customary to speak of the color of objects because of the ability of many objects to modify the color of the light that strikes them. When light strikes an object, it is transmitted, reflected or absorbed. If we turn a white light on a red ball, most of the red light is reflected, but large amounts of the other colors are absorbed so that the light reflected to our eyes is predominantly red.

ADDITIVE COLOR SYNTHESIS

The fact that most of the light emitted from natural sources is white, containing all wavelengths, and natural objects are able to modify this light in a great many ways, results in countless colors. The reproduction of all these colors with even approximate accuracy would be an impossible task for color photography were it not for a very important property of human vision. This special property of human vision makes it possible to duplicate all these colors with reasonable accuracy by means of only three colors mixed in various proportions. These three colors, red, green and blue, are known as primaries (Fig. 3a). This point can be

12

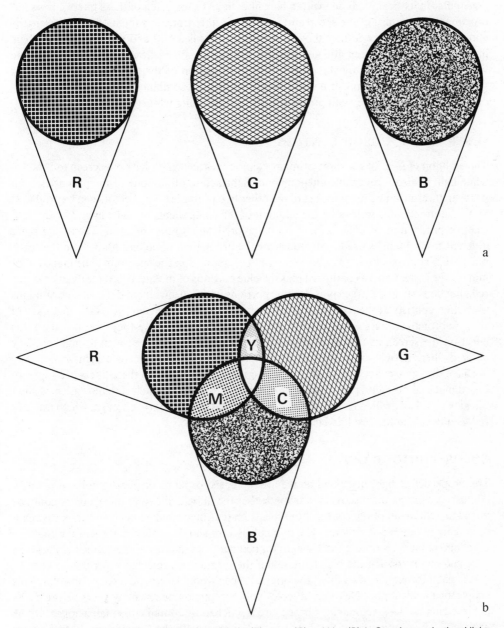

Fig. 3 Additive color mixture. a. Additive primaries red (R), green (G) and blue (B). b. Superimposed colored lights yield mixture colors by addition: magenta (M), yellow (Y), cyan (C).

demonstrated by the use of three light sources, one with a red filter in its beam, one with a green filter in its beam and one with a blue filter in its beam. Each of these filters covers approximately one-third of the spectrum; i.e., the red filter transmits most of the wavelengths above 600 mu; the green filter those wavelengths between 500 and 600 mu; and the blue filter, wavelengths between 400 and 500 mu. Likewise, each of these filters absorb all of the wavelengths transmitted by the others. Any combination of the filters with a single light source would result in black or no light. But when they are combined additively with three individual light sources they can produce any color including white (Fig. 3b).

SUBTRACTIVE COLOR SYNTHESIS

The addition of light of the three primary colors red, green and blue on a screen to produce white light is also a reversible phenomenon. Subtraction of any one of the primaries from white light results in light composed of the other two primaries. Thus colors can be produced by the subtraction as well as by the addition of the components of white light. For the subtractive production of color a new set of colored filters must be used. These filters are different from the ones used to demonstrate the production of color additively in that each one covers approximately two-thirds instead of one-third of the spectrum. The magenta, or minus green filter consists of the red plus the blue portions of the spectrum; the cyan or minus red filter consists of the green plus the blue portions of the spectrum; and the yellow, or minus blue filter, consists of the red plus the green portions of the spectrum (Fig. 4a). Since each of these subtractive filters covers two-thirds of the spectrum, singly they produce the same effect on the screen as two superimposed light sources each filtered with a single primary colored filter. If two subtractive filters are superimposed with a single light source they produce the same effect as a single primary colored filter and if all three filters are superimposed black or no light is obtained. For example, if magenta, which is minus green, is combined with yellow, which is minus blue, the color that remains is red; if cyan, which is minus red, is now added the result is black (Fig. 4b).

COLOR PHOTOGRAPHY

The properties of light discussed above are the basis for all color photographic processes. Almost as soon as the discovery was made that the three additive primary colors could be mixed to achieve all of the colors of the spectrum plus black and white, men began to dream of making photographs in color. The principle is very simple. If three photographs could be used, one of them recording the red light that comes from the scene, one recording the green light and one recording the blue light, and if these could be projected superimposed on the screen each through its own filter, the original scene would be reproduced in full color. This simple idea made it possible to invent color photography on paper many years before it was achieved in practice. Actually, the procedure is much more complicated than it appears to be in theory. The production of the three original pictures with the proper density, the correct contrast, and the correct image size and then projecting them onto the screen in exact superimposition proved to be a formidable task. Although several processes for additive

14

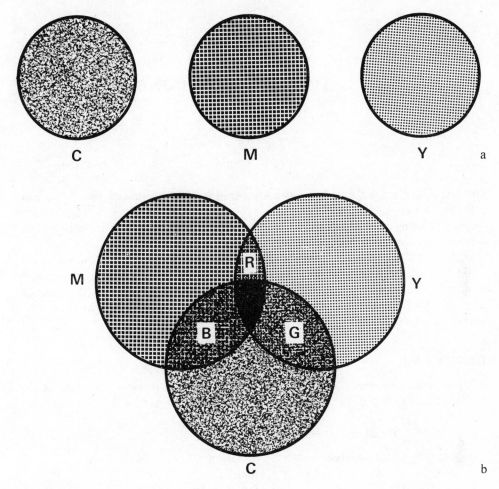

Fig. 4 Subtractive color mixture. a. Filters for the subtractive production of color: cyan (C), magenta (M), yellow (Y). b. Superimposed color filters with white light yield primary colors by subtraction: red (R), green (G), blue (B).

color photography have been proposed, none of them has been able to solve all the technical problems associated with the system. Because of this, almost all of the commercially successful processes to date have been based on the subtractive principle. The characteristics of this system which permit the superimposition of the subtractive dyes in varying degrees makes a single multilayered film and a single light source for projection possible. This characteristic has resulted in the development of several color processes. In the following chapters an attempt will be made to discuss each of these processes in detail.

II TINTING AND TONING

The use of single color tints and tones has paralleled and intermixed with the so-called natural color processes since the introduction of color to motion pictures. Tinting, the earliest means of bringing color to the screen, was in use prior to 1900. The first attempts were hand-painted films that tried to produce natural color pictures. These later gave way to the "natural color" processes, and tints and tones were relegated to the production of color moods through the use of overall colors. In some films only one or two scenes were colored; in others the whole picture was toned a single color. D. W. Griffith used toned sequences in *Birth of a Nation* and *Intolerance*. Erich Von Stroheim used a yellow tone for his symbolic gold sequences in *Greed*.[1]

TINTED BASE

The popularity of the monochrome prints became so great that the film manufacturers offered Black and White positive film on tinted support in several colors.[2]

Tinted Nitrate Base

1. Red	4. Amber	7. Green
2. Pink	5. Light amber	8. Blue
3. Orange	6. Yellow	9. Lavender

The same colors were also offered in tinted acetate safety base. However, these tints were slightly lighter than the corresponding tints on nitrate base.

By the early 1920s it was estimated that during some periods 80 to 90 per cent of the total production was printed on tinted positive film.[3] Then with the introduction of sound the existing types of tinted base became unusable. Unfortunately, the majority of the dyes used in tinting absorbed the wavelengths of radiation to which the sound reproducer cells are most sensitive. The dyes reduced the response of the cell to such a great extent that high amplification of the photoelectric currents was required to obtain sufficient volume of sound. This high amplification increased the inherent cell noises and microphonic disturbances in the amplifier so that the reproduced sound was of intolerably poor quality. For this reason, the use of tinted film was discontinued entirely in the production of positives carrying a photographic

16

sound record. Some viewers thought that this was a serious loss and that the absence of color impaired the beauty and dramatic power of the screen production. The producers and creative men in the studios agreed with them and requested help from the film manufacturers.

A study was made of the dyes available for the production of tinted support and in 1929 Eastman Kodak introduced its series of Sonochrome colored support for motion picture positive. The Sonochrome tints were described as "a spectrum of sixteen delicate atmospheric colors keyed to the mood of the screen, in the new series of Eastman Sonochrome Tinted Positive Films for silent or sound pictures."[4] A list of these appears in the following table.

TABLE 1
SONOCHROME TINTS

Color name	Dominant wavelength	% Transmission	
1. Rose doree	633	57	Deep warm pink
2. Peachblow	619	61	Flesh pink
3. Afterglow	603	66	Orange
4. Firelight	596	66	Yellow-orange
5. Candle flame	585	75	Orange-yellow
6. Sunshine	579	83	Yellow
7. Verdante	520	57	Green
8. Aquagreen	505	40	Blue-green
9. Turquoise	490	46	Blue
10. Azure	484	28	Sky-blue
11. Nocturne	476	28	Violet-blue
12. Purplehaze	455	38	Blue-violet
13. Fleur de lis	575	25	Blue-purple
14. Amaranth	557	31	Red-purple
15. Caprice	537	53	Cool pink
16. Inferno	508	36	Red-magenta
17. Argent	—	71	Neutral

TINTING BY DYES

In addition to the tinted supports which were available prior to the introduction of sound and the Sonochrome tints which became available after the introduction of sound, there were several formulas for the production of a single overall color in motion pictures. Color could be produced either by tinting or toning or by a combination of the two.

Tinting usually means immersing the film in a solution of dye which colors the gelatin causing the whole picture to have a uniform veil of color on the screen. Toning consists in either wholly or partially replacing the silver image of the positive film by some colored compound so that the clear portions or highlights remain uncolored.

Dyes for tinting motion picture positive film were required to have the following properties:

1. The dye should not bleed when the film was washed and the rate of dye removal due to washing should be slow.

17

2. The dye should not be precipitated by alum, calcium, magnesium or iron salts.
3. The dye should not be "dichroic" or change color on dilution.
4. The dye should be fast to light even under the heat of projection so that local fading would not take place.
5. The dye solution should not foam readily.
6. The dye should not be affected by the acid fixing bath.
7. The dye should not attack the gelatin coating of the film even after 24 hours incubation at 212 degrees F.

The following table gives a list of the dyes used, prior to the introduction of sound on film, for tinting or colouring film by stenciling or by hand.[5]

TABLE 2

DYES USED FOR TINTING SILENT FILM PRINTS

Dye	Concentration in grams/liter	Color
Amaranth 40 F	5 gr	Cine red
Azo rubine	2 gr	Cine red
Crocein scarlet M00	2 gr	Cine scarlet
Scarlet G. R.	2 gr	Cine scarlet
Lake scarlet R.	2 gr	Cine orange red
Wool orange C. G.	1 gr	Cine orange
Quinolin yellow	2 gr	Cine yellow
Wool yellow extra conc.	4 gr	Cine yellow
Naphthol green B conc.	4 gr	Cine light-green
Naphthol green M	4 gr	Cinelight green
Acid green L	4 gr	Cine green
Fast acid green B	4 gr	Cine green
Direct blue 6B	2 gr	Cine blue
Niagara sky blue	2 gr	Cine blue
Fast Wool violet B	2 gr	Cine violet
National violet 2 RD	2 gr	Cine violet

All these dyes were manufactured by National Aniline & Chemicals Co., with the exception of Azo Rubine and Naphthol Green B C, from White Tar Aniline Corp., and Scarlet G R, from Levinstein, Boston, Mass.

The time in solution varied from one minute to three minutes at 65 degrees depending on the shade desired. Approximately 20,000 feet of film could be dyed per 50 gallons of dye solution. As the rate of dyeing slowed down, the solution would be replenished with concentrated dye solution.

The amount of light cut off from the screen as a result of tinting depended on the nature of the particular dye used, the concentration of dye in the film and on the purity of color of the dye. Tests made of tinted films indicated that screen brightness was reduced from 25 per cent to 95 per cent as a result of tinting.

After the introduction of sound it was necessary to replace many of the dyes formerly used

18

for tinting with dyes that were more compatible with the sound reproduction system. The dyes and concentrations listed in the table below were successfully used with the black and white films used for sound-on-film motion pictures.[6]

TABLE 3
DYES USED FOR TINTING SOUND FILM PRINTS

| Dye | Concentration in grams/liter | | | Color |
	Weak	Medium	Strong	
Crocein scarlet	0·1	1·0	5·0	Red
Crocein scarlet (Flesh)		0·5		Orange
Sepia brown 36645		5·0		Amber
Flesh tone 4767B	1·0	2·5	5·0	Dark amber
Deep yellow 34795		2·5	5·0	Yellow
Light yellow 3479B		2·5	5·0	Light yellow
Deep green 1376-2 conc.	1·0	2·5	5·0	Green
Anthraquinone blue G	1·0	2·5	5·0	Blue
Acid blue B43270	1·0	2·5	5·0	Cyan
Pontacyl violet HBL	0·5	1·0	2·5	Violet

Crocein scarlet, Anthraquinone blue and Pontacyl violet were made by Du Pont and Deep green 1376-2 by General Dyestuffs; the rest were manufactured by National Aniline & Chemicals Co.

The time in solution was normally three minutes at a temperature of 65 degrees to 70 degrees F., but longer or shorter times were used depending on tint desired. After tinting the film would be rinsed, squeegeed and dried. Approximately 40,000 feet of film could be dyed per 50 gallons of dye solution. As the rate of dyeing slowed down the bath would be replenished with concentrated dye solution, not by adding acid. When the bath became muddy it would have to be replaced.

METALLIC TONING

A somewhat different effect than that obtained by tinting can be obtained by toning the film either by metallic salts or by combinations of metallic salts and dyes, or both. A good example of toning in a major feature picture was the MGM production *The Good Earth*, which was given an overall brown tone with a Uranium Nitrate Toner. Regarding this film John Nickolaus, Manager of MGM Laboratory, 1937, stated that "to the best of our knowledge this is the first complete major release to be toned in its entirety, and furthermore, it is the first picture to be toned in a modern developing machine."

The picture *The Good Earth* was approximately 12,000 feet long consisting of 14 reels. There were approximately 500 release prints made from the original negative, all of which were toned.[7]

Toning differs from tinting in that it produces a colored image embedded in a layer of colorless gelatin. Thus the highlights remain colorless while the half-tones and the shadows are colored. When a silver image is treated in a solution containing potassium ferricyanide and a metal salt, it is oxidized and converted to silver ferrocyanide and at the same time a colored metal ferrocyanide is precipitated. For example:[8]

Cyan-Blue Tone

$$4Fe(Fe(CN)_6) + 4Ag = Ag_4(Fe(CN)_6) + Fe_4[(Fe(CN)_6)]_3$$
Ferric ferricyanide + silver = silver ferrocyanide + ferric ferrocyanide

Red-Orange Tone

$$4Ag + 2K_3Fe(CN)_6 + 2(UO_2)(NO_3)_2 = Ag_4(Fe(CN)_6) + (UO_2)_2(Fe(CN)_6) + 6KNO_3$$
Silver + potassium + uranium = silver + uranium + potassium
ferricyanide nitrate ferrocyanide ferrocyanide nitrate

Suitable solutions for metallic toning in this way were:

Cyan-Blue Tone

Ammonium persulfate	0·5 gram
Ferric alum	1·25 grams
Oxalic acid	3·0 grams
Potassium ferricyanide	1·0 gram
Ammonium alum	5·0 grams
Hydrochloric acid (10%)	1·0 ml
Water to	1·0 liter

Orange-Red Tone

Uranyl nitrate	2·5 grams
Potassium oxalate	2·5 grams
Potassium ferricyanide	1·0 gram
Ammonium alum	6·0 grams
Hydrochloric acid (10%)	5·0 ml
Water to	1·0 liter

Red Tone

Potassium citrate	70·0 grams
Copper sulfate	12·0 grams
Potassium ferricyanide	12·0 grams
Ammonium carbonate	6·0 grams
Water to	1·0 liter

Sepia effects were obtained by a two-bath process which produced a silver sulfide image:

Sepia Tone

Solution A

Potassium ferricyanide	20·0 grams
Potassium bromide	5·0 grams
Water to	1·0 liter

Solution B

Sodium sulfide	5·0 grams
Water to	1·0 liter

Film was first bleached in solution A then toned in solution B.

DYE TONING

Because of the limited number of metallic compounds available for toning purposes it is possible to obtain only a limited range of tones by metal toning alone. The addition of a basic dye to the metallic salt mordanting bath increases the range to a large number of tones that can be used singly or in combination with dye tints or tinted base. This addition can be accomplished in two ways:

1. The film is first immersed in a mordanting bath which converts the metallic silver image to silver ferrocyanide. Then it is washed and dyed in a basic dye solution.
2. The film is immersed in a bath which contains the mordanting agent potassium ferricyanide and a basic dye.

Cabtree and Ives in their paper, "Dye Toning with Single Solution," give a list of the dyes which are suitable for dye toning with a single solution, as shown below. The authors arrived at these ten after trying nearly 200 possible basic dyes. To the following formula the proper type and concentration of a basic dye were added to produce the desired results.

Dye	X grams (from Table 4)
Acetone	100·0 ml
Potassium ferricyanide	1·0 gram
Acetic acid (glacial)	5·0 ml
Water to	1·0 liter

The color of the tone produced varied with the time in solution. Dyeing continued up to a point, then the highlights began to block up with dye and gradation was lost. The limiting point would be determined by test with short strips before the actual prints were toned. As the solution became exhausted it was necessary to prolong the time of toning. The solution would be discarded when the time for toning to a given color was double the time necessary in a fresh solution.

TABLE 4
DYES FOR TONING WITH A SINGLE SOLUTION

Dye	Color	Concentration in grams/liter
Tannin heliotrope	Magenta	2·0 grams
Safranine 6B	Magenta	2·0 grams
Safranine base	Red	1·0 gram
Pink B	Pink	12·0 grams
Chrysoidine—Y base	Orange	2·0 grams
Chrysoidine 3R	Orange	2·0 grams
Thioflavine T	Yellow	2·0 grams
Auramine	Yellow	4·0 grams
Victoria green	Green	4·0 grams
Rhodamine B	Magenta	4·0 grams

All these dyes were manufactured by National Aniline & Chemicals Co., except for Thioflavine (General Dyestuffs Corp.) and Auramine (Du Pont).

PATHECHROME

The Pathechrome process was a dye tinting process invented in 1905 by Charles Pathe. With this process selected portions of frames were tinted using a stencil to precisely and rapidly apply the dye. Single or multiple colors could be used provided that a separate stencil was cut for each color. Several silent features and short subjects were released in this process. Among those listed under Pathecolor by J. L. Limbacher are *A Rose Among the Briars*, *The Beloved Vagabond*, *Queen Margaret*, *The Three Masks*, and *Cyrano De Bergerac*.[9]

To produce color prints by the Pathechrome process it was necessary to prepare a stencil for each area to be colored. The stencil was prepared using a positive print as the stencil material and a second print as a guide. The operator cutting the stencil sat before a screen and followed the outline of the projected picture with the arm of a pantograph. A vibrating electronically driven needle at the opposite end of the arm cut away the film base on the stencil film. Each frame was individually traced in this manner until a stencil was obtained for the entire scene.

After the stencil was cut, the remaining emulsion was removed from the film base and the base was cleaned, leaving a clear film with cutouts of the proper shape where the color was to be applied. To insure proper registration the release prints were made on a step registering printer. These were normal black and white prints processed in the normal manner. The color was applied after processing by bringing the stencil and the positive to be colored into contact over a sprocket wheel while a ribbon wiped the color through the stencil onto the positive. The ribbon, a loop approximately 12 inches in diameter, was fed the dye by a series of brushes so that it did not receive too much dye. The machine used for this purpose operated at a speed of 60 feet per minute.[10]

In preparing multiple color prints it was frequently the practice to tone the prints with an overall toner or to use tinted base as the first step. The choice of this overall color was governed by the scene to be toned.

Dye Used for Tinting in Pathechrome

Blue	Diazol Nl	5 g/l
Yellow	Tartrazine	5 g/l
Amber	Cocceine orange	7 g/l
Fire-red	Ponceau NR	20 g/l
Blue-green	Acid green Nd	4 g/l
Light-green	Naphthol green NB	5 g/l
Rose	Acid amaranthe	2 g/l
Violet	Acid violet 5B	1 g/l
Orange-rose	Ponceau NR	7 g/l

THE HANDSCHIEGL PROCESS

The Handschiegl Process was invented in 1916 by Max Handschiegl and Alvin Wyckoff of the Famous Players–Lasky Corp. Studio Laboratory. In principle this process was the application of multicolor lithographing techniques to motion pictures. Dye was transferred from a matrix or color plate to selected areas of a black and white print.

This process was first developed for the De Mille picture *Joan the Woman*; it was advertised first as the Wyckoff Process then the De Mille–Wyckoff Process. Later it became popular as the Handschiegl Process.[11] Some of the other productions that used this process[12] were *The Red Light, Greed, Irene, The Volcano, The Flaming Forest, Phantom of the Opera, The Merry Widow, The Big Parade, Sally, Seven Keys to Baldpate, The Viennese Medley, The Splendid Road, Mike*, and *Lights of Broadway*.

As used by Handschiegl the process was not an attempt to produce natural color photography. In its early form it was used principally to apply color to selected areas within a scene. The customer furnished normal black and white prints which were colored by dye transfer with one, two or three dyes. If more than one color was to be transferred, then a separate plate was made for each of the colors.

After a production had been edited a print was made of the scenes that were to be colored on a registration step printer. This print was blacked out with opaque material in the area which was to be colored;[13] this could be done by hand with a brush or other suitable instrument. From this print a duplicate negative was made. After development the duplicate negative was clear in the areas which were to be colored. The remaining areas contain a negative silver image. At this point the process makes use of the effect that a gelatin emulsion becomes more insoluble or harder in those areas acted upon by light than in those areas where no exposure takes place. The duplicate negative was immersed in a tanning bleach which fixed and solidified the exposed and developed portions of the scene, hardening them so that they would not absorb dye, but not affecting the viscous consistency of the unexposed or clear portions of the scene. When bleaching was completed the negative was fixed, washed and dried. The bleached negative was then immersed in a saturated solution of dye in water, approximately two pounds of dry dye to five gallons of water. The surplus dye was removed by squeegeeing and the negative dried once more. It was then ready for transfer, by pressure and contact, to the positive prints. The print to be colored passed into a solution of oxgall and water which softened and wetted the emulsion sufficiently to dissolve and absorb dye from the negative film. Contact time varied depending on the area and amount of dye to be

23

transferred. Time could be changed by changing the position of the keeper roller. One dyeing of the negative was good for transferring dye of equal density to two release prints. The life of the negative matrix was 40 runs.[14]

The machines for imbibing the dyes are described in USP 1303836. Each machine had three transferring stations consisting of a large sprocketed drum approximately 12 inches in diameter and two smaller adjustable sprockets. Both the matrix and the release print were stretched onto the large wheel to provide vertical register; horizontal register was provided by micrometer adjustment of the smaller sprockets (Fig. 5).

A satisfactory bleach for the duplicate negative was:

Potassium dichromate	19·0 grams
Potassium bromide	28·0 grams
Potassium ferricyanide	19·0 grams
Acetic acid	5·0 ml
Potassium alum	25·0 grams
Water to	1·0 liter

Dyes of the acid type were used such as:

Pontacyl light red 4bl
Pontacyl carmine 2g
Pontacyl carmine 2b
Alizarin Rubinol R

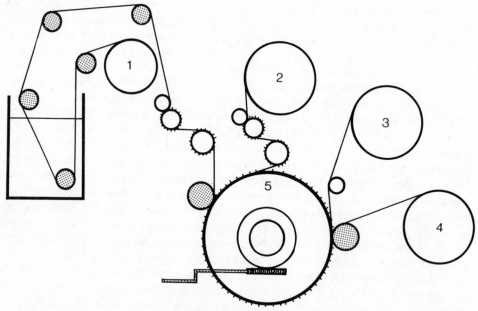

Fig. 5 Handschiegel dye transfer machine. The bleached and dyed negative is brought into contact with the positive on a large sprocket drum for transfer of dye. 1. Positive Supply, emulsion in. 2. Negative Supply, emulsion out. 3. Negative Take-up, emulsion in. 4. Positive Take-up, emulsion out. 5. Transfer Sprocket Wheel.

REFERENCES

[1] FULTON, A. R., *Motion Pictures: The Development of an Art from Silent Films to the Age of Television* (Norman, Okla.: University of Oklahoma Press, 1960), p. 109.

[2] *Tinting and Toning of Eastman Positive Motion Picture Film* (Rochester, N.Y.: Eastman Kodak Co., 1927), p. 7.

[3] JONES, L. A., "Tinted Films for Sound Positives," *Transactions of the Society of Motion Picture Engineers*, May, 1929, p. 199.

[4] *Ibid.*, p. 208.

[5] *Tinting and Toning . . .*, pp. 15–16.

[6] "Tinting Eastman Fine Grain Release Positive Film with Dye Solutions," (Eastman Kodak Co., Rochester, N.Y., 1955), p. 3. (Mimeographed.)

[7] NICKOLAUS, J. M., "Toning Positive Film by Machine Methods," *Journal of The Society of Motion Picture Engineers*, July, 1936, p. 67.

[8] GLAFKIDES, PIERRE, *Photographic Chemistry* (London: Fountain Press, 1960), II, 647–651.

[9] LIMBACHER, J. L., "A Historical Study of the Color Motion Picture," 1963. (Mimeographed.)

[10] KELLEY, W. V. D., "The Handschiegl and Pathechrome Color Process," *Journal of The Society of Motion Picture Engineers*, August, 1931, pp. 230–234.

[11] *The Autobiography of Cecil B. De Mille*, ed. D. HAYNE (Englewood Cliffs, N.J.: Prentice-Hall, 1959), p. 175.

[12] KELLEY, W. V. D., "Imbibition Coloring of Motion Picture Films," *Transactions of The Society of Motion Picture Engineers*, February, 1927, pp. 238–241.

[13] KELLEY, W. V. D., "The Handschiegl and Pathechrome Color Processes," *loc. cit.*

[14] *Ibid.*

25

III ADDITIVE PROCESSES

OPTICAL, MECHANICAL AND SHARED AREA

Although the tinting and toning processes produced some interesting effects they did not produce natural color. Color photography as it is used today evolved from a demonstration prepared by James Clerk Maxwell for presentation to the Royal Institution, London, in May 1861. He stated that the visual appearance of any color could be matched by the proper mixture of three primary colors, red, green and blue. To prove his theory he took three pictures, on black and white film, from the same camera position, through three colored filters. After processing, he made positive transparencies from each of the negatives and projected them in registration on a screen. In front of the lens of each projector he placed the filter through which the original negative was taken. This result was a colored picture.

In the following years workers in the field of color retained the principles advanced by Maxwell but many improvements were made on his method. (1) The flat flasks containing colored solutions, that were used as filters, were replaced by sheets of gelatin containing a suspension of dye. (2) The speeds of photographic emulsions were increased by the use of better sensitizers. (3) Other reproduction methods were devised to replace the use of three positive transparencies and three projectors. (4) Two-color systems were introduced. (5) Several variations were developed for obtaining the negatives for both the two-color and the three-color systems. These variations eventually fell into two classes: those employing special cameras or optical systems, which will be discussed in this and the following three chapters, and those employing the use of multiple coatings of emulsions, which will be discussed in the chapter on "Monopacks."

The first practical application of color to motion picture photography was a two-color additive system called Kinemacolor. This process was the first in a whole series of two-, three- and four-color additive systems that employed the use of special optics and/or mechanical devices to produce successive frame or area shared separation negatives. It is interesting that none of the systems discussed under this section achieved any substantial degree of commercial success with the exception of Kinemacolor, even though the time period they encompass is the entire period covered by this study.

KINEMACOLOR

The first commercially successful system of color cinematography was a two-color additive

26

system invented in England called "Kinemacolor." Although this process was not invented in the United States and therefore does not properly belong in this study, it has been included because of its importance in the field of color cinematography and because it was introduced in the United States through the formation of the Kinemacolor Company of America with studios in Los Angeles and New York.

The Kinemacolor process originally invented by Edward R. Turner was a three-color additive process in which successive frames were photographed and projected through red, green and blue-violet filters mounted in a rotating disk. Although the photographs were taken and projected at 48 or more frames per second, the process was subject to considerable fringeing. Turner's first backer was F. Marshall Lee, whose name appears with Turner's on the original BP 6202 and USP 645477. Lee later sold his interest in the process to Warwick Trading Company who after six months of trying unsuccessfully to solve the problems, resold their interest to Charles Urban. With Urban's backing, Turner continued to work on the process, producing results that were encouraging but just short of success. He died in 1902 without solving the projection problem. To carry on his work Urban retained G. Albert Smith, a photographer and scientific experimenter. Smith was equally unsuccessful in his attempts with a three-color process. Finally in 1906 he abandoned this approach and at the suggestion of Urban he reduced the process to a two-color process by the elimination of the blue-violet filter and the substitution of a blue-green filter for the green filter and a red-orange filter for the red-filter. In July 1906 Urban and Smith produced their first successful color motion pictures using this system. They named the process Kinemacolor.

The first public demonstration of Kinemacolor was presented May 1, 1908 at Urbanora House, Wardour St., London.[1]

The first American demonstration was given December 11, 1909 in the concert hall of Madison Square Garden, New York City. The program lasted approximately two hours and consisted of a variety of subject matter, including flowers, animals, birds, harvest scenes, military reviews, waterfalls, surf, etc.[2]

The Kinemacolor process as used commercially was a two-color additive system. The Kinemacolor camera (Fig. 6) had a shutter containing a red-orange gelatin filter in one opening and a blue-green gelatin in the other (Fig. 7). The film was exposed at a rate of 32 frames per second, giving 16 frames through the red filter and 16 frames through the green filter, the two exposures being alternated. When the pictures were projected in the same manner as photographed, persistence of vision merged the two images into a color picture. After exposure the negative was developed in a conventional black and white developer and printed on ordinary black and white print film. Disadvantages of this process were the special projection equipment required and the problem of fringeing which was experienced when fast moving objects were photographed.[3]

In an attempt to simplify the projection of Kinemacolor prints W. H. Fox of the Kinemacolor Company of America developed a system for coloring the alternate frame prints, thus eliminating the need for the rotating filters on the projector. He also developed a two-speed projector that could be operated at 16 frames per second for black and white projection and 32 frames per second for color projection. The projector is described in the patent USP 1166120 granted in 1915. The print coloring method is described in USP

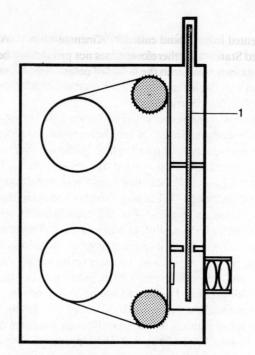

Fig. 6 Kinemacolor camera. 1. Rotating Filter Disk.

Fig. 7 Kinemacolor color filter disk. Frames were exposed alternately through the red-orange and blue-green sectors of the filter disk.

1166123 granted the same year. A description of the process from the patent follows:

" 1. A two-color alternate frame record of the subject is photographed on panchromatic film through successive red and green filters at 32 frames per second.
2. The negative is developed, fixed, washed and dried in the normal manner used for black and white photography.
3. The red record negative is printed first, by skip frame printing.
4. This print is developed in a normal black and white print developer then immersed in an acid stop bath consisting of 1 per cent acetic acid in water.
5. The developed image is toned in a solution which converts the image to ferric ferrocyanide and silver ferrocyanide.
6. The film is immersed in a 1 per cent solution of sodium thiosulfate which is strong enough to dissolve the silver ferrocyanide but not strong enough to affect the unexposed silver bromide. Approximately 30 seconds is sufficient for this to take place.
7. Wash and dry.
8. The green record negative is printed in superimposition on the blue-green positive image of the red record negative. This exposure should be about one-quarter to one-half that required for a normal black and white negative.
9. Print is developed in a normal black and white developer, fixed and washed. During development of the image from the green record negative the color of the image from the red record negative is almost completely washed out. In order to restore this color the film is immersed in a bath containing a weak solution of ferric chloride and hydrochloric acid.
10. Mordanting bleach. This bath converts the silver image from the green record negative to a mordanted yellow image which has the property of absorbing basic dyes.
11. Fix.
12. Wash.
13. Dye toning—the print is immersed in a weak solution of basic red dye.
14. Wash and dry."

Blue-Green Toning Bleach

Ferric chloride	10·0 grams
Potassium ferricyanide	10·0 grams
Hydrochloric acid	5·0 ml
Water to	1·0 liter

Yellow Mordant Bleach

Vanadium chloride	2·0 grams
Potassium ferricyanide	2·0 grams
Oxalic acid	2·0 grams
Water to	1·0 liter

29

Dye Toner

*Dye	5·0 grams
Acetic acid	5·0 ml
Water to	1·0 liter

*Rhodamin
Azin red
Acridin red
Safranine

PANCHROMOTION

Panchromotion was the name of a company formed in 1913 by W. Van Doren Kelley for the development of an additive process for color cinematography.[4] The process that evolved from this venture was a four-colour additive system which employed a segmented rotating disk on both the camera and the projector. Exposure was made on successive frames, each frame containing a color exposure and a white light exposure. The colors used for the rotating disk were red-orange, blue-green, blue-violet and yellow; Figure 8a illustrates the position of the filters in the color disk. Figure 8b illustrates the position of the color records in the successive frame negative and print.[5]

The Panchromotion Company had a very short life, failing to produce anything that was shown commercially in a theater. The process, however, lasted somewhat longer. Although it had all of the deficiencies of the original Kinemacolor process and no advantages to offset them, Kelley continued to work with this additive system and finally produced "Our Navy," released as Prizma Color.

DOUGLASS COLOR

Douglass Color was a two-color additive system for color cinematography invented in 1916 by L. F. Douglass. According to the inventor his unique method of exposing the negative produced a stereoscopic as well as a color effect.[6]

A demonstration of the Douglass Color system was presented in New York City, February 14, 1918. Subjects included bathing beauties and scenic views of Yosemite and Yellowstone National Parks. The reviewer for the *New York Times* was impressed by the "apparently unlimited" range of colors obtainable with the process.[7]

The Douglass Color process was a complete system for color cinematography consisting of a method of exposing a pair of negatives, a printing method, and projection system. A stereo camera exposed alternate frames on two separate films, one through a red filter and one through a green filter (Fig. 9). Each film was advanced by a double frame pull down mechanism. After exposure the negatives were developed, fixed, washed, and dried in the normal manner for black and white films. The result was a red separation negative with alternate frames clear and a green separation negative with alternate frames clear. These negatives were printed onto normal black and white print film on a printer with a double frame pull down mechanism, producing a print with alternate frames containing an image

30

Fig. 8 Panchromotion system. a. Panchromotion color filter disk was made up of four colors, Red-orange (1), Blue-green (2), Yellow (3) and Violet-blue (4), each with central clear sectors. b. Position of the color records in the Panchromotion system; each successive frame was exposed partly through a color sector and partly through the clear area of the filter disk.

from each negative (Fig. 10). After processing the prints were projected additively through a rotating shutter that contained a red filter in one opening and a green filter in the other opening. Prints were projected at double speed.

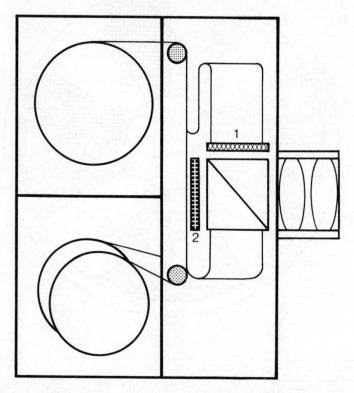

Fig. 9 Douglass color beam splitter camera. Alternate frames exposed on two separate films. 1. Green Filter. 2. Red Filter.

The process as described above had the same limitations as the other processes that relied on a special additive projection system. Its successful presentation depended on the projectionist and the projection equipment and it required special equipment for theatrical presentation. Apparently Douglass soon became aware of this, because in 1919 he filed an application for a patent which described a method of producing dye toned prints from two separation negatives.[8]

Prints were made from two separation negatives on normal single coated black and white print film simultaneously in a special printer having individual intensity control for each side. With the print film in the middle, the red record negative was printed in contact with the emulsion and the green record negative printed in contact with the base. The print was developed

Fig. 10 Douglass color. Separation negatives and print. 1. Red Negative. 2. Green Negative. 3. Combined Print.

in a normal black and white developer, washed and bleached in a ferricyanide toning bleach. It was then washed and dyed with a basic dye, washed, and treated with a sodium hydroxide solution that removed the ferric ferricyanide image. The film was then rebleached in the ferricyanide toning bleach. This treatment affected the bottom image only; the top red-orange image was not affected. After washing, the bottom blue ferric ferricyanide image was converted to blue-green by immersion in a toning solution. This was followed by an acid rinse, washing and drying.

Bleach—one minute

Potassium dichromate	0·01 gram
Ferric alum	5·0 grams
Oxalic acid	12·0 grams
Potassium ferricyanide	4·0 grams
Ammonium alum	20·0 grams
Hydrochloric acid	4·0 ml
Water to	1·0 liter

Red Dye Bath—five minutes

Fuchin P	0·5 gram
Auramine O	1·5 grams
Alcohol	250·0 ml
Glycerin	15·0 ml
Acetic acid (glacial)	6·0 ml
Water to	1·0 liter

Green Toner—Converts ferric ferricyanide image from blue to green-blue

Potassium ferricyanide	8·0 grams
Chromic acid	8·0 grams
Water to	1·0 liter

Acid Rinse

1% solution glacial acetic acid

GILMORE COLOR

Gilmore color was a two-color additive process for color cinematography based on a patent granted to F. E. Ives in 1918.[9] A special optical device was used to obtain two images taken in pairs side by side on 35 mm film. One of the pair was exposed through a red filter and the other through a green filter. Prints were made in the normal manner on conventional black and white print film. For projection the projector had to be equipped with a special optical device which turned and superimposed the two images in register on the screen.

Examination of the patent referred to above, USP 1262954, reveals a complicated optical system with several potential sources of difficulty. Perhaps this is the reason there appears to be no record of the process actually having been used for commercial production.

KESDACOLOR

Kesdacolor was a two-color additive line screen process invented in 1918 by W. V. D. Kelley and C. H. Dunning. Although this process had a relatively short life, Cornwell-Clyne records that a 50 foot length of Kesdacolor was shown at the Rivoli and Rialto Theaters in New York, September 12, 1918.[10] The subject presented was the American Flag.

The process as illustrated in USP 1431309 was a two-color additive process, but it is stated that it could be a three- or four-color process. For the original photography, the negative was exposed through a line screen composed of alternate bands of red and green filters. The film was advanced two frames at a time, one frame containing the picture image and one frame containing an image of one color of the line screen. The image of the screen was formed by a supplementary lens located above the picture-forming lens. This lens was fitted with a filter and a right-angle mirror or prism above the base of which was placed a diffusing surface (Fig. 11). After exposure the negative was developed in a normal black and

Fig. 11 Kesdacolor optical system and negative. The film was advanced two frames at a time. One frame contained the picture image photographed by the lens 1 exposed through a colored line screen 2. The other frame contained an image of one color of the screen selected by the filter 3 and illuminated through the screen lens 4 by light from the sky 6 through prism 5.

white developer, fixed, washed and dried. At this point in the process it contained alternate frames of picture and a record of one color of the screen, leaving the area of the other section of the screen clear. Prints were made on duplitized positive film. The picture was printed on one side and the screen on the other. The lines of the screen opposite the red color record lines of the picture printed in black on the positive; these lines were bleached and toned red with a uranium toner. The alternate lines which were clear on the positive were dyed green-blue by using the dye known as Acid Green L. The final print is composed of a picture made up of banded red and green records on one side and a banded red and green filter on the other side.

WARNER–POWRIE COLOR PROCESS

The Warner–Powrie Color process was a line screen three-color additive color process invented by J. H. Powrie in 1924. The process was first developed as a plate process for still photography, but failed to materialize commercially although it possessed some advantage over other existing processes. Powrie then interested Warner Bros. in the possibilities of the process for use in motion pictures and a pilot operation was set up at the Warner Research Laboratory in New York City.[11]

For the original photography, the process used 47 mm panchromatic negative film having a line structure of 900 parallel lines to the inch running lengthwise on the film. The film was advanced horizontally through the camera, exposing through the base a frame whose aspect ratio was the same as standard 35 mm film but with four times greater area. This negative was printed in a special optical printer with a one-half reduction onto 35 mm positive film which also had parallel lines running lengthwise on its base. Since the positive was running vertically through the printer, the lines would be vertical and cross those of the negative image. A positive printed in this manner would normally reproduce only one-third of the color of the negative; however, this was overcome with an inappreciable loss of sharpness by shifting the lined structure of the negative image during the printing operation to a second and a third position, the total shift being that of the period of the pattern of the lined screen structure. The negative and the positive prints were processed in conventional black and white processing solutions. Color was obtained by additive projection through the line screen.[12]

The line screen on both the negative and the print film consisted of a series of dichromated gelatin lines coated on the face of the film and dyed red, green and blue.

To prepare the line screen, clear film base was coated with dichromated gelatin. After drying, a series of tanned gelatin lines were formed by printing from a very fine grain line negative. The lines on the negative were twice the width of the intervening spaces. The excess gelatin was removed by washing and the remaining tanned lines dyed with an opaque neutral dye. This became a matrix or submaster for subsequent printing. The opposite side of the base was then coated with dichromated gelatin. After drying, a series of tanned gelatin lines were formed by printing through the base with an arc light. The light was transmitted through the transparent base 0·005 inches thick and formed an insoluble gelatin line on the other side. The light reached the film not at right angles to the surface but at a predetermined angle, the thickness of the support displacing by parallax the position of the light beam. Where the first series of lines had been formed the base was washed to remove the untanned gelatin. Then, utilizing a principle disclosed in USP 802471, the insolubilized colloid was dyed first with an acid yellow dye, Aurophenin, then with a basic red dye, Safranin, and mordanted with tannic acid. The base was recoated with dichromated gelatin and an adjacent series of lines were formed by a second printing, removing the light to a position at the opposite side of the right angle. The base was washed to remove the untanned gelatin and the remaining colloid dyed first with acid Aurophenin then with Brilliant Green, a basic dye, and mordanted with tannic acid. The temporary matrix of opaque lines that served to form the first and second colored lines was then removed by buffing in an alkaline solution. The base was washed and dried and again coated with dichromated gelatin and a third series of lines

36

was formed by exposure through the base. The existing red and green lines acted as a matrix and prevented any light action except in the undyed area. The excess gelatin was removed by a wash and the remaining untanned gelatin dyed first with acid blue, then basic Methyl blue or Violamin R. The result was a screen composed of sets of colored lines without any colorless interspaces. The film was dried and a protective coating applied to prevent injury to the screen when the emulsion was applied. A sensitive panchromatic emulsion was coated on top and the film was ready to be slit and perforated for use.

There is no record of this process ever being used for theatrical presentation. In the opinion of the writer, the inventor found considerable difficulty translating his process, which was quite acceptable for still photography, to use in motion picture production. Producing one picture on a glass plate does not present the same problems as producing several thousand on a long roll of film.

MAGNACHROME FILM

The Magnachrome Film Process was a two-color additive system for color for color cinematography.[13] For this process the original photography was accomplished by exposing bipack negative in a conventional camera. The only change in the camera was that it was fitted with a half-size aperture gate. After exposure and development the two half-frame negatives were printed in sequence so that on the print each normal size frame contained a pair of half-size positives, one from each negative record. The prints were projected at a speed of 90 feet per minute with an intermittent movement, using an eight-sided cam instead of the usual four-sided cam. This gave 48 pictures a second instead of the usual 24 pictures per second. At this speed, which was effectively twice normal projection speed, many of the defects obtained with the old two-color sequential frame additive processes were eliminated. No fringeing was discernible since the negatives were exposed in pairs at the same time. To prevent mismatch in splicing or projecting the film, frame lines were tinted with alternate spaces of red and blue-green.

Experimental work on this process was done by Roy Hunter of Universal Pictures. There is no record of the process ever having been used in actual production.

ROTOCOLOR

The Rotocolor process was an additive system for color cinematography. The process was announced in 1931 by H. Muller. According to an article in *Film Daily*, April 12, 1931, and *The Motion Picture Herald*, April 11, 1931, the process consisted of a shutter device attachable to a standard projector. The device was easily removable permitting switching between black and white and color. Apparently the system was not commercially successful since no further mention appears in either the trade or technical literature. Examination of the patent literature 1927 to 1940 failed to uncover any patents for colour motion pictures granted to Mr. Muller.

OPTICOLOR

The Opticolor process was a three-color additive system for color cinematography announced in April 1933 by company president Merril Waide.[14] Through the use of special optics (Figs. 12a, 12b) three substandard size pictures were obtained on 35 mm black and white film (Fig. 13).[15] Incorporated in the optical system were three color filters so that the result obtained was a record of the red, green and blue light components of the original scene. After

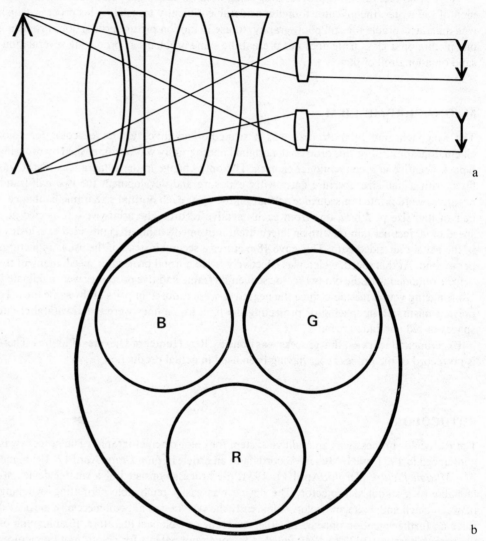

Fig. 12 Opticolor. a. Opticolor lens system for producing three separation negatives on one film. b. Opticolor triple lens arrangement with filters Red (R), Blue (B) and Green (G).

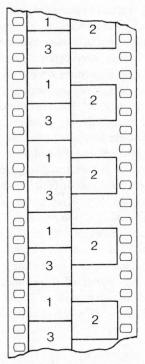

Fig. 13 Opticolor. Separation negatives, three in the area of a standard frame: 1. Red record. 2. Green record.
3. Blue-violet record.

processing in conventional black and white processing solutions prints were made on black and white print film. This film was also processed using the normal black and white solutions. The finished prints were projected through a special optical system similar to the camera lens which combined the three positive records to make a full color picture on the screen.[16]

Examination of the patent literature 1930 to 1940 indicates several patents were granted to Waide for systems of color photography. Some of these were assigned to Natural Color, Inc., and some were assigned to Opticolor. One, USP 1970678, which describes a lens system for photography and for projection, was divided and one-half, USP 2115153, was assigned to Opticolor.

Although this process was announced as ready for production in 1933 there appears to be no further mention of it in the trade and technical papers. Because of the nature of the process, requiring a special lens for both camera and projector, the system probably failed to compete with the subtractive processes which used conventional equipment.

MORGANA COLOR PROCESS

The Morgana Color Process was a two-color additive process for 16 mm color cinematography introduced in 1933 by Bell and Howell Company.[17] Like the Kodacolor

39

Process described in Chapter IV it was not intended that this process should be used for entertainment motion pictures. It was introduced as a home movie system for motion pictures with possible application in the field of industrial and medical cinematography.

In a special camera alternate frames were exposed through a red and blue-green filter mounted in an oscillating filter holder. Exposures were made on conventional panchromatic black and white reversal film which was developed normally. Because of the filter factors of the color filters used, an exposure increase of approximately three to four lens stops was required. No limits were imposed on focal length of lenses and diaphragm opening.

After exposure and development the film was projected on a special projector equipped with a color filter wheel. The filter wheel was divided into two color sectors, red and blue; each of these was composed of smaller sectors and transparent spacings. The red sector was divided into two segments, the blue sector was divided into three segments. The color and the area of each sector was chosen so that they would correct for the color transmission of the camera filter and the color characteristics of the projector lamp.

The most unusual feature of the projector was its sequence of projection, two frames forward then one frame backward. The rate of projection at the aperture was therefore 72 frames per second although the linear motion of the film corresponded to a speed of 24 frames per second. Each frame was projected three times. The purpose of this multiple projection of each frame was to eliminate a problem known as "color flicker."

Some of the advantages of the Morgana Process over other two- and three-color processes were:

1. Conventional film and processing were used.
2. Any focal length or aperture lens could be used.
3. Prints could be made on conventional continuous printing equipment.
4. Less light was required for color photography using this system.
5. Flicker and color fringeing were eliminated.

Some of the disadvantages of the process were:

1. It was a two-color process.
2. Special camera and projection equipment were required.
3. The mechanics of projection was physically hard on the film.

CINEMACOLOR

In 1934 the Cinemacolor Corporation of Chicago, Illinois announced a two-color additive process for color cinematography. Two substandard size images were produced side by side in the area normally occupied by a standard 35 mm frame (Fig. 14a).[18] The process employed split optics and a special lens system was introduced for both the camera and the projector.[19] Although six patents were granted to Otto C. Gilmore in 1934 and assigned to this company, a search of the patent literature 1930–1950 indicates no further activity by the company. Gilmore, however, was identified with another very similar process, Cosmocolor, 1935–1943. Comparison of the 1934 Cinemacolor patents with those granted to

40

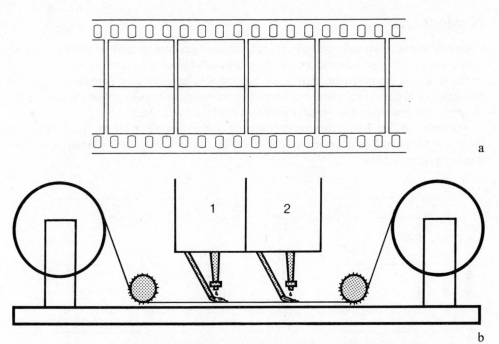

Fig. 14 Cinemacolor. a. Cinemacolor negative, two sub-standard size images produced in the area normally oc-cupied by a standard 35 mm frame. b. Cinemacolor film coloring machine for dyeing two adjacent sub-standard size images simultaneously and continuously. 1. Red-orange Dye. 2. Blue-green Dye.

Cosmocolor in 1936 indicates a possible connection between the two processes. Further in-dication is:

1. The processes are both two-color additive processes.
2. They both employ substandard size images having the same orientation on 35 mm film.
3. Otto C. Gilmore is listed as inventor on the patents assigned to both companies.

An interesting device patented by Cinemacolor was a film coloring machine for dyeing the two adjacent substandard size images simultaneously and continuously (Fig. 14b).[20] The film was advanced from one rewind to another passing over two sprockets, one a guide sprocket and the other a drive sprocket connected by pulleys to a motor and the right-hand rewind. Between the two sprockets were two dyeing stations. Brushes replenished by drip bottles were used to apply red-orange dye to the image in one area of the film and blue-green dye to the image in the other area of the film. To the author this appears to be a rather com-plicated method for adding color to the prints. Special optics had to be used for projection so that the images could be rotated 90 degrees and superimposed; therefore, the introduction of colored filters in the projectors instead of dyeing the prints would have produced more even color results and would have eliminated one step in the production of the prints. The projec-tor light output would have been the same if color filters or colored prints were used.

COSMOCOLOR

Cosmocolor was a two-color additive process for color cinematography invented by Otto C. Gilmore in 1935.[21] Special optics composed of a series of block prisms were required on both the camera and the projector. Before the process was actually used commercially it was changed to a two-color subtractive process. Special optics were still used on the camera but the prints were two-color subtractive prints on duplitized positive film.[22]

According to J. L. Limbacher the only feature motion picture on record that is known to have been filmed in Cosmocolor was *The Isle of Destiny*, produced and released by R-K-O Radio Pictures in 1940.[23]

Fig. 15 Cosmocolor. Cosmocolor negative, two sub-standard images produced in the area normally occupied by a standard size 35 mm frame. 1. Red frames. 2. Green frames.

The two-color additive Cosmocolor process was a system which employed a series of block prisms to produce two adjacent substandard size images in the area of a normal 35 mm frame (Fig. 15). Exposures were made on panchromatic film, the right image through a red filter and the left image through a green filter. The negatives were processed in conventional black and white processing solutions and prints were made on normal black and white film. These prints were projected with special optics on the projector which rotated the two images 90 degrees and superimposed them on the screen.[24]

The two-color subtractive Cosmocolor process introduced in 1939 utilized the same optical system as the additive system to produce the original negatives. After the negatives were processed, a set of color master positives were made on a special step registration optical printer. In this printer the negative ran horizontally and the master positive vertically (Fig. 16). Therefore, there was no need to rotate the image optically, although a slight enlargement was necessary. To complete a set of master positives, it was necessary for the film to pass through the printer two times. When this was accomplished a set of master positives were produced which were normal for size and orientation. Then prints could be made on duplitized positive by any of the several two-color printing systems.[25]

A third basic change in the Cosmocolor process appeared in 1943. USP 2315783 and BP 556426 described a three-color system for color cinematography. In this system three sub-standard size images were produced on a normal size 35 mm frame. A series of block prisms

Fig. 16 Cosmocolor optical printer. The negative runs horizontally and the master positive runs vertically.

similar to those employed in the Cosmocolor two-color process were used to produce the three images, two normally oriented and one rotated 90 degrees (Fig. 17). There is no information concerning the method Gilmore intended to employ in printing these negatives. Also there is no record of this process having been used for actual production.[26]

TELCO COLOR

Telco Color was a two-color additive color process announced in 1936 by Leon Ungar and K. R. Hoyt.[27] Through the use of a special optical system on both the camera and the projector, "natural color" was obtained using conventional equipment and ordinary black and white single coated film. No special processing or after treatments were necessary.

In 1936 Universal Pictures Corporation announced its intent to use Telco for feature production; however, there is no record of its use as an additive system. The system was finally converted to a two-color subtractive process employing duplitized positive and standard bipack negative. It was used by Universal in 1938 for the short subject "Cavalcade of Texas" and later for independent feature release on low budget pictures. One of these, Monogram's *Lure of the Wasteland*, was, according to the reviewer from *Parents' Magazine*, "marred by unsuccessful color photography."[28]

It appears that basically Telco offered no advantages that the other two-color processes of the period did not also offer. A major disadvantage was that the emulsions available at the time were not capable of producing good quality on a large screen from a half-frame negative.

Fig. 17 Cosmocolor three-color negative. On 35 mm film there were two normally oriented sub-standard size images and one rotated through 90°.

As originally designed, Telco Color was a two-color system of color photography employing a special system of split optics. Two pictures of one-half the normal height were obtained side by side on a standard 35 mm width panchromatic black and white film. A normal camera with conventional pull-down stroke was fitted with a special aperture plate and lens system. One set of pairs was exposed on alternate half-frames throughout the length of the roll, then the film was advanced two sprocket holes and the remaining half-frames were exposed. The interocular distance of the split optics was variable so that the objectives could be adjusted for parallax as well as focus. A camera operator photographing a moving shot from long-shot to close-up could adjust for both focus and parallax while the shot was in progress.[29]

After its failure to achieve success as an additive system the process was changed to a subtractive process employing duplitized positive for release prints. The unique feature of the Telco duplitized prints was the manner of applying and controlling the color.

USP 2134129 describes a machine for applying dye to one side of double or single-coated

44

Fig. 18 Telco color. Machine for applying dye to one side of double coated film. 1. Fountain Roller. 2. Transfer Roller. 3. Application Cylinder. 4. Back-up Roller. 5. Film Path.

Fig. 19 Telco color. Drum for dyeing machine used for dyeing sequential frame prints.

film (Fig. 18). Dye was picked up from the supply tank by a roller called the fountain roller. From there it was transferred to the applying cylinder by the transfer roller. The film which was to be dyed passed between the applying cylinder and a back-up roller and on to the take-up. For dyeing double-coated film, two units were used, one for each side. The machine could also be used for sequential frame dyeing by using a cylinder like the one illustrated by Figure 19.

USP 2290060 described a color control inspection machine which consisted of a projector and a polishing machine. With this unit an inspector could locate and remove excess dye from finished release prints. A similar unit with the projector is described in USP 2125260.

Information is not available concerning the dyes and the formulas used for this process but the color control units mentioned above indicate that they were probably of the Pinatype class.

THOMASCOLOR

Thomascolor was a three-color additive system of color cinematography invented by Richard Thomas. Examination of the patents granted to Thomas, 1934–1941, indicates he started his research in an attempt to solve the parallax problem for a two-color system, and

Fig. 20 Thomascolor. Four segmented optical units arranged about a common axis and separated by septums are used to produce four color separation negatives within a single frame on 65 mm film.

from this work evolved a three-color system.[30] Although demonstrated successfully several times, the Thomascolor process was never used for feature production.

For original photography the Thomascolor process employed a conventional type 65 mm camera equipped with a special optical system. Four segmented optical units arranged around a common axis and separated by septums were used to produce four color separation negatives within a single frame (Fig. 20). The upper left image was the red record, the upper right image was the green record and the two lower images were the blue record. Thomas states that two images were necessary for the blue record in order to compensate for the sensitivity of panchromatic emulsions to blue and ultraviolet light. By using very dense filters and obtaining two partially exposed violet images, much better color rendition was obtained and the process was more readily controlled. The Wratten 25 filter was suggested for the red record, Wratten 58 filter for the green record and Wratten 47 for the blue records.[31] Ordinary black and white panchromatic film was used in the camera. An adjustment of $1\frac{1}{2}$ lens stops was necessary when calculating the correct exposure because of the light loss in the optical system. After exposure, the negative received normal development in a conventional black and white developer. Prints were made on black and white print film by optical reduction to 35 mm. A conventional reduction printer was used.

A disadvantage of the Thomascolor process that possibly had some effect on its lack of acceptance by the motion picture industry was the need for a special optical system in order to project the Thomascolor prints in color. Its use in a production would require every theater that showed the picture to obtain the special Thomascolor optics for both projectors.

COLORVISION

In May 1950, Colorvision, Inc., was formed for the purpose of developing a three-color additive system of color cinematography for the newly emerging field of color television. According to the promotional literature of the company the additive system of color photography was chosen for the following reasons:

1. Maximum economy in photographing.
2. Maximum color rendition.
3. Maximum scope for color control.
4. Maximum facilities for processing of film.
5. High speed in processing of film.

Actual work on the proposed system began in March 1951. Studies of the additive method were made and an optical system was devised which would meet the following requirements:

1. Sufficient light transmission for use at low levels of illumination.
2. Freedom from both time and spatial parallax.
3. Availability of a wide choice lens to permit a choice of angle of view.
4. Compatibility with existing equipment.

To confirm the practicability of the proposed system an experimental model of the camera optical unit was made and a 1000 foot test reel was prepared. This film was shown privately in four theaters in California in April 1952. Comments regarding the film were very

47

favorable at all four showings. Therefore, work was started on the construction of regular production models of the Colorvision optical unit.[32]

In October 1954 the Colorvision process was described and demonstrated at the Society of Motion Picture and Television Engineers Convention at Los Angeles.[33] Since then the company's efforts have been directed toward the design and construction of a complete operational system which would meet the requirements of the professional producer.

A status report and a further demonstration of the process was given at the Society of Motion Picture and Television Engineers Convention at Los Angeles in April 1958.[34] Improvements in the basic system were shown and the practicability of using the Colorvision system for color kinescope recording was confirmed. At this time it was announced that four Colorvision optical units for use with N. C. Mitchell cameras were operational and that an optical unit has been aligned with an Acme Process Camera for animation, titling, etc.

The third paper concerning the Colorvision process was presented at the Society of Motion Picture and Television Engineers Convention at Los Angeles in March 1965.[35] This paper described an application of the process to current laboratory practice. In the making of separation positives for protection or archival storage it was proposed that the Colorvision system of area sharing be used in place of three separate films.

The Colorvision optical system was a beam-splitter with a relative aperture in excess of $f/2 \cdot 0$. The light which entered the system through a single entrance pupil was divided into its red, green and blue components by means of multilayered interference filters and forms three geometrically similar images at the film plane. Each image had an area 40 per cent greater than that of a normal 16 mm frame. Exposures were made on fast black and white panchromatic negative in an unmodified N. C. Mitchell camera. Normal Mitchell accessories such as matte box, view finder, etc., were also used. Each unit was provided with interchangeable bayonet-mounted 35 mm, 50 mm, 75 mm and 125 mm objective lenses. The basic exposure level was 200 ft candles for Eastman Tri X Panchromatic Negative Film, Type 5233 and 400 ft candles for Eastman Plus X Panchromatic Negative Film, Type 4231 at Colorvision aperture T-2. Depth of field at this aperture was equal to a normal lens aperture of $f/4 \cdot 5$. After exposure the negative was processed in a conventional black and white developer to a gamma of $0 \cdot 60$, fixed, washed and dried. Daily prints could be made by continuous contact printing on black and white print film for additive projection in color or they could be made by optical superimposition on subtractive color film. For final release printing, a 35 mm superimposed master positive could be made on Eastman Color Intermediate Film, Type 5253, or a set of three matrices could be made for Technicolor release.

If the process was used for the making of protection master positives as proposed by L. H. Wheeler in 1965, all three master positives were produced on a single roll with a single pass through the printer. This resulted in considerable savings in labor, film cost, and processing cost, as well as a reduction by two-thirds in the amount of storage space necessary for storing the protection master positives.

Although this system produced excellent results and fulfilled a real need, the Colorvision Corporation went bankrupt! The company's remaining assets were sold at auction in April 1966. The printing equipment that Colorvision had proposed to use for making protection master positives was purchased by Consolidated Film Industries.

48

REFERENCES

1 RAMSAYE, TERRY, *A Million and One Nights* (New York: Simon and Schuster, 1926), pp. 562–572.

2 "An American Demonstration of the Urban–Smith Process of Animated Color Photography," *Scientific American*, December 25, 1909, p. 487.

3 GREGORY, C. L., *Motion Picture Photography* (New York: Falk Publishing Co., Inc., 1927), pp. 334–335.

4 CORNWELL-CLYNE, ADRIAN, *Colour Cinematography* (3rd ed.; London: Chapman and Hall, Ltd., 1951).

5 USP 1216493.

6 USP 1313587.

7 *New York Times*, February 15, 1918.

8 USP 1632278.

9 "Report of The Color Committee," *Journal of The Society of Motion Picture Engineers*, July, 1931, p. 117.

10 CORNWELL-CLYNE, *op. cit.*, p. 17.

11 WALL, E. J., *History of Three-Color Photography* (Boston: American Photographic Publishing Co., 1925), p. 484.

12 POWRIE, J. H., "A Line Screen Film Process for Motion Pictures in Color," *Transactions of the Society of Motion Picture Engineers*, April, 1928, pp. 320–334.

13 "Color Committee Report," *Journal of The Society of Motion Picture Engineers*, January, 1931, pp. 101–102.

14 *Motion Picture Herald*, April 11, 1933, p. 13.

15 USP 2115153.

16 *Ibid.*

17 DUBRAY, J. A., "The Morgana Color Process," *Journal of the Society of Motion Picture Engineers*, November, 1933, pp. 403–412.

18 USP 1978789, USP 1958617, Otto C. Gilmore, assigned to Cinemacolor Corp.

19 USP 1953958, USP 1962501, Otto C. Gilmore, assigned to Cinemacolor Corp.

20 USP 1964257, Otto C. Gilmore, assigned to Cinemacolor Corp.

21 USP 205023, Otto C. Gilmore, assigned to Cosmocolor.

22 USP 205024, Otto C. Gilmore, assigned to Cosmocolor.

23 LIMBACHER, J. L., "A Historical Study of the Color Motion Picture," Dearborn, Michigan, 1963. (Mimeographed.)

24 USP 205023.

25 USP 205024.

26 USP 2315783, Otto C. Gilmore, assigned to Cosmocolor.

27 *New York Times*, July 12, 1936, Sec. IX, p. 3.

28 "Family Movie Guide," *Parents' Magazine*, October, 1939.

29 USP 2090398.

30 The Thomascolor two-color system is described briefly in "Report of the Color Committee," *Journal of The Society of Motion Picture Engineers*, July, 1931, p. 116.

31 USP 2152224.

32 "Colorvision—A New Additive Process for Color Photography" (Los Angeles: Colorvision, Inc., 1954), p. 2.

33 BRUNSWICK, L. F., "Separation Process for Additive Color Motion Picture Photography on Black and White Film," *Journal of the Society of Motion Picture and Television Engineers*, March, 1955, pp. 126–128.

34 WHEELER, L. H., "A New Additive Color System for Motion Picture Photography," *Journal of the Society of Motion Picture and Television Engineers*, November, 1958, pp. 747–749.

35 WHEELER, L. H., "A New Color Separation Technique for Color Negative Protection," Paper presented at the 97th Conference of The Society of Motion Picture and Television Engineers, Los Angeles, March 30, 1965.

49

IV LENTICULAR ADDITIVE PROCESSES

One of the many methods proposed for making additive color motion pictures was the lenticular or embossed film process. In principle the process was a screen process which utilized optical means to form its screen. This was accomplished through the use of a special type of film having lenticular elements or microscopic cylindrical lenses molded into its support.

The principle of lenticular film was first suggested by Gabriel Lippmann in 1908.[1] He theorized that if a film support was impressed with a honeycomb structure each element would act as a tiny lens. Each of these lenses would image only that portion of the light which was directly in front of it. The final image would consist of a series of dots, each dot being formed by the lens immediately in front of it. If the dots were beyond the resolving power of the eye they would not be seen as individuals but as a single blended picture.

In 1909 Rudolph Berthon expanded on this idea and introduced a banded three-color filter placed in front of the lens. If this filter completely fills the lens aperture the final image will consist of three dots behind each lens, one formed by each of the red, green and blue light rays transmitted by the filter. Since optical processes are reversible, a color picture would be obtained if a positive image achieved by reversal development could be projected with an optical system consisting of a lens having the same focal length and aperture as the camera lens and a similar banded color filter.

Although Lippmann was the first to suggest the possibility of lenticular film and Berthon was the first to successfully apply its use to produce color pictures, the basis for their ideas had been published several years before. In 1895 F. W. Lancaster, an English engineer, proposed that a screen be placed in the rear focal plane of a camera objective where the elements of the screen would act as individual pin-hole cameras (British Patent 16548/95). In the following year the use of a banded filter was proposed by R. E. Liesegang in an article that appeared in the *British Journal of Photography*, XLIII (1896). Unfortunately it is not clear whether he proposed to use the subtractive colors, cyan, magenta and yellow, for his filter, or a mixture of the additive primaries red and blue and the subtractive color yellow. In either case the system he proposed would have been unworkable, since the subtractive filters each transmit two colors.

KISLYN COLOR

Kislyn color was a three-color additive system based on the 1909 invention of Rudolph

Berthon. This process used a banded three-color filter to expose black and white film through an embossed lenticular base.

The Kislyn Corporation which was formed for the development and promotion of Berthon's process in the United States was founded in 1930 by the principals Kessel, Kennicutt and Merrill Lynch. During the period of 1930–1931 a research program was conducted in Englewood, N.J. by C. L. Gregory, the Company's technical director. As a result of this program several U.S. patents were issued.

Although showing great promise the process was not used commercially in the U.S. The laboratory was closed in December, 1931. This relatively short life was due to a number of factors: the general depression of business in the U.S., technical difficulties in producing the release prints, and a series of law suits regarding patents between Berthon and his former associates, Societé du Film in Couleurs Keller–Dorian. After the close of the Kislyn plant Berthon and his Societé Françoise Cinechromatique continued to work toward perfecting the process. Also, the German version of the process Opticolor was continued by Seimens and Halske.[2] In 1936 the first short feature film "The Beauty Spot" had its premier in Berlin. This film was followed by a documentary on Germany, shown to the Paris exhibition in 1937. Siemens closed their laboratory in 1939.

KELLER–DORIAN COLOR

The Keller–Dorian system of color cinematography was a three-color additive system based on the 1909 invention of Rudolph Berthon. This process used a banded three-color filter to expose black and white film through an embossed lenticular base. The first commercial use of the Keller–Dorian system was the Kodacolor process introduced in 1928. The Eastman 16 mm Kodacolor lenticular film was manufactured under the Keller–Dorian patents through a license agreement between Eastman Kodak and Keller–Dorian Companies.[3]

In December 1930, the Keller–Dorian Company entered into an agreement with Eastman Kodak Company and Paramount Pictures, Inc., and a research program was begun in an effort to utilize the lenticular process for 35 mm entertainment motion pictures. Considerable effort and money was spent, with only limited success, in an attempt to make the system practical for motion picture release prints. In 1936 Paramount withdrew from the agreement and Kodak directed its primary efforts to the future development of the new Kodachrome color process invented in 1935 (Chapter VII).

Some years later, in 1951, the process was revived by Kodak and Twentieth Century-Fox in another attempt to utilize the system for making motion picture release prints (Eastman Embossed Print Film). No prints were made for theatrical release, however, and once more the system was abandoned.[4]

With the introduction of color television, the system was revived again in the form of Eastman Embossed Color Kinescope Recording Film, introduced in 1956. This process met with very limited success; however, it was used commercially by the National Broadcasting Company to record several shows.[5] It was finally abandoned after a few years and at the present time there is no commercial use of the lenticular process for color motion pictures.

KODACOLOR

The Kodacolor process was a three-color additive process announced for amateur cinematography by Eastman Kodak in 1928.[6] With this process all the advantages of a three-color fine line screen could be realized without actually ruling the microscopic filter units onto the film support. After exposure the film was developed by reversal to a black and white positive which could be projected either as a black and white picture or as a color picture if a banded three-color filter was used on the projector lens.

Fig. 21 Kodacolor. Light reflected from the subject photographed passes selectively through a banded color filter and is focussed by the camera lens onto the tiny lenses embossed on the film which re-focus it as separate red, green and blue para-vertical bands on the emulsion.

The basic element in the Kodacolor process was the film support. Through its unique optical characteristics a colored object could be photographed on black and white film and the black and white image could be projected in full color. Microscopic cylindrical lenses arranged longitudinally were embossed into the film support by passing it through steel rollers. The number of these lenses used in the Kodacolor process was 22 to the linear millimeter. When threaded in a camera the embossed support faced the camera lens and the emulsion was away from the lens. Light reflected from the subject photographed passed selectively through a banded color filter (Fig. 21) and was focused by the camera lens onto the tiny embossed lenses where it was re-focused as separate red, green and blue paravertical bands on the emulsion.[7]

Figure 22 illustrates the effect that would take place on a single lens element if a red object is photographed. The red light reflected from the object is transmitted by the red portion of

52

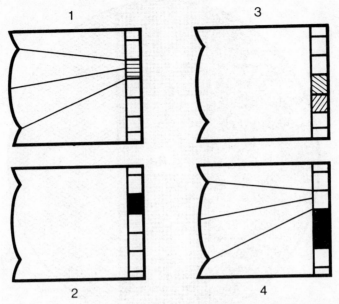

Fig. 22 Kodacolor. The effect that occurs on a single lens element when a red object is photographed: 1. The red light exposes an area about one-third of the total under the lens element. 2. During development in the first black and white developer this area becomes opaque. 3. The film is then bleached and the remaining silver salts are given a controlled exposure and developed. 4. The area affected by red light is now clear and the areas which received no exposure are opaque. When white light is directed on this single lens section a red spot will be formed on the screen.

the banded filter and exposes approximately one-third of the area under the lens element. After reversible development this area of the film is clear and the remaining two-thirds of the film, corresponding to the blue and green segment of the filter, is opaque.

In order to compensate for variations in emulsion sensitivity it was necessary to have some method of controlling the exposure for the separate colors. This was accomplished by cutting down the length of the color filters (Fig. 23a) used in the camera, with a device called a diaphragm ratio cap (Fig. 23b). After each emulsion had been tested caps were selected that correspond to the color sensitivity of each individual batch of emulsion and packaged with each roll of film.[8]

It can be seen from the shape of the aperture of the cap that a conventional iris diaphragm could not be used for exposure control. Any closing down of aperture would change the color ratio, therefore the lens had to be used at full aperture and neutral density filters were used to control exposure.

It is a well known optical principle that any optical system is reversible; therefore, if the developed film were re-threaded in the camera in exactly the same position it occupied during exposure, and illuminated from behind, the scene photographed could be projected on a screen in full color. The camera, however, is not normally used as a projector and projector lenses are usually of longer focal length than those used in cameras. If the lenses have the same relative aperture the focal length difference can be compensated for by the addition of a

53

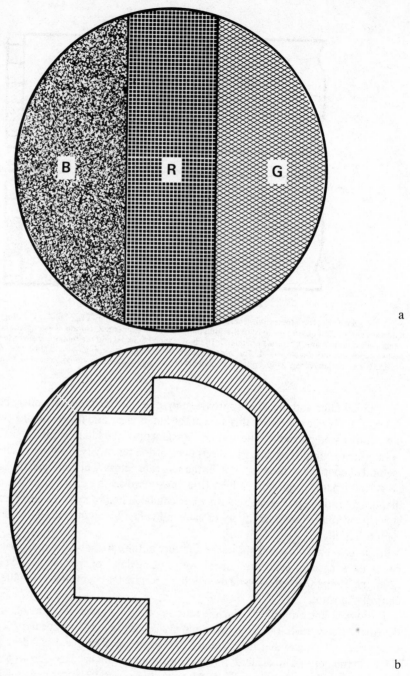

Fig. 23 Kodacolor. a. Kodacolor banded filter, Blue (B), Red (R) and Green (G). b. Ratio diaphragm cap for camera lens.

plane concave lens in front of the film gate. In addition to preserving the color balance on the screen the only apparent effect of the supplementary lens is to give a slightly smaller picture than the same projection throw would produce without it.[9]

Although the Kodacolor process was an amateur rather than a professional motion picture process, it is worthy of mention in this report because it was the first commercially successful application of the Berthon–Keller–Dorian principle.

Also worthy of consideration is the reason for the success of Kodacolor as an amateur and not as a professional process. The prime reason was that Kodacolor represented a "systems" approach to motion pictures, which consisted of:

1. Film: A black and white reversal panchromatic film on an embossed lenticular support.
2. Camera: A cine-Kodak fitted with a 25 mm F/1·9 lens.
3. Banded filter: A banded three-color designed for a 25 mm f/1·9 lens.
4. A diaphragm cap: A lens cap designed to fit the 25 mm f/1·9 lens to compensate for emulsion sensitivity difference.
5. Processing: A black and white reversal processing service.
6. Projection A: A conversion unit for existing "Model A" 16 mm Kodascope projectors.
7. Projection B: A new "Model 13" Kodascope projector designed for Kodacolor or black and white film projectors.
8. Screen: The compatibility of a small screen with home projection.
9. Simplicity: With the simple addition of the filter and diaphragm cap it was as easy to use as black and white.
10. Cost: With a relatively small investment existing equipment could easily be converted to color. New equipment would cost relatively the same as black and white equipment.

This "systems" approach which made Kodacolor film ideally suitable for amateur motion pictures made it completely impracticable for professional motion pictures. Unfortunately, without the systems approach, Kodacolor film represented a single incompatible unit in the total motion picture process.

1. Optics: Lenses available in studio camera departments were optically unsuitable for the Kodacolor process.
2. Printing: A suitable system for making prints from lenticular originals had not been devised.
3. Emulsion sensitivity: A simple correction for emulsion sensitivity variations in form of a lens "diaphragm cap" was impossible due to the number of different lenses used in motion picture studios.
4. Process: For distribution purposes multiple copies were needed; a negative-positive process would have been more desirable than a reversal process from the standpoint of cost and increased latitude.
5. Projection A: Projection optics available in the theaters were generally unsuitable for use with the Kodacolor process.
6. Projection B: Projection light sources were inadequate for additive projection.

Although the color quality produced by the Kodacolor process was excellent, the process

was rapidly replaced by Kodachrome, a subtractive process which utilized multilayered film, discussed in a later chapter.

EASTMAN EMBOSSED PRINT FILM

In November 1951 Eastman Kodak Company presented a method of making motion picture release prints using embossed film, introducing for this purpose Eastman Embossed Print Safety Film, Type 5306. This method of additive color photography differed from previous systems which used lenticular film in that the lenticular film was not used as the original camera taking material, and was not processed by reversal methods to give a direct positive image. Color release prints were made from separation negatives using a special optical printer. In developing this system Eastman worked closely with Twentieth Century-Fox Corporation.[10] Earl Sponable of the Twentieth Century-Fox Research Laboratory directed much of the experimental work which resulted in the development of a commercially workable process.

Although Twentieth Century-Fox announced in January 1953[11] that they planned to use this process as a release printing system, the project was dropped in favor of the use of Eastman Color process. The factors which brought this about were:

1. The development of a single strip color negative capable of good color quality.
2. The development of a companion print film.
3. The need for two and one-half times more light for the projection of the lenticular prints.
4. The need to equip the theater with projection filters and possibly new f/2·0 projection lens and high gain screens.
5. The interest in 3-D and wide screen presentations.
6. The introduction of the Fox "CinemaScope."

No feature production has been released in this system by Twentieth Century-Fox, or any other company.

The film Eastman Embossed Print Safety Film, Type 5306 which was the chief component of the process was described by the manufacturer as a 35 mm film composed of a special fine grain positive type of emulsion coated on an embossed support. The emulsion had a slightly higher contrast than regular black and white release print film and also was designed to give better image sharpness and resolution.[12]

The film support was 0·0055 inches thick with the lenticules embossed horizontally across its width. On each millimeter of film length there were embossed 25 transverse lenticules each having a radius of approximately 0·032 mm and an effective aperture of approximately f/2·3.

In order to prepare motion picture release prints on Eastman Embossed Print it was necessary to have three separation negatives. These could be obtained in any of several available ways.

1. Three-color separation negatives which were derived from materials exposed in a beam splitter type camera.

2. Three-color separation negatives which were derived from a color negative original.
3. Three separation negatives which were derived from Eastman Multilayer Stripping Negative Film, Type 5249.
4. Three separation negatives which were derived from a color reversal original.

The images of the blue and green separation negatives were each split into two components and the red separation negative was imaged as one component for each picture element. There were therefore five component images corresponding to each part of the picture area behind each lenticule.

The component images were arranged symmetrically with the red component in the center, the two green components above and below it, and the two blue components in the top and bottom portions (Fig. 24). If the processed film was projected using a similar banded

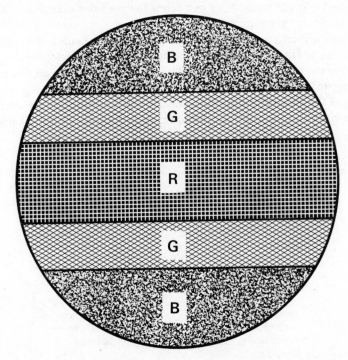

Fig. 24 Eastman embossed print film. Banded tri-color filter, Blue (B), Red (R) and Green (G).

filter on the projector lens excellent color reproduction and tone quality could be obtained. At normal viewing distances no objectionable hue pattern was observed in the screen image as a result of the lenticules on the film. These lenticules were so small and their contrast was so low that on projection they could barely be resolved by the eye at minimum viewing distances. The fact that they were embossed horizontally across the film also aided in eliminating any objectionable line structure.

57

For printing Eastman Embossed Print Film a specially constructed optical printer was necessary. The picture area of the film had to be printed in register three times, once for each of the separation negatives. The sound track also had to be printed separately, making four printing operations. Since a number of printing operations is undesirable from a laboratory production standpoint, it was desirable to use a printer containing three heads for printing the picture and a separate head for printing the sound track. Each of the three picture printing heads was essentially a one-to-one optical printer with a special optical system plate having a fixed aperture (or two apertures in the case of the heads for the blue and green separations) placed in the optical system. The aperture plate for the red printer contained a single central aperture to correspond with the central zone of the five-banded tri-color filter on the projection lens. The plate for the green printer contained two apertures located symmetrically above and below the central area used for the red printer aperture plate. The plate for the blue printer contained two apertures above and below the positions occupied by the apertures used in the plate for the green printer.[13]

The design of the printer was such that adjustment could be made in the relative exposure contributed by each of the three heads, thus permitting changes in color balance and to a certain extent contrast while release printing. The sound negative was prepared in the usual manner and printed continuously by contact in a separate head.

Processing of the Embossed Print Film was accomplished in a normal black and white positive developer.[14] A typical developer that would be satisfactory for this purpose is:

Positive Developer

Elon	1·6 grams
Sodium sulfite (anhydrous)	20·0 grams
Hydroquinone	2·6 grams
Sodium carbonate (anhydrous)	19·0 grams
Potassium bromide	1·0 grams
Water to	1·0 liter

Fix

Sodium sulfite (anhydrous)	15·0 grams
Sodium thiosulfate	240·0 grams
Acetic acid (28%)	48·0 ml
Boric acid	7·5 grams
Potassium alum	15·0 grams
Water to	1·0 liter

In projecting the embossed release print, the five component images behind each lenticule were combined to produce an image in full color. The projection lens was equipped with a special tri-color filter having five horizontal bands (Fig. 25), blue, green, red, green, blue. Because of the filter it was necessary to increase the light output of the projection approximately two and one-half times that required for normal projection. The modification

Fig. 25 Eastman embossed print film. Banded filter, projection lens and film.

required in the projection system in order to obtain this increase in light would vary depending on the theater. The basic items needed were:

1. A projection lens having a relative aperture of f/2·0.
2. An illuminating system that would fill the full f/2·0 aperture of the projection lens with light.
3. Optimum utilization of the available light.
4. A high gain projection screen.

EASTMAN EMBOSSED COLOR KINESCOPE RECORDING FILM

With the introduction of color television on a commercial basis a need developed for a method of recording live color television shows so that they could be stored and shown at a later time. This was desirable for two reasons:

1. The delayed re-broadcast of network shows was necessary because of the different time zones of the East and West coast of the United States.
2. Stations that did not carry the network show for its initial broadcast could, through the use of film, broadcast it at a later date. Also, the network could re-use a show if it was recorded.

Because of the nature of television operations the film recording was needed as soon as possible after the live broadcast. This requirement made the use of conventional systems of color photography impossible because they were both complex and time consuming. A simple, easy-to-process film that could be handled like conventional black and white kinescope recording film was needed. The lenticular or embossed film method of color photography which had been known for almost fifty years appeared to be ideally suited for this purpose.[15] Eastman Embossed Kinescope Recording Film, Type 5209, as demonstrated in 1956 consisted of a black and white emulsion coated onto an embossed film base. Unlike the 16 mm

59

lenticular film "Kodacolor," introduced in 1928 for amateur cinematography, the cylindrical lenses or lenticules extended horizontally across the width of the film. In each millimeter of film length there were embossed 25 transverse lenticules, each one 0·00157 inches high. Since the film width is 35 mm, the active length of each lenticule was 0·816 inches.[16] The film was placed in the camera with its base toward the lens so that the light entering the camera must travel through the lenticule before striking the light sensitive emulsion.

Two methods of color kinescope recording using Eastman Embossed Kinescope Recording Film, Type 5209, were suggested by the Kodak Research Laboratories.

1. Color-television kinescope recording by means of a banded filter.

This method made use of a red, green and blue emitting kinescope in conjunction with a banded filter placed over the camera lens. The color separation was actually performed by the television system itself (Fig. 26). The red, green and blue filter bands ensured that each

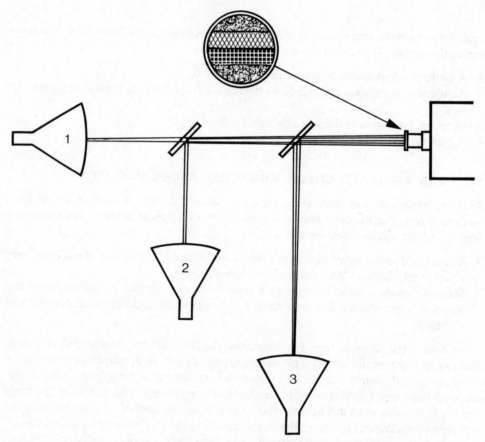

Fig. 26 Eastman embossed color recording film. Color-television kinescope recording by means of a banded filter.
1. Green Kinescope. 2. Blue Kinescope. 3. Red Kinescope.

60

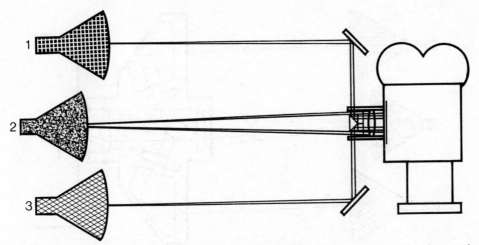

Fig. 27 Eastman embossed color recording film. Color-television kinescope recording by means of geometrical separation. 1. Red Signal. 2. Blue Signal. 3. Green Signal.

kinescope was separately recorded in the proper areas of the film. Disadvantages of this method were the inefficiencies of the filters and the requirement of panchromatic film to record the color images.

2. Color-television kinescope recording by means of geometrical separation (Fig. 27).

This method also made use of three separate kinescopes to present the three channels of a color television system. However, in place of red, green and blue emitting phosphors the same blue emitting phosphor was used for all three kinescope screens. Thus a color-blind or blue sensitive film could be used in place of a panchromatic film. The banded filter used in method number one was replaced with a series of apertures corresponding in size and position to the filter bands. In order to combine the images of the three kinescopes behind each lenticule, the red and green apertures were replaced by two silvered faces of a prism placed in front of the camera lens. The blue apertures were formed by the outer edges of the prism and the aperture of the camera lens (Fig. 28). The advantage of this method over method number one was its greater photographic efficiency. Also, since only a blue sensitive film was required it was possible to obtain electronically reversed images from the kinescope which could be handled in processing just like any standard black and white positive film. The recordings made by NBC in their Burbank, California studios in 1957 were processed in a special laboratory set up for the purpose by Consolidated Film Industries. Two 35 mm black and white spray developing machines were employed. The embossed film was developed as a direct positive using a modified D 16 formula.

After processing, special optics are required for televising the embossed film but otherwise any of the methods commonly used for televising motion picture film could be used.[17] For the flying spot scanner system the emulsion side of the embossed film faced the scanning tube, with the scanning spot focused sharply on the emulsion. Light transmitted by the black and

61

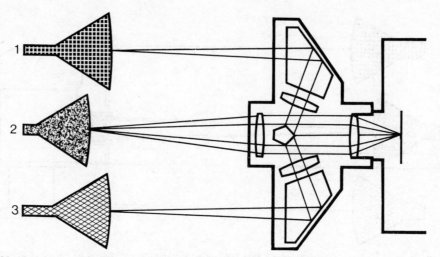

Fig. 28 Eastman embossed color recording film. Color-television kinescope recording by means of geometrical separation. 1. Red Signal. 2. Blue Signal. 3. Green Signal.

Fig. 29 Eastman embossed color recording film. Color-television reproduction from embossed film by means of vidicons. 1. Illuminated embossed film. 2. Red Vidicon. 3. Blue Vidicon. 4. Green Vidicon.

white recorded color separations was then projected by the lenticules in bands corresponding to the apertures of the taking unit. These bands were focused by a lens or a system of lenses upon a plane where light from each of the three individual color records was divided and directed to three photomultipliers (Fig. 29). One method of accomplishing this was by means of silvered glass prisms, or integrating bars. These were arranged so that each band of light image at the plane fell on the unsilvered entrance face of an integrating bar. The unsilvered exit face of each integrating bar was placed next to the photocathode of an end-on photomultiplier. Two integrating bars were required for the blue channel because a double aperture was used in recording the blue record. To ensure efficient collection of the light, all except the entrance and exit surfaces of the integrating bars were silvered.

If instead of a flying spot scanner three vidicons were used it is necessary to employ a more complicated light collecting system.

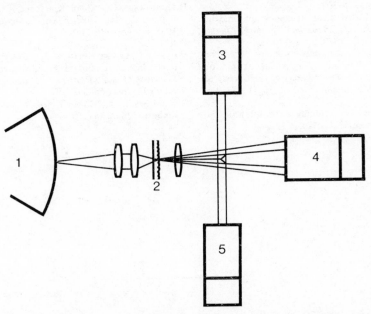

Fig. 30 Eastman embossed color recording film. Reproduction from embossed film in a kinescope television system. 1. Flying Spot Kinescope. 2. Embossed film. 3. Red Photomultiplier. 4. Blue Photomultiplier. 5. Green Photomultiplier.

The three color images had actually to be formed and scanned on three storage surfaces and this introduced critical registration problems which were both optical and electronic in nature. In spite of these problems it was felt that the high signal-to-noise ratio of the vidicon justified its use.[18] A system that proved to be practical commercially was one that was effectively the inverse of the recording system (Fig. 30). This system was used by NBC at its Burbank, California studios for more than a year. It was discontinued for a number of reasons, some technical, others purely operational. One important reason was the decline of color programming; another was the announcement of a color video tape recorder.

63

REFERENCES

[1] FRIEDMAN, J. S., *History of Color Photography* (Boston: The American Photographic Publishing Co., 1944), pp. 222–225.

[2] KOSHOFER, GERT, "30 Years of Modern Colour Photography." *British Journal of Photography*, July 1966, p. 563.

[3] FROST, G. E. AND OPPENHEIM, S. CHESTERFIELD, "Technical History of Professional Color Motion Pictures" (The Patent, Trademark and Copyright Foundation, George Washington University, Washington, D.C., 1960). (Mimeographed.)

[4] *Variety*, January 14, 1953.

[5] EVANS, C. H. AND SMITH, R. B., "Color Kinescope Recording on Embossed Film," *Journal of the Society of Motion Picture and Television Engineers*, July, 1956, pp. 365–371.

[6] MEES, C. E. K., "Amateur Cinematography and the Kodacolor Process," *Journal of the Franklin Institute*, January, 1929, pp. 1–17.

[7] CAPSTAFF, J. G. AND SEYMOUR, M. W., "The Kodacolor Process for Amateur Color Cinematography," *Transactions of the Society of Motion Picture Engineers*, No. 36 (1928), pp. 940–947.

[8] MEES, "Amateur Cinematography and the Kodacolor Process," *loc. cit.*, p. 15.

[9] CAPSTAFF, J. G. AND SEYMOUR, M. W., "The Kodacolor Process for Amateur Color Cinematography," *loc. cit.*, pp. 943–945.

[10] "The Present Status of Motion Picture Color Films and Processes for Professional Use" (Motion Picture Film Department, Eastman Kodak Company, New York, December, 1950), p. 11.

[11] *Variety*, January 14, 1953.

[12] "Preparation of Release Prints on Eastman Embossed Print Safety Film for Additive Color Projection" (Motion Picture Film Department, Eastman Kodak Company, New York, November, 1951), p. 2.

[13] *Ibid.*, p. 4.

[14] *Ibid.*, p. 5.

[15] TARNOWSKI, O., "Color Kinescope Recording on Embossed Film," *British Kinematography*, May, 1958, pp. 123–136.

[16] *Ibid.*

[17] EVANS, C. H. AND SMITH, R. B., "Color Kinescope Recording on Embossed Film," *Journal of the Society of Motion Picture and Television Engineers*, July, 1956, pp. 365–371.

[18] TARNOWSKI, O., "Colour Kinescope Recording on Embossed Film," *loc. cit.*

64

V SUBTRACTIVE PROCESSES

OPTICAL, MECHANICAL AND SHARED AREA PHOTOGRAPHY

The methods for color cinematography described in the preceding chapter all resulted in a final picture on the screen that was made by superimposing or adding lights of two or three primary colors. In nature, however, colors are viewed by subtraction, they absorb or subtract certain component parts of the visible spectrum of white light and reflect the remainder which the eye sees as color. During the period that the additive systems were attempting to produce natural color additively there were a whole series of processes that approached the problem by the use of subtractive means. This group of processes invented prior to the introduction of practical multilayered integral tripack films retained the additive method for the original photography and used the subtractive method for the final prints.

Some advantages of this sort of an arrangement were:

1. The color, good or bad, became a part of the print before it left the laboratory. This eliminated problems introduced by the use of the wrong film/filter combination during projection. Also, lack of synchronization between color records and lack of superimposition of the records was eliminated.
2. The same projection equipment used for black and white films could be used to project subtractive color prints. From the distribution and exhibition standpoint this made every theater a potential market for the product.
3. Less light was needed to project the subtractive prints.

The importance of the exhibition aspect of the color processes was something many of the early workers in color failed to realize. Dr Herbert T. Kalmus of the Technicolor Corporation made the following comment regarding projection difficulties that occurred during a showing of the first feature picture to be made in Technicolor additive process:

> During one terrible night in Buffalo I decided that such special attachments on the projector required an operator who was a cross between a college professor and an acrobat, a phase which I have since heard repeated many times. Technicolor then and there abandoned additive process and special attachments on the projector.[1]

COLORGRAPH PROCESS

The Colorgraph Process, also called Cinecolorgraph, was a two-color subtractive process invented by A. Hernandez-Mejia in 1912. Although there is evidence that a company was

65

formed to promote this process,[2] there does not appear to be any record of its successful use in a motion picture. For the original photography two negatives were exposed in such a manner that the images were reversed in respect to each other. One negative was exposed through a red filter and the other through a green filter. A beam-splitter camera using a semi-transparent mirror was suggested to obtain the two negatives, one reversed with respect to the other. Prints were made on duplitized positive film which was dyed or toned blue-green on one side and red-orange on the other side.

Two different systems for coloring the prints were described by the inventor:

1. Prints are made on double-coated positive film. The two negative records pass through the printer at the same time with the print film in the middle. The print film is color blind and contains a yellow dye to prevent print through. The prints are developed in a normal black and white developer by the rack and tank method. After development and fixing, the prints are bleached with an iodide mordant bleach and toned with basic dyes. The print from the red record negative is dyed green with a dye of malachite character. The print from the green record negative is dyed red with fuchsine or rhodimine. An 80 gallon tank will dye 3000 feet of film at a cost of four to five dollars.[3]
2. Prints are made on double-coated positive film. The two negative records pass through the printer at the same time with the print film in the middle. The print film is color blind with the substratum dyed yellow on one or both of the sides to prevent print through. Each emulsion layer contains a metallic salt in addition to silver halide. For example, cupric sulfate on one side and ferric chloride on the other side. After printing and developing in a normal black and white developer the print is immersed in a restrained potassium ferricyanide solution which will convert the image on one side to blue-green ferric ferrocyanide and silver ferrocyanide and the image on the other side to red copper ferrocyanide and silver ferrocyanide. The silver ferrocyanide can then be removed by fixing in a sodium thiosulfate solution leaving a toned image on each side.[4]

The former system appears to be the one he intended to use. This is substantiated by two patents granted to Hernandez-Mejia after his death and assigned to the Colograph Company. One describes a machine for dyeing prints on duplitized film (Fig. 31).[5] The other, a method of making color prints on duplitized film, expands on patent 1174144.[6]

KODACHROME (EARLY TWO-COLOR)

The Kodachrome process invented by J. G. Capstaff in 1913 was a two-color subtractive process designed for still photography. The principle which made this process possible was discovered accidentally by Capstaff in 1910. He found that when a negative is treated with a tanning bleach, the negative image is removed and the area where it existed is differentially tanned. Subsequent treatment of the film with dyes capable of dying soft gelatin produced a positive dye image.[7]

Examples of the results obtainable with the process were first shown publicly in November 1914 at the Memorial Art Gallery, Rochester, New York. Exhibits were also sent to London and to the Panama Pacific Exposition in San Francisco.

Fig. 31 Colorgraph system. Colorgraph machine for dyeing prints made on duplitized film. 1. Drive Sprockets. 2. Mordant Baths. 3. Wash. 4. First Dye Applicator. 5. Second Dye Applicator on other surface.

Because of its success as a process for still photography, experiments began the following year to adapt its principles to motion picture photography. A camera was constructed which used two lenses mounted one above the other to expose two frames at the same time, one through a red filter and one through a green filter. The film was advanced two frames at a time. The release prints consisted of a film support having dyed gelatin images on each side composed of the images from each pair of frames printed in accurate register.

The first story filmed in this process was an experimental film approximately 600 feet long called "Concerning One Thousand Dollars," produced in July 1916. According to G. E. Mathews[8] it is believed that this picture was the first motion picture story to be photographed by a two-color subtractive process.

In 1929 this process was adopted by the Fox Film Corporation for introduction as Fox Nature Color. A laboratory for producing prints by this method was constructed in Hollywood at a stated cost of one million dollars. The addendum on pages 244–254 is a reproduction of the Instructions For Cameramen issued by Fox Film Corporation in 1929.

Transformation of the Kodachrome process from a process for still photography using glass plates into a workable process for motion picture photography presented several serious problems. Solution of the problem of obtaining a red light and a green light image by the simultaneous exposure of two frames through two lenses introduced the problem of parallax. When the object being photographed was at a distance the error due to the separation of the lenses was quite small, but when the object was at close range it became very objectionable. One method of overcoming this difficulty was to place a beam-splitter in front of the two lenses. The beam-splitter (Fig. 32) consisted of a system of prisms constructed in such a way that the normal light falling into one lens was blocked out and that falling into the other was divided into two beams, one entering each lens. The use of the beam-splitter,

67

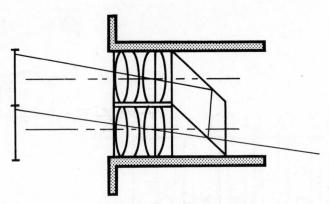

Fig. 32 Kodachrome. Kodachrome twin lens optical system with correcting prism.

however, introduces a second error, particularly in the photographing of objects at very close range, namely a difference in the magnification of the two images. This is due to the fact that the optical path from the object to the lens which receives the light reflected by the prism is greater than the path from the object to the lens which receives the light transmitted by the prism.

In addition to the optical errors which it introduced, the double frame method of exposure employed in the Kodachrome process introduced certain physical limitations. The maximum diameter for any circular lens used in the process was the height of a single frame. Thus a two inch lens was limited to a speed of f/2·8 and a three inch lens to a speed of f/3·7. The effective speed was even further reduced by the use of a beam splitter and the filter factors of the red and green filters.

Because of the need for increased light and the general limitation of the amount of light that can be used on a subject in close up, it was frequently desirable to omit the beam splitter and thus increase the exposure obtainable with any given amount of light. When this was done the parallax could be corrected during one of the printing steps. However, the background would be out of register by an amount which would be greater for the more distant planes. This effect was more pronounced if distinct horizontal lines were noticeable in the background.

Processing of the original alternate frame red/green negative was accomplished in normal black and white developing equipment using normal black and white developer.

After the exposure and processing of the original negative the next step in the process was the preparation of the master positives. The camera negative contained a number of defects which must be corrected either during this stage or in the making of the final prints. These defects were:

1. Stereoscopic parallax and other horizontal errors in registry.
2. Lack of vertical registration.
3. Difference in magnification.
4. Differences in frame line position.

68

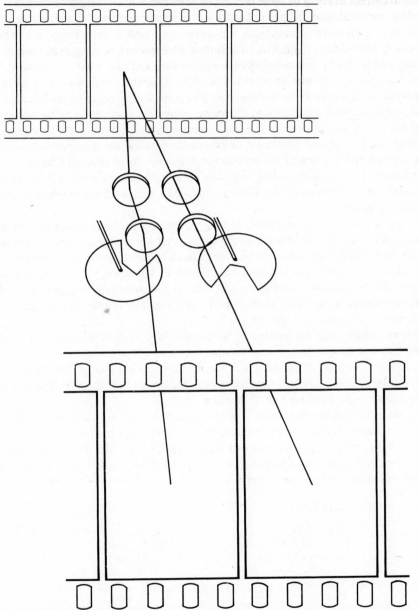

Fig. 33 Kodachrome. Optical printer for printing Kodachrome master positive. The two frames are imaged at a one-to-one magnification on a single frame.

5. Differences in exposure on the two frames.
6. Differences in contrast.

In order to correct as many of these defects as possible, a special optical printer (Fig. 33) was employed for the printing of the master positive. This printer consisted of a projector with a film gate and pull-down mechanism for advancing and illuminating two frames simultaneously with diffuse light. The two frames were imaged at a magnification of approximately one-to-one by two lenses upon a single frame aperture in the camera head. The raw stock was pulled down one frame at a time; once while the two frames of negative are being pulled down and once in the middle of the rest period of the negative. Shutters located in front of each lens were timed so that the frames were alternately exposed onto alternate frames of master positive raw stock. The lens system was adjustable as a unit for changes in overall magnification, or each lens could be adjusted separately along its parallel axis or at right angles to the axis to correct for differences in individual image size, parallax and lack of vertical registry. To permit individual exposure control of each record, both lenses were equipped with adjustable diaphragms. Changes in overall contrast could be made by inserting filters in the beams.

In the early stages of the development of this process the master positives were contact printed without correction. Therefore, any corrections that were necessary had to be made in printing the final prints. This proved to be both difficult and uneconomical. It soon became evident that it was more practical and economical to introduce the corrections while preparing the master positive where speed and cost per foot were not important. Using this procedure, the release prints could be printed on a much simpler printer. The optical system for such a printer is shown in Figure 34.

The master positive was illuminated by a specular light system. By means of a beam splitter the alternate frames were printed on opposite sides of the double-coated print film.[9] The film advance mechanism pulled down one frame of double coated film for each two frames of master positive. Shutters were included in the beams so that each frame of master positive was only printed on one side of the print film.[10]

After printing, the double coated film was developed to a negative in a conventional black and white developer, washed for ten minutes, then bleached in a bath which hardened the gelatin only in the areas where the image had been printed. Fixing after development was unnecessary since the bleach converted the silver to silver bromide which had to be removed by fixing after bleaching.

Bleach

Solution A

Potassium ferricyanide	37·5 grams
Potassium bromide	56·25 grams
Potassium dichromate	37·50 grams
Acetic acid	10·0 ml
Water to	1·0 liter

Solution B

Potassium alum	5% solution

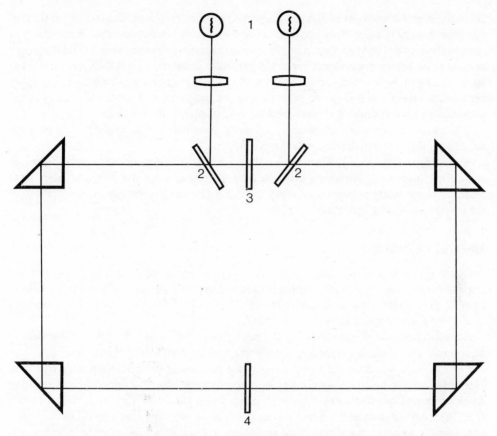

Fig. 34 Kodachrome. Optical system for printing both sides of double-coated print film simultaneously. 1. Twin lamps. 2. Twin semi-reflecting mirrors. 3. Master Positive film. 4. Double-coated Print film.

Fig. 35 Kodachrome. Film dyeing machine for coloring release prints. 1. Mordant Bath. 2. Dye Bath.

Solutions A and B were mixed in equal proportions. When bleaching was completed the film was fixed in an acid, alum-free hypo solution and washed for twenty minutes. This wash was followed by immersion in a solution of 5% ammonia for three minutes, then an additional five minutes wash before it was dried. Figure 35 illustrates in diagram form the machine used to apply the dye to the finished print.[11] As the film passed through the machine a series of roller applicators applied the dye to one side of the duplitized positive. Then the film was washed and dried and run through a second machine which applied the dye to the other side.

The amount of dye was controlled by counter tension rollers. The applicator rollers were not driven; only the mordanting rollers were driven.

Special dyes known as Kodachrome red and Kodachrome green were used in the dye applicating machine.[12] Although their names and formulas are not available, they were probably of the pinatype family since they were only absorbed by the non-tanned portions of the print in the dyeing operation.

BREWSTER COLOR

Brewster Color was a two-color subtractive color process introduced in 1915. For the original photography a red and a green separation negative was exposed in a beam splitter camera. Prints were made on duplitized positive film. The process was extensively modified after 1930 and made into a three-color system.

Although Brewster Color seems to have been used commercially there does not appear to be any reference available regarding specific pictures or studios that made use of it.

For the two-color Brewster Color process the red and green separation negatives were exposed simultaneously in a special beam-splitter camera which contained a beam-splitting block prism and two film gates. The block prism was replaced by a mirror surfaced shutter (Fig. 36) mounted at an angle so that the negatives in the two film gates were exposed.[13] After exposure the negatives were developed separately to obtain matched gamma.[14] Brewster is one of the few workers in the early days of color processing who identified and attempted to compensate for the defect inherent in most two color processes, i.e., mismatch of contrast which produced warm shadows and cold highlights. He proposed that sensitometric exposures be made using films and filters of the same type that were to be used for taking the separation negatives. With these sensitometric exposures a developing time series would be processed and developing times producing matched gammas for the red and green records would be chosen.

When a proper set of negatives had been obtained, prints were made on duplitized positive film. After exposure the prints were developed in a conventional black and white positive developer to produce a low contrast, low density image, fixed and washed. This was followed by hardening in a 10% solution of formalin, washing and bleaching.

Bleach

Iodine	1·0 gram
Potassium iodide	50·0 grams
Water to	1·0 liter

72

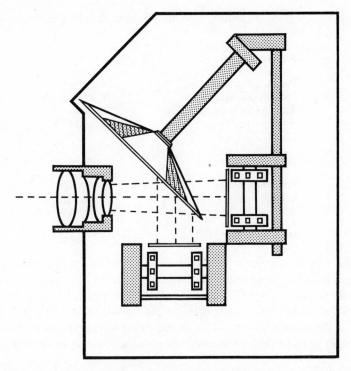

Fig. 36 Brewster color camera. A mirror-surface shutter was used to expose separate negatives in two film gates.

After bleaching the film was washed and cleared in a 2% solution of sodium bisulfite and dyed in basic aniline dye. The side printed from the red record negative was dyed with malachite green, the side printed from the green record was dyed with Rhodamin. The film was then washed and dried.

The bleach described in the Miller patent USP 1214940 (formula above) unfortunately presented some problems when put into practical use. Its keeping qualities were not good; also, it had a tendency to dissolve out some of the silver iodide from the film which caused a loss of highlight detail. Also some of the silver iodide in the solution transferred to and was retained by the film; this silver absorbed dye like the image-bearing portions of the film producing muddy white.

To overcome these problems Brewster proposed a modification of the process in which the bleach was formed within the image layers. In the modified process the film was developed, fixed and washed, then hardened in a formaldehyde solution, cleared and dried. Next it was treated with an alkalin solution of potassium iodide and potassium iodate, 8 to 1 proportion, forming a 10% solution. From this pre-treatment it passed into a chamber where it was exposed to acetic acid fumes which reacted with the iodate and the iodide to form iodine. An alternative proposal was to bleach the image by immersion in an acid bleach instead of the acid fume treatment. When bleaching was completed by either method the excess iodine was

73

cleared by treatment with a 2% sodium bisulfite solution, and the film was dyed in a basic aniline dye.

Pre-Bath

Potassium iodide	63·6 grams
Potassium iodate	14·4 grams
Ammonium hydroxide 28%	0·1 ml
Water to	1·0 liter

Bleach

Potassium iodide	60·0 grams
Iodine	2·0 grams
Ammonium chrome alum	5·0 grams
Acetic acid 98%	5·0 ml
Water to	1·0 liter

As the demand for three-color in place of two-color prints increased, Brewster Color was changed from a two-color to a three-color process. Under the new system two-color prints were made in the normal manner of duplitized positive. The third color, yellow, was added by first transferring a mixture of cuprous chloride and hydrochloric acid to the print from a matrix and then dyeing in a solution of auramine. Prints were prepared for transfer by first "laking" the dyes to make them as insoluble as possible. If the dyes were basic dyes mor-

Fig. 37 Brewster color. Dye transfer machine for application of third color. 1. Drive Sprockets. 2. Transfer Sprocket. 3. Double-coated Positive. 4. Matrix. 5. Water pre-bath. 6. Color dye solution. 7. Roller Applicator of KI solution. 8. Wash.

danted on silver iodide, "laking" was not necessary.[15] The matrix was prepared by printing the blue separation negative through the base of the matrix film and developing up a relief image through the use of a pyro tanning developer and a warm water wash off.[16] The silver image was then removed by treatment with a ferricyanide bleach followed by fixing in a non-hardening fixing bath. This was followed by another wash, then the matrix was soaked in the cuprous chloride solution and was ready for the transferring step. Transfer took place very rapidly, in approximately one-tenth of a second, on a machine illustrated diagrammatically in Figure 37.[17] Immediately after transfer the print was treated with a 20 to 50% solution of potassium iodide, washed and dyed in an auramine dye. After dyeing the film received an acid rinse to set the dye and was washed and dried.

A demonstration of three-color Brewster Color was presented April 12, 1935 to a joint meeting of the Colour and Kinematograph groups of the Royal Photographic Society.[18] Among the films presented was "Let's Look at London," a film which showed interior and exterior scenes, including a ballet performance. Comments regarding the showing were "remarkable steadiness," "extraordinarily good reds." It was believed that the lack of sharpness was due to the imbibition printing.

Matrix Developer

Pyro	8·0 grams
Sodium hydroxide	3·0 grams
Ammonium chloride	1·5 grams
Potassium bromide	1·5 grams
Citric acid	0·2 gram
Water to	1·0 liter

Transfer solution

Cuprous chloride	25·0 grams
Ammonium chloride	100·0 grams
Hydrochloric acid	50·0
Potassium metabisulfite	10·0 grams
Water to	1·0 liter

POLYCHROMIDE

The Polychromide process was a two-color subtractive system of color cinematography invented in 1918 by Aron Hamburger. While this process was invented by an American, it cannot truly be called an American process since it was developed and used commercially in England rather than the United States.[19]

For this process an orthochromatic and a panchromatic negative were exposed in a beam-splitter camera. With the introduction of Bi-Pack negatives the use of a beam splitter camera was dropped in favor of conventional cameras and Bi-Pack negative films. After exposure the negatives were processed in a normal black and white developer, fixed, washed and dried. Prints were made on double coated positive film which was dye toned red-orange on one side

and blue-green on the other side. Hamburger claimed that the dye mixture he used had special properties when applied to a photographic image. With his two-color process he claimed to reproduce foliage as green and the sky as purplish blue. Yellows were reproduced due to the addition of auramine to the magenta dye.

Polychromide prints were made on a Debrie printer which exposed both sides of the positive film simultaneously. After exposure a low density, low contrast image on both sides of the film was developed by immersion in a metol developer. Next the dye was applied to each side separately by a series of application wheels. The side printed from the orthochromatic negative was dyed with a mixture of Fuchsin and Auramine. The side printed from the panchromatic negative was dyed with a mixture of Malachite Green and Helio Safranine. Dyeing was followed by immersion into a combination bleach and mordant, then into a clearing bath, followed by a wash and drying. According to Cornwell-Clyne, the use of the dye first followed by the bleach and mordant resulted in a considerable gain in overall evenness in the process.[20]

Positive Developer

Metol	7·0 grams
Sodium sulfite (anhydrous)	25·0 grams
Sodium carbonate	125·0 grams
Potassium bromide	1·7 grams
Water to	1·0 liter

Bleach and Mordant

Potassium iodide	70·0 grams
Potassium ferricyanide	10·0 grams
Chromic acid	2·0 grams
Potassium dichromate	5·0 grams
Water to	1·0 liter

Clear

Potassium metabisulfite	5% Sol.

Red-Orange Dye

Solution A	
Magenta or fuchsin	2·0 grams
Alcohol	15·0 ml
Water	100·0 ml

Solution B	
Auramine O	2·0 grams
Alcohol	100·0 ml

For use mix: 100 parts A
 25 parts B
 10 parts glycerine

Blue-Green Dye

Solution A

Malachite green	40·0 grams
Alcohol	225·0 ml
Water	1,000·0 ml

Solution B

Helio safranin	40·0 grams
Alcohol	200·0 ml
Water (212°F.)	1,000·0 ml

For use mix: 100 parts A
 32 parts B
 3 parts acetic acid
 6 parts glycerine

TECHNICOLOR

The Technicolor process as introduced in 1916 was a two-color additive process that employed double projectors to superimpose the two-color components of the picture on the screen, one through a red filter and one through a green filter. In 1919 the process was changed to a two-color subtractive process that employed two prints cemented, base to base. The process was changed again in 1928 to a single print film with the two colors imbibed one on top of the other. In 1932 a third color was added and since then Technicolor has been a three-color subtractive process producing prints by the imbibition method.[21]

The first picture produced in the Technicolor process was *The Gulf Between*. This was the first and only production photographed and exhibited using the Technicolor additive system. The difficulties encountered with the exhibition of this film convinced the Technicolor personnel that to be successful a color process had to employ standard projection equipment and procedures. The two-component cameras used for the additive system were retained and work was begun on the development of a compatible two-color subtractive color print system.[22]

The first Technicolor production by the subtractive method was *The Toll of the Sea*, released in 1922 by MGM. The first showing was given at the Rialto Theater in New York during the week of November 26, 1922. The prints for *The Toll of the Sea* were made at the Technicolor Laboratory in Boston at a cost of approximately 27 cents per foot. Other early Technicolor films released by the cemented-together subtractive color print methods were *The Wanderer of the Wasteland*, *The Black Pirate*, and *The Viking*, insert portions of *Cytherea* and *Ben Hur* and twelve two-reel short subjects.[23]

Two-color imbibition prints using the Technicolor process were released in 1928. The first all-talking color motion picture, *On With the Show*, used this printing method. With the success of *On With the Show* (grossed over $3,500,000) interest in color increased rapidly. In 1929 it was necessary for Technicolor to double its laboratory capacity. Print orders for 1930 amounted to approximately 60,000,000 feet. Outstanding examples of the two-color

system released during this period were Warner Bros. *Wax Museum*, and Goldwyn's *Whoopee*, and several other films or portions of films for all of the major production companies.[24]

Three-color imbibition prints were first available in 1932. During that year Walt Disney used one of the three-color cameras to produce three-color negatives for the three-color imbibition release of his *Flowers and Trees*, a *Silly Symphony*. It was not until September, 1937, that he first used the sequential frame system to produce a picture called *Lonesome Ghosts*. The first full-length feature to use the three-color Technicolor system was *Becky Sharp* released by Pioneer Pictures. Print cost at this time had dropped to $5\frac{1}{2}$ cents per foot.[25]

From 1932 to the present Technicolor has continued to improve its three-color system. In an attempt to eliminate the cumbersome three-strip cameras "Monopack," a multilayered tripack of the Kodachrome variety (Chapter VIII) was introduced in 1942. This film was first used for a full length feature production in the 20th Century-Fox picture, *Thunderhead*, in 1944.[26] Monopack, however, failed to match the quality obtainable with the three-strip films and the beam-splitter cameras. Three-strip negative remained the standard of quality until the introduction of the tungsten-balanced Eastman Color Negative film in 1953.

The first Technicolor system was a two-color additive process that employed a special film, camera and projector.

The camera used for this process contained an ingenious light-splitting device located behind a single lens.[27] This device, which consisted of a perforated silver mirror coated on the interface of one of a series of double reflecting prisms, made possible the simultaneous exposure of two standard size frames, one through a red filter, the other through a green filter. These frames were separated the distance of two pictures, thus in each foot of film frames one and four made a pair, three and six, five and eight, seven and ten, etc. The film was advanced two frames at a time exposing sixteen frame pairs per second. The somewhat complicated optical system resulted in a considerable loss of light reaching the film, therefore a special hypersensitized panchromatic negative film had to be designed into the system. Prints were made on conventional black-and-white film.[28] The projector had two lenses positioned one above the other, one having a red filter and the other a green filter. The separation between the pairs of frames made it possible to project a matched pair at the same time using the normal projection speed of sixteen frames per second. Registration of the two images was accomplished while the picture was running through the use of two adjusting glasses mounted between the two image apertures and the two lenses of the projector.

Both of these glasses were mounted between pivots, the upper being rotatable about a horizontal axis while the lower plate rotated about a vertical axis.

Because of the large loss of light due to the additive projection system it was necessary to design and fabricate a horizontal magnetically-controlled arc which gave one-third more light for the same current. In addition to producing the needed light increase this also greatly improved the light uniformity at the film plane.[29]

The next Technicolor system tried was a two-color subtractive process. At first the same beam-splitter cameras used for the additive system were used for the subtractive process. However, since the frame separation was not required for projecting the new subtractive prints the use of a simpler beam-splitter with a corresponding reduction in light loss was now

78

possible. The new camera was similar to the Bell & Howell Standard in basic design although it differed in several details. Through the use of a beam-splitter prism two standard size frames were exposed simultaneously, one through a red filter and one through a green filter. The film was advanced two frames at a time so that at normal camera speed twice as much film was used as for black and white photography. The two corresponding frames were adjacent to each other on the film, one inverted in respect to the other. The registration relationships were symetrical around the center line between two such adjacent frames and were controlled by the position of the pictures with respect to the sprocket holes. Registration was determined in the beginning by the accurate adjustment of the optical system on the camera and from then on it was automatic. Each camera came with two sets of prism and filter combinations, one for tungsten illumination, the other for daylight or arc illumination.

The previous additive system had used conventional black and white prints introducing the color during projection, this new subtractive system employed dyed prints and normal projection.

Using a special printer separate prints were made from the red and green filter negatives on relief print film that was one-half the thickness of ordinary motion picture positive film. After printing, the two films were cemented together with sprocket holes in perfect registration and with the emulsion sides out. The cemented prints were then processed in a tanning developer, which tanned the image bearing portions of the gelatin leaving the remainder unaffected. The film was then washed and immersed in a ferricyanide solution which converted the developed silver to halide. This was followed by a hot water etch which removed the non-image bearing gelatin leaving a relief image on both sides of the film. The thickness of the relief varied with the density of the image which produced it. The silver image that had been converted by the bleach was then removed in a fixing bath and the film washed and dried. The side printed from the red filter negative was dyed blue-green and the side printed from the green filter dyed red-orange.[30]

The third fundamental change in the Technicolor process was the abandoning of the cemented-together two-color subtractive print system and the introduction of true imbibition color prints on single-coated positive film. For this process the first step was the preparation of a relief image print or matrix from each of the two negative records. These matrices were prepared in the same manner as the cemented-together prints. Their difference lies in the fact that they were two separate films and that each one was coated on extra thick (7 mil) base instead of the half-thickness used in the previous process. When finished each matrix contained a gelatin relief image of one color aspect of the scene.

After development and etching to form the relief image the matrices were put on a special transfer machine where they function like a half-tone plate in lithography. The matrix printed from the red filter record negative was dyed with a cyan-blue dye and then pressed into contact with a special transfer film. While in contact the dye transferred from the matrix to the transfer film producing a positive dye image. When the transfer was complete the transfer film passed into contact with the matrix printed from the green filter record negative. The red dye from this matrix was transferred on top of the cyan-blue image produced by the other matrix. The transferred print was then washed and dried and was ready for projection.[31]

The fourth major change in the Technicolor process incorporated fundamental changes in

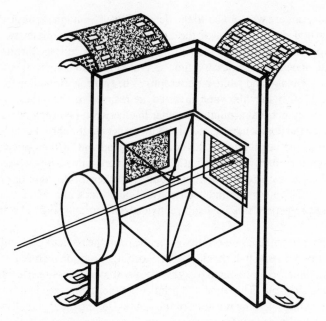

Fig. 38 Technicolor three-color beam splitter. The prism divides the light from the camera lens to expose a green-sensitive negative at one aperture and a bi-pack at the other.

both the camera and the print process. In order to produce a three-color subtractive color process a new three-strip beam-splitter camera was developed (Fig. 38), and the third matrix was added to the matrix printing and transfer system.

The new camera employed a special optical system which exposed the green-sensitive negative film at one picture aperture and a bipack at a second picture aperture. The bipack consisted of a red-sensitive negative film which was placed emulsion to emulsion with a blue-sensitive negative film. The front element of the bipack was the blue-sensitive film. To prevent any blue and green light from reaching the rear red-sensitive film, the blue-sensitive emulsion, which was exposed through the base, contained a red-dyed gelatin overcoating which performed the dual function of antihalation layer for the blue negative and a filter which prevented all but the red light from reaching the red negative.

After exposure the three negatives were developed to a gamma of 0·65 in a conventional black and white developer, fixed, washed and dried.[32]

From each of the separation negatives, which had been combined with three duplicate negatives containing any added special effects, a matrix was exposed through the base on an optical step registration printer. As in the two-color process these matrices were developed in a tanning developer which tanned the gelatin in the image bearing areas leaving the remainder of the film unaffected. After washing the film was immersed in a ferricyanide bleach which converted the silver in the image to silver halide. This was followed by a hot water etch which removed the main image-bearing gelatin leaving a relief image. The

80

thickness of the relief varied with the density of the image which produced it. The silver that had been converted by the bleach was then removed by immersion in a fixing bath. The three matrices then had a hardened gelatin relief image which corresponded to the red, green and blue components of the picture, and were ready for imbibition printing.

Before the actual transfer was made to the blank transfer film, the sound track was printed from a black and white optical sound negative. From this a silver sound track was developed using a normal black and white developer. The track was fixed, washed and dried and the blank was then ready for picture transfer.

The three matrices were passed through temperature controlled dye baths where the hardened images absorbed dye in proportion to the degree of relief in various areas of the images. The dye transfer operation brought each dyed matrix while still wet into contact with a blank film on which the gelatin mordant receptive layer was already swollen. Dye transfer took place in approximately 45 seconds at a raised temperature of 110°F. The yellow dyed matrix was first to be brought into intimate contact with the blank in the transfer machine. During the transfer operation the two films were held in accurate registration on a continuous stainless steel pin-belt. After the major portion of the dye had been transferred from the matrix to the blank the films were separated and the matrix passed into decrocienating solution which removed any remaining dye, then it was washed and dried and was ready for re-use. The blank was washed and dried and was then ready to receive the cyan image which is transferred on top of the yellow image in accurate register. Once more the blank was washed and dried and the magenta image was transferred on top of the yellow and cyan images. The film now received a final wash and was dried ready for projection.

The fifth major change in the Technicolor process has been the replacement of the beam-splitter cameras and the three-strip negative film. With the introduction of Eastman Color Negative Film Type 5248 producers had available to them a film capable of producing a high quality negative color image without the use of special cameras. Further, since the processing steps used with this film were far less complicated than those required with previous color systems, processing was available at all of the major commercial laboratories. Eastman Color Negative has become the almost universal film used in original photography. During production daily prints are made on Eastman Color Print film; when the picture has been finished and edited, matrices are made directly from the Eastman Color originals. After the matrices have been prepared the final prints are made by imbibition in the manner described previously.[33]

Developer—Negative

Modified D-76 was used to develop beam-splitter negatives for both the two-color and three-color processes.

Developer—Matrix[34]

Pyro	8·2 grams
Citric acid	0·2 grams
Potassium bromide	4·0 grams
Sodium hydroxide	3·4 grams
Ammonium chloride	1·7 grams
Water to	1·0 liter

Oxidizing Bath[35]

Potassium ferricyanide	15% Solution

Fix

Sodium thiosulfate	10% Solution

Two-Color Dye System[36]

Red

Fast red S (3% Sol.)	555·0 ml
Acid magenta B N (6% Sol.)	250·0 ml
Metanil yellow	1·7 grams
Acetic acid	50·0 ml
Water to	1·0 liter

Green

Pontacyl green S N (4½% Sol.)	335·0 ml
Metanil yellow	1·2 grams
Acetic acid	54·0 ml
Water to	1·0 liter

Three-Color Dye System[37]

Yellow

Anthracene yellow G R	5·0 grams
Acetic acid	25·0 ml
Water to	1·0 liter

Magenta

Acid magenta 2B (6% Sol.)	220·0 ml
Acid magenta B N (6% Sol.)	16·0 ml
Fast red S (3% Sol.)	85·0 ml
Acetic acid	35·0 ml
Water to	1·0 liter

Cyan

Pontacyl green S N (4½% Sol.)	15·0 ml
Fast acid green B (3% Sol.)	45·0 ml
Acetic acid	35·0 ml
Water to	1·0 liter

Note: These dyes given as an example of what could be used (USP 1,900,140). There is no data published as to the actual dyes used by Technicolor Corp.

KELLEY COLOR

In 1926 William V. D. Kelley became associated with Max Handschiegl, and Kelley Color Films, Inc., was formed. It was the aim of this company to extend the Handschiegl system of imbibition coloring to a two-color subtractive process. In a paper presented to the Society of Motion Picture Engineers in October 1926, Kelley described the former Handschiegl process and its extension from a tinting process for portions of scenes to a natural color, two-color process.[38] The process he described is apparently the one covered by USP 1316791 granted to Max Handschiegl, September 23, 1919.

For the original photography, panchromatic film was exposed through the two-color filters, orange-red and blue-green, using successive frame exposure. This negative was developed in a normal black-and-white developer, fixed, washed and dried. From this negative a positive print was made on a skip-frame printer which advanced two frames of negative for every frame of positive. After development the silver image was converted to silver iodide or silver ferricyanide and dyed green. The iodide or ferricyanide acted as a mordant for the dye and resulted in a uniformly dyed print which was then washed and dried. Returning to the original negative, a second print was made on a skip-frame printer, this time omitting the frames that were printed previously and printing the alternate frames. From this second positive a duplicate negative was printed and developed in a normal black-and-white developer. After development the duplicate negative was immersed in a tanning bleach that fixed and solidified the exposed and developed portions of the scene, hardening them so that they would not absorb dye, but not affecting the viscous consistency of the unexposed or clear portions of the scene. When bleaching was completed the negative was fixed, washed and dried. The bleached negative was then immersed in a saturated solution of red dye in water. When it had absorbed sufficient dye it was removed, squeegeed and dried. The two films were now ready for transfer using the equipment described in USP 125028.

Unfortunately this process originated by Handschiegl did not work when attempts were made to apply it to production. It was not found possible to use any known color toning system without producing some relief or differential hardness on the surface of the print, even when printed through the base. Therefore the process in this form was abandoned and a new method was attempted.

Judging by a second article presented to the Society of Motion Picture Engineers by Kelley,[39] the new method was a procedure outlined in his patent USP 1505787. Printing negatives were prepared by printing the green negative and a print from the red negative superimposed to produce the red printing negative. The green printing negative was prepared by printing the red negative and a print from the green negative superimposed. The blue printing negative was prepared by printing either the red or green negatives and the blue positive superimposed. The three printing negatives were developed normally and bleached in a tanning bleach. The negatives were then washed in warm water, dried and dyed with the appropriate dyes, squeegeed and dried.

Before the transfer step a key image was printed from the red negative onto the film that is to receive the transfer. This film was developed, fixed, washed and dried in the normal manner for black and white prints. The black and white key image print was then run in con-

tact with each of the three printing negatives through the three transfer stations on the transfer machine described under USP 1295028. The finished film, "in full color,"[40] consisted of a single coating containing a black-and-white record, and a red, green and blue record superimposed. For projection the film is handled in the same manner as black and white positives.

According to Kelley the bleach used for this process is the one described by E. J. Wall in his book *Practical Color Photography*.[41]

Bleach

Hydrogen peroxide	30·0 ml
Cupric sulphate	20·0 grams
Nitric acid	5·0 ml
Potassium bromide	0·5 grams
Water to	1·0 liter

Dyes

Red Printing Negative
Crocein scarlet 4BX: Sodium salt of p-sulphonaphthalene-azo-B-naphthol-disulphonic acid.

Green Printing Negative
Guinea green: Sodium salt of di-ethyl-di-benzyl-di-amino tri-phenyl carbinol tri-sulphonic acid.

Blue Printing Negative
Ponceau R: Sodium salt of xylene-azo-B-naphthol-disulphonic acid.

Although this method produced some very excellent results, it had the disadvantage that anything black in the subject received the greatest quantity of dye from the matrix which, when imbibed to the positive print, inclined to splash over where it would show the most.

This problem could have been solved by the elimination of the key print and the substitution of a blank. Unfortunately, at the speed of 360 feet per hour the matrices did not produce sufficient color on a blank for the transfers to make the blacks opaque enough for projection without the black and white key prints.

The death of Max Handschiegl on May 1, 1928 and the inability to solve the problems associated with the imbibition process caused the Kelley Color Company to abandon this system and try a third system.

For this new system the separation negatives were printed onto normal single-coated black and white positive film. The red-separation negative was printed first with its emulsion toward the base of the print film. After exposure, the print was developed and washed, then toned blue-green with an iron toner. When toning was complete the print was washed, cleared, rewashed and dried. All these operations were performed in the dark. The film was then returned to the printer where the remaining silver halide was exposed from the emulsion side through the green-separation negative. This second exposure was developed in a developer that did not destroy the blue-green image produced by the iron toner. After washing one of two separate proposals could be followed.

84

1. (USP 1674174) Bleach for five minutes in a chromic acid, potassium ferrocyanide, bleach, clear, wash, fix in a non-hardening hypo, wash and dry.
2. (USP 1562268) Fix in a non-hardening hypo, wash, and tone in a uranium ferrocyanide toner. The remaining silver which had been converted to silver chloride was removed by fixing in a hypo solution and the finished print was washed and dried.

Developer—3 minutes

Diamidophenol	5·0 grams
Sodium sulphite	30·0 grams
Potassium bromide	94·0 grams
Potassium iodide 10% sol.	1·0 ml
Water to	1·0 liter

Iron Toner

Oxalic acid	5·0 grams
Vanadium oxalate 10% sol.	1·0 ml
Ferric ammonium oxalate	14·0 grams
Potassium ferricyanide	5·0 grams
Water to	1·0 liter

Clear—10 minutes

Ammonium bromide	6·0 grams
Potassium bichromate	6·0 grams
Water to	1·0 liter

Solutions for remaining steps

USP 1674174

Bleach—5 minutes

Chromic acid	6·0 grams
Potassium ferrocyanide	6·0 grams
Water to	1·0 liter

Clear

1% Sol. Potassium metabisulfite

Fix—5 minutes

Sodium thiosulphate	600·0 grams
Potassium metabisulphite	60·0 grams
Water to	1·0 liter

Dye

Serichrome blue (triphenylmethane)	1·0 gram
Wool Orange A	
(diphenylnaphthylmethane)	1·0 gram
Water to	1·0 liter

USP 1561168

Fix—5 minutes

Sodium thiosulphate	600·0 grams
Potassium metabisulphite	60·0 grams
Water to	1·0 liter

Toner—5 minutes

Uranium nitrate	9·0 grams
Potassium oxalate	4·0 grams
Hydrochloric acid	3·5 grams
Water to	1·0 liter

Fix—5 minutes

Sodium thiosulphate	600·0 grams
Potassium metabisulphite	60·0 grams
Water to	1·0 liter

HARRISCOLOR

Harriscolor was a two-color subtractive process for color cinematography invented by J. B. Harris, Jr., in 1929. According to Cornwell-Clyne,[42] the Harriscolor Company purchased the Kelley Color Company.

Harriscolor was a complete process for color cinematography offering both a camera system and a printing system. Two separation negatives were obtained by exposing a panchromatic and an orthochromatic film in a beam-splitter camera. Prints were made on yellow dyed single-coated print film. Simultaneously the red-record negative was printed emulsion to emulsion on the print film while the green-blue negative was printed emulsion to the base of the print film. The yellow dye in the print film prevented overlapping of the red and green record exposures. After exposure the latent image from the red-record negative was developed in a black and white developer, washed, and toned blue-green in a ferric toner. The film then passed into a sensitizing bath that prepared the lower latent image from the green record negative for development. The lower image was developed and toned red in a copper toner that did not affect the top image, washed and dried.[43]

A variation of the above printing method was described in the SMPE color committee report, 1930.[44] The red record negative was printed through the base of the positive film. This

latent image located in the lower part of the print film emulsion was developed in a black and white developer, washed, and toned blue-green in a ferric toner. The film was then washed and dried in the dark. The green-blue record negative was then printed on the surface of the emulsion. This image was developed in a developer that did not affect the lower blue-green image. The film was then fixed and washed, then toned in a uranium toner, washed and dried.

Print Developer for First Black and White Development

Hydroquinone	18·0 grams
Sodium sulfite	100·0 grams
Potassium bromide	4·5 grams
Sodium hydroxide	18·0 grams
Water to	1·0 liter

Ferric Toner

Ferric ammonium oxalate	6·0 grams
Potassium ferricyanide	6·0 grams
Citric acid	6·0 grams
Water to	1·0 liter

Sensitizing Bath

Potassium dichromate	10·0 grams
Ammonium bromide	10·0 grams
Water to	1·0 liter

Second Developer

Diamidophenol hydrochloride	5·0 grams
Sodium sulfite	60·0 grams
Lactic acid	5·0 ml
Water to	1·0 liter

Copper Toner

Sodium citrate	50·0 grams
Cupric sulfate	10·0 grams
Potassium ferricyanide	5·0 grams
Water to	1·0 liter

PHOTOCOLOR

The Photocolor process was a two-color subtractive system of color cinematography introduced in 1930. The October 8, 1930 issue of the *Hollywood Reporter* carried an item that the Photocolor Corporation of New York was planning to build a laboratory in Hollywood with a capacity of 1,000,000 feet of film a week. It was expected that the new plant would be in operation shortly after the first of the year, 1931.

When the process was introduced photography was accomplished through the use of a twin lens camera operating at two and one-half times normal speed. Two frames were exposed simultaneously, one through a red filter, one through a green filter. The wide frame line obtained between the pairs of frames was eliminated during printing.[45] This system was apparently abandoned after a short time. In his report to the Color Committee of the Society of Motion Picture Engineers, January, 1931, A. G. Waddingham, technical director of the Photocolor Corp., described a camera of special design which employed a beam-splitter and special taking filters to produce two separation negatives. After exposure the negatives were developed in a conventional black and white developer, fixed, washed and dried.[46]

Prints were made on a special optical printer which printed the two images simultaneously on duplitized positive film. The print was developed in a black and white developer, fixed, washed and dried. The side printed from the red-orange filter negative was then toned blue-green by floating it face down on the surface of the toning bath. This bath oxidized the metallic silver image, converting it to silver ferrocyanide; at the same time blue-green ferric ferricyanide was precipitated, toning the image cyan. The film was then washed and immersed in a bath which leaves the blue-green image unaffected and toned the side printed from the green filter negative red-orange.[47]

Although there have been no details published regarding the formulas used in the Photocolor process, it can be deduced from the process information given that formulas similar to the following must have been used:

Blue-Green Toner

Ammonium persulfate	0·5 gram
Ferric alum	1·25 grams
Oxalic acid	3·0 grams
Potassium ferricyanide	1·0 gram
Ammonium alum	5·0 grams
Water to	1·0 liter

Orange-Red Toner

Uranyl nitrate	2·5 grams
Potassium oxalate	2·5 grams
Potassium ferricyanide	1·0 gram
Ammonium alum	6·0 grams
Hydrochloric acid (10%)	5·0 ml
Water to	1·0 liter

REFERENCES

[1] KALMUS, H. T., "Technicolor Adventures in Cinemaland," *Journal of the Society of Motion Picture Engineers*, December, 1938, p. 566.
[2] The Colorgraph Company, Exchange Building, 145 West 45th Street, New York City, New York.
[3] HERNANDEZ-MEJIA, A., "The Colorgraph Process of Color Cinematography," *British Journal of Photography*, October, 1912, pp. 805–807.
[4] USP 1174144.
[5] USP 1525423.
[6] USP 1562828.
[7] CAPSTAFF, J. G., USP 1196080 applied for September 21, 1914.
[8] MATHEWS, G. E., "A Motion Picture Made in 1916," *Journal of the Society of Motion Picture Engineers*, November 1930, pp. 624–626.

[9] CAPSTAFF, J. G., USP 1273457 applied for 1918.

[10] CAPSTAFF, J. G., USP 1478599 applied for 1923.

[11] CAPSTAFF, J. G., USP 1351834 applied for 1920.

[12] FRIEDMAN, J. S., *History of Color Photography* (Boston: The American Photographic Publishing Company, 1944), pp. 467–468.

[13] USP 1752477.

[14] USP 1410884.

[15] USP 2070222.

[16] WALL, E. J., *History of Three Color Photography* (Boston: The American Photographic Publishing Company, 1925), p. 356.

[17] USP 2070222.

[18] "The Brewster Colour Process," *The Photographic Journal*, The Royal Photographic Society of Great Britain, August, 1935, pp. 455–456.

[19] CORNWELL-CLYNE, ADRIAN, *Colour Cinematography* (London: Chapman and Hall, Ltd., 1951), p. 19.

[20] *Ibid.*, p. 340.

[21] KALMUS, H. T., "Technicolor Adventures in Cinemaland," *Journal of the Society of Motion Picture Engineers*, Dec., 1938, pp. 564–584.

[22] *Ibid.*, p. 565.

[23] *Ibid.*, pp. 567–571.

[24] *Ibid.*, p. 573.

[25] *Ibid.*, pp. 578–580.

[26] CLYNE, A. C., *Colour Cinematography*, London: Chapman and Hall, Ltd., 1951, p. 457.

[27] USP 1231710.

[28] GREGORY, C. L., *Motion Picture Photography*, New York: Falk Publishing Co., Inc., 1927, pp. 338–340.

[29] KALMUS, H. T., p. 566.

[30] GREGORY, C. L., p. 341.

[31] GREGORY. C. L., p. 343.

[32] CLYNE, A. C., p. 463.

[33] *Elements of Color in Professional Motion Picture*, New York: Society of Motion Picture and Television Engineers, 1957), pp. 32–83.

[34] USP 1535700.

[35] FRIEDMAN, J. S., *History of Color Photography*, Boston: American Photographic Publishing Co., 1944, p. 474.

[36] *Ibid.*, p. 480.

[37] USP 1900140.

[38] KELLEY, Wm. V. D., "Imbibition Coloring of Motion Picture Films," *Transactions of the Society of Motion Picture Engineers*, X, No. 28, pp. 238–242.

[39] KELLEY, Wm. V. D., "The Handschiegl and Pathechrome Color Processes," *Journal of the Society of Motion Picture Engineers*, August, 1931, pp. 230–234.

[40] USP 1505787.

[41] WALL, E. J., *Practical Color Photography* (Boston: American Photographic Publishing Company, 1928), p. 92.

[42] CORNWELL-CLYNE, ADRIAN, *op. cit.*, p. 18.

[43] USP 1825863.

[44] "Report of Color Committee, May 1930," *Journal of the Society of Motion Picture Engineers*, November, 1930, pp. 722–723.

[45] PECK, A. P., "Movies Take On Color," *Scientific American*, April, 1930, p. 285.

[46] "Color Committee Report," *Journal of the Society of Motion Picture Engineers*, January, 1931, pp. 97–98.

[47] PECK, A. P., "Movies Take On Color," *loc. cit.*

VI SUBTRACTIVE PROCESSES USING BIPACK
PHOTOGRAPHY

The role of the bipack in the development of color processes in America was important and varied. Several of the early two-color subtractive processes were based on the use of bipack negative for the original photography. The individual color processes were in reality systems for the production of release prints rather than complete systems of color cinematography.

It is generally agreed that the idea of bipack was first suggested by Ducos du Hauron in his *Handbook to Photography in Color* and by French patent FP 250862, 1895. Several applications of this principle to still photography followed and several patents were granted. One of the first to apply the principle to motion picture photography was P. D. Brewster, USP 1222925.

The bipack system of negative photography is a two-color system which uses only two records instead of the three required for natural color phoography. An ordinary motion picture camera with slight modifications is used to obtain an acceptably sharp image on both records by exposing them in the camera emulsion to emulsion. The front element of the bipack which is exposed through the base consists of a red dye overcoated orthochromatic emulsion. The rear element which is exposed in contact with the red dye overcoat is a panchromatic emulsion (Fig. 39). Both emulsions are carefully balanced for speed and contrast.

Fig. 39 Bipack negative. The bipack consists of two separate films: Front Film 1. Film Base. 2. Orthochromatic emulsion. 3. Red dye overcoat. Rear Film 4. Panchromatic emulsion. 5. Film base. 6. Anti-halation layer.

The red dye overcoat on the rear of the front emulsion in addition to acting as a filter for the rear film serves as its own anti-halation layer.[1]

Because it is a two-color process bipack does not reproduce all colors as they appear in

nature. The following table given in Cornwell-Clyne's *Colour Cinematography* lists several common colors and their reproduction through a bipack system.

Color of Original	Color Reproduced
White	White
Grey	Grey
Black	Black
Red	Red-Orange
Orange	Light Red-Orange
Yellow	Very pale Orange (Pinkish)
Yellow-Green	Grey
Green	Grey Green-Blue
Blue-Green	Green-Blue
Blue	Deep Green-Blue
Blue-Violet	Blackish Green-Blue
Violet	Black
Purple	Reddish-Grey
Rose	Grey Red-Orange
Flesh Color	Fairly correct
Foliage	Grey Blackish-Green
Sky-Blue	Pale Blue-Green

The actual shades and tones obtained will vary depending on the manufacturer of the bipack material and the print process used.

PRIZMA COLOR

Prizma was the name given to a series of color processes invented and developed by W. V. D. Kelley. Experimental work began in 1912. The first process that evolved was a four-color additive process called Panchromotion (see Chapter III).[2] Some time later Prizma, Inc., was formed and all subsequent processes were called Prizma Color. After an expenditure of six years and nearly three-quarters of a million dollars,[3] the company finally began producing results.

The first Prizma film was "Our Navy," shown in 1917 at the 44th Street Theater, New York City.[4] The process used for this showing was a four-color additive process which used a rotating color filter disk in front of both the camera and projector apertures. Color was synthesized by successive projection.

This was followed by a showing of scenic views and animal pictures at the Strand Theater, February 25, 1917.[5] Before this showing the process was changed to a two-color process in which the rotating color filter disk was eliminated from the projector in favor of dyed pictures on the print. The print was made up of successive frame pictures dyed red-orange and blue-green which were projected at twice normal speed.

With the introduction of duplitized positive the process was again changed. The result was a two-color print, one side dyed red-orange, the other side blue-green; projection speed was returned to normal, thus the prints could be shown in any theater. This new Prizma process

was introduced with the showing of "Everywhere with Prizma" at the Rivoli Theater, New York City. It is interesting to note that the advertisement for the Rivoli on opening night had no indication that a color picture would be shown. The review for the *New York Times*[6] commented that the color varied from excellent to poor and only served to emphasize that color photography had not yet been perfected. In spite of the opinion expressed by the *New York Times*, the process was successful. In 1922 Prizma was used for the first full length feature picture produced in color. *The Glorious Adventure* produced by J. Stuart Blackton[7] was successful in England, but not in the United States. Following the introduction to feature films, Prizma was used in several subsequent productions. In 1928 the process was sold to Consolidated Film Industries and the name was changed to Magnacolor.[8]

The original Prizma Color process was a four-color additive system for color cinematography. Red, green, yellow and blue were used for the colors. Pictures were made by the sequential frame method through rotating filters. To obtain more exposure and more light for projection the filters were wedged from full saturation to clear (Fig. 40). The film was advanced during the opaque time when the shutter is closed.

Fig. 40 Prizma color. Four-color filter disk for additive cinematography. 1. Red. 2. Green. 3. Yellow. 4. Blue.

Attempting to operate as a three- or four-color process by sequential frame photography, Prizma had problems similar to those that occurred in the Kinemacolor Process. Therefore, the process was changed to a two-color process using red-orange and blue-green for camera and projection filters. Also, camera and projection speed was reduced to 32 frames per second.

Even as a two-color process the additive projection was difficult. In order to eliminate the rotating filter disk from the projector altogether, the alternate frame negatives were printed onto normal black and white print film in superimposition. The red exposure was printed first giving less exposure than is normally required for black and white positives. After exposure the print was developed to convert the latent image into a gray silver image of low density and contrast. Development was followed by a clearing bath and wash. The film was then immersed in a 5% copper chloride solution, washed and immersed in a 1% solution of potassium iodide which converted the image to silver iodide, which was removed by immersion in a clearing bath until only a faint image remained. Once more it was washed, then it was dyed green. After an additional wash the emulsion was resensitized in an ammonium dichromate bath and dried. The film was now ready for printing of the green printing positive. After printing the excess dichromate was removed by washing in cold water and the print was dyed red. This was followed by an acid rinse to fix the pinatype dyes, then the remaining silver was removed by a fixing bath and the print was washed and dried. The pinatype dye had the property of attacking soft gelatin which had not been affected by light due to being covered by the dark portions of the printing positive, and it did not attack those portions which had become relatively hard owing to having been exposed to light through the open portions of the printing positive.[9]

In its final form Prizma made use of duplitized positive film. As in previous Prizma systems, the original negatives were alternate frame sequential exposures. The Prizma negative was printed on both sides of the positive film in a special printer. After developing in a normal black and white developer it was bleached in a bath that converted the two images to silver iodide. Two methods appear to have been used for dyeing the duplitized prints:

1. The film was wound tightly on a drum and the exposed side was dyed. When this step was completed, the film was dried and reversed onto a second drum and dyed the other color.[10]
2. The print was coated with a removable resist on the side printed from the blue-green negative. The red-orange negative side was then dyed blue-green. When the dyeing was completed the resist was removed and the film was dried. Next the red-orange side was coated with resist and the other side of the print was dyed red-orange.[11]

Solutions for Single-Coated Two-Color Prints (USP 1278161)

Developer

Potassium metabisulfite	300·0 grams
Distilled water (boiling)	1·0 liter
Paramidophenol	100·0 grams
Sodium hydroxide (add slowly enough to dissolve the precipitate formed)	

Note: Dilute 30 to 1 with water for use.

Clear

Sodium thiosulfate	600·0 grams
Potassium metabisulfite	60·0 grams
Water to	1·0 liter

Dye

Malachite green	40·0 grams
Water to	1·0 liter

Sensitizing Bath

Ammonium dichromate	25·0 grams
Water to	1·0 liter

Dye

Pinatype complementary red D	40·0 grams
Water to	1·0 liter

Solutions for Duplitized Prints (USP 1411968)

Developer

Normal black and white developer such as D-16.

Fix

Normal black and white acid fix.

Hardener

10% Formalin solution.

Bleach

Potassium dichromate	4·75 grams
Potassium bromide	9·5 grams
Copper sulfate	14·0 grams
Hydrochloric acid	10·0 grams
Water to	1·0 liter

Note: Temp. 100° to 110°F.

Dyes

Fast acid green B
Ponceau NR
Pontacyl green SN
Pontacyl light yellow 3g
Pontacyl carmine 2b
Tartrazine
Acid green Nd

Note: Dye used as ½% solution at 110° to 130°F. If used at 70°F it was necessary to add 20 ml of acetic acid per gram of dye.

COLOR FILM PROCESS

The Color Film Process was a two-color subtractive process developed in 1927 by A. G. Waddingham of Color Cinema Productions.[12] Bipack negative exposed in conventional cameras was used for the original photography. Prints were made on duplitized positive film on a special step contact printer. The side printed from the orthochromatic record of the bipack film was toned red in a uranium toner. The side printed from the panchromatic record of the bipack film was toned blue-green with a ferrous sulfate, ferric chloride toner.

The bipack negatives were developed, fixed, washed and dried in the normal manner. After processing they were printed in register on opposite sides of the duplitized positive print film. The prints were treated as follows:[13]

1. Black and white development: normal black and white developer such as Kodak D 16.
2. Wash.
3. Fix.
4. Wash.
5. Bleach: 2 to 3 minutes at 67°F.
6. Wash: 15 minutes.
7. Red tone: 4 to 5 minutes at 67°F. The images on both sides of the duplitized positive were toned red.
8. Wash: 5 minutes.
9. Fix: 1 minute at 67°F to remove the remaining silver and leave only the ferrocyanide image.
10. Wash: 15 to 20 minutes.
11. Dry.
12. Green tone: 6 minutes at 67°F. The green tone was applied by running the prints with the image from the panchromatic negative in contact with roller applicators that dip into the green toner. This converted the red uranyl ferrocyanide image to ferric ferrocyanide by replacement.
13. Wash: 1 minute.
14. Dry.

Bleach

Potassium ferrocyanide	34·8 grams
Ammonium hydroxide	43·9 grams
Water to	1·0 liter

Red Toner

Uranium nitrate	127·2 grams
Hydrochloric acid	70·0 ml
Water to	1·0 liter

Fix

Sodium thiosulfate	195·0 grams
Water to	1·0 liter

Green Toner

Ferrous sulfate	62·0 grams
Ferric chloride	17·6 grams
Sulfuric acid	7·4 ml
Water to	1·0 liter

VITACOLOR

The Vitacolor Process was a two-color subtractive color process for making motion picture release prints. In 1930 this company purchased over thirty of the Prizma Color patents covering many stages of making additive and subtractive color motion pictures. Several of these patents were subsequently licensed to Consolidated Film Industries for the operation of its Magnacolor Process.[14]

This process was one of the several two-color processes which evolved from the original Prizma Color patents. Its use was limited to short subjects and low-budget pictures. In his study "A Historical Study of the Color Motion Picture," J. L. Limbacher reports a reorganization of the Vitacolor Company in 1948 and the use of the process for the Columbia feature picture, *The Last of the Redmen*, and the Eagle-Lion picture, *The Return of Rin Tin Tin*. He also erroneously reports that the process employed the three primary colors in making prints.

Prints made by the Vitacolor Process were made on single-coated print film rather than the double-coated type used in the Prizma and Magnacolor processes. The positive film used was a special type which contained a fugitive yellow dye such as a yellow mono azo salt of sodium that could be washed out in the first development.[15] The function of this dye was to slow down the passage of light through the emulsion to such an extent as to leave a substantial residue of sensitivity in the portion of the emulsion opposite the area where the light entered during the first exposure. The first image was printed from the red record negative through the base. At the same time a negative image was printed on the emulsion side from a print of the green record negative. After developing the print and washing out the fugitive yellow dye the film was placed in a hardening bleach for approximately thirty seconds. The action of the bleach was to remove the negative metallic silver image by rendering it invisible and transparent and at the same time hardening or tanning the gelatin *in situ* with the image so that it would repel a gelatin dye. The bleach also cleared the lower positive image by slight reduction of the metallic silver. After bleaching the film was washed and fixed in a plain sodium thiosulfate solution, leaving the surface hardened where the silver of the top negative image existed and an unbleached black silver positive image in the lower portion of the film. The lower image printed from the red record negative was then dye toned or chemically toned green, then it was fixed, washed and dried.

96

If dye toning was to be used the film was first bleached and fixed and dyed in basic dyes such as a mixture of chrysoidine and methylene blue. The film was then washed and dried and immersed in a bath of Pinatype Red D dye for approximately three minutes to dye the top negative. Finally, it was washed and dried.

If chemical toning was to be used the bottom positive image printed from the red record negative was toned blue-green with a ferric nitrate potassium ferricyanide toner, and the top negative image printed from the green record positive was toned red-orange with a uranium nitrate toner.

Pyro Developer

Pyrogallic acid	5·0 grams
Sodium sulfite	20·0 grams
Sodium carbonate	25·0 grams
Potassium bromide	1·0 gram
Water to	1·0 liter

Bleach

Potassium ferricyanide	4·5 grams
Potassium bromide	7·0 grams
Potassium dichromate	4·5 grams
Glacial acetic acid	1·5 ml
Potassium alum	7·5 grams
Water to	1·0 liter

Cyan Blue Toner

Potassium oxalate	6·0 grams
Ferric nitrate	5·5 grams
Potassium ferricyanide	5·0 grams
Hydrochloric acid (conc.)	3·0 ml
Water to	1·0 liter

Orange-Red Toner

Potassium oxalate	20·0 grams
Uranium nitrate	60·0 grams
Hydrochloric acid (conc.)	140·0 ml
Water to	1·0 liter

Mordanting Bleach

Oxalic acid	5·0 grams
Vanadium oxalate (10% Sol.)	25·0 ml
Potassium ferricyanide	5·0 grams
Water to	1·0 liter

SENNETT COLOR

Sennett Color was a two-color subtractive color process announced in 1930 by the Sennett Laboratory in Studio City, California. This process used a new bipack film produced in England called "Film Pack" for the original photography.[16] Prints were made on duplitized film.

The films used to make up the "Film Pack" bipack consisted of a panchromatic negative and a specially made negative known as the Red Ortho Front Negative. This film had a blue sensitive negative emulsion overcoated with red filter layer. Two color separation negatives were obtained by placing these films emulsion to emulsion in the camera and exposing them simultaneously. The light coming through the camera lens passed through the base of the Red Ortho negative exposing the blue record. The red filter overcoat permitted only the red light to pass on to expose the red record. After exposure the negatives were developed in a normal black and white developer, fixed, washed and dried. The red filter dye was removed from the overcoat of the blue record negative by immersion in a 3% solution of sodium hydrosulfite.[17]

Release prints were made on duplitized positive film. After exposure on a step registration printer both sides were developed in a conventional black and white positive developer and then toned. The side printed from the red record negative was toned blue-green and the side printed from the blue record negative was toned red. The tones are two metallic colors from iron and uranium.[18]

No further information is given concerning formulas or techniques used. A search of the patent literature 1920 to 1940 indicates that no patents for a color process were issued to the Sennett Company. Therefore, it appears that the well known ferric ferricyanide and uranium ferricyanide toners were used.

Cyan-Blue Toner

Ammonium persulfate	0·05 grams
Ferric alum	1·25 grams
Oxalic acid	3·0 grams
Potassium ferricyanide	1·0 gram
Ammonium alum	5·0 grams
Hydrochloric acid (10%)	1·0 ml
Water to	1·0 liter

Red-Orange Toner

Uranyl nitrate	2·5 grams
Potassium oxalate	2·5 grams
Potassium ferricyanide	1·0 gram
Ammonium alum	6·0 grams
Hydrochloric acid (10%)	5·0 ml
Water to	1·0 liter

COLORATURA

Coloratura was a two-color subtractive process for color cinematography operated by the Pathe Exchange, Bound Brook, New Jersey. Negatives were made with normal bipack film in a standard camera, adjusted for bipack. Prints were made on duplitized positive film. One side was toned blue-green and one side was dyed red-orange. According to the SMPE color committee report in 1931,[19] the prints were first given a special treatment on one side to make it dye selective and then the film was submerged for the rest of the process.

Although no further information is available concerning the process, a possible treatment would be to tone the side printed from the panchromatic negative of the bipack blue-green by wheel application or flotation on a bath containing potassium ferricyanide and a ferric salt. This would produce a silver ferrocyanide plus a ferric ferricyanide image on one side leaving a metallic silver image on the other side.[20] Subsequent immersion in an acid solution containing potassium iodide and iodine forms a transparent silver iodide–potassium iodide mordant which can be dyed red-orange with Rhodamine and Auramine.[21] This would be followed by a wash and a fix which would remove the remaining silver leaving the dye image on one side and the metal toned image on the other side.

MAGNACOLOR

The Magnacolor process was a two-color subtractive process for color cinematography announced in 1931 by Consolidated Film Industries.[22] Bi-Pack negative film was used for the original photography. Prints were made on duplitized film.

The Magnacolor process was not a unique, independently invented process. It represented the utilization of Prizma and other patents which were licensed by Consolidated Film Industries.

The first use of the process was for a series of short subjects released by Paramount Pictures, Inc. Its first use for feature pictures was in Westerns produced by Consolidated's parent company Republic Pictures. Among those presented in Magnacolor were:[23]

Man from Rainbow Valley	*Home on the Range*
Rough Riders of Cheyenne	*Last Frontier Uprising*
Santa Fe Sunset	

For original photography the Magnacolor Process utilized Bi-Pack negative which could be used in any standard camera. Two films were used in combination passing through the camera aperture emulsion to emulsion. The front film had an orthochromatic emulsion overcoated with a red-orange dye layer. The rear film had a panchromatic emulsion. Films of this type were DuPont Du-Pac Negative and Eastman Bi-Pack Negative.

The exposed negatives were developed in a conventional black and white developer, fixed, washed and dried. After processing the two negatives were printed onto oppposite sides of double sided positive film such as Eastman Duplitized Positive or DuPont Duplicoat.[24]

Prints were made on modified Duplex Type Contact Step Printers in which the orthochromatic negative was placed in one gate of the twin head and printed onto one side of

the print film and the panchromatic negative was placed in the other gate of the twin head and printed on the opposite side of the print film.

The print was developed in a conventional black and white positive developer, fixed, washed and dried. Color was added by toning the side printed from the panchromatic negative blue-green and the side printed from the ortho negative red-orange. The blue-green image was obtained by floating the print with the side printed from the red record negative face down on the surface of a solution containing potassium ferricyanide and a ferric salt. After washing and fixing, the red-orange image was obtained by immersing the print in an iodide mordanting solution which converted the image from the orthochromatic negative to silver iodide which has the property of absorbing basic dyes. Then the print was washed and floated with the side printed from the blue-green record face down on the surface of a red-orange dye solution. After dyeing was completed the print was washed and dried.[25]

MULTICOLOR

The Multicolor Process was a two-color subtractive process introduced in 1928. This process offered a complete system for color motion pictures. A new bipack, "Rainbow Negative," was used for the original photography and metal-toned prints were made on duplitized positive film for the release prints. Among the advantages of this process was the fact that conventional cameras and projectors could be used.

In the spring of 1931 the company opened a new $1,500,000 laboratory advertised as the most modern and best equipped in Hollywood. It had a normal capacity of 1,000,000 feet of film per week and a peak capacity of 3,000,000 feet of film per week.

Although the motion picture industry expressed interest in the process it was used almost entirely for short subjects and cartoons. Three of the major studios used Multicolor for color sequences in black and white productions:

MGM	*Good News*
Paramount	*The Great Gabbo*
20th Century-Fox	*The Fox Movietone Follies of 1929*

Unfortunately no one used the process for a full feature picture. By 1932 the company failed and the laboratory equipment was sold at auction. Howard Hughes, one of the financial backers of the company, wound up with the building.[26]

The Multicolor process used the bipack method of photography to produce two separation negatives. A special film with an orthochromatic emulsion and a standard panchromatic film were used emulsion to emulsion. The orthochromatic emulsion was coated with a layer of gelatin containing a red-orange dye. When this film was exposed through the base, the dyed layer of gelatin acted as a filter and prevented the rear panchromatic film from receiving any blue light exposure. The exposed negative films were developed in a conventional black and white developer. The panchromatic component was developed to a gamma of $0 \cdot 56$ and the orthochromatic component to a gamma of $0 \cdot 53$. The negatives were printed on a special step contact printer operating at a speed of 21 feet per minute.

In printing the two negatives went through the printer together with the duplitized positive

film between them. The positive emulsions were blue sensitive and contained a yellow dye to prevent light from one side exposing both emulsions. This yellow dye washed out during development. The chief problem in printing was obtaining good registration; unequal shrinkage of the two negatives was a continuing source of trouble. The sound track was printed on a Bell and Howell continuous printer as a separate operation. After printing the positive was developed in a black and white developer, fixed, washed and dried. It was now ready for toning. The side printed from the panchromatic negative was floated face down on the surface of the cyan toning bath. At the end of five minutes the developed silver in this layer was completely converted into a blue toned image. The film was then washed and treated with a uranium toner which had the dual function of toning the image printed from the orthochromatic negative and mordanting this image so that it would accept a basic dye. The film was then washed and floated on the surface of an orange-red dye solution with the image from the orthochromatic negative face down. This was followed by a fix, wash, drying and varnishing on both sides. The varnishing greatly increased the life of the print.[27] All of the above mentioned color processing steps were performed as a continuous operation on a horizontal processing machine that was 180 feet long. The film passed in a single strand the length of the machine, then up to the dry box and back the length of the machine for drying.[28]

Blue-Green Toner[29]

Ferric ammonium oxalate	9·0 grams
Potassium ferricyanide	4·0 grams
Ammonium chloride	8·0 grams
Hydrochloric acid	4·0 ml
Water to	1·0 liter

Uranium Toner and Mordant

Uranyl Nitrate	3·0 grams
Potassium oxalate	8·0 grams
Potassium ferricyanide	2·25 grams
Hydrochloric acid (conc.)	8·0 ml
Water to	1·0 liter

Fix

Sodium thiosulfate	265·0 grams
Sodium bisulfite	6·6 grams
Potassium chrome alum	4·8 grams
Potassium alum	4·8 grams
Potassium iodide	6·3 grams
Water to	1·0 liter

Dye Bath[30]

Stock Solution A

Basic magenta	1·0 gram
Distilled water	250·0 ml
Glacial acetic acid	5·0 ml

Stock Solution B

Auramine	1·0 gram
Distilled water	250·0 ml
Acetic acid	5·0 ml

Note: For use mix 50 ml of Sol. A and 25 ml of Sol. B in 200 ml of water.

CINECOLOR

The Cinecolor Process, a two-color subtractive color process announced in 1932, was a direct descendant of the Multicolor process. When the Multicolor Company failed in 1932 the process was renewed under the Cinecolor name.[31] For the original photography bipack negative films were exposed in a conventional camera. Prints were made on positive film with emulsion coated on both sides; one side was toned blue-green and the other side red-orange.

The process was first used by the smaller producing companies: Monogram, Producers Releasing Corporation, Screen Guild Productions, Eagle-Lion, etc. The first feature length picture to be released in the Cinecolor Process was *The Gentleman from Arizona*, produced by Monogram Pictures in 1940.[32]

The popularity of the Cinecolor Process continued to grow during the next ten years, 1940 to 1950. Eventually the process was used by MGM, Twentieth Century-Fox, Paramount, Warner Bros., Columbia, United Artists, and Universal. At its peak the laboratory was processing approximately 120 million feet of release print per year.

In 1950 the laboratory installed the Eastman Color process and began using Eastman Color Negative Film, Type 5247, for original photography, Eastman Color Print Film, Type 5381, for daily prints and Supercinecolor for release prints. This enabled Cinecolor to use conventional unmodified camera equipment for three-color photography and to produce three-color daily prints on a 24-hour delivery basis with final three-color release prints in the most economical process available. The first Cinecolor three-color feature produced in this manner was *The Sword of Monte Cristo*, an Alperson Production released by Twentieth Century-Fox.[33]

Although the sales volume of the company increased substantially during the late forties, the company encountered management and other difficulties, and by 1954 had to discontinue operation.[34]

When the Cinecolor Process was introduced in 1932 Eastman Bi-Pack or DuPont Dupack films were used for the original photography. Exposures were made in a conventional camera equipped with a special Cinecolor bipack camera roller pressure plate and a double magazine. After exposure the negatives were processed in a normal black and white negative developer, fixed, washed and dried. The blue-green separation negative called the orange-red printer was printed on one side of Eastman Duplitized Safety Film, Type 5509. The orange-red separation negative, called the blue-green printer, was printed simultaneously on the opposite side. During this step the sound track was also printed onto the blue-green image side in a separate sound printing head. In order to maintain registration of the two images a specially designed step registration contact printer was used. Push-down pins located

just above the aperture were used rather than the conventional pull-down pins which are usually located below the aperture. The object of this design was to minimize wear and tear on the perforations utilized for registration by causing the registration pins of the printers to enter sprocket holes in the film which were no more than a small fraction of an inch away from the holes utilized for advancing the film. The two separation negatives were passed simultaneously through a film gate with their emulsions facing each other and with the duplitized positive film sandwiched in the middle. The sound track negative met the duplitized positive below the picture printing aperture and passed in contact to the continuously driven master sound sprocket containing a printing aperture which was illuminated from below.

The exposed duplitized positive was processed in a special continuous processing machine designed to provide means of treating individually the emulsion on both sides of the film by flotation methods. The machine consisted of three long shallow horizontal troughs located one above the other with a drying chamber on top extending the entire length of the machine. During processing the film passed in a single strand through each of the troughs to the take-up reel which was located right above the feed-on reel. Although the machine only operated at 12 feet per minute it was wide enough to handle ten strands at a time so that the effective output was 120 feet per minute when all channels were running. The immersion time in each solution and wash was held constant by the spacing between partitions or dams. The steps in the Cinecolor two-color process were as follows:

1. Black and white development. The two picture records and the sound track were developed to a black and white silver image.
2. Wash and squeegee.
3. Blue-green toning. The print was floated on the surface of the cyan toning bath with the image from the red record and the sound track facing down.
4. Wash.
5. Fix.
6. Pre-dip.
7. Mordanting. The film was immersed in a mordanting solution which converted the silver image from the blue-green record to a silver iodide which has the property of absorbing basic dyes. The side containing the cyan ferric ferrocyanide image was not affected by this treatment.
8. Clearing bath. Clear in a 2% solution of sodium bisulfite.
9. Wash and squeegee.
10. Red-orange toning. The print was immersed in a orange-red dye solution.
11. Final wash and drying.

Ferric Toner

Ferric ammonium oxalate	6·0 grams
Potassium ferricyanide	6·0 grams
Hydrochloric acid	5·0 ml
Water to	1·0 liter

Iodide Mordant

Potassium iodide	50·0 grams
Iodine	5·0 grams
Acetic acid 28%	5·0 grams
Sodium acetate	5·0 grams
Water to	1·0 liter

Orange-Red Dye

1.	Fuchsine crystals	30·0 ml
	Auramine	70·0 ml
2.	Safranine Y	70·0 ml
	Rhodamine B (extra conc.)	30·0 ml

Note: Solution made by dissolving 1 gram of solid dye in 100 ml of water.

Although prints by the two-color Cinecolor process were satisfactory for their purpose, the motion picture industry was insistent in its demands for a three-color process. To meet these demands a third color was added to the Cinecolor release print process and the process was renamed Supercinecolor.[35]

For this new improved three-color process Eastman Color Negative Safety Film, Type 5247, was used as the original camera-taking material. In order to produce release prints with incorporated effects, it was necessary to make three-color separation master positives and corresponding three-color separation duplicate negatives from the original negatives. When Supercinecolor was introduced there was no panchromatic master positive film available, therefore it was necessary to reverse normal procedure and use Eastman Fine Grain Duplicating Panchromatic Negative Safety Film, Type 5203, as the master positive material and Eastman Fine Grain Duplicating Positive Safety Film, Type 5365, as the duplicate negative material. These films were developed in the normal manner in conventional black and white processing equipment.

The next step in the process after the preparation of the three separation negatives was their transfer onto Eastman Duplitized Positive Safety Film, Type 5509. The red and the green records and the sound track negative were first printed in a single pass through the special Cinecolor step contact printer in the same manner as described for the two-color Cinecolor process. The sound track was printed on the side which received the picture exposure from the red record and which was to be toned cyan. The blue record was printed as an additional step after the first stage of the processing was completed.

The duplitized positive was processed in the same horizontal machine used for the two-color Cinecolor process but the solutions and the processing steps were different. The processing steps in the Supercinecolor process were as follows:

1. Black and white development. The red and green record prints and the sound track were developed to black and white silver images. The yellow dye contained in the print film was bleached out during development.

2. Wash and squeegee.
3. Cyan (blue-green) toning. The print was floated on the surface of the cyan toning bath with the image from the red record and the sound track facing down.
4. Wash.
5. Immersion in a solution which converted the silver ferrocyanide to silver bromide.
6. Wash.
7. Harden.
8. Wash and dry.
9. Removal of film from the machine for the blue record printing.
10. The blue record negative in contact with a low gamma negative mask printed from the red separation positive was printed onto the side of the duplitized positive containing the cyan image and the re-sensitized silver bromide.
11. Black and white development. The print was floated on the surface of a black and white developer with the exposed image facing down. This resulted in a positive silver image which would be dyed yellow later in the process.
12. Wash.
13. Fix.
14. Wash.
15. Pre-dip. The print was immersed in an acid solution of potassium iodide.
16. Mordanting solution. Oxidizing bleach which converted the silver images (blue and green records) to a dye mordant.
17. Clearing bath. Clear in a 2% solution of sodium bisulfite.
18. Wash, squeegee, and dry.
19. Yellow dye toning. The print was floated on the surface of the yellow toning bath with the image from the blue record facing down. The mordanted image accepted the yellow dye according to the magnitude of the mordanted deposit.
20. Wash.
21. Magenta dye toning. The print was immersed in the magenta toning bath. The mordanted image accepted the magenta dye according to the magnitude of the mordanted deposit.
22. Wash.
23. Cyan regenerating bath. Print was immersed in a solution of potassium ferrocyanide (25 grams/liter).
24. Acid rinse in hydrochloric acid.
25. Wash, squeegee and dry.

Ferric Toner

Ferric ammonium oxalate	6·0 grams
Potassium ferricyanide	6·0 grams
Ammonium chloride	10·0 grams
Hydrochloric acid (conc.)	5·0 ml
Water to	1·0 liter

Potassium iodide	50·0 grams
Acetic acid 28%	5·0 ml
Sodium acetate	5·0 grams
Water to	1·0 liter

Bleach

Potassium iodide	20·0 grams
Iodine	5·0 grams
Acetic acid 28%	5·0 ml
Sodium acetate	5·0 grams
Water to	1·0 liter

DUNNING COLOR

Dunning Color was a subtractive color process for making 35 mm color release prints. The original process was a two-color process for making prints from standard bipack negatives on duplitized positive film. In 1937 a method of adding a third color was perfected and the process became a three-color system.[36]

In addition to this system for 35 mm release prints the Dunning Color Laboratory also produced three-color subtractive 16 mm color prints on Kodachrome duplicating film (Kodachrome Duplicating Film, Type 5265), which were processed by the Eastman Kodak Co.

Prints by the three-color Dunning Color process were made on double-coated positive film from three separation negatives. The red record negative was printed on one side and after development the positive image was toned blue-green using a ferric ferricyanide toner. The green record negative was printed on the other side and dyed magenta red. The third color, yellow, was applied by imbibition from a matrix printed from the blue record negative.[37]

FULLCOLOR

The Fullcolor Process was a subtractive color process for making motion picture release prints invented in 1942 by L. S. Trimble.[38] Either two- or three-color prints could be made depending on the system used for the original photography.

During the period 1942 to 1948 the process was used for several commercial films and low budget feature pictures. In 1947 it was used for the reissue of the Technicolor feature *The Goldwyn Follies*. Fullcolor prints were also made of the United Artists picture, *The Angry God*.[39]

Prints made by the Fullcolor process were made on duplitized positive film. When making three-color prints the blue and the green separation negatives were printed simultaneously on opposite sides of the print film. After this first exposure the print film was developed in a conventional black and white positive developer. This was followed by a wash and a four minute

immersion in a potassium dichromate bleach which according to Trimble functioned as a chemical seal. Next the film was washed and dried.

The print was then ready for its second printing. The sound track was printed through an ultraviolet filter and the red separation negative was printed through the blue separation negative and the yellow record. In order that this printing operation could be carried out successfully the blue separation negative and the yellow positive must have matched gammas so that combined they acted as neutral density. After exposure the cyan record printed from the red separation negative was developed in a conventional black and white positive developer. This was followed by a wash then immersion in a ferricyanide bleach which converted the metallic silver image, produced by development of the red separation negative exposure, to ferric ferrocyanide and silver ferrocyanide. The images produced by exposure from the blue and green negatives were left unaffected. The print then received another wash and was immersed in a solution of sodium thiosulfate and sodium sulfite for five minutes, then the film was immersed in an iodide mordant which did not affect the ferric ferrocyanide image. This was followed by a wash and clearing in a 5% solution of sodium bisulfite. Next the side containing the exposure from the green separation negative was floated face down on the surface of a bath of Rhodamine dye producing a magenta dye image. Then the film was washed and squeegeed and the side containing the exposure from the blue separation negative was floated face down on the surface of a bath of Auramine dye. This was followed by a final wash and dry.[40]

Chemical Seal

Potassium dichromate	2–3% Sol.
Potassium bromide	2–3% Sol.
pH	Above 3·5

Blue-Green Toner

Ferric ammonium oxalate	6·0 grams
Potassium ferricyanide	6·0 grams
Sulfuric acid (conc.)	1·0 ml
Water to	1·0 liter

Bleach

Iodine	3·0 grams
Potassium iodide	50·0 grams
Aluminium sulfate	10·0 grams
Acetic acid 28%	5·0 ml
Sodium acetate	5·0 grams
Water to	1·0 liter

Clear

Sodium bisulfite	10·0 grams
Water to	1·0 liter

Dye—Magenta

Methyl alcohol	33·0 ml
Acetic acid 28%	10·0 ml
Rhodamine	5·0 grams
Water to	1·0 liter

Dye—Yellow

Methyl alcohol	33·0 ml
Acetic acid	10·0 ml
Auramine	5·0 grams
Water to	1·0 liter

TRUCOLOR

The Trucolor process was introduced in 1948 by Consolidated Film Industries, Inc., a division of Republic Pictures, Inc., as a replacement for its Magnacolor process.[41] At the time of its introduction, Trucolor was a two-color subtractive color process. Prints were made from Bipack or successive frame negatives on a special duplitized positive film which contained color-forming couplers dispersed in the emulsion. Approximately three years later the capability of the process was expanded to include a three-color release system which utilized DuPont Color Positive Film, Type 275.[42] This film was replaced by Eastman Color Print Film, Type 5382.[43] Thus in its life span of approximately twelve years, 1946 to 1958, the Trucolor process was in reality three distinct systems by which color release prints were made, all bearing the same screen credit, "Trucolor." Three different films and processes were employed.

1. Eastman Two-Color Safety Film, Type 5380: Color blind duplitized positive; incorporated couplers; two-color subtractive system.
2. DuPont Color Positive Film, Type 275: Three color sensitive layers on one side of film; synthetic polymer binders and color formers; three-color subtractive system.
3. Eastman Color Print Film, Type 5382: Three color sensitive layers on one side of film; incorporated couplers; three-color subtractive system.

Some of the feature pictures released during this period in each of the three systems were:[44]

System 1 (two-color)	*Hell's Fire*
System 2 (three-color DuPont)	*Honeychile*
System 3 (three-color Eastman 5382)	*Johnny Guitar*

For original photography the two-color Trucolor method utilized bipack negative which could be used in any standard camera. Two films were used in combination, passing through the photographing aperture emulsion to emulsion. The front film was orthochromatic, to record the blue-green portion of the picture. Its emulsion carried a red dye overcoat which was equivalent in color transmission to a Wratten 23A filter. The rear film was panchromatic to record the red-orange portion of the picture. Since the rear film was exposed through the

red filter layer of the front film the blue and green portions of the picture were not recorded on the rear film.[45] Films used as bipack components for the Trucolor system were:

Eastman Bi Pack Ortho (exterior) Negative Safety Film, Type 5234
Eastman Bi Pack Ortho (interior) Negative Safety Film, Type 5236
Eastman Bi Pack Panchromatic Negative Safety Film, Type 5235

The negatives were developed in a normal MQ Borax type negative developer such as:

N-1 Developer

Elon	1·50 grams
Hydroquinone	1·30 grams
Sodium sulfite	75·0 grams
Borax	4·5 grams
Potassium bromide	0·4 gram
Water to	1·0 liter

The orthochromatic record was developed to a gamma of approximately 0·65, fixed in a normal acid fixing bath, washed and dried.

The panchromatic record was developed to a gamma of approximately 0·65, fixed in a normal acid fixing bath, washed and dried.

After processing the two black and white separation negatives were printed onto opposite sides of Eastman Two-Color Print Safety Film, Type 5380. This print film was similar to other duplitized positive film having an emulsion on both sides of the support. Each of these emulsion layers contained a color-forming dye coupler which formed a dye image along with the silver image obtained when the film was printed and developed.[46]

Prints were made on modified Duplex Type Contact Step Printers on which the blue-green negative record was placed in one gate of the twin head and printed onto one side of the print film and the red-orange negative record was placed in the other gate of the twin head and was printed on the opposite side of the print film. The two negatives were fed into and taken up on each side of the twin head. The print film passed into one head, was looped back to the second head and there passed to the take up. In this way it was possible to expose through both picture negatives in a single pass through the printer.[47] The side which was printed from the blue-green separation negative contained a mixture of magenta and yellow couplers which produced an orange-red dye image along with a silver image when it was developed. The side which was printed from the red-orange separation negative contained a cyan coupler which produced a blue-green image along with a silver image when it was developed. After development the unexposed and undeveloped silver halide was removed by treatment in a normal acid fixing bath such as Kodak F-5 Fixer. The remaining developed silver was converted to silver halide by immersion in a ferricyanide bleach and removed by a second treatment in an acid fixing bath. The film, which now contained a cyan dye image on one side superimposed on a yellow and magenta dye image on the other side, was washed and dried.

While the above system proved to be satisfactory for the picture area the dye sound tracks obtained were low in volume and showed high background noise. This problem was overcome by an edge-applied sulfide treatment of the sound track area to produce a combination

cyan dye and sulfide sound track. Since the bleach treatment converted all the remaining silver (both picture and sound track) to silver halide it was necessary to convert the sound track to insoluble silver sulfide with a sulfide treatment before it entered the final fix.

The following is an outline of the processing steps and formulas for the two-color Trucolor process.

1. Bi-Pack negative exposure.
2. a. Development of orthochromatic component.
 b. Development of panchromatic component.
3. Wash.
4. Fix.
5. Wash.
6. Dry.
7. Print onto special duplitized positive in Duplex Printer.
8. Color development. 10 minutes
9. First fix. 5 minutes
10. Bleach. 5 minutes
11. Sound track application. 30 seconds
12. Final fix. 5 minutes
13. Wash. 5 minutes
14. Dry. 15 minutes

Color Developer

Calgon (sodium hexametaphosphate)	0·5 gram
2-amino-5-diethylaminotoluene monohydrochloride	2·0 grams
Sodium sulfite	10·0 grams
Sodium carbonate	20·0 grams
Potassium bromide	2·0 grams
Water to	1·0 liter

Bleach

Water	800·0 ml
Potassium ferricyanide	50·0 grams
Potassium bromide	20·0 grams
Water to	1·0 liter

Fixing Bath

Water	600·0 ml
Sodium thiosulfate	240·0 grams
Sodium sulfite	15·0 grams
Acetic acid 28%	48·0 ml
Boric acid	7·5 grams
Potassium alum	15·0 grams
Water to	1·0 liter

110

AMERICOLOR

The Americolor process was a two-color subtractive color process announced in 1947 by the Color Film Company of America. It was not a technical success and no production was released other than a demonstration roll. It was reported by Limbacher[48] that this process was used previously in making slide films.

For the original photography, Bi-Pack negative was exposed in the normal manner. After exposure it was developed in a black and white negative developer. Prints were made on Eastman Duplitized Positive Film, Type 5509. In addition to using this system for slide films, it was also used to make some Ford commercials and MPA theater advertising films. In technical detail, the prints were made in the same manner as those described under the Brewster Color process in Chapter V.

At a later date, this company also produced a three-color process for slide film duplication using a special camera to produce three separation negatives. The red and green separations were printed onto duplitized positive film in the same manner as conventional bi-pack negative. The blue separation record was used to expose a matrix, which was then used for the imbibition transfer of a yellow dye image on top of the print from the green separation negative.

REFERENCES

[1] *Eastman Motion Picture Films for Professional Use* (Motion Picture Film Department, Eastman Kodak Company, 1942), p. 48.

[2] CORNWELL-CLYNE, A., *Colour Cinematography* (London: Chapman and Hall, Ltd., 1951), p. 17.

[3] RAMSAYE, TERRY, *A Million and One Nights* (New York: Simon and Schuster, 1964), p. 571.

[4] CORNWELL-CLYNE, A., *loc. cit.*

[5] *New York Times*, February 26, 1917.

[6] *New York Times*, January 20, 1919.

[7] RAMSAYE, TERRY, *op. cit.*, p. 571. Also, *New York Times*, April 24, 1922.

[8] CORNWELL-CLYNE, A., *op. cit.*, p. 18.

[9] USP 1278161.

[10] GREGORY, C. L., *Motion Picture Photography* (New York: Falk Publishing Company, Inc., 1927), pp. 336–337.

[11] USP 1278162.

[12] USP 1633652.

[13] *Ibid.*

[14] "Report of the Color Committee," *Journal of the Society of Motion Picture Engineers*, November, 1930, pp. 723–724.

[15] USP 1810180.

[16] "Color Committee Report," *Journal of the Society of Motion Picture Engineers*, January, 1931, p. 101.

[17] *Ibid.*, p. 98.

[18] "Color Committee Report," *Journal of the Society of Motion Picture Engineers*, November, 1930, pp. 721–722.

[19] "Report of the Color Committee," *Journal of the Society of Motion Picture Engineers*, July, 1931, p. 116.

[20] GLAFKIDES, PIERRE, *Photographic Chemistry* (London: Fountain Press, 1960), II, 646–649.

[21] FRIEDMAN, J. S., *History of Color Photography* (Boston: American Photographic Publishing Company, 1944), p. 340.

[22] "Magnacolor Film Announced," *American Cinematographer*, March, 1931, p. 20.

[23] LIMBACHER, J. L., "A Historical Study of the Color Motion Picture," Dearborn, Michigan, 1963, p. 17. (Mimeographed.)

[24] "Report of the Color Committee," *Journal of the Society of Motion Picture Engineers*, July, 1931, p. 117.

[25] *Ibid.*

[26] FROST, GEORGE E. AND OPPENHEIM, S. CHESTERFIELD, "Technical History of Professional Color Motion Pictures," (The Patent, Trademark and Copyright Foundation, George Washington University, Washington, D.C., 1960), p. 37. (Mimeographed.)

[27] OTIS, R. M., "The Multicolor Process," *Journal of the Society of Motion Picture Engineers*, July, 1931, pp. 5–10.

[28] BURNS, B., "The Multicolor Laboratory," *Journal of the Society of Motion Picture Engineers*, July, 1931, pp. 11–17.

[29] FRIEDMAN, J. S., *op. cit.*, p. 319.

[30] USP 1897369.

[31] Frost, George E. and Oppenheimer, S. Chesterfield, *op. cit.*, p. 37.

[32] Limbacher, J. L., *op. cit.*, p. 18.

[33] Frost, George E. and Oppenheimer, S. Chesterfield, *op. cit.*, p. 38.

[34] Frost, George E. and Oppenheim, S. Chesterfield, *op. cit.*, p. 40.

[35] Gundelfinger, A. M., "Cinecolor Three Color Process," *Journal of the Society of Motion Picture Engineers*, January, 1950, pp. 74–86.

[36] Limbacher, J. L., *op. cit.*, p. 16.

[37] Rose, J. J., *American Cinematographer Handbook and Reference Guide* (Los Angeles: Southland Press, 1939), p. 132.

[38] USP 2396726.

[39] Limbacher, J. L., *op. cit.*

[40] USP 2396726.

[41] Fleet, R., "The Trucolor Process," *American Cinematographer*, March, 1948, p. 79.

[42] Rose, J. J., *op. cit.*, p. 71.

[43] Personal interview with R. M. Grubel, Chief Chemist, Consolidated Film Industries.

[44] Personal interview with S. P. Solow, Vice President and General Manager, Consolidated Film Industries.

[45] Rose, J. J., *op. cit.*

[46] Gavey, T. W., "A Survey of the Factors Affecting Color Rendition of Bipack Two-Color Processes" (unpublished Master's thesis, University of Southern California, 1948).

[47] *Ibid.*

[48] Limbacher, J. L., *op. cit.*, p. 19.

VII MULTILAYERED SUBTRACTIVE PROCESSES

The Monopack or Integral Tripack has become the most popular method used for color cinematography. Its use eliminates the complicated devices used in other methods and enables both the amateur and the professional to produce pictures in color with almost any camera.

The essential principles of Monopack construction in all color processes are the same. The film consists of a base coated with three light sensitive emulsions one on top of the other (Fig. 41). To record the image in the layer where it belongs, emulsions of three different sensitivities are used, and since all emulsions are slightly sensitive to blue light some precaution must be taken to prevent blue light exposure of the other two layers.

Fig. 41 Typical Monopack construction. 1. Blue sensitive emulsion. 2. Yellow filter layer. 3. Green sensitive emulsion. 4. Clear gelatin. 5. Red sensitive emulsion. 6. Film base. 7. Anti-halation backing.

The first specific disclosure of the use of a monopack for the purpose of color reproduction came from K. Schinzel.[1] Unfortunately neither the photographic nor the dye industry was sufficiently advanced to allow his proposal to be put to practical use.

One of the biggest problems in the early development of the monopack was the conversion of the three silver images into color images. This was at last solved by using organic developers whose oxidation products reacted with color couplers to form dyes which are deposited in the emulsion with the silver formed by the development of the image. In general

this reaction may be performed in two ways: by incorporating the color forming couplers in the emulsion layers or by incorporating them in the developers. At the time of this study both of these methods are being used successfully commercially.[2]

KODACHROME

Kodachrome is the name given by Eastman Kodak to several film and process combinations introduced first in 1935. Since its introduction there have been several additions, revisions and improvements in both film and process so that the present products bear little resemblance to the original film and process invented by L. D. Mannes and L. Godowsky. The film bearing the Kodachrome name have all been integral tripacks of the non-incorporated coupler type which produce a three-color picture by subtractive methods, and the processes have all been reversal, producing a direct positive.

Kodachrome films have been used in the production of thousands of 16 mm industrial, educational and religious motion pictures. Kodachrome Commercial, the first 16 mm color film designed for use by the professional cinematographer, was used for one of the first television series to be photographed in color. In addition to its use in 16 mm, Kodachrome has been enlarged to 35 mm for theatrical release in productions of varying scope from World War II combat films like *The Fighting Lady* to Walt Disney's Real Life adventure films such as *Beaver Valley*.

Structurally, Kodachrome films are made up of three light sensitive emulsions coated one on top of the other on a single film base (Fig. 42). The emulsion nearest the base is sensitive to red light and blue light, the middle emulsion is sensitive to green light and blue light, and the top emulsion is sensitive to blue light. Between the top blue sensitive emulsion and the other two emulsions is a layer of gelatin containing finely divided silver particles called a "Carey Lea layer" for Carey Lea, the early American worker in photographic science, who discovered the basic method of preparation which is used. These silver particles absorb blue light and act as a filter that prevents blue light exposure in the middle and bottom emulsion layers.[3]

After exposure Kodachrome is developed in an elon-hydroquinone black and white developer to produce a negative silver image. Then the film passes over a reversal exposure lamp containing a red filter. This exposes through the base the unexposed silver halide in the bottom or red sensitive layer, which is now developed in a dye coupling cyan developer, so that a positive cyan dye image is formed. This solution is followed by a black and white clean-up developer which develops any silver halide in the bottom layer that may have been exposed but not developed by the cyan developer (this solution is omitted in some processes). The film now passes under a reversal exposure lamp containing a blue filter exposing the unexposed silver halide in the top or blue sensitive layer which is developed in a dye coupling yellow developer so that a positive yellow dye image is formed. This solution is also followed by a black and white clean-up developer whose function is to develop any silver halide in the top layer that may have been exposed but not developed by the yellow developer. The film now passes into a third and final color developer which contains a fogging agent that takes the place of a third reversal exposure, and a magenta forming dye coupling agent so that a

114

Fig. 42 Kodachrome film structure. 1. Blue sensitive emulsion. 2. Gelatin interlayer containing Carey Lea silver which acts as a yellow filter. 3. Green sensitive emulsion. 4. Colorless gelatin interlayer. 5. Red sensitive emulsion. 6. Sub-stratum. 7. Film base. 8. Anti-halation backing. A Before Development. B After Color Development. C After Bleach and Fix.

positive magenta dye image is formed in the middle or green sensitive layer. In some Kodachrome processes this is followed by a third auxiliary developer. At this point in the process the film contains three positive dye images together with the metallic silver formed by the multiple development operations. The silver is opaque, therefore it must be removed. To accomplish this the film passes through a ferricyanide bleach that converts the silver to silver bromide, then into a fixing bath where the silver salts are removed, leaving the dye images.[4]

KODACHROME DUPLICATING SAFETY COLOR FILM, TYPE 5265

In 1944 Kodachrome Duplicating Safety Color Film, Type 5265, was introduced as a 16 mm reversal color print film. This film was designed for making prints from reversal color originals. A basic filter pack was required to correct for differences in individual printers and for each emulsion. In general this was the only color correction used. Individual scenes were corrected for density only. Sound tracks could be either variable area or variable density printed by either contact or optical printing. Since the sound track as well as the picture was processed as a reversal image it was necessary to print from a positive track.

A considerable number of prints were made on this material during its period of use. In addition to industrial, educational, religious, travel and sport pictures, several prints were made

115

of feature motion pictures by reduction printing for distribution to the armed forces overseas.[5]

Kodachrome Duplicating Safety Color Film, Type 5265, was replaced in 1955 by Eastman Reversal Color Print Film, Type 5269.

The following was the processing cycle and formulas for processing Kodachrome Duplicating Safety Color Film, Type 5265.[6]

Solution	Time	Temperature
Prehardener	2 min.	70°F
Wash	2 min.	70°F
First Developer	6–7 min.	70°F
Wash	4 min.	70°F

Note: Red light exposure through the base (Corning 2410 filter 3 mm thick) approximately 2100 ft candles.

Cyan Developer	11 min.	70°F
Wash	4 min.	70°F

Note: Blue light exposure emulsion side (Wratten 39 Filter 2 mm thick) approximately 14,000 ft candles.

Solution	Time	Temperature
Yellow Developer	6·25 min.	70°F
Wash	2 min.	70°F
Auxiliary Developer	4 min.	70°F
Wash	2 min.	70°F
Sound Track		
Developer Application	10 sec.	70°F
Wash	2 min.	70°F
Magenta Developer	6·25 min.	70°F
Wash	6 min.	70°F
Bleach	4 min.	70°F
Fix	2 min.	70°F
Wash	6 min.	70°F
Dry	20 min.	70°F

Prehardener

Calgon	0·6 gram
Sodium bisulfite	5·0 grams
Sodium carbonate (monohydrate)	5·0 grams
Sodium sulfate (anhydrous)	150·0 grams
Potassium bromide	1·0 gram
Formalin	20·0 ml
Sodium hydroxide	0·21 gram
Water to	1·0 liter

116

1st Developer

Calgon	0·6 gram
Sodium bisulfite	10·0 grams
Elon	4·8 grams
Hydroquinone	2·0 grams
Sodium carbonate (monohydrate)	30·0 grams
Sodium sulfite	63·5 grams
Potassium bromide	3·25 grams
Potassium iodide (0·1% sol.)	20·0 ml
Isopropylamine (100%)	6·55 grams
Water to	1·0 liter

Cyan Developer

Calgon	0·6 gram
Foamex	0·4 ml
Alkanol B	0·3 gram
Sodium sulfite	20·0 grams
2-amino-5-diethylamino toluene hydrochloride	1·75 grams
Sodium carbonate (monohydrate)	25·0 grams
Potassium bromide	1·0 gram
Sodium thiocyanate (50% sol.)	6·0 ml
Sodium hydroxide	4·6 grams
6-nitrobenzimidazole nitrate	0·3 gram
2,6-dibromo-1,5-dihydroxy naphthalene	1·45 grams
Mono-N-benzyl p-aminophenol hydrochloride	1·15 grams
Potassium iodide (0·1% sol.)	3·0 ml
Water to	1·0 liter

Yellow Developer

Calgon	0·6 gram
Sodium sulfite	5·0 grams
2-amino-5-diethylamino toluene hydrochloride	0·6 gram
Sodium sulfate	25·0 grams
Sodium carbonate (monohydrate)	42·0 grams
Potassium bromide	1·0 gram
Sodium thiocyanate (50% sol.)	1·7 ml
Potassium iodide (0·1% sol.)	17·0 ml
6-nitrobenzimidazole nitrate (1·0% sol.)	1·0 ml
Sodium hydroxide	3·0 grams
4-p-toluene sulfonylamino-omega-benzoyl acetanilide	2·25 grams
Water to	1·0 liter

117

Auxiliary Developer

Calgon	2·0 grams
Sodium bisulfite	8·3 grams
Elon	3·5 grams
Hydroquinone	2·25 grams
Sodium carbonate (monohydrate)	30·0 grams
Sodium sulfite	63·5 grams
Potassium bromide	2·5 grams
5-nitroindazole (0·5% sol.)	2·0 ml
Potassium iodide (0·1% sol.)	20·0 ml
Isopropylamine (100%)	5·20 grams
Sodium thiocyanate (50% sol.)	5·5 ml
Water to	1·0 liter

Sound Track Developer

Sodium sulfide ($Na_2S \cdot 3H_2O$)	20·0 grams
Ethyl alcohol	250·0 ml
Distilled water to	1·0 liter

Magenta Developer

Calgon	0·6 gram
Sodium sulfite	18·0 grams
2-amino-5-diethylamino toluene hydrochloride	1·75 grams
Sodium sulfate	15·0 grams
Sodium thiocyanate (50% sol.)	12·4 ml
Ethylene diamine (68–70% by weight)	5·0 ml
Sodium carbonate (monohydrate)	40·0 grams
Potassium bromide	1·45 grams
Sodium hydroxide	1·50 grams
1-(2 benzothiazoyl 1)-3-amino-5-pyrazolone	0·50 grams
Water to	1·0 liter

Ferricyanide Bleach

Calgon	0·6 gram
Potassium ferricyanide	100·0 grams
Potassium bromide	15·0 grams
Sodium chloride	20·0 grams
Water to	1·0 liter

Fix

Calgon	1·0 gram
Sodium thiosulfate	200·0 grams
Sodium sulfite	10·0 grams
Water to	1·0 liter

KODACHROME COMMERCIAL SAFETY COLOR FILM, TYPE 5268

In 1946 Kodachrome Commercial Safety Color Film, Type 5268, was introduced as a 16 mm camera film for the professional worker. It was a tungsten balanced reversal color film having a speed of E.I. 10 to tungsten illumination of 3200°K and a speed of E.I. 8 to daylight when used with a Wratten 83 filter. It differed from the other films in the Kodachrome group because it was designed to produce a low contrast original intended for printing not projection.

Since its introduction this film has been used extensively for industrial, educational, medical, religious and travel motion pictures, also for television drama and to a limited extent for enlargement to 35 mm for theater release. The *Cisco Kid* series, one of the first television series photographed with 16 mm color film, produced over 500 episodes using Kodachrome Commercial for the original photography.

Kodachrome Commercial Safety Film, Type 5268, was replaced in 1958 by Ektachrome Commercial Film, Type 7255.

The following was the processing cycle and formulas for processing Kodachrome Commercial Safety Color Film, Type 5268.[7]

Solution	Time	Temperature
Prehardener	2 min.	72°F
Wash	2½ min.	70°F
1st Developer	15 min.	
Wash	5 min.	

Note: Red light exposure through the base (Corning 2410 filter 3 mm thick) approximately 2000 ft candles.

Cyan Developer	10 min.	70°F
Wash	2½ min.	70°F
Auxiliary Developer	2½ min.	70°F
Wash	5 min.	70°F

Note: Blue light exposure emulsion side (Wratten 39 filter 2 mm thick) approximately 5500 ft candles.

Yellow Developer	8 min.	70°F
Wash	2½ min.	70°F
Auxiliary Developer	2½ min.	70°F
Wash	5 min.	70°F
Magenta Developer	8 min.	70°F
Wash	7½ min.	70°F
Bleach	5 min.	70°F
Fix	2½ min.	70°F
Wash	7½ min.	70°F
Dry	25 min.	70°F

119

Prehardener

Calgon	0·6 gram
Sodium carbonate (monohydrate)	5·0 grams
Sodium bisulfite	5·0 grams
Sodium sulfate (anhydrous)	150·0 grams
Potassium bromide	1·0 gram
Formalin	30·0 ml
Water to	1·0 liter

1st Developer

Calgon	0·6 gram
Sodium sulfite (anhydrous)	8·5 grams
Elon	4·0 grams
Hydroquinone	1·10 grams
Sodium carbonate	30·0 grams
Sodium sulfite	45·0 grams
Potassium bromide	15·0 grams
5-nitroindazole (0·5% sol.)	5·0 ml
Potassium iodide (0·1% sol.)	10·0 ml
Isopropylamine	6·5 grams
Sodium bisulfite	8·4 grams
Water to	1·0 liter

Cyan Developer

Calgon	0·6 gram
Foamex	0·2 ml
Alkanol B	0·2 gram
Sodium sulfite (anhydrous)	5·0 grams
Resorcinol	0·150 gram
2 amino-5-diethylaminotoluene hydrochloride	2·9 grams
Sodium carbonate (monohydrate)	15·0 grams
Potassium bromide	2·5 grams
Potassium iodide	2·0 ml
Sodium hydroxide	2·75 grams
6-nitrobenzimidazole nitrate	0·18 gram
2, 4-dichloro-5-p-toluene sulfonylamino-1-naphthol	1·35 grams
Water to	1·0 liter

Auxiliary Developers 1 and 2

Calgon	0·6 gram
Sodium sulfite (anhydrous)	8·5 grams
Elon	4·0 grams
Hydroquinone	1·4 grams

Sodium carbonate (monohydrate)	26·0 grams
Sodium sulfite	45·0 grams
Potassium bromide	4·5 grams
5-nitroindazole (0·5% sol.)	4·0 ml
Potassium iodide (0·1% sol.)	8·0 ml
Water to	1·0 liter

Yellow Developer

Calgon	0·6 gram
Sodium sulfite	10·0 grams
p-aminodiethylaniline hydrochloride	2·30 grams
Sodium carbonate (monohydrate)	20·0 grams
Potassium bromide	1·5 grams
Potassium iodide (0·1% sol.)	1·5 ml
Sodium hydroxide	1·7 ml
4-p-toluene sulfonylamino-omega- benzoylacetanilide	1·15 grams
Water to	1·0 liter

Magenta Developer

Calgon	0·6 gram
Sodium sulfite	6·0 grams
2-amino-5-diethylamino toluene hydrochloride	1·05 grams
Sodium sulfate	40·0 grams
Sodium thiocyanate	3·0 grams
Ethylene diamine (68%)	5·0 ml
Sodium carbonate (monohydrate)	40·0 grams
Potassium bromide	1·10 grams
Sodium hydroxide	1·5 grams
2-Cyanoacetylcoumarone	0·95 gram
Potassium iodide (0·1% sol.)	2·0 ml
Water to	1·0 liter

Bleach

Calgon	0·6 gram
Potassium ferricyanide	130·0 grams
Potassium bromide	15·0 grams
Borax (·10 H_2O)	10·0 grams
Boric acid	5·0 grams
Sodium chloride	26·0 grams
Water to	1·0 liter

Fix

Calgon	1·0 gram
Sodium sulfite (anhydrous)	10·0 grams
Sodium thiosulfate	200·0 grams
Water to	1·0 liter

EASTMAN REVERSAL COLOR PRINT FILM, TYPE 5269

In 1955 Eastman Reversal Color Print Film, Type 5269, was introduced as an improved 16 mm reversal color print film to replace Kodachrome Duplicating Safety Color Film, Type 5265. Structurally the new film was similar to the general family of Kodachrome films. It was composed of three light-sensitive non-coupler incorporated emulsions superimposed one on top of the other. The top emulsion was sensitive to blue light, the middle emulsion to blue and green light and the bottom emulsion to blue and red light. Processing was similar to 5265 but a slightly different processing order was followed. Also the sound track underwent a complete revision and was no longer processed as a reversal image along with the picture. Through special treatment during processing the positive silver image obtained in the initial black and white development step was preserved. Therefore, it was now necessary to print the sound track from a negative rather than a positive original.

Other than the change in pre-print material required for the sound track, printing 5269 was very much like printing 6265. A basic filter pack was required to correct for differences in individual printers and for each emulsion. In general this was the only color correction used. However, new printing equipment capable of color correcting individual scenes was beginning to appear and some laboratories were offering scene-to-scene color as well as density correction.

Eastman Reversal Color Print Film, Type 5269, was replaced in 1964 by Eastman Reversal Color Print Film, Type 7387.[8]

The processing cycle and formulas for processing Eastman Reversal Color Print Film, Type 5269, in the RCP-1 Process,[9] and Eastman Reversal Color Print Film, Type 7387, in the RCP-2 Process,[10] are given in the processing manuals, available to all licensees.

ANSCO COLOR

The Ansco Color process is a three-color subtractive system for color cinematography introduced commercially in 1945 by the Ansco Division of General Aniline and Film Corporation.[11] This process, introduced originally during World War II, was first used chiefly for military photography. The films offered commercially in 1945 were a direct projection reversal color film available in 16 mm and 35 mm for amateur use and a group of three 35 mm reversal color films for professional motion picture use.

The first theatrical use of Ansco Color film was for a two-reel short subject, *Climbing the Matterhorn*, released in 1948 by Monogram Pictures. The success of this picture resulted in the release of a feature length picture in the process by Monogram, *Sixteen Fathoms Deep*. Other pictures made using the Ansco Color reversal color system were:[18]

> *The Man on the Eiffel Tower*
> *New Mexico*
> *Tembo*
> *Island of Allah*

The Ansco Color reversal color process for professional motion pictures consisted of three

Fig. 43 Ansco color film structure. 1. Blue sensitive emulsion plus yellow dye forming coupler. 2. Yellow filter layer. 3. Green sensitive emulsion plus a magenta dye forming coupler. 4. Clear gelatin. 5. Red sensitive emulsion plus a cyan dye forming coupler. 6. Film base. 7. Anti-halation layer. A Before Development. B After Color Development. C After Bleach and Fix.

elements that could be used either singly or together. The films were a reversal color camera original film, a duplicating film and a release print film. Each of the three films was a multilayer reversal color film which contained three light-sensitive emulsions sensitized to red, green and blue light respectively and coated on a single film support (Fig. 43). Incorporated in the emulsion layers were colorless dye couplers which react simultaneously during development to produce a separate dye image in each layer complementary to the sensitivity of the layer.[13]

After exposure the film was developed in a metol-hydroquinone developer which produced a negative silver image in each layer that is a record of the red, green and blue components of the original scene photographed. From the developer the film passed through a rinse and then into a short stop which arrested any further development. Next the film went into a chrome alum hardener which was followed by a wash. From this point on, the film could be handled in normal room light. Second exposure was accomplished by exposing both sides of the film to GE PS-25, Photoflood-type lamps.

During the second exposure the silver halide remaining in the film which had not been affected by the camera exposure and first development was exposed. The positive latent image produced by this exposure was developed to a silver plus a dye image in a color-forming developer. This was followed by a rinse and a second short stop which arrested any further

123

action of the developer. After the second short stop the film was given a second hardening treatment in a chrome alum hardening bath which was followed by a wash.

The metallic silver images located in all three layers were then converted back to silver halide by immersion in a ferricyanide bleach. This treatment was followed by a wash, then the silver was removed with a hypo solution, leaving only the dye images. After a final wash the film was dried and was ready for use.

The three reversal color films having the general characteristics described above have been manufactured as Ansco Color Film:

Ansco Color, Type 735[14]

Ansco Color, Type 735, was a reversal color camera film balanced for use under average daylight conditions. The speed of this film was E.I. 12. For studio exposures high-intensity carbon arcs modified by Y-1 gelatin filters and tungsten lamps modified by Macbeth Whiterlite filters. The contrast of this film was lower than that of films intended for projection; also, the color balance was purposely slightly off neutral.

Ansco Color, Type 132[15]

A reversal color duplicating film designed for making duplicates that could be intercut with reversal originals. The speed of this film was two to four times less than that of black and white positive release print film. The contrast of Type 132 was approximately 1·0 so that a duplicate on this film was substantially equal to the camera original.

Ansco Color, Type 732[16]

A reversal color print film balanced for printing with filtered tungsten illumination. The speed of this film was approximately two to four times less than black and white release print film.

ANSCOCHROME

Several years after the introduction of Ansco Color a new improved reversal color film was introduced by the Ansco Division of General Aniline and Film Corporation. This film introduced in the spring of 1955 was called Anscochrome.[17] Its general structure and processing was similar to Ansco Color, which it replaced. Its improved characteristics were improved grain structure, greatly improved speed and an improved dye system that produced better red and blue reproductions.

Although Anscochrome was available in either 16 mm or 35 mm, there is no evidence that it was ever used for a 35 mm theatrical production. Its use in the 35 mm size has been limited to military and instrumentation photography. The films manufactured as Anscochrome are:

Anscochrome Daylight Types 231 (16 mm) and 531 (35 mm)[18]

A reversal color camera film balanced for use under average daylight conditions. The speed of this film was E.I. 32. Anscochrome differs from previous reversal color films in that the three emulsion layers respond alike to changes in developing time over a wide range. This makes it possible to adjust processing conditions to the exposure as in black and white work.

Anscochrome Tungsten Types 232 (16 mm) and 532 (35 mm)[19]

A reversal color camera film balanced for tungsten illumination of 3400°K. The speed of this film was E.I. 32 Tungsten and E.I. 25 Daylight with a Wratten 85 filter.

The processing steps and times for processing the Ansco Color Film are listed below.

Super Anscochrome Daylight Types 225 (16 mm) and 525 (35 mm)[20]

A high speed reversal color film of medium granularity balanced for use under average daylight conditions. The speed of this film was E.I. 100. This film was introduced in 1957 as a supplement to the regular Anscochrome.

PROCESSING STEPS FOR ANSCO REVERSAL COLOR FILMS

	Type			Types 231 & 232[a]			Types 225 & 226				Process	
	735	132	732	E.I. 32	E.I. 64	E.I. 125	E.I. 80	E.I. 100	E.I. 150	E.I. 200	AR 1[b]	AR 2[b]
First developer	4 min.	8 min.	10 min.	15 min.	19 min.	30 min.	14 min.	16 min.	19 min.	22 min.	8–10 min.	3–5 min.
Rinse	5 sec.	5 sec.	5 sec.	15 sec.	15 sec.	15 sec.	—	—	—	—	—	[c]
Short stop	3 min.	3 min.	3 min.	3 min.	3 min.	3 min.	2 min.	2 min.	2 min.	2 min.	2–5 min.	1–5 min.
Hardener	3 min.	3 min.	3 min.	3 min.	3 min.	3 min.	4 min.	4 min.	4 min.	4 min.	—	
Wash	3 min.	3 min.	3 min.	3 min.	3 min.	3 min.	5 min.	5 min.	5 min.	5 min.	2–5 min.	2 min.
Re-exposure	4 GE PS-25 lamps			620 Watt fluorescent lamps: 1200 ft/c/sec. on each side								
Color developer	11 min.	9 min.	18 min.	15 min.	17 min.	20 min.	14 min.	14 min.	18 min.	18 min.	10–12 min.	4 min.
Rinse	20 sec.	20 sec.	20 sec.	15 sec.	15 sec.	15 sec.	—	—	—	—	—	
Short stop	3 min.	3 min.	3 min.	3 min.	3 min.	3 min.	2 min.	2 min.	2 min.	2 min.	2–5 min.	1–5 min.
Hardener	3 min.	3 min.	3 min.	3 min.	3 min.	3 min.	4 min.	4 min.	4 min.	4 min.	—	
Wash	3 min.	3 min.	3 min.	3 min.	3 min.	3 min.	5 min.	5 min.	5 min.	5 min.	2–5 min.	2 min.
Bleach	6 min.	6 min.	6 min.	6 min.	6 min.	6 min.	5 min.	5 min.	5 min.	5 min.	4–5 min.	2 min.
Wash	3 min.	3 min.	3 min.	3 min.	3 min.	3 min.	3 min.	3 min.	3 min.	3 min.	2–5 min.	30 sec.
Fix	6 min.	6 min.	6 min.	6 min.	6 min.	6 min.	4 min.	4 min.	4 min.	4 min.	2–3 min.	2 min.
Wash	9 min.	9 min.	9 min.	6 min.	6 min.	6 min.	10 min.	10 min.	10 min.	10 min.	5 min.	1 min.
Wetting agent	—	—	—	—	—	—	—	—	—	—	10 sec.	15 sec.

[a] All solutions at 68°F.

[b] All solutions, except washes, at 80°F.

[c] Wash water at 75–80°F.

Super Anscochrome Tungsten Types 226 (16 mm) and 526 (35 mm)[21]

A high speed reversal color film of medium granularity balanced for tungsten illumination of 3200°K. The speed of this film was E.I. 100 Tungsten and E.I. 80 Daylight with a Wratten 85 filter.

Anscochrome D/50[22]

A reversal color camera film balanced for use under average daylight conditions. The speed of this film is E.I. 50. Introduced in 1964, this film replaced Anscochrome 231 and 531. Its improved characteristics include higher speed, higher definition, finer grain and improved color reproduction.

Anscochrome D/100[23]

A reversal color camera film balanced for use under average daylight conditions. The speed of this film is E.I. 100. Introduced in 1965 as a supplement to the Anscochrome films, this film is considered to be an intermediate speed film even though it is as fast as Super Anscochrome.

Anscochrome D/200[24]

A high speed reversal color camera film balanced for use under average daylight conditions. The speed of this film is E.I. 200. Introduced in 1965 as a replacement for Super Anscochrome, the improved characteristics of this film include higher speed, higher definition, finer grain and higher color contrast.

Ultra-Speed Anscochrome[25]

An extremely high speed reversal color camera film balanced for use under average daylight conditions. The speed of this film was E.I. 250, although in practice it was used at speeds of 500 and above. Introduced in 1965, the improved characteristics of this film include high speed and moderate gain.

Anscochrome D/500[26]

A high speed color motion picture film that can be processed either as a reversal film or as a color negative. The film speed E.I. 500 is the same for both conditions. This film also has the capability of being forced in processing to a speed of E.I. 1000. This film is slightly coarser in grain than D/200 but the color saturation, color reproduction and image quality are quite similar. Introduced in 1967 this film replaced Ultra-Speed Anscochrome.

126

Anscochrome T/100[27]

A reversal color camera film balanced for tungsten illumination of 3200°K. The speed of this film is E.I. 100 Tungsten and E.I. 64 Daylight with a Wratten 85 B filter. Introduced in 1965.

Anscochrome Professional Type 242[28]

A reversal color camera film balanced for Tungsten illumination of 3200°K. The speed of this film was E.I. 25 Tungsten. Originally introduced as Type 242 with a speed of E.I. 10, this film was a slow speed, fine grain, low contrast material designed for use as an original where high quality prints are desired.

Anscochrome Duplicating Types 238 (16 mm) and 538 (35 mm)[29]

A reversal color print film balanced with filtered tungsten illumination. Introduced in 1955, this replaced Ansco Color Type 732; its improved characteristics included finer grain, greater sharpness and improved color rendition.

In processing 16 mm Anscochrome a conditioning bath is introduced midway in the final wash stop. This bath is a solvent water mixture which flattens the finished film and makes it more pliable.

Examination of the chart containing the processing steps indicates little change in the basic number of solutions required to process Ansco color reversal films since their introduction. Changes have been made in the film and in the chemical composition of the solutions. The first group of formulas listed below are those published with the introduction of Ansco Color in 1946. The second group of formulas listed below are those published for the AR-2 process in 1965.

Ansco Color Reversal Processing Formulas[30]

First Developer

Metol	3·0 grams
Sodium sulfite	50·0 grams
Hydroquinone	6·0 grams
Sodium carbonate	40·0 grams
Potassium bromide	2·0 grams
Sodium thiocyanate	2·0 grams
Water to	1·0 liter
pH 9·8—10·0	

First and Second Short Stop

Acetic acid (glacial)	5·0 ml
Sodium acetate	30·0 grams
Water to	1·0 liter
pH 5·3—6	

Color Developer

Sodium bisulfite	1·0 gram
Colamine	4·0 grams
Sodium carbonate	67·0 grams
Potassium bromide	1·0 gram
Water to	1·0 liter
pH 10·0–10·3	

First and Second Hardener

Potassium chrome alum	30·0 grams
Water to	1·0 liter
pH 3·8–4·5	

Bleach

Potassium ferricyanide	100·0 grams
Potassium bromide	10·0 grams
Dibasic sodium phosphate	40·0 grams
Sodium bisulfate	35·0 grams
Water to	1·0 liter
pH 6·2	

Fix

Sodium thiosulfate	200·0 grams
Water to	1·0 liter
pH 7·3–8	

Anscochrome Process AR-2[31]

First Developer

Ethylenediamine tetra-acetic acid	0·8 gram
Phenidone B	1·0 gram
Metol	3·0 grams
Sodium sulfite (anhydrous)	50·0 grams
Hydroquinone	12·0 grams
Sodium hydroxide	12·0 grams
Borax $5H_2O$	30·0 grams
Sodium bromide	2·0 grams
Sodium thiocyanate	4·0 grams
Potassium iodide	0·012 gram
D A-7	1·0 gram
Water to	1·0 liter
pH (80°) 10·35	

Short Stop Hardener 907

Potassium alum sulfate $12H_2O$	20·0 grams
Sodium sulfate (anhydrous)	20·0 grams
Boric acid	4·0 grams
Sodium acetate	25·0 grams
Acetic acid (glacial)	12·0 ml
Water to	1·0 liter
pH (80°) 4·5	

Color Developer 625

Ethylenediamine tetra-acetic acid	0·8 gram
Sodium sulfite (anhydrous)	2·0 grams
Sodium hydroxide	10·7 grams
Borax $5H_2O$	30·0 grams
Sodium bromide	0·86 gram
Sodium sulfate (anhydrous)	100·0 grams
D A-3	3·5 grams
S-5 (Dicolamine)	5·0 grams
Water to	1·0 liter
pH (80°) 10·75	

Bleach 718B

Potassium ferricyanide	80·0 grams
Potassium ferrocyanide $3H_2O$	5·0 grams
Sodium bromide	15·0 grams
Sodium nitrate	30·0 grams
Sodium acetate	10·0 grams
Acetic acid	1·5 ml
Water to	1·0 liter
pH (80°) 5·2	

Fix 806A

Sodium thiosulfate (anhydrous)	130·0 grams
Sodium sulfite (anhydrous)	4·0 grams
Borax $5H_2O$	6·0 grams
Ethylenediamine tetra-acetic acid	0·8 gram
Sodium hydroxide (76% flakes)	0·80 gram
Formalin (40%)	15·0 ml
Water to	1·0 liter
pH (80°) 10·0	

Conditioning Bath (16 mm only)

Methyl cellulose acetate	40·0 ml
Diethyl carbitol	30·0 ml
Water to	1·0 liter

129

Wetting Agent

Water (75–85°F)	750·0 ml
Dow Corning silicone emulsion 36B	2·0 ml
Water to	1·0 liter
pH (80°) 7·5	

EASTMAN MULTILAYER STRIPPING FILM

While it was generally acknowledged that the best all around results in color photography were obtained by the "three-strip" method, the problems of registration and equipment bulk experienced with the three-strip cameras caused many workers to investigate methods of producing an integral tri-pack that could be used in any standard camera. Multilayered monopacks such as Kodachrome and Ansco Color were one approach to the problem. An entirely different approach was Eastman Multilayer Stripping Film which was designed to make use of the best elements of both systems.

The first and only use of this film for a feature picture was for the Columbia picture, *The Stranger Wore a Gun*, released in 1953. The release prints were imbibition prints made by Technicolor Laboratory.[32]

In 1940 the Eastman research laboratories began work on a film which would consist of three color-sensitive emulsions coated on a single base. Between each of the emulsions would be a special interlayer which would permit stripping of the two outer layers when wet. The order of the layers was the same as that used for the monopack films, red sensitive layer on bottom, then a stripping layer, then the green sensitive layer, then a second stripping layer, a yellow filter layer, and on top the blue sensitive layer (Fig. 44). As in the monopack the yellow filter was necessary to prevent exposure of the red and green sensitive layers by blue light. The first experiments for this system were aimed at producing a successful two-layer film, since it was assumed that if a two-layer film could not be produced successfully it would

Fig. 44 Eastman multilayer stripping film. 1. Blue sensitive layer. 2. Yellow filter layer. 3. Stripping layer. 4. Green sensitive layer. 5. Stripping layer. 6. Red sensitive layer. 7. Film base. 8. Anti-halation layer.

130

be useless to attempt a three-layer film. A successful two-layer film was produced in 1941 and a year later in 1942 a successful three-layer film was available for camera testing.[33] The overall thickness of this film was approximately the same as Eastman Plus X Negative Film, Type 5231, thus eliminating the necessity for any special modifications of standard motion picture camera gates or mechanism. The speed and keeping characteristics were approximately the same as Eastman Background X Panchromatic Negative Safety Film, Type 5230.

Because of their thinness the three emulsions yielded slightly low contrast on development: the red and green sensitive layers yielding gammas of approximately 0·55 and the blue sensitive layer yielding a gamma of 0·30. The low contrast obtained from the blue-sensitive layer was due to the intentionally low silver halide content of this emulsion, compounded in this way to prevent excessive light scatter and resultant loss of sharpness in the green and red sensitive layers. To increase the contrast of the blue record to the level of the other two records it was necessary to intensify it after development or to make a duplicate negative.

An important feature of this film was the provision for separating the three layers before processing. This permitted separate development of the three records thereby avoiding defects arising from developer reaction by-products diffusing from the lower layers to the upper layers. The second advantage available through separate processing, that of individual gamma control, was not realized with this film since all three films were developed to gamma infinity in order to obtain maximum emulsion speed and contrast.

The separation of the multilayered film into three black and white color separation negatives was accomplished on a special stripping machine. On this machine the exposed unprocessed multilayered negative entered the feed elevator with two strands of a special transfer film. The multilayered film and one strand of transfer film passed into tank 1 (Fig. 45a), which was a tank of 70°F water in which the multilayer stripping film and the transfer film were immersed for approximately 10 seconds. On leaving the solution the two films met at the rubber covered wringer rollers, 2, where they were rolled into intimate contact. Four inches beyond this point of contact the perforations of the two films were brought into accurate register by means of a specially designed sprocket 3 and a contact socket roller 4. The sprocket roller was positively driven at a film speed of 30 feet per minute. To compensate for differences in perforation pitch the shorter pitched film was stretched to match the pitch of the longer one. This was accomplished by means of two additional sprocket and contact socket rollers 5–6 located 18 inches above 3–4, and 7–8 located 48 inches above 5–6. These additional sprockets were driven by a friction clutch with an overdrive of approximately 5 per cent to maintain the required tension.

By the time the two films left the water bath and reached sprocket 7–8 the adhesion between the top emulsion layer of the multilayer film and the transfer film was such that tension is no longer necessary although the bonding was not firm enough for stripping.

The two films still in intimate contact (Fig. 45b) passed over a sheave 1, then through a loop system and finally up to two simple stripping rollers, 2. At this point the blue sensitive emulsion layer which was now bonded to the transfer film was stripped away from the multilayer film. After separating, the two films passed through a dry cabinet and the blue record

131

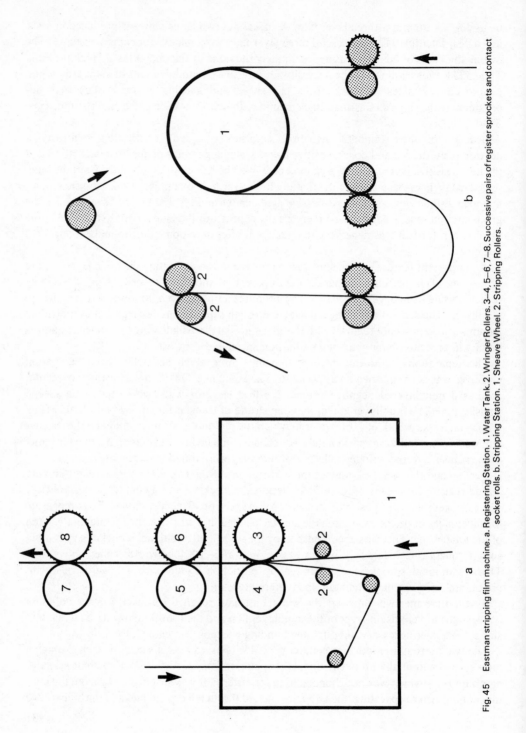

Fig. 45 Eastman stripping film machine. a. Registering Station. 1. Water Tank. 2. Wringer Rollers. 3–4, 5–6, 7–8. Successive pairs of register sprockets and contact socket rolls. b. Stripping Station. 1. Sheave Wheel. 2. Stripping Rollers.

passed onto the take-off at the end of the machine. The multilayer film which now contained the green and red records passed onto a second wetting and stripping station where the green record was stripped onto a transfer film using the same procedure described for the blue record. The three take-up spindles on the end of the machine now contained three separation negatives ready for black and white development. The red and green record negatives were developed to a gamma of 0·55 in a normal black and white developer, fixed, washed and dried. The blue record receiving the same development was developed to gamma of approximately 0·15. After development, fix and wash the blue record was bleached and intensified to a gamma of approximately 0·35.

The solutions used to intensify the blue record were the following[34]:

Bleach

Lead nitrate	7·8 grams
Potassium ferricyanide	12·2 grams
Acetic acid (glacial)	4·0 grams
Water to	1·0 liter

Redeveloper

Sodium sulfide	5·2 grams
Water to	1·0 liter

The negatives were then ready for printing by one of the methods that employ three separation negatives as the original material for release printing.

The Capstaff triple-head rotary registry printer used was designed primarily for a color process which contemplated the making of release prints from color-separation negatives such as those obtained with Eastman Multilayer Stripping film.

The three printing stations printed the red, green, and blue images successively in accurate registration. A station for printing sound was incorporated so that a complete color release print was produced by one pass of the print stock through the machine. The printer could be operated at 75 fpm and 112 fpm. For picture printing it used an 8 inch diameter, 132 tooth sprocket which drove the films through the printer and registered the films as described above. It was equipped with supply and hold-back sprockets and supply and take-up spindles for the several films.

Tension rollers in the film loops between the feed sprockets and the printing sprocket ensured good engagement of the driving teeth with the perforations of the respective films.

Cleaning stations were provided to remove lint, dust, and other free dirt from the negatives and the raw stock.

A single shutter, located in a plane immediately behind the main casting, intercepted all three light beams and was timed to allow correct functioning of the sprocket teeth in registering and transporting the two films with freedom from relative movement during exposure. The lamp houses were located at the rear of the instrument and all lamp filaments

were vertical. By means of prisms in the illuminating system, the light beams were directed onto the film at the printing stations.

The printing operation at each station was briefly as follows: a pair of rollers guide each pair of films to the sprocket and another pair of rollers strip the films off the sprocket. These rollers were so positioned that the films were engaged with the sprocket for 8 pitch lengths (2 frames). Only one pair of teeth engaged the leading edge of the perforations: these drove the films and exercised longitudinal register. These teeth engaged the perforations immediately ahead of the picture frame about to be printed. The height of the printing aperture was equal to one picture frame including the frame line. The exposure was initiated when the frame line above the picture frame began to leave the printing aperture, and it was terminated when the top of the picture frame began to leave the printing aperture. During the dark period the films were stripped from one pair of driving teeth and were relocated by the next pair of teeth, bringing the films into registration before the next exposure began.

After passing the first printing station (the red on the left-hand side of the printing sprocket), the films travelled through a free loop to the next feed sprocket. The negative went to the take-up reel, while the raw stock passed through a loop and back to another feed sprocket where it engaged a second negative (the green). These two films were then advanced through the tensioning system to the next printer station (the green, at the top of the main sprocket).

In order to realize the maximum benefit from consistent registration and freedom from individual variations between sprocket teeth and perforations, the film paths were chosen so that a given tooth registered the films while a given frame was printed at each of the three successive stations.

A sound sprocket of the radial-tooth type was mounted on the shaft which drove the main printing sprocket and the sound track was printed between the steps of printing the green and blue picture negatives.

The relative intensities of the three printing beams were controlled by rheostats mounted on the control panel. In addition, a control tape was run through the red beam at one-quarter the speed of the film. This tape comprised a series of neutral filters of varying densities and controlled the intensity of the light in the red beam in such a manner as to achieve correct color balance of the print from scene to scene.

DUPONT STRIPPING NEGATIVE

S. T. Tripac, a black and white stripping film that produced three separation negatives, was introduced by the E. I. DuPont Company in 1949.[35] Exposure was made using a conventional motion picture camera whose gate had been adjusted to accommodate the extra thickness of the film.

S. T. Tripac had a film speed of A.S.A. 12 when exposed to a tungsten light source having a color temperature of 3200°K. The film speed to daylight was A.S.A. 8 when exposed through a Wratten 85B filter.

The structure of the film was similar to the combination of a bipack and a single film cemented together (Fig. 46). The three light sensitive emulsions were in the center between

134

Fig. 46 Dupont S T tripac. 1. Film base. 2. Blue record. 3. Green record. 4. Red filter. 5. Red record. 6. Film base.
7. Anti-halation layer.

two film bases. When loaded in the camera the side of the film toward the lens was the bipack with its support facing the lens and the blue and green sensitive layer following it. This was connected to the third or red sensitive layer and its support by a red filter layer. After exposure the film was developed in a conventional black and white developer and fixed in a hardening fixer. Then the film was immediately immersed in a fresh stop bath and the front bipack film was stripped from the rear film and its support.

The excess solution was removed and the bipack was immersed in the transfer solution for two minutes. It was then rolled in contact with a gelatin coated support and left to set for two minutes. The two layers could then be separated by pulling off at an angle, the green record being transferred to the new support (Fig. 47). The three separate films were then washed and dried and were ready for printing by one of several methods that employ three separation negatives as the original.[36]

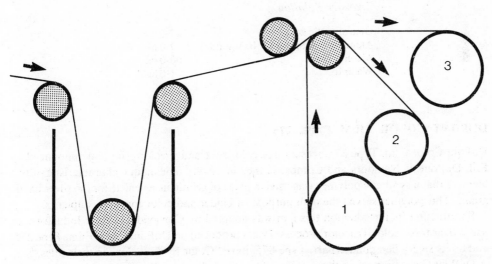

Fig. 47 Dupont S T tripac. Stripping the front bipack. 1. Base for Green Record. 2. Green Record. 3. Blue Record.

In following the procedure outlined above considerable difficulty was encountered. In addition to the problem of obtaining even development, by-products produced serious interimage effects. While attempting to overcome these problems two alternate procedures were developed. First the top layer and its support were stripped off before processing. The result was a noticeable improvement, but the problem was only partially solved; the development by-products of the middle and bottom layer still produced undesirable interimage effects. The next step was to remove the middle layer also, and transfer it to its support before processing. This change solved the evenness and interimage problems but introduced other problems, because using this method the stripping operations had to be accomplished in total darkness.[37]

Developer[38]

Metol	1·5 grams
Sodium sulfite (anhydrous)	60·0 grams
Hydroquinone	15·0 grams
Potassium carbonate	64·0 grams
Potassium bromide	4·5 grams
Water to	1·0 liter

Stop Bath

Borax	120·0 grams
Sodium sulfate	10·0 grams
Water to	1·0 liter

Transfer Solution

Glacial acetic acid	20·0 ml
Aluminum chloride (32° Be solution)	7·0 ml
Alcohol 70%	800·0 ml
Water to	1·0 liter

DUPONT COLOR FILM TYPE 275

DuPont Color Film, Type 275, was a three-color subtractive color print film announced by E. I. DuPont de Nemours and Company, Inc., in 1949.[39] The unique characteristic of this film was that a synthetic polymer was used in place of gelatin as a vehicle for the silver halide grains. This polymer served the dual purpose of binder and color forming coupler.

Shortly after its introduction this film was adopted by Consolidated Film Industries for use in their three-color Trucolor process. Prints produced on DuPont Color Film, Type 275, and on its safety film counterpart, Type 875, have "Color by Trucolor" in their titles.[40]

DuPont Color Film was a three-color subtractive color print film composed of three emul-

sion layers superimposed on one side of a standard film base. The top layer which was sensitive to blue light had a binder which formed a magenta dye. The middle layer which was sensitive to red light had a binder which formed a cyan dye. The bottom layer which was sensitive to green light has a binder which formed a yellow dye. Between each emulsion layer was a separator layer which prevented migration of oxidized developer molecules between adjacent layers. To prevent blue light exposure in the bottom two layers the top emulsion contained a yellow dye which came out during processing (Fig. 48).

Fig. 48 Dupont color film type 275. 1. Blue sensitive emulsion plus a binder which forms a magenta dye. 2. Separator layer. 3. Red sensitive emulsion plus a binder which forms a cyan dye. 4. Separator layer. 5. Green sensitive emulsion plus a binder which forms a yellow dye. 6. Substratum. 7. Film base. 8. Substratum. 9. Anti-halation backing. A Before Development. B After Color Development. C After Bleach and Fix.

To make prints on DuPont Color Film, three color separation negatives had to be printed in register in the following manner. The green record negative was printed in the top layer through a blue filter. The red record negative was printed in the middle layer through a red filter. The blue record negative was printed in the bottom layer through a green filter. Conventional types of registration printers, either contact or optical, could be used. The negative contrast desirable for printing onto DuPont Color Film was slightly higher than that desirable for normal black and white printing. While negatives for black and white use nor-

137

mally have a contrast of 0·65 to 0·70, negatives for contact printing on Type 275 had to be 0·85 to 0·90. For printing the three separation negatives onto the print film the following filters were recommended:

Blue	Corning 5113 (½ normal thickness)
Green	Defender 60 g
Red	Corning 2403

After exposure the print film was developed in a dye coupling developer to form a silver plus dye image in each layer. Following a wash the film passed to the first fix where all the un-exposed silver was dissolved. Once more it was washed, then it passed into a bleach which converted the silver image into silver ferrocyanide. This was followed by a wash and a second fix which dissolved the remaining silver, a final wash and drying.[41]

The processing cycle and formulas for developing DuPont Color Film, Type 275, were as follows:

Solution	Time	Temperature
Developer	10–12 min.	70°F
Wash	1–2 min.	70°F
First Fix	6 min.	70°F
Wash	5 min.	70°F
Bleach	5 min.	70°F
Wash	1 min.	70°F
Sound Track Application	1 min.	70°F
Wash	4 min.	70°F
Second Fix	4 min.	70°F
Wash	10 min.	70°F
Dry		

Developer

p-aminodiethylaniline mono-hydrochloride	2·5 grams
Sodium sulfite (anhydrous)	10·0 grams
Sodium carbonate (monohydrate)	47·0 grams
Potassium bromide	2·0 grams
Water to	1·0 liter

First Fix

Sodium thiosulfate	240·0 grams
Sodium sulfite (anhydrous)	15·0 grams
Borax	18·0 grams
Acetic acid (28%)	43·0 grams
Potassium alum	20·0 grams
Water to	1·0 liter

Bleach

Potassium ferricyanide	100·0 grams
Boric acid	10·0 grams
Borax	5·0 grams
Water to	1·0 liter

Second Fix

Sodium thiosulfate	200·0 grams
Water to	1·0 liter

Sound Developer

Sodium carboxymethylcellulose	20·0 grams
Sodium sulfide	63·0 grams
Water to	1·0 liter

THE ANSCO COLOR NEGATIVE/POSITIVE PROCESS

The Ansco Color Negative/Positive Process was a three-color subtractive system for color cinematography introduced in 1953 by the Ansco Division of General Aniline and Film Corporation.[42] When it was introduced the process consisted of three elements that could be used singly or together: a coupler-incorporated three-color negative film for an original photography, a coupler-incorporated three-color duplicating negative film, and a coupler-incorporated three-color release print film.

The first feature picture photographed in the Ansco Color Negative/Positive Process was the MGM picture, *The Wild North*. The negatives and release prints for this picture were processed in the MGM laboratory on converted black and white processing equipment.[43] The success of this first venture into color processing was followed by several more features in Ansco Color at MGM.[44]

Seven Brides for Seven Brothers
The Student Prince
Brigadoon
Kiss Me Kate
Take the High Ground
The Long, Long Trailer

Following the introduction of its color negative film the Ansco Company continued to improve its product. Three different camera negative films were manufactured before the film was eventually discontinued.

The camera negative films manufactured under the name of Ansco Color Negative were multilayered color films which consisted of three light-sensitive emulsions sensitized to red, green and blue light respectively, and coated on a single film support (Fig. 49). Incorporated

139

A B C

Fig. 49 Ansco color negative film structure. 1. Gelatin surface layer. 2. Blue sensitive emulsion plus yellow dye forming coupler. 3. Yellow filter layer. 4. Green sensitive emulsion plus magenta dye forming coupler. 5. Gelatin separation layer. 6. Red sensitive emulsion plus cyan dye forming coupler. 7. Film base. 8. Anti-halation layer. A Before Development. B After Color Development. C After Bleach and Fix.

in the emulsion layers were dye couplers which reacted simultaneously during development to produce a separate dye image in each layer, complementary to the sensitivity of the layer. The light and dark areas of the image were reversed with respect to those of the original subject. Also the various color areas of the negative were complementary in color to the corresponding areas in the original scene. In order to obtain maximum image sharpness it was necessary to produce a dye image in closest proximity with the originally exposed silver halide grain. To accomplish this it was important that the color coupler surround the grain so that the coupling reaction can take place *in situ* with the silver halide grain. The Ansco Color couplers were anchored in the emulsion layers by means of the specific chemical configuration of the color coupler molecules. A fatty acid molecule of large molecular size was chemically combined with the dye coupler molecule through a short linkage.

Three different color negative films having the general characteristics described above have been manufactured as Ansco Color Negative Film:

Ansco Color Negative Film, Type 843

A color negative film balanced for use under average daylight conditions, that is, for a mixture of sunlight and some blue sky. The speed of this film was E.I. 16. For daylight or arc

140

light exposure it was recommended that an ultraviolet absorbing filter such as the Ansco UV 16 be used on the camera lens. Normal contrast for this film was Red 1·00, Green 1·00, and Blue 1·25.

Ansco Color Negative Film, Type 844[45]

A color negative film balanced for use with 3200°K tungsten quality illumination. The speed of this film was E.I. 16 tunsten. According to the manufacturer this film could be used with daylight illumination without loss of speed by using a suitable conversion filter such as the Wratten 85 B. Normal contrast for this film was Red 1·00, Green 1·00, Blue 1·25.

Ansco Color Negative Film, Type 845[46]

A color negative film balanced for use with 3200°K quality illumination. The speed of this film was E.I. 25 tungsten and 16 daylight, with a Wratten 85 filter. This film was manufactured with a safety base which contained an orange tint which remained after processing. The purpose of this tint was to match the camera negative to inter-negative films which have a dye mask and thus permit intercutting of the camera negative and internegative. Normal contrast for this film was obtained by developing to a green gamma of approximately 0·70.

The Ansco color duplicating negative film was a multilayered color negative film similar in layer arrangement and color absorption characteristics to Ansco Color Negative Film. Its color sensitivity, however, was different from the camera negative film. It was similar to the color print film.

Ansco Color Duplicating Negative Film, Type 846[47]

A duplicating negative film which consisted of three light sensitive emulsions sensitized to red, green and blue light, respectively. The sensitivity of this film was balanced for exposure by a tungsten light source of approximately 3000°K. The exposure index was 0·60 to 1·0. Normal contrast was 0·90 to 1·20; however, development could be carried to gamma 1·5 or higher, if necessary.

The print film manufactured to be used with Ansco Color negative and duplicate negative films was multilayered color film which consisted of three light sensitive emulsions sensitized to red, green and blue, respectively, and coated on a single film support. Incorporated in the emulsion layers were dye forming couplers which react simultaneously during development to produce a separate dye image in each layer. When printed from a color negative, a color duplicate negative or a set of tri-color separation negatives, a three-color reproduction of the original was obtained. The couplers used in this film are similar to those described previously for the negative film.

141

Ansco Color Positive Release Printing Film, Type 848[48]

A color positive film balanced for printing with filtered tungsten illumination. The speed of this film was similar to black and white positive, approximately E.I. 1·5.

The processing steps and times for the negative and positive processes are given in the following tables:

PROCESS FOR ANSCO COLOR NEGATIVE FILMS

	843	844	845	846
Pre-bath		2 min.	10–20 sec.	
Rinse		30 sec.	10–20 sec.	
Color developer	10–12 min.	10–14 min.	12 min.	6–7 min.
	Rinse		Rinse	Rinse
Short stop	30 sec.	30 sec.	10–20 sec.	30 sec.
			Fix	
Hardener	8 min.*	4 min.	4 min.	8 min.*
Wash	4 min.	4 min.	4 min.	4 min.
Bleach	6 min.	6 min.	6 min.	6 min.
Wash	4 min.	4 min.	4 min.	4 min.
Fix	8 min.	4 min.	4 min.	8 min.
Wash	6 min.	8 min.	6 min.	6 min.
Stabilizer		2 min.	2 min.	
Dry	20–25 min.	20–25 min.	20–30 min.	25 min.

*Combination—hardener and fix.

PROCESS FOR ANSCO COLOR POSITIVE FILM

	848
Pre-bath	2 min.
Rinse	30 sec.
Color developer	11–14 min.
Rinse	30 sec.
Hardener fix	8 min.
Wash	4 min.
Bleach	6 min.
Wash	4 min.
Squeegee and sound track treatment	30 sec.
Wash	2 min.
Fix	4 min.
Wash	8 min.
Stabilizing bath	2 min.
Rinse	1 sec.
Dry	25 min.

Processing Formulas

Pre-bath

Solution A

Water	850·0 ml
Sodium hexametaphosphate	1·0 gram
Sodium sulfate	30·0 grams
Sodium carbonate	75·0 grams
Sodium bicarbonate	3·0 grams

Solution B

Water	100·0 ml
Sodium lauryl sulfate	4·0 grams

Add Solution A to B with manual stirring.
pH 11·0 ± 0·2

Negative Color Developer—608

	Tank	Repl.
Water	900 ml	750 ml
Sodium hexametaphosphate	1·0 gram	1·0 gram
Sodium sulfite	3·0 grams	3·75 grams
Dicolamine (S5 type)	7·0 grams	11·0 grams
Sodium carbonate	75·0 grams	75·0 grams
Sodium sulfate	30·0 grams	30·0 grams
Potassium bromide	2·0 grams	1·0 gram
Ansco DA-1 accelerator (5% sol.)	5·0 ml	6·0 ml
Potassium iodide	0·002 gram	
Sodium hydroxide		2·0 grams
Water to	1·0 liter	1·0 liter
pH	10·29	10·75

Positive Color Developer—609

Water	90 ml	750 ml
Sodium hexametaphosphate	1·0 gram	1·0 gram
Sodium sulfite	2·0 grams	750 ml
Dicolamine (S5 type)	5·0 grams	7·5 grams
Sodium carbonate	60·0 grams	60·0 grams
Potassium bromide	1·0 gram	
Potassium iodide	0·001 gram	
Sodium hydroxide		2·0 grams
Water to	1·0 liter	1·0 liter

Acid Rinse—859B

Acetic acid (glacial)	3·0 ml	10·0 ml
Sodium acetate (anhydrous)	30·0 grams	20·0 grams
Water to	1·0 liter	1·0 liter
pH 5·4–5·8		

Hardening Fix—804

	Tank	Repl.
Water	750 ml	
Potassium chrome alum	30·0 grams	
Potassium alum	20·0 grams	
Sodium acetate	10·0 grams	
Sodium sulfite	10·0 grams	
Sodium thiosulfate	200·0 grams	
Water to	1·0 liter	
pH	4·0	

Bleach—715A

	Tank	Repl.
Water	750 ml	750 ml
Sodium hexametaphosphate	0·5 gram	0·5 gram
Potassium ferricyanide	100·0 grams	200·0 grams
Sodium acetate	20·0 grams	20·0 grams
Acetic acid (glacial)	2·25 ml	9·0 ml
Water to	1·0 liter	1·0 liter
pH	4·5–4·7	4·5–5·0

Fix—800

Water	750 ml
Sodium thiosulfate	200·0 grams
Water to	1·0 liter

Stabilizer

Formaldehyde 2% Sol.

144

Formulas for Processing Ansco Color Negatives 845

Color Developer—3470-62

	Tank	Repl.
Sodium hexametaphosphate	1·0 gram	1·0 gram
Sodium sulfite	12·0 grams	13·0 grams
Dicolamine (S5 type)	4·0 grams	4·0 grams
Sodium carbonate	60·0 grams	60·0 grams
Potassium bromide	1·3 grams	1·3 grams
Potassium iodide	0·002 gram	0·006 gram
Sodium hydroxide		0·5 gram
Water to	1·0 liter	1·0 liter
pH	10·80 0·05	10·95 0·05

First Fix—204

Sodium thiosulfate	240·0 grams
Sodium sulfite	15·0 grams
Acetic acid (28%)	75·0 ml
Borax	14·5 grams
Potassium alum	15·0 grams
Water to	1·0 liter

Bleach—715C

	Tank	Repl.
Potassium alum	10·0 grams	15·0 grams
Acetic acid	9·0 ml	9·0 ml
Sodium acetate	20·0 grams	20·0 grams
Potassium ferricyanide	95·0 grams	200·0 grams
Potassium ferrocyanide	5·0 grams	
Water to	1·0 liter	1·0 liter
pH	4·5–4·9	4·5–4·9

Final Fix—805

Sodium thiosulfate	200·0 grams
Sodium sulfite	3·0 grams
Sodium acetate	20·0 grams
Boric acid	7·5 grams
Acetic acid	8·0 ml
Potassium alum	5·0 grams
Water to	1·0 liter
pH	4·7–5·0

Stabilizer—915C

	Tank	Repl.
Water	750 ml	750 ml
Formalin (37% sol.)	2·5 ml	12·5 ml
Dow Corning silicone 36	2·5 ml	10·0 ml
Water to	1·0 liter	1·0 liter

REFERENCES

[1] SCHINZEL, K., *British Journal of Photography*, LII (1905), p. 608.

[2] FRIEDMAN, J. S., *History of Color Photography* (Boston: American Photographic Publishing Co., 1944), p. 127.

[3] NEBLETTE, C. B., *Photography: Its Principles and Practices* (New York: D. Van Nostrand Company, Inc., 1947), p. 813.

[4] MEES, C. E. K., "Direct Processes for Making Photographic Prints in Color," *Journal of the Franklin Institute*, January, 1941, pp. 45–46.

[5] "Technical News," *Journal of the Society of Motion Picture Engineers*, March, 1945, p. 220.

[6] "A Manual for Processing Kodak Duplicating C-P Color Film, 16 mm, Type 5265" (Motion Picture Film Department, Eastman Kodak Company, New York).

[7] "A Manual for Processing Kodak Commercial C-P Color Film, 16 mm, Type 5268" (Motion Picture Film Department, Eastman Kodak Company, New York).

[8] THOMAS, D. S., Jr., REES, H. L. AND LOVICK, R. C., "A New Reversal Print Method for a Color Production System," *Journal of the Society of Motion Picture and Television Engineers*, August, 1965, pp. 671–675.

[9] "A Manual Describing the Processing of Eastman Reversal Color Print Film, Type 5269 (16 mm), Process RCP-1" (Motion Picture Film Department, Eastman Kodak Company, New York).

[10] "A Manual Describing the Processing of Eastman Reversal Color Print Film, Type 7387 (16 mm), Process RCP-2" (Motion Picture and Education Markets Division, Eastman Kodak Company, New York).

[11] DUERR, H. H. AND HARSH, H. C., "Ansco Color for Professional Motion Pictures," *Journal of the Society of Motion Picture Engineers*, May, 1946, p. 357.

[12] LIMBACHER, J. L., "A Historical Study of the Color Motion Picture," Dearborn, Michigan, 1963, p. 19. (Mimeographed.)

[13] DUERR, H. H. AND HARSH, H. C., "Ansco Color for Professional Motion Pictures," *loc. cit.*, p. 358.

[14] *Ibid.*, pp. 359–360.

[15] *Ibid.*, pp. 360–361.

[16] *Ibid.*

[17] FORREST, J. L., "Processing Anscochrome Motion Picture Films for Industrial and Scientific Applications," Journal of the Society of Motion Picture and Television Engineers, December, 1955, p. 679.

[18] *Ibid.*

[19] *Ibid.*

[20] GIFFORD, A. F. AND GERHARDT, F. H. "Characteristics of Super Anscochrome Film," *Photographic Science and Engineering*, July, 1951, pp. 12–14.

[21] "Ansco Motion Picture Films" (Professional Motion Picture Department, Ansco Division of General Aniline and Film Corporation, Binghamton, New York, January, 1959), p. 1.

[22] "Ansco Cine Films" (Ansco Photo Products, General Aniline and Film Corporation, Binghamton, New York, 1964).

[23] *Ibid.*

[24] *Ibid.*

[25] *Ibid.*

[26] FOSGARD, F. C., GIFFORD, A. F., WHITTEMORE, C. M. AND WIFE, W. L., "Characteristics and Applications of a New High Speed Color Film—Anscochrome D/500." *Journal of the Society of Motion Picture and Television Engineers*, Oct., 1968, pp. 1150–1152.

[27] "Ansco Cine Films", *loc. cit.*

[28] FORREST, J. L., "A New 16mm Camera Color Film for Professional Use," *Journal of the Society of Motion Picture and Television Engineers*, January, 1957, pp. 12–13.

[29] FORREST, J. L., "Machine Processing of 16mm Ansco Color Film," *Journal of the Society of Motion Picture Engineers*, November, 1945, p. 316.

[30] *Ibid.*

[31] "Anscochrome Motion Picture Process AR-2 (A Short Process for Anscochrome Reversal Motion Picture Films)" (Professional Motion Picture Department, Ansco Division, General Aniline and Film Corp., Binghamton, New York, May, 1964), pp. 6–12. (Mimeographed.)

[32] Personal interview with G. P. Rackett.

[33] CAPSTAFF, J. G., "An Experimental 35mm Multilayer Stripping Negative Film," *Journal of the Society of Motion Picture and Television Engineers*, April, 1950, pp. 445–453.

[34] Private communication from R. G. Hufford, Eastman Kodak Company.

[35] SEASE, V. B., "DuPont's New Color Film," *American Cinematographer*, 1949, pp. 240, 257–258.

[36] SPILLER, GINO, "Modern Techniques of Color Film Processing" (unpublished Master's thesis, University of Southern California, 1952).

[37] Private communication from Wilton R. Holm, Motion Picture Film Department, E. I. DuPont de Nemours and Company.

[38] GLAFKIDES, PIERRE, *Photographic Chemistry* (London: Fountain Press, 1960), II, 559.

[39] JENNINGS, A. B., STANTON, W. A. AND WEISS, J. P., "Synthetic Color-Forming Binders for Photographic Emulsions," *Journal of the Society of*

146

Motion Picture and Television Engineers, November, 1950, pp. 455–476.

[40] ROSE, J. J., *American Cinematographer Handbook and Reference Guide* (Los Angeles: Southland Press, 1950), p. 71.

[41] JENNINGS, A. B., *et al.*, "Synthetic Color-Forming Binders for Photographic Emulsions," *loc. cit.*, p. 470.

[42] DUERR, H. H., "The Ansco Color Negative-Positive Process," *Journal of the Society of Motion Picture and Television Engineers*, June, 1952, pp. 465–479.

[43] ROWAN, A., "*The Wild North* Introduces MGM's New Ansco Color Process," *American Cinematographer*, March, 1952, pp. 106–107, 122–124.

[44] *Variety*, January 6, 1954, p. 51.

[45] "Technical Service Bulletin # 6.41" (Professional Motion Picture Department, Ansco Division, General Aniline and Film Corporation, Binghamton, New York, December 1, 1957).

[46] "How to Use and Process Ansco Color Negative" (Professional Motion Picture Department, Ansco Division, General Aniline and Film Corporation, Binghamton, New York, April, 1957).

[47] "Technical Service Bulletin # 6.31" (Professional Motion Picture Department, Ansco Division, General Aniline and Film Corporation, Binghamton, New York, October 15, 1951).

[48] DUERR, H. H., "The Ansco Color Negative–Positive Process," *loc. cit.*, p. 470.

VIII EASTMAN COLOR AND EKTACHROME

EASTMAN COLOR

The Eastman Color Process is a three-color subtractive color process introduced in 1950 by the Eastman Kodak Company.[1] When it was introduced the process consisted of two elements that could be used singly or together: a coupler-incorporated, integral mask, three-color negative, and a coupler-incorporated, three-color print film. The negative achieved almost immediate success and has become the basic unit for most of the 35 mm color motion pictures photographed in the United States. The print film was used first chiefly for daily prints but its popularity has consistently increased and at present it is one of the most popular films used for motion picture release printing. A large part of the success of the Eastman Color Films has been due to the continuing effort of the Kodak Research Laboratories. Since the introduction of the process there have been six different camera negative films and seven different print films; also two different panchromatic separation films, four different inter-negatives, a reversal color intermediate which produces a duplicate negative directly from an original color negative, and a color intermediate film which can be used as either an intermediate positive or an intermediate negative.

During the first few years following its introduction Eastman Color Negative Film, Type 5247 was used to photograph feature films released in several print processes.

Columbia Pictures
The Redskin Rode	Super Cinecolor
The Texas Ranger	Super Cinecolor
Barefoot Mailman	Super Cinecolor
Hurricane Island	Super Cinecolor
Sunny Side of the Street	Super Cinecolor
Magic Carpet	Super Cinecolor

Warner Bros.
The Lion and the Horse	Warner Color
Carson City	Warner Color
The Miracle of Our Lady of Fatima	Warner Color
Springfield Rifle	Warner Color
House of Wax	Warner Color

Stop, You're Killing Me	Warner Color
She's Back on Broadway	Warner Color

Twentieth Century-Fox
Sword of Monte Cristo	Super Cinecolor
The Robe	Technicolor
How to Marry a Millionaire	Technicolor
Beneath the Twelve Mile Reef	Technicolor

Paramount
Sangeree	Technicolor

United Artists
Drums in the Deep South	Super Cinecolor

Republic Pictures
Fair Wind to Java	Trucolor
Lady Wants Mink	

Negative Materials

The camera negative films manufactured under the name of Eastman Color Negative are multilayered color films which consist of three light-sensitive emulsions sensitized to red, green and blue light respectively, and coated on a single film support (Fig. 50). Incorporated in the emulsion layers are dye couplers which react simultaneously during development to produce a separate dye image in each layer complementary to the sensitivity of the layer. The light and dark areas of the image are reversed with respect to those of the original subject. Also the various color areas of the negative are complementary in color to the corresponding areas in the original scene. The overall orange cast of the negative film is due to the color contributed by the unused coupler in the red and green sensitive layers. These colored couplers act as masks to correct for the deficiencies of the dyes which form the image.

The dyes used in color photography, whether they are produced by dye coupling or by any other means, have absorption characteristics which lead to undesirable results when a color reversal film is duplicated or a color negative film is printed to a color positive film. In addition to the desired absorption, there is a certain amount of unwanted absorption in other regions of the spectrum which tends to degrade the color reproduction. The cyan-dye image absorbs some blue and green light in addition to the red light which it is intended to absorb, the magenta-dye image absorbs some blue light in addition to the green light which it is intended to absorb and the yellow-dye image absorbs some green light in addition to the blue light which it is intended to absorb. The effects of this unwanted absorption can be minimized through the use of separate silver masks as described by T. H. Miller.[2] However, this type of correction is most suitable for still photography; when applied to motion picture photography it becomes both cumbersome and expensive. A more suitable method for motion picture reproduction is to use couplers which have an original color that is nearly

149

Fig. 50 Eastman color negative film structure. 1. Gelatin overcoat. 2. Blue sensitive emulsion plus colorless yellow dye forming coupler. 3. Carey Lea silver layer. 4. Blue and green sensitive emulsion plus yellow colored magenta dye forming coupler. 5. Gelatin interlayer. 6. Red and blue sensitive emulsion plus reddish-orange colored cyan dye forming coupler. 7. Film base. 8. Anti-halation backing. A Before Development. B After Color Development. C After Bleach and Fix.

equivalent to the unwanted absorption of the dye images found after coupling.[3] The use of this technique to obtain improved color reproduction in motion pictures represents a significant advance in the state of the art. Couplers of this type were used for the first time in a motion picture film in the red and green sensitive layers of Eastman Color Negative Film. The cyan dye-forming coupler is colored orange. When it is converted by exposure and development to cyan dye the orange color is destroyed in proportion to the amount of development which takes place. The unexposed areas where no development takes place retain their original color forming an orange-colored positive image along with the negative cyan image in the red sensitive layer. The magenta dye-forming coupler is colored yellow. When it is converted by development to magenta dye the yellow color is destroyed in proportion to the amount of development which takes place. The unexposed areas where no development takes place retain their original color forming a yellow color positive image along with the negative magenta image in the green sensitive layer. The yellow dye-forming coupler is colorless because at the time when the process was developed there were no entirely suitable magenta colored couplers. If such a coupler were available it would be possible to improve the reproductions of yellow and green.

Six different color negative films having the general characteristics described above have been manufactured as Eastman Color Negative Films:

150

Eastman Color Negative Safety Film, Type 5247[4]

A color negative film balanced for use under average daylight conditions, that is for the mixture of sunlight and some blue skylight. The speed of this film was E.I. 16, introduced in 1950.

Eastman Color Negative Film, Type 5248[5]

A color negative film balanced for use with 3200°K Tungsten illumination. The speed of this film was E.I. 25 Tungsten and 16 Daylight with a Wratten 85 Filter. Introduced in 1953 this film replaced the earlier type 5247 film. In addition to having a higher speed for tungsten exposure it had finer grain and improved color reproduction compared to its predecessor.

Eastman Color Negative Film, Type 5250[6]

A color negative film balanced for use with 3200°K Tungsten illumination. The speed of this film was E.I. 50 Tungsten and 32 Daylight with a Wratten 85 Filter. Introduced in 1959 this film replaced the earlier type 5248 film. Its improved characteristics included one camera stop more film speed and a new yellow-forming dye-coupler which produced an image dye having less absorption for green light, giving improved color reproduction.

Eastman Color Negative Film, Type 5251[7]

A color negative film balanced for use with 3200°K Tungsten illumination. The speed of this film was E.I. 50 Tungsten and 32 Daylight with a Wratten 85 Filter. Introduced in 1962 this film replaced the earlier Type 5250 film. Its improved characteristics were substantially improved color balance.

Eastman Color Negative Film, Type 5254[8]

A color negative film balanced for use with 3200°K Tungsten illumination. The speed of this film was E.I. 100 Tungsten and 64 Daylight with a Wratten 85 Filter. Introduced in 1968 this film replaced the earlier Type 5251 film. Its improved characteristics included one lens stop more film speed with no increase in graininess maintaining the same sharpness and preserving the same color rendition.

Eastman Color Negative Film, Type 5247/7247[9]

A color negative film balanced for use with tungsten illumination. The speed of this film was E.I. 100 Tungsten and 64 Daylight with a Wratten 85 Filter. Introduced in 1972 this film replaced the earlier Type 5254 film. Its improved characteristics include a significant increase in sharpness, and reduction in graininess along with a substantial reduction in processing time.

Fig. 51 Eastman color print film structure. 1. Gelatin overcoat. 2. Green sensitive emulsion plus colorless magenta dye forming coupler. 3. Red sensitive emulsion plus colorless cyan dye forming coupler. 4. Gelatin interlayer. 5. Blue sensitive emulsion plus colorless yellow dye forming coupler. 6. Substratum. 7. Film base. 8. Anti-halation backing. A Before Development. B After Color Development. C After Bleach and Fix.

Positive Materials

The print films manufactured under the name of Eastman Color Print Film are multilayered color films which consist of three light-sensitive emulsions sensitized to blue, red and green light respectively and coated on a single film support (Fig. 51). Incorporated in the emulsion layers are dye couplers which react simultaneously during development to produce a separate dye image in each layer. When printed from a color negative or additively from three color-separation negatives a three-color reproduction of the original subject is obtained. The couplers used in these films are colorless.

Eastman Color Print Safety Film, Type 5281 [10] (35 mm), 7381 (16 mm)

A color positive film balanced for printing with filtered tungsten illumination. The manufacturer's instructions stated that better contrast and color reproduction could be obtained if this film was printed by additive rather than subtractive means. Introduced in 1950.

Eastman Color Print Film, Type 5382 [11] (35 mm) and 7382 (16 mm)

A color positive film balanced for printing with filtered tungsten illumination. Introduced in

152

1953 this film replaced the earlier Type 5381 film. Its improved characteristics included better sharpness, better sound track and a new magenta dye-forming coupler which resulted in improved red reproduction.

Eastman Color Print Film, Type 7383[12] (16 mm)

A color positive film balanced for printing with filtered tungsten illumination. Introduced in 1959 this film was only available in the 16 mm size where its improved sharpness could be used with the greatest advantage.

Eastman Color Print Film, Type 5385[13] (35 mm) and 7385 (16 mm)

A color positive film balanced for printing with filtered tungsten illumination. Introduced in 1962 this film replaced the earlier Type 5382 (35 mm) and Type 7383 (16 mm). Its improved characteristics included better sharpness in the 35 mm size and higher effective speed and improved color balance in both 35 mm and 16 mm sizes.

Eastman Color Print Film, Type 7380[14]

A color positive film balanced for printing with filtered tungsten illumination. Introduced in 1968 this film was only available in small format sizes where its improved sharpness and finer grain characteristics could be used with the greatest advantage. Since the improvements mentioned above were accompanied by a substantial loss in film speed a demand never developed for this film in larger formats.

Eastman Color Print Film, Type 5381[15] (35 mm) and 7381 (16 mm)

A color positive film balanced for printing with filtered tungsten illumination. When it was originally introduced in 1970 this film was only available in small format sizes (8 mm and Super 8). In January 1972 it became available in 35 mm formats. Its improved characteristics included sharpness and grain levels equal to Type 7380 with a speed increase equal to 5385/7385; these improvements were particularly significant in laboratories making high-speed reduction prints in 8 mm or Super 8 formats. A later improvement introduced in mid-1974 improved the yellow color reproduction.

Eastman Color Print Film, Type 5383 (35 mm) and 7383 (16 mm)[16]

A color positive film balanced for printing with filtered tungsten illumination. Introduced in 1974, this film was sold concurrently with Type 5381/7581. Its general characteristics were similar except this film had a hardened emulsion which permitted it to be processed in the higher temperature more rapid access ECP-2 process.

Duplicating Materials

Approximately one year after the introduction of the first Eastman Color Negative and Print Films the system was made complete by the addition of two intermediate films:

1. A black and white panchromatic film having a contrast range intermediate between the negative and positive films usually used in black and white work.

Eastman Panchromatic Separation Film, Type 5216[17]

The emulsion of this film was slower, sharper and had finer grain structure than the usual panchromatic duplicating films. Its purpose was for making three-color separation positives from color negatives. Introduced in 1951.

Eastman Panchromatic Separation Film, Type 5235[18]

A black and white panchromatic duplicating positive film used for making three-color separation positives from color negatives. Introduced in 1956 this film replaced the earlier Type 5216 film.

Fig. 52 Eastman color internegative film structure (false sensitized). 1. Gelatin overcoat. 2. Blue sensitive emulsion plus yellow colored magenta dye forming coupler. 3. Gelatin interlayer. 4. Blue and green sensitive emulsion plus reddish-orange colored cyan dye forming coupler. 5. Gelatin interlayer. 6. Blue and red sensitive emulsion plus colorless yellow dye forming coupler. 7. Film base. 8. Anti-halation backing. A Before Development. B Ater Color Development. C After Bleach and Fix.

154

2. A multilayered duplicating color negative film which consisted of three light-sensitive emulsions sensitized to red, green and blue light respectively (Fig. 52). Incorporated in the emulsion layers were dye-forming couplers which react simultaneously during development to produce separate dye images in each layer. This film differed significantly from its companion camera film Type 5247 in that the dyes formed were not complementary to the sensitivity of the emulsion layers. The magenta dye-forming coupler was in the top blue-sensitive layer so that the blue light exposure led to the formation of magenta dye. The cyan dye-forming coupler was in the middle green-sensitive layer so that the green light exposure led to the formation of cyan dye. The yellow dye-forming coupler was in the bottom red-sensitive layer so that the red light exposure leads to the formation of yellow dye. This arrangement of dye forming couplers and sensitizing was used to give maximum sharpness.

The internegative contained colored couplers similar to those used in Eastman Color Negative which provided automatic masking to correct in part for the unwanted absorption of the cyan and magenta dyes of the negative.

Eastman Color Internegative Safety Films, Type 5243[19]

A multilayered duplicating color negative film which consisted of three light-sensitive emulsions sensitized to red, green and blue light respectively. Introduced in 1951.

Eastman Color Internegative Film, Type 5245[20]

A multilayered duplicating color negative film which consisted of three light-sensitive emulsions sensitized to red, green and blue light respectively. Introduced in 1953 this film replaced the earlier Type 5243 film. Its general characteristics were similar to those of its predecessor with improvements in graininess and sharpness.

In 1956 the Eastman Color system was augmented by the addition of two new films, Type 5270 a duplicating negative for use with reversal color originals and Type 5253 a color intermediate that can be used as either a color master positive or a duplicate negative. The latter eventually replaced completely the Type 5245 internegative.

Eastman Color Internegative Film, Type 5270[21] (35 mm) and 7270 (16 mm)

A slow, fine-grain, long latitude multilayered duplicating color negative film which consisted of three light-sensitive emulsions sensitized to red, green and blue light respectively (Fig. 53). As in the Eastman Color Negative Film colored dye-forming couplers were employed to provide color correction for unwanted absorption of the image dyes of the reversal original.

Eastman Color Internegative Film, Type 5271[22] (35 mm) and 7271 (16 mm)

A slow, fine-grain, long latitude multilayered duplicating color negative film for use with reversal camera originals. Introduced in 1968, this film replaced the earlier Type 5270/7270

155

Fig. 53 Eastman color internegative film structure (normal sensitized). 1. Gelatin overcoat. 2. Blue sensitive emulsion plus colorless yellow dye forming coupler. 3. Carey Lea silver layer. 4. Blue and green sensitive emulsion plus yellow colored magenta dye forming coupler. 5. Gelatin interlayer. 6. Blue and red sensitive emulsion plus reddish-orange colored cyan dye forming coupler. 7. Film base. 8. Anti-halation backing. A Before Development. B After Color Development. C After Bleach and Fix.

film. Its improved characteristics included improved sharpness, finer grain, improved color reproduction, slightly higher speed, improved curve shape and increased processing compatibility. Optimum processing is obtained in the Eastman Color Print Process at 75°F using the same solution composition, times, and temperatures required to process Eastman Color Print Film.

Eastman Color Intermediate Film, Type 5253[23] *(35 mm) and 7253 (16 mm)*

A multilayered duplicating color film that can be used for the preparation of either a color master positive or a color duplicate negative. In addition to the color-forming coupler this film contains absorbing dyes which prevent scattered light traveling within the emulsion layers. This improves image sharpness to the degree that it is not necessary to use the inverted order of layers employed in Types 5243 and 5245 (Fig. 54).

As advances in emulsion technology continued to progress it became possible to design a new film which by reversal processing could produce a duplicate negative in a single printing and processing operation. This advancement improved laboratory efficiency but more important to the final screen image it also improved graininess, color reproduction and sharpness. Introduced in 1968 the new film was an immediate success.

156

Fig. 54 Eastman color intermediate film structure. 1. Gelatin overcoat. 2. Blue sensitive emulsion plus colorless yellow dye forming coupler. 3. Carey Lea silver layer. 4. Blue and green sensitive emulsion plus yellow colored magenta dye forming coupler. 5. Gelatin layer. 6. Blue and red sensitive emulsion plus reddish-orange colored cyan dye forming coupler. 7. Film base. 8. Anti-halation backing. A Before Development. B After Color Development. C After Bleach and Fix.

Eastman Color Reversal Intermediate Film, Type 5249[24] (35 mm) and 7249 (16 mm)

A multilayered incorporated-coupler duplicating color film which by reversal processing produces duplicate color negatives directly from the original negative. The spectral sensitivity and image dye absorption characteristics are similar to those of Eastman Color Intermediate Type 5253 permitting intercutting with the original and other color negative duplicating films. With this new film it is necessary to place the original base to emulsion in an optical printer when exposing the duplicate. This is required to preserve orientation as well as to introduce effects or change picture format, also modified techniques are required for fades and dissolves. An additional requirement for the use of this new film is the installation of a new processing machine and process CRI-1.

Eastman Color Processing

The films employed in the Eastman Color family can be processed in conventional type continuous processing machines with minor modifications to allow for all of the steps required. Until the introduction of the ECN-2 process in 1972 the processing steps had remained approximately the same throughout the evolution of the process. Improvements as they came

157

were accomplished in film manufacturing. The only significant exception was the change in processing times necessary when the film was changed from Type 5247 to 5248. The introduction of ECN-2 process in 1972 had a major effect on motion picture laboratory operation. The processing time was reduced from approximately 45 minutes to 12 minutes, also substantial changes were made in solution chemistry. The result was more rapid access to the developed negative and a reduction of processing machine size for a given level of productivity. A more gradual evolution has taken place in the print process. Changes in film manufacture made possible increases in solution temperature with subsequent reduction in processing time.

The following tables give the processing steps and times for the various members of the Eastman Color Process family described in the previous sections.[25] Table 1 shows the ECN-1 process for color negatives and internegatives, the reduced times for the higher temperature ECN-2 process being given in Table 2. The steps of the positive process ECP-1 are shown in Table 3, with the ECP-2 process in Table 4. Table 5 indicates the steps of the reversal process CRI-1.

TABLE 1

PROCESS ECN-1

Processing Steps for Eastman Color Negative and Internegative

	5247	5248	5250	5251	5254	5243	5245	5253
Pre-bath	1–2 min.	10 sec.	10 sec.	10 sec.	10 sec.	1–2 min.	10 sec.	10 sec.
Spray rinse	—	10–20 sec.	10–20 sec.	10–20 sec.	10–20 sec.	—	10–20 sec.	10–20 sec.
Color developer	24–27 min.	12 min.	12 min.	12 min.	12 min.	12 min.	9 min.	6 min.
Spray rinse	—	10–20 sec.	10–2 sec.	10–20 sec.	10–20 sec.	—	10–20 sec.	10–20 sec.
First fix	4 min.	4 min.	4 min.	4 min.	4 min.	4 min.	4 min.	4 min.
Wash	4 min.	4 min.	4 min.	4 min.	4 min.	4 min.	4 min.	4 min.
Bleach	8 min.	8 min.	8 min.	8 min.	8 min.	8 min.	8 min.	8 min.
Wash	4 min.	4 min.	4 min.	4 min.	4 min.	4 min.	4 min.	4 min.
Final fix	4 min.	4 min.	4 min.	4 min.	4 min.	4 min.	4 min.	4 min.
Wash	8 min.	8 min.	7 min.	7 min.	7 min.	8 min.	8 min.	7 min.
Stabilizing bath	—	—	—	1 min.	1 min.	—	—	1 min.
Rinse	—	—	—	1–5 sec.	1–5 sec.	—	—	1–5 sec.
Wetting agent	1 min.	5–10 sec.	1 sec.	1 sec.	1 sec.	1 sec.	5–10 sec.	1 sec.
Dry	15–20 min.	15–20 min.	15–20 min.	15–20 min.	15–20 min.	15–20 min.	15–20 min.	15–20 min.

Note: Solution temperatures 70°F.

TABLE 2

PROCESS ECN-2

	5247 (ECN-II)	
	Time	*Temp.*
Pre-bath	10 sec.	80°
Backing removal and rinse	5 sec.	80–100°
Color developer	3 min.	106°
Stop bath	30 sec.	80–100°
Wash	30 sec.	80–100°
Bleach	3 min.	100°
Wash	1 min.	80–100°
Fix	2 min.	100°
Wash	2 min.	80–100°
Stabilizer	10 sec.	80–100°

Note: All temperatures are in degrees Fahrenheit.

TABLE 3

PROCESS ECP-1

Processing Steps for Eastman Color Print and Internegative

			70°F			75°F	75°F	80°F
	5381	5382	5383	5385	5270	5271	5381*	5381*
Pre-bath	1–2 min.	10 sec. to 1 min.	10 sec.	10 sec.	10 sec.	10 sec.	10 sec.	10 sec.
Spray rinse	—	10–20 sec.	10–20 sec.	10–20 sec.	10–20 sec.	15 sec.	15 sec.	15 sec.
Color developer	12–15 min.	12–15 min.	14 min.	14 min.	6 min.	8 min.	8 min.	5 min. to 20 sec.
Spray rinse	—	10–20 sec.	10–20 sec.	10–20 sec.	10–20 sec.	15 sec.	15 sec.	15 sec.
First fix	4 min.	4 min.	4 min.	4 min.	4 min.	2 min.	1 min. to 45 sec.	1 min.
Wash	4 min.	4 min.	4 min.	4 min.	4 min.	1 min.	1 min.	40 sec.
Bleach	8 min.	8 min.	8 min.	8 min.	8 min.	6 min.	6 min.	4 min.
Wash	2 min.	2 min.	2 min.	2 min.	—	2 min.	2 min.	1 min.
Sound track dev.	10 sec.	10–20 sec.	10–20 sec.	10–20 sec.	—	—	10–20 sec.	10–20 sec.
Wash	2 min.	2 min.	10–30 sec.	10–30 sec.	—	—	15 sec.	15 sec.
Final fix	4 min.	4 min.	4 min.	4 min.	4 min.	2 min.	2 min.	2 min.
Wash	8 min.	8 min.	7 min.	7 min.	7 min.	6 min.	6 min.	5 min.
Stabilizing bath	1–5 sec.	5–10 sec.	5–10 sec.	5–10 sec.	1 min.	10 sec.	10 sec.	10 sec.
Spray rinse	—	—	—	—	1–5 sec.	—	—	—
Wetting agent	—	—	—	—	1 sec.	—	—	—
Dry	15–20 min.	15–20 min.	15–20 min.	15–20 min.	15–20 min.	15–20 min.	15–20 min.	15–20 min.

*New 5381 introduced in 1969.

159

TABLE 4

PROCESS ECP-2

	Time	Temp.
Pre-bath	10–20 sec.	$80° \pm 2$
Rem-jet removal and spray rinse	1–2 sec.	$80° \pm 5$
Developer	3 min.	$97° \pm 0\cdot2$
Stop bath	40 sec.	$80° \pm 2$
Wash	40 sec.	$80° \pm 5$
First fix	40 sec.	$80° \pm 2$
Wash	40 sec.	$80° \pm 5$
Bleach	1 min.	$80° \pm 2$
Wash	40 sec.	$80° \pm 5$
Sound dev.	10–20 sec.	$80° \pm 5$
Spray rinse	1–2 sec.	$80° \pm 5$
Second fix	40 sec.	$80° \pm 2$
Wash	1 min.	$80° \pm 5$
Stabilizer	10 sec.	$80° \pm 2$

TABLE 5

PROCESS CR1-1

Processing steps for Eastman Color Reversal Intermediate

	5249	
	Time	Temp.
Prehardener	2 min. 35 sec.	95°
Neutralizer	30 sec.	95°
Backing removal and rinse	5 sec.	100°
First developer	2 min. 30 sec.	96°
First stop bath	30 sec.	95°
Wash	1 min.	100°
Color developer	3 min. 35 sec.	110°
Second stop bath	30 sec.	95°
Wash	1 min.	100°
Bleach	1 min. 30 sec.	95°
Fix	1 min. 30 sec.	95°
Wash	1 min.	100°
Stabilizer	30 sec.	95°
Dry		

Note: All temperatures are in degrees Fahrenheit.

Formulas for ECN-1 and ECP-1

Pre-Bath (for Black Backing Removal)

Water	800·0 ml
Borax	20·0 grams
Sodium sulfate (desiccated)	100·0 grams
Sodium hydroxide	10·0 ml
Water to	1·0 liter

ECN-1 Negative Color Developer

Water	950·0 ml
Benzyl alcohol	3·8 ml
Sodium hexametaphosphate	2·0 grams
Sodium sulfite (desiccated)	2·0 grams
Sodium hydroxide (10% sol.)	5·5 ml
CD-3*	5·0 grams
Potassium bromide	1·0 gram
Sodium carbonate (monohydrate)	50·0 grams
Water to	1·0 liter

*4-amino-N-ethyl-N(B-methanesulfonamidoethyl)-m-toluidine sesquisulfate monohydrate.

Fixing Bath 1st and 2nd

Water	600·0 ml
Sodium thiosulfate	240·0 grams
Sodium sulfite	15·0 grams
Acetic acid (28% sol.)	48·0 ml
Boric acid	7·5 grams
Potassium alum	15·0 grams
Water to	1·0 liter

ECP-1 Positive Color Developer

Water	800·0 ml
Sodium hexametaphosphate	2·0 grams
Sodium sulfite	4·0 grams
CD-2*	3·0 grams
Sodium carbonate	20·0 grams
Potassium bromide	2·0 grams
Water to	1·0 liter

*2-amino-5-diethylaminotoluene monohydrochloride.

Sound Track Developer

Solution A

Water	250·0 ml
Sound coating aid*	2·0 grams
Hexylene glycol	10·0 ml

Solution B

Water	600·0 ml
Sodium hydroxide	80·0 grams
Sodium sulfite	60·0 grams
Hydroquinone	60·0 grams
Ethylenediamine (98% by weight)	15·0 ml
Water to	1·0 liter

*Copolymer of methyl vinyl ether and maleic anhydride.

ECP-1 Dichromate Bleach

Water	800·0 ml
Potassium bromide	20·0 grams
Potassium dichromate	5·0 grams
Potassium alum	20·0 grams
Water to	1·0 liter

ECN-1 Ferricyanide Bleach

Water	800·0 ml
Potassium ferricyanide	50·0 grams
Potassium bromide	20·0 grams
Water to	1·0 liter

ECN-1 Negative Stabilizing Bath

Water	800·0 ml
Dibasic sodium phosphate	8·5 grams
Monobasic sodium phosphate	1·3 grams
Sodium hexametaphosphate	1·0 gram
Water to	1·0 liter

ECP-1 Positive Stabilizing Bath

Formaldehyde (37% sol.)	2·0 ml
Kodak Photo-Flo	2·0 ml
Water to	1·0 liter

Formulas for ECN-2 and ECP-2

Pre-Bath (PB-2)

Water	800·0 ml
Borax (decahydrated)	20·0 grams
Sodium sulfate (anhydrous)	100·0 grams
Sodium hydroxide	1·0 gram
Water to	1·0 liter

ECN-2 Negative Developer (SD-49)

Water	850·0 ml
Kodak Anti-Calcium No. 4	2·0 ml
Sodium sulfite (anhydrous)	2·0 grams
Kodak Anti-Fog No. 9	0·22 gram
Sodium bromide (anhydrous)	1·2 grams
Sodium carbonate (anhydrous)	25·6 grams
Sodium bicarbonate	2·7 grams
CD-3*	4·0 grams
Water to	1·0 liter

*4-amino-N-ethyl-N (B-methanesulfonamidoethyl)-m-toluidine sesquisulfate monohydrate.

ECP-2 Positive Developer (SD-50)

Water	900·0 ml
Kodak Anti-Calcium No. 4	1·0 ml
Sodium sulfite (anhydrous)	4·35 grams
CD-2*	2·95 grams
Sodium carbonate (anhydrous)	17·1 grams
Sodium bromide (anhydrous)	1·72 grams
Sodium hydroxide**	
Sulfuric acid (7·0 N)	0·62 ml
Water to	1·0 liter

*2-amino-5-diethylaminotoluene monohydrochloride.
**As necessary to adjust pH

Stop (SB-14)

Water	900·0 ml
Sulfuric acid (7·0 N)	50·0 ml
Water to	1·0 liter

ECN-2 Negative Bleach (SR-18)

Water	800·0 ml
Kodak bleach additive	143·0 grams
Kodak bleaching agent BL-1	90·0 grams
Sulfuric acid (7·0 N)*	14·8 ml
Water to	1·0 liter

* *Caution:* Do not attempt to use concentrated acid in this mix. Add acid slowly with good agitation and good room ventilation.

ECP-2 Positive Bleach (SR-27)

Water	900·0 ml
Potassium ferricyanide (anhydrous)	30·0 grams
Sodium bromide (anhydrous)	17·0 grams
Water to	1·0 liter

ECP-2 Fixer (F-35)

Water	800·0 ml
Ammonium thiosulfate (58% sol.)	100·0 ml
Sodium sulfite (anhydrous)	2·5 grams
Sodium bisulfite (anhydrous)	10·3 grams
Water to	1·0 liter

ECN-2 Fixer (F-34)

Water	700·0 ml
Ammonium thiosulfate (58% sol.)	185·0 ml
Sodium sulfite (anhydrous)	10·0 grams
Sodium bisulfite (anhydrous)	8·4 grams
Water to	1·0 liter

ECN-2 Final Rinse

Water	1·0 liter
Photo-Flo 600	2·0 ml

ECP-2 Stabilizer (S-1a)

Water	900·0 ml
Formaldehyde (37% sol.)	15·0 ml
Photo-Flo 600	2·0 ml
Water to	1·0 liter

CRI-1 Formulas

Prehardener

Water	800·0 ml
Kodak solubilizing agent SA-1	1·0 gram
Kodak hardening agent HA-2	8·5 grams
Sodium sulfate (anhydrous)	82·0 grams
Magnesium sulfate 7 H_2O	257·0 grams
Sodium bromide (anhydrous)	2·0 grams
Sodium acetate (anhydrous)	15·0 grams
Formalin	27·0 ml
Glacial acetic acid	2·4 ml
Kodak Anti-Fog No. 6	0·03 gram
Water to	1·0 liter
pH at 80°F	4·85 ± 0·10
SpGr at 80°F	1·193 ± 0·003

Neutralizer

Water	800·0 ml
Kodak neutralizing agent NA-1	18·0 grams
Sodium bromide (anhydrous)	17·0 grams
Glacial acetic acid	10·0 ml
Sodium hydroxide (flake)	6·75 grams
Sodium sulfate (anhydrous)	52·0 grams
Water to	1·0 liter
pH at 80°F	5·10 ± 0·20
SpGr at 80°F	1·068 ± 0·003

Rem Jet Backing Removal Solution

Water	800·0 ml
Kodak Anti-Calcium No. 4	1·0 ml
Sodium carbonate (anhydrous)	60·0 grams
Sodium sulfate (anhydrous)	50·0 grams
Sodium hydroxide (flake)	0·5 gram
Water to	1·0 liter
pH at 80°F	11·50 ± 0·20
SpGr at 80°F	1·097 ± 0·003

First Developer

Water	800·0 ml
Quadrofos	2·0 grams
Sodium bisulfite (anhydrous)	8·0 grams
Phenidone	0·35 gram

165

First Developer (*cont'd*)

Sodium sulfite (anhydrous)	37·0 grams
Hydroquinone	5·50 grams
Sodium carbonate (anhydrous)	28·2 grams
Sodium thiocyanite (anhydrous)	1·38 grams
Sodium bromide (anhydrous)	1·30 grams
Potassium iodide	7·0 mg
Water to	1·0 liter
pH at 80°F	9·90 ± 0·10
SpGr at 80°F	1·074 ± 0·003

First and Second Stop Baths

Water	800·0 ml
Glacial acetic acid	30·0 ml
Sodium hydroxide	1·65 grams
Water to	1·0 liter
pH at 80°F	3·50 ± 0·20

Color Developer

Water	800·0 ml
Kodak Anti-Calcium No. 4	3·0 ml
Benzyl alcohol	4·50 ml
Sodium sulfite (anhydrous)	7·50 grams
Trisodium phosphate ·12 H_2O	36·0 grams
Sodium bromide	0·90 grams
Potassium iodide	90·0 grams
Sodium hydroxide	3·25 grams
Citrazinic acid	1·50 grams
C D-3	11·0 grams
Ethylenediamine	3·0 grams
Kodak reversal agent RA-1	0·07 grams
Water to	1·0 liter
pH at 80°F	11·65 ± 0·10
SpGr 80°F	1·036 ± 0·003

Ferricyanide Bleach

Water	800·0 ml
Sodium bromide	37·0 grams
Sodium ferrocyanide · 10 H_2O	245·0 grams
Potassium persulfate	45·0 grams
Borax ·5 H_2O	1·0 gram
Carbowax 1540	3·6 grams
Sodium hydroxide or sulfuric acid	to adjust pH
Water to	1·0 liter
pH at 80°F	7·80 ± 0·50
SpGr at 80°F	1·152 ± 0·005

Fix

Water	800·0 ml
Kodak Anti-Calcium No. 4	2·0 ml
Sodium thiosulfate (pentahydrated)	204·0 grams
Sodium sulfite	5·0 grams
Sodium bisulfite	4·25 grams
Monosodium phosphate	12·7 grams
Water to	1·0 liter
pH at 80°F	5·5 ± 0·10
SpGr at 80°F	1·114 ± 0·005

Final Bath

Water	800·0 ml
Kodak stabilizer additive	0·14 ml
Water to	1·0 liter

EKTACHROME

In 1958 Ektachrome Commercial Film, Type 7255, was introduced as a 16 mm camera film for the professional worker. This film is a multilayered subtractive three-color film intended as an improved replacement for Kodachrome Commercial Safety Color Film, Type 5268.[26] ECO is balanced for exposure to a tungsten light source with a color temperature of 3200°K. Its exposure index with this type of illumination is 25. For daylight exposure ECO has an exposure index of 16 when used with a Wratten 85 Filter.

Structurally ECO is similar to its predecessor KCO, consisting of three light sensitive emulsions coated one on top of the other on a single film base (Fig. 55). The emulsion nearest the base is sensitive to red light and blue light, the middle emulsion is sensitive to green light and blue light and the top emulsion is sensitive to blue light. Between the top blue sensitive emulsion and the other two emulsions is a layer of gelatin containing finely divided silver particles called a "Carey Lea layer." These silver particles absorb blue light and act as a filter that prevents blue light exposure of the middle and bottom emulsion layers. The chief structural difference between ECO and its predecessor is that the color forming couplers are incorporated in the Ektachrome emulsions. The red sensitive emulsion layer contains a cyan dye-forming coupler, the green sensitive emulsion layer contains a magenta dye-forming coupler, and the blue sensitive emulsion layer contains a yellow dye-forming coupler.

After exposure Ektachrome Commercial is developed in an Elon Hydroquinone black and white developer to produce a negative silver image. This is followed by wash to remove the excess developer then the film is hardened in a chrome alum hardener which serves as a combination hardener and stop bath. To prevent sludging in the wash after the hardener, the film first passes into an acid rinse which maintains its low pH. This is followed by a normal wash and the reversal exposure. The reversal exposure is made with white light, and can be either from the emulsion side or the base side, or both as long as it is sufficient to expose all the

Fig. 55 Ektachrome film structure. 1. Blue sensitive emulsion plus yellow dye forming coupler. 2. Carey Lea silver layer. 3. Green sensitive emulsion plus magenta dye forming coupler. 4. Clear gelatin. 5. Red sensitive emulsion plus cyan dye forming coupler. 6. Film base. 7. Anti-halation backing. A Before Development. B After Color Development. C After Bleach and Fix.

remaining silver halide in each of the three light sensitive layers. The white light exposure is followed by development in the color developer. During development the oxidized developing agent in the developer couples with the dye forming couplers located in each emulsion layer forming a positive dye image along with the positive silver images. The excess color developer is removed by a wash followed by a second hardening in a chrome alum hardener. After hardening the film passes into another acid rinse and wash; then the metallic silver image is converted to silver halide by immersion in a ferricyanide bleach and removed in the fixing bath. A final wash is followed by a stabilizing bath; then the film is dried.[27]

Prints can be made in several different ways.

1. Direct reversal color prints by contact or optical printing onto Ektachrome Reversal Print Film, Type 7386.
2. Direct reversal color prints by contact or optical printing onto Eastman Reversal Color Print Film, Type 7387.
3. Direct reversal black and white prints by contact or optical printing onto Eastman Reversal Duplicating Film, Type 7361.

168

4. Color prints on Eastman Color Print Film, Type 7585, made by first printing an internegative on Eastman Color Internegative Film, Type 7270.
5. Color prints on either of the films listed in the first two methods using 7255, 7386, or 7387 as a reversal color master positive.
6. Black and white prints on Eastman Fine Grain Release Positive Film, Type 7302 or Type 7303, made by first printing a duplicate negative on Eastman Fine Grain Panchromatic Duplicating Negative Film, Type 7234.
7. 35 mm color or black and white prints can be made by enlargement to the 35 mm equivalents of the film listed above in methods 1, 4 and 6.
8. 35 mm or 16 mm Technicolor imbibition prints were also made printing three separation negatives from the Ektachrome and from these separations preparing three matrices.

The following is the processing cycle and formulas for processing Ektachrome Commercial Film, Type 7255, in process ECO-1.[30]

Solution	Time	Temperature
1st Developer	6 min.	80°F
Wash	1 min. 30 sec.	75°F
1st Hardener	1 min. 30 sec.	75°F
Acid Rinse	45 sec.	75°F
Wash	45 sec.	75°F

White light exposure either from the emulsion or the base side approximately 14,300 ft cdl sec.

Color Developer	5 min.	80°F
Wash	45 sec.	75°F
2nd Hardener	1 min. 30 sec.	75°F
Acid Rinse	45 sec.	75°F
Wash	45 sec.	75°F
Ferricyanide Bleach	1 min. 30 sec.	75°F
Fix	1 min. 30 sec.	75°F
Wash	2 min. 15 sec.	75°F
Stabilizer	45 sec.	75°F
Dry		

First Developer

Water	800·0 ml
Sodium tetraphosphate	0·6 gram
Sodium bisulfite	2·5 grams
Elon	4·65 grams
Sodium sulfite	47·0 grams
Hydroquinone	3·0 grams
Sodium sulfate	59·0 grams
Sodium carbonate	30·0 grams
Sodium thiocyanide	2·6 grams
Sodium bromide	2·0 grams
Potassium iodide (0·1% sol.)	4·0 ml
Water to	1·0 liter

169

Hardener—1st and 2nd

Water	800·0 ml
Potassium chrome alum	30·0 ml
Water to	1·0 liter

Acid Rinse—1st and 2nd

Water	800·0 ml
Glacial acetic acid	30·0 ml
Sodium hydroxide	1·75 grams
Water to	1·0 liter

Color Developer

Water	800·0 ml
Sodium tetraphosphate	5·0 grams
Benzyl alcohol	4·51 ml
Sodium sulfite	5·20 grams
Sodium bromide	0·6 gram
Ethylenediamine	2·50 grams
Potassium iodide (0·1% sol.)	10·0 ml
Sodium hydroxide	1·8 grams
Trisodium phosphate ($Na_3PO_4 \cdot 12H_2O$)	40·0 grams
CD-3*	11·3 grams
Citrazinic acid	1·9 grams
Water to	1·0 liter

*4-amino-N-ethyl-N-[B-methane-sulfonamidoethyl]-m-toluidene sesquisulfate monohydrate.

Ferricyanide Bleach

Water	800·0 ml
Sodium bromide	38·0 grams
Sodium ferrocyanide (decahydrate)	182·0 grams
Potassium persulfate	48·0 grams
Carbowax # 1540 (50% sol.)	10·0 ml
Water to	1·0 liter

170

Fixing Bath

Water	800·0 ml
Sodium thiosulfate ($Na_2S_2O_3 \cdot 5H_2O$)	180·0 grams
Sodium sulfite (desiccated)	9·0 grams
Water to	1·0 liter

Stabilizing Bath

Water	800·0 ml
Formalin (formaldehyde 37·5% sol.)	4·0 ml
Water to	1·0 liter

Ektachrome Commercial Film, Type 7255[28]

A low contrast reversal color camera film balanced for use under tungsten illumination of 3200°K. Its speed under this type of illumination is E.I. 25. For daylight exposure ECO has an exposure index of 16 with a Wratten 85 Filter.

Ektachrome Commercial Film, Type 7252[29]

A low contrast reversal color camera film balanced for use under tungsten illumination of 3200°K. Introduced in 1969 this film was intended as a replacement for Ektachrome Commercial Film Type 7255 having the same speed E.I. 25 under tungsten illumination and E.I. 16 under daylight illumination with a Wratten 85 Filter. Its improved characteristics included better sharpness, increased latitude and greater process stability. The new process recommended for this film was ECO-3. It had the same chemical and mechanical specifications as the ME-4 process with the exception of the first developer and the backing removal step.

After the ECO-1 process had been in commercial use for approximately four years, a new improved process, ECO-2, was introduced. This new process operated at a higher temperature and featured a greatly reduced processing time and a cleaner process. A prehardener was introduced and the chrome alum hardeners were eliminated.

The following are the processing cycle and formulas for processing Ektachrome Commercial Film, Type 7255, in process ECO-2.[31]

Solution	Time	Temperature
Prehardener	2 min. 30 sec.	95°F
Neutralizer	30 sec.	100°F
1st Developer	3 min.	100°F

171

1st Stop Bath	30 sec.	100°F
Wash	30 sec.	100°F
Color Developer	3 min.	110°F
2nd Stop Bath	30 sec.	100°F
Ferricyanide Bleach	1 min. 30 sec.	100°F
Fix	1 min. 30 sec.	100°F
Wash	1 min.	100°F
Stabilizer	30 sec.	100°F
Dry		

Prehardener

Water	800·0 ml
p-toluenesulfinic acid (sodium salt)	0·5 gram
Sulfuric acid 18 N	5·41 ml
Dimethoxytetrahydrofuran	4·30 ml
Sodium sulfate	154·0 grams
Sodium bromide	2·0 grams
Sodium acetate	20·0 grams
Formalin (37% formaldehyde sol.)	27·0 ml
Water to	1·0 liter

Neutralizer

Water	800·0 ml
Hydroxylanine sulfate	22·0 grams
Sodium bromide	17·0 grams
Glacial acetic acid	10·0 ml
Sodium hydroxide	6·0 grams
Sodium sulfate	50·0 grams
Water to	1·0 liter

1st Developer

Water	800·0 ml
Sodium tetraphosphate	2·0 grams
Sodium bisulfite	3·8 grams
Phenidone (PD-2)	0·19 gram
Sodium sulfite	35·0 grams
Hydroquinone	4·0 grams
Sodium sulfate	54·0 grams
Sodium carbonate (anhydrous)	30·0 grams
Sodium thiocyanate	2·60 grams
Sodium bromide	2·0 grams
Potassium iodide (0·1% sol.)	6·0 ml
Water to	1·0 liter

172

1st and 2nd Stop Bath

Water	800·0 ml
Glacial acetic acid	30·0 ml
Sodium hydroxide	1·75 grams
Water to	1·0 liter

Color Developer

Water	800·0 ml
Sodium tetraphosphate	5·0 grams
Benzyl alcohol 5·6 ml	
Sodium sulfite	5·5 grams
Trisodium phosphate · $12H_2O$	37·0 grams
Sodium bromide	0·90 gram
Potassium iodide (0·1% sol.)	31·0 ml
Sodium hydroxide	3·25 grams
Citrazinic acid	3·60 grams
CD-3	5·50 grams
Ethylenediamine 98%	1·76 grams
Tertiary butylamine borane	0·07 gram
Water to	1·0 liter

Ferricyanide Bleach

Water	800·0 ml
Sodium bromide	35·0 grams
Sodium ferrocyanide (decahydrate)	240·0 grams
Potassium persulfate	67·0 grams
Borax ($Na_2B_4O_7 \cdot 5H_2O$)	1·0 gram
Sodium hydroxide	0·10 gram
Water to	1·0 liter

Fixing Bath

Water	800·0 ml
Sodium thiosulfate (pentahydrate)	200·0 grams
Sodium sulfite	9·0 grams
Water to	1·0 liter

Stabilizing Bath

Water	800·0 ml
Formalin (37·5% formaldehyde)	12·0 ml
Water to	1·0 liter

In May 1960 two new reversal color films for use by the professional cinematographer and a new reversal color print film for laboratory use were introduced by the Eastman Kodak Company.[32] These films, designated by the manufacturer as Ektachrome ER (Daylight) Types 5257 (35 mm) and 7257 (16 mm), Ektachrome ER (Type B), Types 5258 (35 mm) and 7258 (16 mm), and Ektachrome Reversal Print Film, Types 5386 (35 mm) and 7386 (16 mm), were three-color multilayered subtractive color films having incorporated color forming couplers.

The camera films in this group were designed for use under difficult lighting conditions where a high film speed is necessary. The print film was designed for processing in the same solutions as the camera films so that prints could be quickly made for editing and limited release.

The daylight balanced 5257 and 7257 have been used chiefly for instrumentation and data-gathering photography. Its high film speed permits the use of high-speed cameras and/or long focal length lenses. The tungsten balanced 5258 and 7258 have been used for in-plant photography, nighttime sporting events, color newsreel work and dramatic shows. The first use of Ektachrome ER to photograph a complete dramatic show was the one-hour Kraft Suspense Theater presentation "Once Upon a Savage Night."[33] This story was photographed in the Chicago area at night with existing light using 35 mm Ektachrome ER (Type B), Type 5258. From this reversal original an internegative was made on Eastman Color Internegative Film, Type 5270, and prints were made in the normal manner on Eastman Color Print Film, Type 5385. While the show received considerable attention from the entertainment industry, it did not create a trend. The use of Ektachrome ER continued to be limited to the photographing of single difficult scenes for productions in which the normal scenes were photographed with conventional color films.

Structurally these films were like Ektachrome Commercial Film, Type 7255 (Fig. 55), having the same layer arrangement and producing similar color reproduction.

The general properties of the camera films were as follows:[34]

Eastman Ektachrome ER Film (Daylight Type), Types 5257 (35 mm) and 7257 (16 mm)

A high-speed reversal color camera film balanced for use under average daylight conditions. The speed of this film is E.I. 160. Introduced in 1960 as a regular product, this film was previously available on special order as Eastman Color Reversal Film, Daylight Type, SO-260 (35 mm and 16 mm).

Eastman Ektachrome ER Film (Type B), Types 5258 (35 mm) and 7258 (16 mm)

A high-speed reversal color camera film balanced for use under tungsten illumination of 3200°K. The speed of this film is E.I. 125. Introduced in 1960 as a regular product, this film was previously available on special order as Eastman Color Reversal Film, Type B, SO-270 (35 mm and 16 mm).

The general properties of the print film were as follows:[35]

Eastman Reversal Print Film, Types 5386 (35 mm) and 7386 (16 mm)

A reversal color print film balanced for printing by tungsten quality illumination having a color temperature of 2900°K, with appropriate balancing filters in the light beam.

Like the film structure, the processing steps and solutions are also similar to those used for Ektachrome Commercial Film; differences are in the two developers and in the solution times and temperatures. The similarity between the Ektachrome Commercial process ECO-1 and the Ektachrome ER process ME-2A is such that the same processing machine can be used for both processes. To accomplish this it is necessary to have auxiliary storage tanks and suitable pumping arrangements so that one set of solutions can be held in the storage tanks while the other set of solutions is in use. If such an arrangement is used the times required in the various solutions permit operation of the ECO-1 process at 50 feet per minute at 80° and the ME-2A process at 30 feet per minute at 75°F It is not desirable to operate the ECO-1 process at 75°F at the same processing machine speed as the ME-2A process, because this would result in a loss of effective emulsion speed of the Ektachrome Commercial Film. It is also not desirable to operate the ME-2A process at 80°F because of the danger of reticulation of the Ektachrome ER Films.

Process Step	Ektachrome Commercial Film Process ECO-1 50 Feet Per Minute			Ektachrome ER Film Process ME-2A 30 Feet Per Minute		
	Time	Temp.	Remarks	Time	Temp.	Remarks
Backing Buffer	1 sec.			1 sec.		
First Developer	6′00″	80°F	Repl. Rate 375 ml/m (F) 50 ml/m (L)	10′00″	75°F.	Repl. Rate 500 ml/m (F) 50 ml/m (L)
Wash	1′32″	75°F		2′33″	75°F	
First Hardener	1′32″	75°F		2′33″	75°F	
Acid Rinse	46″	75°F		1′13″	75°F	
Wash	46″	75°F		1′13″	75°F	
Blowback Re-Exposure Prtr.			14,300 ft cdl sec.			14,300 ft cdl sec.
Color Developer	5′00″	80°F		8′20″	75°F	
Wash	0′46″	75°F		1′13″	75°F	
Second Hardener	1′32″	75°F		2′33″	75°F	
Acid Rinse	46″	75°F		1′13″	75°F	
Wash	46″	75°F		1′13″	75°F	
Ferri Bleach	1′32″	75°F		2′33″	75°F	
Fixing Bath	1′32″	75°F	Repl. Rate 150 ml/m (F) 50 ml/m (L)	2′33″	75°F	Repl. Rate 300 ml/m (F) 100 ml/m (L)
Wash	2′18″	75°F		3′50″	75°F	
Stabilizer Final Squeegee	0′46″	75°F		1′13″	75°F	

The table on page 175 lists a comparison of the required times and temperatures for the use of a single machine for processes ECO-1 and ME-2A.[36]

Approximately four years after the introduction of the Ektachrome ER and the ME-2A process, a new medium speed reversal color camera film was added to the group. This film, called Eastman Ektachrome MS Film, Types 5256 (35 mm) and 7256 (16 mm), had structural characteristics similar to those of the Ektachrome ER films and was also processed in the same ME-2A process.

The general properties of this third camera film were as follows:[37]

Eastman Ektachrome MS Film, Types 5256 (35 mm) and 7256 (16 mm)

A medium speed reversal color camera film balanced for use under average daylight conditions. The speed of this film is E.I. 64. Introduced in 1963, the improved characteristics exhibited by this film are lower graininess, better color reproduction and improved sharpness when compared with the Ektachrome ER film.

Concurrently with the introduction of the ECO-2 process in July 1964, a corresponding new color process for the higher speed Ektachrome films[38] was also introduced. This process, designated ME-4, was recommended for the processing of:

Eastman Ektachrome ER Film (Daylight), Types 5257 and 7257
Eastman Ektachrome ER Film (Type B), Types 5258 and 7258
Eastman Ektachrome MS, Types 5256 and 7256
Eastman Reversal Print Film, Types 5386 and 7386

The relationship between the ME-4 process and the ECO-2 process is similar to that which existed between the ME-2A process and the ECO-1 process. All solutions, with the exception of prehardener, first developer and color developer, are common to both processes. The solutions have been adjusted so that at given developing machine speed the times in solution are the same for both processes.

The following are the processing cycle and formulas for the Ektachrome ME-4 process.

Solution	Time	Temperature
Prehardener	2 min. 30 sec.	95°F
Neutralizer	30 sec.	100°F
First Developer	3 min. 30 sec.	100°F
First Stop Bath	30 sec.	100°F
Wash	30 sec.	100°F
Color Developer*	3 min. 30 sec.	110°F
Second Stop Bath	30 sec.	100°F
Wash	1 min.	100°F
Bleach	1 min. 30 sec.	100°F
Fixing Bath	1 min. 30 sec.	100°F
Wash	1 min.	100°F
Stabilizer	30 sec.	100°F
Dry		

*No reversal exposure is necessary. The reversal of the image is accomplished chemically by the inclusion of a reversal agent in the color developer.

176

Prehardener

Water	800·0 ml
p-toluenesulfinic acid (sodium salt)	0·5 gram
Sulfuric acid 18N	5·41 ml
Dimethoxytetrahydrofuran	4·30 ml
Sodium sulfate	154·0 grams
Sodium bromide	2·0 grams
Sodium acetate	20·0 grams
Formalin (37% formaldehyde sol.)	27·0 ml
N-methyl benzothiazolium-p-toluene sulfonate	0·03 gram
Water to	1·0 liter

Neutralizer—See Process ECO-2

First Developer

Water	800·0 ml
Sodium tetraphosphate	2·0 grams
Sodium bisulfate	8·0 grams
Phenidone (PD-2)	0·35 gram
Sodium sulfite	37·0 grams
Hydroquinone	5·5 grams
Sodium carbonate (anhydrous)	28·2 grams
Sodium thiocyanate	2·6 grams
Potassium iodide (0·1% sol.)	6·0 ml
Sodium bromide	1·30 grams
Water to	1·0 liter

First and Second Stop Bath—See Process ECO-2

Color Developer

Water	800·0 ml
Sodium tetraphosphate	5·0 grams
Benzyl alcohol	4·5 ml
Sodium sulfite	7·5 grams
Trisodium phosphate · 12H_2O	36·0 grams
Sodium bromide	0·30 gram
Potassium iodide (0·1% sol.)	24·0 ml
Sodium hydroxide	3·25 grams
Citrazinic acid	1·50 grams
CD-3	11·0 grams
Ethylenediamine 98%	3·0 grams
Tertiary butylamine	0·07 gram
Water to	1·0 liter

Ferricyanide Bleach—See Process ECO-2

Fixing Bath—See Process ECO-2

Stabilizing Bath—See Process ECO-2

In November 1965 the Eastman Kodak Company announced that "recent advances in emulsion technology have made it possible to produce two new high-speed color reversal films." These new films, designated Ektachrome EF, represent improvements in practically all the important characteristics by which films are judged. It is significant that these improvements were accomplished without a change in the processing solutions or processing steps, provided that the laboratory had already changed from the ME-2A process to the ME-4 process.[39]

The general properties of these camera films were as follows:

Eastman Ektachrome EF Film (Daylight Type), Types 5241 (35 mm) and 7241 (16 mm)

A high-speed reversal color camera film balanced for use under average daylight conditions. The speed of this film is E.I. 160. Introduced in 1965, this film replaced Eastman Ektachrome ER, Types 5257 and 7257. Its improved characteristics include finer grain, better sharpness and better color reproduction.

Eastman Ektachrome EF Film (Type B), Types 5240 (35 mm) and 7242 (16 mm)

A reversal color camera film balanced for use under tungsten illumination of 3200°K. The speed of this film is E.I. 125. Introduced in 1965, this film replaced Eastman Ektachrome ER Film, Types 5258 and 7258. Its improved characteristics include finer grain, better sharpness and better color reproductions.

Since its introduction Ektachrome EF, Type 7242, has been extremely popular for use as a television news film. This film's ease of handling for both the photographer and the processor has resulted in several television stations installing their own color newsreel processing facilities.[40]

Parallel with the development of improved camera films that could be processed in the Ektachrome process a series of reversal color print films also evolved.

Eastman Ektachrome R—Print Film 7388[41]

A low contrast reversal color print film designed for use in making direct prints from projection contrast original films. This film was balanced for filtered tungsten illumination of approximately 2900°K. Introduced in 1966 this film was designed to fill the need for a low contrast print film which could be processed in the ME-4 process. The sound track on 7388 was silver sulfide produced in the same manner and using the same formula that was used to produce a sound track on 7386 print film.

Eastman Ektachrome R—Print Film 7389[42]

A low contrast reversal color print film designed for use in making direct prints from projection contrast original films. This film was balanced for filtered tungsten illumination of approximately 2900°K. Its improved characteristics included the capability to produce a silver

178

optical sound track increasing sound quality considerably. Introduced in 1969 this film replaced Eastman Ektachrome R Print Film 7388.

Eastman Ektachrome Print Film 7390[43]

A reversal color print film designed for use in making projection contrast prints from lower contrast reversal originals such as Ektachrome Commercial Film 7255 or 7452. This film was balanced for filtered tungsten illumination of approximately 2900°K. In a modified ME-4 process (reduced 1st developer time) it can be processed to yield a silver optical sound track or a silver sulfide sound track. Introduced in 1971 this film replaced Eastman Reversal Print Film 7386.

REFERENCES

[1] HANSON, W. T., "Color Negative and Color Positive Film for Motion Picture Use," *Journal of The Society of Motion Picture and Television Engineers*, March 1952, p. 223.

[2] MILLER, T. H., "Masking: A Technique for Improving The Quality of Color Reproductions," *Journal of The Society of Motion Picture Engineers*, Feb. 1949, pp. 133–155.

[3] HANSON, W. T., "Color Correction With Colored Couplers," *Journal of The Optical Society of America* 40, March 1950, pp. 166–171.

[4] HANSON, W. T., "Color Negative and Color Positive Film for Motion Picture Use," *loc. cit.*, pp. 223–230.

[5] HANSON, W. T. AND KISNER, W. I., "Improved Color Films for Color Motion Picture Production," *Journal of The Society of Motion Picture and Television Engineers*, Dec. 1953, pp. 670–680.

[6] DUNDON, M. L. AND ZWICK, D. M., "A High Speed Color Negative Film," *Journal of The Society of Motion Picture and Television Engineers*, Nov. 1959, pp. 735–738.

[7] KISNER, W. I., "A New Color Negative Film for Better Picture Quality," *Journal of The Society of Motion Picture and Television Engineers*, Oct. 1962, pp. 776–779.

[8] BEELER, R. L., MORRIS, R. A. AND WESTON SIMONDS, C., "A New Higher Speed Color Negative Film," *Journal of The Society of Motion Picture and Television Engineers*, Sept. 1968, pp. 988–990.

[9] ANDERSON, R. G., BONHEYO, G. L., CLIFFORD, J. D., DANIELSON, A. D., HESTER, J. R. AND SHAFER, R. K., "Improved Emulsion and Processing Technology for Motion Picture Negative Film."

[10] HANSON, W. T., "Color Negative and Color Positive Film for Motion Picture Use," *loc. cit.*, pp. 231–238.

[11] HANSON, W. T. AND KISNER, W. I., "Improved Color Films for Color Motion Picture Production," *loc. cit.*, pp. 681–692.

[12] KISNER, W. I., "A Higher Speed Color Print Film," *Journal of The Society of Motion Picture and Television Engineers*, Oct. 1962, p. 779.

[13] *Ibid.*, pp. 779–781.

[14] "New Products," *Journal of The Society of Motion Picture and Television Engineers*.

[15] "New Products," *Journal of The Society of Motion Picture and Television Engineers*.

[16] SCHAFER, R. K., BAPTISTA, J., O'CONNELL, R. AND KNUTSEN, E. V., "A New Color Print Film with a Shortened Processing." *Presented at 115th Technical Conference of The Society of Motion Picture and Television Engineers*, Los Angeles, April 1974.

[17] ANDERSON, C., GROET, N. H., HORTON, C. H. AND ZWICK, D., "On Intermediate Positive Internegative System For Color Motion Picture Photography," *Journal of The Society of Motion Picture and Television Engineers*, March 1953, pp. 217–225.

[18] Internal Memo, Motion Picture Film Department—Eastman Kodak Company, 1956.

[19] ANDERSON, C., *et al.*, "An Intermediate Positive Internegative System for Color Motion Picture Photography," *loc. cit.*, pp. 217–225.

[20] HANSON, W. T. AND KISNER, W. I., "Improved Color Films for Color Motion Picture Production," *loc. cit.*, pp. 694–696.

[21] ZWICK, D. M., BELLO, H. I. AND OSBORNE, C. E., "A New Color Internegative Film for Use in Color Motion Picture Photography," *Journal of The Society of Motion Picture and Television Engineers*, August 1956, pp. 426–428.

[22] BROWN, R. C., MORRIS, R. A. AND O'CONNELL, R. J., "An Improved Color Internegative Film," *Journal of The Society of Motion Picture and Television Engineers*, Sept. 1968, pp. 990–994.

23 BELLO, H. J., GROET, N. H., HANSON, W. T., OSBORNE, C. E. AND ZWICK, D. M., "A New Color Intermediate Positive Intermediate Film System for Color Motion Picture Photography," *Journal of The Society of Motion Picture and Television Engineers*, April 1957, pp. 205–209.

24 BECKETT, C., MORRIS, R. A., SCHAFER, R. K. AND SEEMANN, J. M., "Preparation of Duplicate Negatives Using Eastman Color Reversal Intermediate Film," *Journal of The Society of Motion Picture and Television Engineers*, October 1968, pp. 1053–1056.

25 "Production of Motion Pictures in Color Using Eastman Color Films." (Motion Picture Film Department, Eastman Kodak Co., Rochester, N.Y., 1952, 1954, 1960, 1963.)

26 GROET, N. H., LIBERMAN, M. AND RICHEY, F., "An Improved Professional 16 mm Reversal Camera Film," *Journal of the Society of Motion Picture and Television Engineers*, January, 1959, pp. 8–10.

27 *Ibid.*

28 GROET, N. H., *et al.*, "An Improved Professional 16 mm Reversal Camera Film," *loc. cit.*, pp. 8–10.

29 GRIGSBY, P. H., KENT, F., McDONOUGH, J. M., MILLER, D. R., WOLF, W. L., "A New Eastman Ektachrome Commercial Film." *Presented at 106th Technical Conference of the Society of Motion Picture and Television Engineers*, Los Angeles, Sept. 1969.

30 Abridged Specifications for Processing Ektachrome Commercial Film, Type 7255 (Process ECO-1) (Motion Picture Film Department, Eastman Kodak Company, New York).

31 Abridged Specifications for Processing Ektachrome Commercial Film, Type 7255 (Process ECO-2) (Motion Picture Film Department, Eastman Kodak Company, New York).

32 GROET, N. H., MURRAY, T. J. AND OSBORNE, C. E., "Two High-Speed Color Films and a Reversal Print Film for Motion Picture Use," *Journal of the Society of Motion Picture and Television Engineers*, November, 1960, pp. 813–817.

33 "Eastman Videbuts Ektachrome on NBC-TV's 'Suspense Theater,'" *Daily Variety* (Hollywood), March 2, 1964, p. 4.

34 GROET, N. H., *et al.*, "Two High-Speed Color Films and a Reversal Print Film for Motion Picture Use," *loc. cit.*, p. 816.

35 *Ibid.*, p. 817.

36 "The Use of a Single Machine for Processing of Ektachrome Commercial Film, Type 7255, and Ektachrome ER Film, Types 7257 and 7258" (Motion Picture Film Department, Eastman Kodak Company, February, 1960), Table 1.

37 "MS for Medium Speed," Kodak Tech Bits, Eastman Kodak Company, No. 3 (1963).

38 Abridged Specifications for Processing of Ektachrome ER, MS and Reversal Print Films Through Process ME-4 (Motion Picture and Education Markets Division, Eastman Kodak Company, January, 1966).

39 BEILFUSS, H. R., THOMAS, D. S. AND ZUIDEMA, J. W., "Two New High-Speed Ektachrome Motion Picture Films," *Journal of the Society of Motion Picture and Television Engineers*, April, 1966, pp. 344–345.

40 "What's new in news? A report in full color," *Broadcasting*, January 3, 1966, pp. 62–66.

41 REES, H. L., VOGT, H. W. AND ZUIDEMA, J. W., "A new low-contrast reversal color print film," *Presented at 100th Technical Conference of the Society of Motion Pictures and Television Engineers*, Los Angeles, Oct., 1966.

42 BURTON, G. L. AND BAUER, R. W., "Processing of Optical Sound Tracks on Color Films with Emphasis on Silver Sound tracks on Improved Eastman Ektachrome R Print Film." *Presented at 106th Technical Conference of the Society of Motion Picture and Television Engineers*, Los Angeles, September, 1969.

43 CLIFFORD, J. D., BAUER, R. W., AND HAGENBUCH, B. R., "A New Reversal Print Film for Low Contrast Originals." *Presented at 110th Technical Conference of the Society of Motion Picture and Television Engineers*, Montreal, Canada, October, 1971.

IX FUJI, AGFA-GEVAERT AND FERRANIA

The films and processes described in this chapter are presented because of their significance in the U.S. and world motion picture markets. They were all developed and used successfully in Europe and/or Asia before their introduction in the United States. In general, their acceptance by American laboratories and production companies has been favorable. An important factor in this acceptance was their compatibility with existing equipment and processes. In a single processing machine a laboratory could process Eastman Color Print Film, Gevacolor Print Film, Fujicolor Print Film, or Ferrania Color Print Film without changing solutions. This has stimulated competition both in pricing and in quality. While a study of the pricing criteria used by the various film manufacturers involved is beyond the scope of this book, a look at the improvements made in the quality of the multilayered three-color negative/positive systems is appropriate. Each of the four film manufacturers whose products are mentioned above has contributed significantly to the state of the art technology of color motion pictures. A review of any one of these processes indicates a steady progression towards improved quality and simplification of process techniques.

FUJICOLOR

The Fujicolor process is a three-color subtractive negative/positive process introduced in 1955 by the Fuji Photo Film Co., Ltd., Tokyo, Japan.

When the process was introduced it consisted of two elements that could be used singly or together. A coupler-incorporated three-color negative and a coupler-incorporated three-color print film. Initially the films were only used in Japanese domestic markets. During this period both films were improved several times. Film speed, graininess, sharpness, and color reproduction were improved as the negative films evolved from Type 8511 through 8516 and the print films evolved from Type 8811 through 8818. This later film was introduced in the United States in April 1967. Some of the feature pictures released on Fujicolor print film in the United States have been:

That Man George	Allied Artists
The Day the Fish Came In	20th Century-Fox
Hells Angels on Wheels	Independent

181

Conrack	20th Century-Fox
Cinderella Liberty	20th Century-Fox
The Golden Voyage of Sinbad	Columbia
Wild Season	Universal
Savage Land	Universal
Vengeance of She	Universal
Tora Tora Tora	20th Century-Fox
The Last American Hero	20th Century-Fox
Summer Dream	Columbia

Some of the feature pictures photographed on Fujicolor negative in the United States have been:

No Mercy, Man	Dan Vance Productions
Goodnight Jackie	Calliope Productions
Don't Stop	Dauntless Productions
Pets	Dalia Productions
Sugar Hill	American International Productions
Bobby and Rose	Cine Artists International
Truck Turner	American International Productions
Beat the Drum Louder	J.J.J. Productions
Super Vixen	Eve Productions

Negative Materials

The camera negative films manufactured under the name of Fujicolor negative are multilayered color films which consist of three light sensitive emulsions sensitized to Blue, Green and Red Light, respectively, and coated on a single film support (Fig. 56). Incorporated in the emulsions are dye couplers which react simultaneously during development to produce a separate dye image in each layer complementary to the sensitivity of the layer. The light and dark areas of the image are reversed with respect to those of the original subject. Also, the various color areas of the negative are complementary in color to the corresponding areas in the original scene.

Fujicolor Negative Film, Type 8511–8514

A series of color negative films introduced in Japan during the period 1951–1970. Each film in the series represented a significant improvement in quality. These films were not offered for sale in the United States.

Fujicolor Negative Film, Type 8515 (35 mm)

A color negative film balanced for exposure with 3200°K tungsten lamps. Colored couplers

182

incorporated in the emulsion layers provide automatic masking for color correction. The speed of this film was E.I. 100 Tungsten and E.I. 64 Daylight when exposed with Fuji light balancing filter LBA-12. Introduced in the United States in 1970 this film received somewhat slow acceptance.

Fujicolor Negative Film, Type 8516 (35 mm and 16 mm)

A color negative film balanced for exposure with 3200°K tungsten lamps. Colored couplers incorporated in the emulsion layers provide automatic masking for color correction. This

Fig. 56 Fujicolor negative film structure. 1. Gelatin overcoat. 2. Blue sensitive emulsion plus colorless yellow dye forming coupler. 3. Yellow filter layer. 4. Blue and green sensitive emulsion plus yellow colored magenta dye forming coupler. 5. Gelatin interlayer. 6. Blue and red sensitive emulsion plus reddish-orange colored cyan dye forming coupler. 7. Colloidal silver anti-halation layer. 8. Film base. A Before Development. B After Development. C After Bleach and Fix.

film was introduced in the United States in 1973. Its improved characteristics included finer grain, better sharpness and better color reproduction. The speed remained the same E.I. 100 tungsten and E.I. 64 Daylight when exposed with a Fuji light balancing filter LBA-12 or Kodak Wratten 85.

Positive Materials

The print films manufactured under the name of Fujicolor Positive are multilayered color films which consist of three light sensitive emulsions coated on a single support (Fig. 57). A protective layer is located on the top surface. Incorporated in the emulsion layers are colorless dye couplers which react simultaneously during development to produce a separate dye image in each layer. Interlayers between the sensitized emulsion layers prevent migration

Fig. 57 Fujicolor positive film structure. 1. Gelatin overcoat. 2. Green sensitive emulsion plus colorless magenta dye forming coupler. 3. Red sensitive emulsion plus colorless cyan dye forming coupler. 4. Gelatin interlayer. 5. Blue sensitive emulsion plus colorless yellow dye forming coupler. 6. Substratum. 7. Film base. 8. Anti-halation backing. A Before Development. B After Color Development. C After Bleach and Fix.

of the dyes from one layer to the other layers. The reverse side of the support is coated with a antihalation layer consisting of an alkali removable synthetic hydrophilic resin containing carbon black. The antihalation layer is removed during processing.

Fujicolor Positive Film 8811–8817

A series of color positive films balanced for printing from color negative films with filtered tungsten illumination. The first of these films (8811) was introduced in 1955; these films were only available in Japan.

184

Fujicolor Positive Film 8818 (35 mm), 8828 (16 mm)

A color positive film balanced for printing from color negative films with filtered tungsten illumination. Introduced in the United States in 1967, its improved characteristics included finer grain, better color rendition and better image dye stability.

Fujicolor Positive Film 8819 (35 mm), 8829 (16 mm)[1]

A color positive film balanced for printing from color negative films with filtered tungsten illumination. Introduced in 1970, its improved characteristics included better color reproduction, more neutral shadows, higher resolution, and better process compatibility.

The films employed in the Fujicolor system can be processed in conventional type continuous processing machines with minor modifications for all of the steps required. While the Fuji company has published[2] the following procedures and formulas designed specifically for the processing of Fujicolor film these films can also be processed in the ECN-1 and ECP-1 processes designated by the Eastman Kodak Company for the processing of Eastman Color Films.

PROCESSING STEPS FOR FUJICOLOR NEGATIVE FILM

Processing Steps	Fuji Formula	Time	Temp.*
Color developer	CD-219	12 min.	$70° \pm 0.3°$
Spray rinse	—	10–20 sec.	$61° - 75°$
First fix	CF-511	4 min.	$70° \pm 2°$
Wash	—	4 min.	$61° - 75°$
Bleach	CB-409	8 min.	$70° \pm 2°$
Wash	—	4 min.	$61° - 75°$
Second fix	CF-511	4 min.	$70° \pm 2°$
Wash	—	7 min.	$61° - 75°$
Stabilizing bath	SB-724	1 min.	$70° \pm 4°$
Spray rinse	—	1–5 sec.	$61° - 75°$
Final bath	FB-701	1–5 sec.	$70° \pm 4°$
Dry	—	15–20 min.	$95° - 40°$ — 60% RH

*All temperatures in degrees F.

FUJICOLOR NEGATIVE PROCESSING SOLUTION FORMULAS

Color Developer CD-219

Water	800·0 ml
Benzyl alcohol	4·0 ml
Calgon (sodium hexametaphosphate)	2·0 grams

Colour Developer CD-219 (cont'd)

Sodium sulfite (anhydrous)	2·0 grams
Fujicolor developing agent FCD-03	5·0 grams
Potassium bromide	1·0 gram
Sodium carbonate (monohydrate)	50·0 grams
Sodium hydroxide (10% sol.)	10·0 ml
Water to	1·0 liter
pH	10·75 ± 0·05
SpGr	1·046

Fixing Bath CF-511 (1st and 2nd)

Water	800·0 ml
Sodium thiosulfate (pentahydrate)	240·0 grams
Sodium sulfite (anhydrous)	15·0 grams
Acetic acid (glacial)	12·0 ml
Boric acid	6·0 grams
Potassium alum	15·0 grams
Water to	1·0 liter
pH	4·25 ± 0·30
SpGr	1·140

Bleaching Bath CB-409

Water	800·0 ml
Potassium ferricyanide	50·0 grams
Potassium bromide	15·0 grams
Water to	1·0 liter
pH	6·70 ± 0·30
SpGr	1·036

Stabilizing Bath SB-724

Water	800·0 ml
Disodium phosphate (anhydrous)	1·0 gram
Calgon (sodium hexametaphosphate)	0·5 gram
Water to	1·0 liter
pH	7·60 ± 0·2
SpGr	1·005

Final Bath FB-701

Water	1·0 liter
Driwel (Fuji wetting agent)	5·0 ml

PROCESSING STEPS FOR FUJICOLOR POSITIVE FILM 8818

Processing Steps	Formula	Time at 70°F	Time at 75°F
Pre-bath	Kodak PB-2	20 sec. 70° ± 2°	15 sec. 75° ± 2°
Rinse	—	20 sec. 70° ± 5°	20 sec. 75° ± 5°
Color Dev.	Fuji CD-210	14 min. 70° ±0·3°	8 min. 75° ±0·3°
Rinse	—	10–20 sec. 70° ± 5°	10 sec. 75° ± 5°
1st Fix	Kodak F-5	4 min. 70° ± 2°	2 min. 75° ± 2°
Wash	—	4 min. 70° ± 5°	1 min. 75° ± 5°
Bleach	Kodak SR-4	4 min. 70° ± 2°	4 min. 75° ± 2°
Wash	—	4 min. 70° ± 5°	2 min. 75° ± 5°
Sound Track Dev.	—	10–20 sec. —	10–20 sec. —
Wash	—	10–30 sec. 70° ± 5°	15 sec. 75° ± 5°
2nd Fix	Kodak F-5	4 min. 70° ± 2°	2 min. 75° ± 2°
Wash	—	8–10 min. 70° ± 5°	6–8 min. 75° ± 5°
Stabilizing Bath	Kodak S-1	5–10 sec. 70° ± 5°	5–10 sec. 75° ± 5°
Dry	—	15–20 min. 95°	15–20 min. 95°

PROCESSING FUJICOLOR POSITIVE 8818

Color Developer CD-210

Water	800·0 ml
Calgon (sodium hexametaphosphate)	2·0 grams
Sodium sulfite (anhydrous)	2·0 grams
Diethyl paraphenylenediamine, sulfate	2·0 grams
or Diethyl paraphenylendiamine,	
chloride	1·6 grams
Sodium carbonate (monohydrate)	60·0 grams
Potassium bromide	0·8 grams
Hydroxylamine, sulfate	0·6 gram
Water to	1·0 liter
pH	10·60 ± 0·10

Except for the color developer, the same processing baths used for the Kodak ECP-1 can be used. However, it is recommended that if the Kodak formulas are used the bleach should be according to Kodak formula SR-4.

FUJICOLOR POSITIVE PROCESSING SOLUTION FORMULAS

Pre-Bath PB-101

Water	800·0 ml
Sodium carbonate (monohydrate)	10·0 grams
Sodium sulfate (anhydrous)	50·0 grams
Water to	1·0 liter
pH	10·1 ± 0·30
SpGr	1·055

Color Developer CD-218

Water	800·0 ml
Calgon (sodium hexametaphosphate)	2·0 grams
Sodium sulfite (anhydrous)	4·0 grams
Fuji Color developing agent FCD-02	3·0 grams
Sodium carbonate (monohydrate)	25·0 grams
Potassium bromide	2·0 grams
Water to	1·0 liter
pH	10·65 ± 0·05
SpGr	1·030

Fixing Bath CF-511 (1st and 2nd)

Water	600·0 ml
Sodium thiosulfate (pentahydrate)	240·0 grams
Sodium sulfite (anhydrous)	15·0 grams
Acetic acid (glacial)	12·0 ml
Boric acid	6·0 grams
Potassium alum	15·0 grams
Water to	1·0 liter
pH	4·25 ± 0·3
SpGr	1·140

Bleaching Bath CB-408

Water	800·0 ml
Potassium bromide	20·0 grams
Potassium dichromate	5·0 grams
Potassium alum	40·0 grams
Sodium acetate (trihydrate)	3·0 grams
Acetic acid (glacial)	10·0 ml
Water to	1·0 liter
pH	3·10 ± 0·2
SpGr	1·040

Stabilizing Bath SB-723

Water	800·0 ml
Formalin	10·0 ml
Driwel (Fuji wetting agent)	5·0 ml
Water to	1·0 liter

Sound Track Developer SG-604

Solution A

Water	600·0 ml
Sodium sulfite (anhydrous)	40·0 grams
Monol	40·0 grams
Sodium hydroxide	40·0 grams
Hydroquinone	40·0 grams

Solution B

Water	300·0 ml
Gum tragacanth	5·0 grams
Denatured alcohol	10·0 ml

Solution C

Ethylenediamine (70%)	20·0 ml

Mix Solution A with Solution B. Then add Solution C
and water to make 1·0 liter just before use.

FUJICOLOR REVERSAL

In addition to the negative/positive films intended for motion picture production and release
printing the Fuji Film Company, Ltd. also has produced a series of three-color subtractive
reversal color films intended for television news photography. These films are high-speed
reversal color films balanced for exposure to 3200°K tungsten illumination. Their color
reproduction, gradation and other picture qualities are balanced for color television
transmission.

Structurally the Fujicolor Reversal films are similar to other commercially available
incorporated-coupler color films. They are made up of three light sensitive emulsions coated
one on top of the other on a single film base (similar to Fig. 55). The emulsion nearest the base
is sensitive to red light and blue light and contains a cyan dye-forming coupler. The middle
emulsion is sensitive to green and blue light and contains a magenta dye-forming coupler.
Between the top blue-sensitive layer and the other two emulsion layers is a yellow filter layer;
this is necessary to prevent unwanted blue light exposure of these layers, since they both have
blue light sensitivity. These films are designed for processing with prescribed solutions and
conditions.[3] They can also be processed in the Kodak ME-4 Process which is described in a
previous chapter.

Fujicolor Reversal TV Film RT-100

A reversal color film balanced for exposure with 3200°K tungsten lamps. Colorless couplers
incorporated in the emulsion layers unite with the color developing agent during processing
to form a positive dye image. The speed of this film is E.I. 100 Tungsten and E.I. 64 Daylight
when exposed with a Fuji light balancing filter LBA-12. Introduced in the United States in
1970 to television news departments this film initially achieved very limited success.

Fujicolor Reversal TV Film RT-400

A high-speed reversal color film balanced for exposure with 3200°K tungsten lamps.
Colorless couplers incorporated in the emulsion layers unite with the color developing agent
during processing to form a positive dye image. The speed of this film is E.I. 400 Tungsten
and E.I. 250 Daylight when exposed with a Fuji light balancing filter LBA-12. This film was
introduced to television news departments in the United States on a limited basis in 1974. To

obtain optimum quality when processing RT-400 in the Kodak ME-4 process some changes in the processing steps and some slight chemical modifications are necessary.

1. The use of the Pre-Hardener and Neutralizer is eliminated.
2. The First Developer is adjusted chemically by the addition 1·0 gram per liter of Sodium Thiocyanate.
3. The First Developer temperature is reduced 4°F.
4. The color developer pH is raised 0·15 to 11·80.

GEVACOLOR

The Gevacolor process is a three-color subtractive negative/positive process introduced in 1947 by Gevaert Photo-Producten N.V., Mortsel, Belgium.

When it was introduced the process consisted of two elements that could be used singly or together. A coupler-incorporated, three-color negative, and a coupler-incorporated, three-color print film. Although these films achieved some degree of success in Europe they were not introduced into the United States until 1965.

In the fall of that year the third in a series of print films marketed under the Gevacolor name was described and demonstrated at the 94th S.M.P.T.E. Technical Conference in Boston, Mass. The quality of this film was comparable to other products used for release printing in the United States; however, its use was somewhat limited by the need for a special color developer solution for processing the release films made on this film. The Gevaert Company recognized the need for standardization and developed a new print film having improved sharpness and saturation as well as processing capability; this film was introduced in the spring of 1970.

Some of the features released on Gevacolor print film in the United States have been:

Sergeant Ryker	Universal Pictures
Three Guns for Texas	Universal Pictures
Counterfeit Killer	Universal Pictures
Strategy of Terror	Universal Pictures
The Green Slime	M.G.M.
For Singles Only	Columbia

Negative Materials

The camera negative films manufactured under the name of Gevacolor Negative are multilayered color films which consist of three light-sensitive emulsions sensitized to Blue, Green and Red light, respectively and coated on a single film support (Fig. 58). Incorporated in the emulsion are dye couplers which react simultaneously during development to produce a separate dye image in each layer complementary to the sensitivity of the layer. The light and dark areas of the image are reversed with respect to those of the original subject. Also the various color areas of the negative are complementary in color to the corresponding areas in the original scene.

190

Fig. 58 Gevacolor negative film structure. 1. Gelatin overcoat. 2. Blue sensitive emulsion plus colorless yellow dye forming coupler. 3. Yellow filter layer. 4. Blue and green sensitive emulsion plus magenta dye forming coupler. 5. Gelatin interlayer. 6. Blue and red sensitive emulsion plus cyan dye forming coupler. 7. Substratum. 8. Film base.
A Before Development. B After Color Development. C After Bleach and Fix.

Gevacolor Negative—Type 6·51[4,7]

A color negative film balanced for use with 3200°K tungsten illumination. The speed of this film was E.I. 16; it was introduced in Europe in 1948. This film was also sold for some time as Type "T-48."

Gevacolor Negative—Type 6·52[5,8]

A color negative film balanced for use with 3200°K tungsten illumination. The speed of this film was E.I. 32, it was introduced in Europe in 1954 as a replacement for Type 6·51. Its improved characteristics included a one camera stop increase in speed.

Gevacolor Negative—Type 6·53[6,16]

A color negative film balanced for use with 3200°K tungsten illumination. The speed of this film was E.I. 25 Tungsten and 16 Daylight with a Gevacolor CTO-12 filter. Introduced in 1958 this film replaced the earlier Type 6·52.

191

Gevacolor Negative—Type 6·54[5]

A color negative film balanced for use with 3200°K tungsten illumination. The speed of this film was E.I. 50 Tungsten and 25 Daylight when exposed with an Agfa-Gavaert CTO-12 or a Kodak Wratten 85-B filter. This film was not sold in the United States.

Gevacolor Negative—Type 6·55

A color negative film balanced for use with 3200°K tungsten illumination. The speed of this film was E.I. 100 Tungsten and 64 Daylight when exposed with an Agfa-Gavaert CTO-12-B or a Kodak Wratten 85-B filter. This film was not sold in the United States.

Gevacolor Negative—Type 6·80[14]

A color negative film balanced for use with 3200°K tungsten illumination. The speed of this film was E.I. 100 Tungsten and 64 Daylight with an Agfa-Gavaert CTO-12-B or a Kodak Wratten 85-B filter. This film was introduced in the United States in 1976.

Fig. 59 Gevacolor print film structure (first type). 1. Gelatin overcoat. 2. Blue sensitive emulsion plus yellow dye forming coupler. 3. Yellow filter layer. 4. Blue and green sensitive emulsion plus magenta dye forming coupler. 5. Gelatin interlayer. 6. Blue and red sensitive emulsion plus cyan dye forming coupler. 7. Substratum. 8. Film base. 9. Green dye anti-halation backing. A Before Development. B After Color Development. C After Bleach and Fix.

Positive Materials

The print films manufactured under the name of Gevacolor Print Film are multilayered color films which consist of three light sensitive emulsions coated on a single support. The first of these films differed from later versions in its emulsion composition and layer orientation. In this film silver bromide was the light sensitive material. The layer orientation was nonsensitized top layer containing a yellow dye-forming coupler, gelatin interlayer, yellow filter layer or a Carry Lea Silver layer, gelatin interlayer, green-sensitive layer containing a magenta dye-forming coupler, gelatin interlayer, red-sensitive layer containing a cyan dye-forming coupler, subbing, Acetate base, Green Dye antihalation backing (Fig. 59). This film suffered from a lack of sharpness and color saturation. A substantial improvement was brought about in subsequent versions of this film by changing the position of the light sensitive layers to the order proposed by Dr Bela Gaspar in his U.S. Patent 2344084. Advantage was taken of the low original sensitivity of silver chloride emulsions which is confined to the far blue and ultra-violet zones of the spectrum. This property is used to avoid the use of a Carry Lea Silver Filter layer and to position the Green-sensitive magenta dye-forming layer which contributes 60% of the final image definition at the top layer where light scatter is low. A gelatin interlayer is next followed by the red sensitive layer which contains a cyan dye-forming coupler and contributes 30% of the final image definition. After another gelatin interlayer a non-sensitized silver bromide emulsion containing a yellow dye-forming coupler is next. This followed by the subbing and the acetate film base which is coated with the same green dye antihalation backing used on the previous film. The color-forming couplers used in all of these films are colorless (Fig. 60).

Gevacolor Print Film—Type 9·51[9]

A color positive film balanced for printing with filtered tungsten illumination. Introduced in 1947 subtractive printing was recommended.

Gevacolor Print Film—Type 9·52[9]

A color positive film balanced for printing with filtered tungsten illumination. Introduced in 1954 its improved characteristics included a substantial increase in sharpness.

Gevacolor Positive—Type 9·53[9,16]

A color positive film balanced for printing with filtered tungsten illumination. Introduced in 1958 its improved characteristics include a further and greater improvement in definition accomplished by the removal of the gelatin interlayers reducing emulsion thickness, incorporation of absorbing dyes to prevent light scatter within the emulsions and the use of an improved antihalation backing composed of a removable resin layer containing Carbon Black.

Fig. 60 Gevacolor print film structure (improved type). 1. Gelatin overcoat. 2. Green sensitive emulsion plus magenta dye forming coupler. 3. Red sensitive emulsion plus cyan dye forming coupler. 4. Gelatin interlayer. 5. Blue sensitive emulsion plus yellow dye forming coupler. 6. Substratum. 7. Film base. 8. Carbon-black anti-halation layer. A Before Development. B After Color Development. C After Bleach and Fix.

Gevacolor Positive—Type 9·54[10]

A color positive film balanced for printing with filtered tungsten illumination. Introduced in 1967 this film was designed primarily to meet the increased definition needs of the smaller film formats (16 mm and Super 8). Other improved characteristics included finer grain and better dye stability.

Gevacolor Positive—Type 9·85[17]

A color positive film balanced for printing with filtered tungsten illumination. Introduced in 1970 the improved characteristics of this film included increased sharpness, finer grain and better color reproduction and dye stability. The introduction of this film also represents a fundamental change in the color developer solution formula. This change was made in the interest of standardization; the new color developer formula is compatible with the Eastman Color, Fuji Color, and Ferrania-color processes.

The processing steps and times for the negative process and for the positive process are indicated on page 195.

Processing Gevacolor Negative Film

Solution Temperatures	70°F.					
	Type 651	Type 652	Type 653	Type 654	Type 655	Type 680
Pre-Bath	—					
Backing Removal and Spray Rinse	—					
Color Developer	7 min.			7 min. 30 sec.		
Spray Rinse	10 sec.			30 sec.		
First Fix	8 min.			5 min.		
Wash	15 min.			5 min.		
Bleach	8 min.			5 min.		
Wash	5 min.			2 min.– 30 sec.		
Fix	5 min.			5 min.		
Wash	2 min.			5 min.		
Stabilizer	5 min.			5 sec.		
Spray Rinse	15 min.			—		
Dry	15 min.			15 min.		

Processing Gevacolor Positive Film

Solution Temperatures	65°F	70°F	70°F	75°F	75°F
	Type 951	Type 952	Type 953	Type 954	Type 985
Pre-Bath	—	—	10 sec.	10 sec.	10 sec.
Backing Removal and	—	—		10 sec.	10 sec.
Spray Rinse	—	—	10/60 sec.	—	15 sec.
Color Developer	10 min.	8 min.	8 min.	6 min.	8 min.
Spray Rinse	10 sec.	10 sec.	10/60 sec.	10 sec.	15 sec.
First Fix	8 min.	4 min.	4 min.	2 min.	1 min./ 45 sec.
Wash	15 min.	5 min.	5 min.	1 min.	1 min.
Bleach Colloida (Silver)	4 min.	—	—	—	—
Spray Rinse	2 min.	—	—	—	—
Bleach (Viscous)	4 min.	—	—	—	—
Bleach	—		3 min.	3 min.	6 min.
Wash			3 min.	2 min.	2 min.
Stop Bath	2 min.		—	—	—
Sound Track Development			15 sec.	30 sec.	10–20 sec.
Wash	5 min.		1 min.	1 min.	15 sec.
Fix	5 min.		4 min.	2 min.	2 min.
Wash	2 min.		4 min.	3 min.	6 min.
Stabilizer	5 min.	5 sec.	5 sec.	10 sec.	10 sec.
Spray Rinse	15 min.	—	—	—	—
Dry	15 min.	15 min.	15 min.	15 min.	15–20 min.

SOLUTION FORMULAS

Pre-Bath GP 681

Water	800·0 ml
Sodium hexametaphosphate	2·0 grams
Sodium sulfate (anhydrous)	100·0 grams
Borax	15·0 grams
Sodium hydroxide	0·8 grams
Water to	1·0 liter

Color Developer GP 23 (Negative)

Water	800·0 ml
Sodium hexametaphosphate	1·0 gram
Sodium sulfite (anhydrous)	2·0 grams
N-N-Diethyl paraphenylenediamine sulfate	2·90 grams
Potassium carbonate (anhydrous)	75·0 grams
Potassium bromide	0·50 grams
Hydroxylamine hydrochloride	1·20 grams
Water to	1·0 liter

Color Developer GP 22 Positive for Types 951, 952, 953

Water	900·0 ml
Sodium hexametaphosphate	1·0 gram
Sodium sulfite (anhydrous)	4·0 grams
N-N-diethylparaphenylenediamine sulfate	3·2 grams
Sodium carbonate (anhydrous)	50·0 grams
Potassium bromide	2·5 grams
Sodium bicarbonate	1·5 grams
Water to	1·0 liter

Color Developer GP 29 Positive for Type 954

Water	800·0 ml
Sodium hexametaphosphate	2·0 grams
Sodium sulfite (anhydrous)	4·0 grams
Hydroxlyamine sulfate	1·3 grams
N-N-diethylparaphenylene-diamine sulfate	3·5 grams
Sodium carbonate (anhydrous)	25·0 grams
Potassium bromide	2·2 grams
Water to	1·0 liter

Color Developer GP 31 Positive for Types 985 and 986

Water	800·0 ml
Sodium hexametaphosphate	2·0 grams
Sodium sulfite (anhydrous)	4·0 grams
2- Amino-5-diethylamino toluene monohydrochloride	3·0 grams
Sodium carbonate (anhydrous)	20·0 grams
Potassium bromide	2·0 grams
Water to	1·0 liter

First Fix GP 308

Water	800·0 ml
Sodium thiosulfate (anhydrous)	200·0 grams
Potassium metabisulfite	12·0 grams
Acetic acid (glacial)	12·0 ml
Borax	20·0 grams
Potassium alum	15·0 grams
Water to	1·0 liter

Bleach GP 447

Water	800·0 ml
Potassium bromide	20·0 grams
Potassium dichromate	5·0 grams
Potassium alum	40·0 grams
Sodium bisulfate	0·60 grams
Water to	1·0 liter

Final Fix GP 364 (Negative)

Water	800·0 ml
E.D.T.A. (sodium salt)	1·0 gram
Sodium thiosulfate (anhydrous)	130·0 grams
Sodium sulfite (anhydrous)	10·0 grams
Sodium carbonate (anhydrous)	6·0 grams
Sodium bicarbonate (crystal)	14·0 grams
Water to	1·0 liter

Stabilizer GP 660

Water	250·0 ml
Formalin (40% sol.)	12·5 ml
Saponin (5% sol.)	1·8 ml
Water to	1·0 liter

GEVACHROME

In addition to the negative/positive color films intended for use in the production of theatrical and television motion pictures the Agfa-Gevaert Company manufactured a series of reversal color camera and print films intended for use in producing television news and industrial motion pictures. These films were multilayered reversal color films having incorporated Fisher-type colorless dye-forming couplers. Introduced first in Europe the films were improved several times before introduction to the United States.

Structurally the Gevachrome films are similar to other commercially available incorporated-coupler color films. They are made up of three light-sensitive emulsions coated on a safety base. The top layer is sensitive to blue light and contains a yellow dye-forming coupler. This layer is followed by a yellow filter layer which is necessary to prevent unwanted blue light from reaching the other two emulsion layers. The next layer is sensitive to blue light and green light and contains a magenta dye-forming coupler. This layer is followed by a magenta filter layer which is necessary to prevent unwanted green light from reaching the third emulsion layer. This layer has panchromatic sensitivity but because of the two filter layers records only the red light exposure; it contains a cyan dye-forming coupler. The final layer between the light sensitive emulsions and the support is a black silver antihalation layer which prevents halation and contributes to the high definition of the material. An additional black carbon layer is coated on the other side of the support to give further protection from halation and static discharges.

The camera films marketed under the Gevachrome name were:

Gevachrome Original Normal Speed—Type 6·00[11]

A low contrast reversal color film balanced for exposure with 3200°K Tungsten lamps. The photographic characteristics of this film were designed to meet the requirements of color television transmission. The speed of this film was E.I. 50 Tungsten and E.I. 25 Daylight when exposed with the Gevaert CTO-12 filter or a Kodak Wratten 85 B filter. Introduced in the United States in 1969 the recommended process for this film was the Gevachrome Process 6N1.

Gevachrome Original High Speed—Type 6·05[11]

A low contrast reversal color film balanced for exposure with 3200°K Tungsten lamps. The high speed of this film allows photography under available light conditions. The photographic characteristics of this film were designed to meet the requirements of color television transmission. The speed of Type 6·05 was E.I. 125 Tungsten and E.I. 64 Daylight when exposed with a Gevaert CTO-12 filter or a Kodak Wratten 85 B filter. For exposure under very low level conditions this effective film speed can be doubled to E.I. 250 or E.I. 128 with increased first developments. Introduced in the United States in 1969 the recommended process for this film was the Gevachrome Process 6N1.

The print films marketed under the Gevachrome name were:

Gevachrome Print Film—T9·00[12, 16]

A reversal color print film balanced for printing with filtered tungsten illumination. On this film either a silver sulfide sound track, printed from a positive sound original, or a silver sound track printed from a negative sound original could be made. This was possible because a yellow dye filter and a magenta dye filter were used to limit exposure to a single layer and a dye antihalation layer was used on the support to prevent halation. Introduced in Europe in 1960 this film was not sold in the United States.

Gevachrome Print Film—T9·01[12]

A color reversal print film balanced for printing with filtered tungsten illumination. Its improved characteristics included higher definition, lower contrast and higher exposure latitude. To achieve these improvements it was necessary to give up the capability of producing a silver sound track. The definition of this film was improved by using thinner emulsion layers and through the incorporation of absorbing dyes; also a silver antihalation layer was coated between the emulsion and the support. Introduced in 1964 this film replaced T9·00.

Gevachrome Print Film—T9·02[12]

A reversal color print film balanced for subtractive printing with filtered tungsten illumination. If additive printing is employed an increase of contrast of 5–10% is obtained depending on the characteristics of the printing filters. Its improved characteristics included high definition, lower granularity, improved color saturation through the use of inter-image effects and

Fig. 61 Gevachrome print film structure (Type 9.02) 1. Gelatin overcoat. 2. Blue sensitive yellow dye layer. 3. Yellow filter. 4. Green sensitive magenta dye layer. 5. Magenta filter. 6. Red sensitive cyan dye layer. 7. Gelatin insulating layer. 8. Film base. 9. Carbon-black anti-halation layer.

199

better antistatic characteristics. To achieve these changes the Carry Lea silver layer between the blue and green-sensitive layers was replaced by a yellow non-migratory dye, the silver antihalation layer between the emulsion and the support was replaced by a carbon backing coated on the reverse side of the support (Fig. 61). The total emulsion thickness was reduced from 15 to 11·5 to increase definition and new absorbing dyes were incorporated in the emulsion layers also to increase definition. Along with these changes the capability of producing either a silver or a silver sulfide sound track was regained. Introduced in 1966 this film replaced T9·01.

Gevachrome Print Film—T9·03[13]

A reversal color print film balanced for printing with filtered tungsten illumination. Introduced in 1971 its improved characteristics included improved definition, color reproduction and sound quality.

The films employed in the Gevachrome system can be processed in conventional continuous processing machines with minor modifications for all of the steps required. The processing procedures designated for these films are called Process 6N1.

<div align="center">GEVACHROME PROCESS 6N-1</div>

	Formula	Temp.	6·00	6·05	9·02
Pre-Bath	GP 681	73°F	—	—	10 sec.
Spray Rinse	—	70°F	—	—	10 sec.
Backing Removal	—	—	—	—	—
First Developer	GP 110	73°F	3 min. 30 sec.	3 min. 30 sec.	2 min. 30 sec.
Stop Bath	GP 332	73°F	2 min.	2 min.	2 min.
Wash and	—	70°F	1 min.	1 min.	1 min.
Re-Exposure	—	—	30 sec.	30 sec.	30 sec.
Sound Track	GP 383	—	—	—	Silver .25 sec.
Application	GP 485	—	—	—	Sulfide 30 sec.
Wash	—	70°F	—	—	1 min.
Color Developer	GP 26	73°F	7 min.	7 min.	3–6 min.
Spray Rinse	—	70°F	10 sec.	10 sec.	10 sec.
Fix	GP 308	73°F	2 min.	2 min.	2 min.
Spray Wash	—	70°F	1 min. 30 sec.	1 min. 30 sec.	1 min. 30 sec.
Bleach	GP 446	73°F	3 min.	3 min.	3 min.
Spray Wash	—	70°F	2 min.	2 min.	2 min.
Sound Track	GP 84	—	—	—	Silver 30 sec.
Spray Wash	—	70°F	—	—	1 min.
Fix	GP 308	73°F	2 min.	2 min.	2 min.
Spray Wash	—	70°F	3 min.	3 min.	3 min.
Stabilizer	GP 660	73°F	10 sec.	10 sec.	10 sec.

GEVACHROME PROCESS 6N-1 FORMULAS

Pre-Bath GP 681

Water	800·0 ml
Sodium hexametaphosphate	2·0 grams
Sodium sulfate (anhydrous)	100·0 grams
Borax (10 mole)	15·0 gram
Sodium hydroxide	0·8 gram
Water to	1·0 liter
pH	9·30 ± 0·30

Black and White Developer GP 110

Water	800·0 ml
Sodium hexametaphosphate	2·0 gram
Metol	3·0 grams
Sodium sulfite (anhydrous)	50·0 grams
Hydroquinone	6·0 grams
Sodium carbonate (anhydrous)	40·0 grams
Potassium thiocyanate (50% sol.)	5·0 ml
Potassium bromide	2·3 grams
Potassium iodide (0·1% sol.)	6·0 ml
Water to	1·0 liter
pH	10·20 ± 0·10

Stop Bath GP 332

Water	900·0 ml
Potassium alum	15·0 grams
Acetic acid (glacial)	10·0 ml
Borax (10 mole)	21·0 gram
Water to	1·0 liter
pH	4·30 ± 0·20

Color Developer GP 26

Water	800·0 ml
Sodium hexametaphosphate	2·0 grams
Sodium sulfite (anhydrous)	4·0 grams
Hydroxylamine sulfate	1·4 grams
G-130 (N, N-diethyl-p-phenylenediamine sulfate)	3·6 grams
Sodium carbonate (anhydrous)	25·0 grams
Potassium bromide	2·2 grams
Potassium iodide (0·1% sol.)	4·0 ml
Water to	1·0 liter
pH	10·70 ± 0·10

Fixer GP 308

Water	800·0 ml
Sodium thiosulfate—	
crystals	300·0 grams
or anhydrous	200·0 grams
Sodium bisulfite	12·0 grams
Acetic acid (glacial)	12·0 ml
Borax (10 mole)	20·0 grams
Potassium alum	15·0 grams
Water to	1·0 liter
pH	4·10 ± 0·25

Masking Bleach GP 450

Water	800·0 ml
Potassium ferricyanide	50·0 grams
Borax	20·0 grams
Potassium bromide	15·0 grams
Potassium sulfate	50·0 grams
Sodium bisulfate	4·2 grams
Water to	1·0 liter
pH	8·80 ± 0·10

Bleach GP 446

Water	800·0 ml
Potassium ferricyanide	75·0 grams
Potassium bromide	15·0 grams
Acetic acid (glacial)	10·0 ml
Sodium acetate (anhydrous)	5·0 grams
Potassium alum	45·0 grams
Sodium hydroxide	3·5 grams
Water to	1·0 liter
pH	4·10 ± 0·20

Stabilizer GP 660

Water	250·0 ml
Formalin (40%)	12·5 ml
Wetting agent (5% sol.)	1·8 ml
Water to	1·0 liter
pH	7·45 ± 0·20

GEVACHROME II

In line with the increasing advances in the technology of photographic films and processes the Agfa-Gevaert Co. announced in 1974 a new process called Gevachrome II and a new generation of reversal color films.[14] This system is comprised of three camera films and a color print film all of which are processed in a single simplified color process which features reduced processing time, reduced costs, and ecological improvements when compared with the Gevachrome I process. Two of the camera films are high-speed reversal color films mainly intended for news photography. The third camera film is more specifically intended for production work. The print film which is optimized for television transmission is also processed in the Gevachrome II process. This later film is intended to supplement rather than replace T9·03.

Gevachrome S Type 700

A low contrast reversal color film balanced for exposure with 3200°K tungsten lamps. The photographic characteristics of this film were designed to meet the requirements of color television transmission. The speed of this film was E.I. 80 Tungsten and E.I. 40 Daylight when exposed with an Agfa-Gevaert CTO-12B filter or a Kodak Wratten 85B filter. Introduced in the United States in 1974 this film replaced Type 6·00. The recommended process for Type 700 is the Gevachrome II process.

Gevachrome Type 710

A medium contrast high-speed reversal color film balanced for exposure with 3200°K tungsten lamps. The photographic characteristics of the film were designed to meet the requirements of color television transmission. The speed of this film was E.I. 125 tungsten and E.I. 64 Daylight when exposed with an Agfa-Gevaert CTO-12B filter or a Kodak Wratten 85B filter. For exposure under very low light levels the effective film speed could be increased to E.I. 500 by extending the time in the first developer. Introduced in the United States in 1974 this film replaced Type 6·05. The recommended process for Type 710 is the Gevachrome II process.

Gevachrome D Type 720

A medium contrast, high-speed reversal color film balanced for exposure under daylight conditions 6000°K. The photographic characteristics of this film were designed to meet the requirements of color television transmission. The speed of this film was E.I. 125 Daylight. The photography in artificial light was not recommended since the necessary color temperature conversion filter a dark blue CTB-12 would reduce the useful film speed by two and one-third stops. Like its tungsten balanced counterpart, this film could also be processed to give an effective film speed of E.I. 500. Introduced in the United States in 1974 the recommended process for this film was the Gevachrome II process.[15]

GEVACHROME II PROCESS

| | Formula | Time | | Temp. |
		Camera	Print	
Pre-Bath	GP 602		10 sec.	77° ± 1
Spray Rinse and Backing Removal	—		10 sec.	73° ± 2
1st Developer	GP 112	3 min.	2 min.	77° ±0·2
Stop	GP 342	45 sec.	45 sec.	77° ±0·5
Wash and Re-exposure	—	100,000 Lux × sec.		
		Both sides		
Color Developer	GP 52	4 min.	4 min.	77° ±0·2
		15 sec.	15 sec.	
Fix	GP 372	30 sec.	30 sec.	77° ±0·5
Wash	—	1 min.	1 min.	73° ± 2
Bleach	GP 462	2 min.	2 min.	77° ± 5
Wash	—	1 min.	1 min.	73° ± 2
Fix	GP 372	1 min.	1 min.	77° ±0·5
Wash	—	1 min.	1 min.	73° ± 2
		30 sec.	30 sec.	
Stabilizer	GP 692	10 sec.		77° ± 2
Dry	—	3–5 min.		

GEVACHROME II FORMULAS

Pre-Bath GP 602

Water	600·0 ml
E.D.T.A. Na$_4$	2·0 grams
Sodium sulfate (anhydrous)	100·0 grams
Borax 10 H$_2$O	15·0 grams
Sodium hydroxide	0·8 grams
Water to	1·0 liter
pH	9·30 ± 0·15

1st Developer GP 112

Water	600·0 ml
Sodium heximetaphosphate	2·0 grams
Sodium sulfite (anhydrous)	50·0 grams
Hydroquinone	6·0 grams
Phenidone B	0·5 gram
Sodium carbonate (anhydrous)	25·0 grams
Potassium bromide	2·3 grams
Potassium thiocyanate	3·0 grams
Potassium iodide	6·0 mg
Additive GP 112 AD	5·0 ml
Water to	1·0 liter
pH	10·20 ± 0·10

Stop Bath GP 342

Water	700·0 ml
Potassium alum	15·0 grams
Acetic acid (glacial)	10·0 ml
Borax ·10 H$_2$O	21·0 grams
Water to	1·0 liter
pH	4·20 ± 0·2

Color Developer GP 52

Water	500·0 ml
Sodium hexametaphosphate	2·0 grams
Sodium sulfite	4·0 grams
N, N-diethyl-p-phenylenediamine	3·6 grams
Sulfate or N, N-diethyl-p-phenylenediaminehydrochloride	2·7 grams
Sodium carbonate	25·0 grams
Potassium bromide	0·75 gram
Sodium bicarbonate	0·3 gram
Potassium iodide	4·0 mg
Additive GP 52 AD	2·5 ml
Water to	1·0 liter
pH	10·70 ± 0·1

Acid Hardening Fixer GP 372

Water	600·0 ml
Sodium sulfite (anhydrous)	12·0 grams
Sodium metabisulfite	10·5 grams
Boric acid (crystal)	7·5 grams
Sodium acetate, 3 H$_2$O	21·0 grams
Acetic acid (glacial)	17·3 ml
Aluminium chloride ·6 H$_2$O	12·0 grams
Ammonium thiosulfate	212·0 grams
Water to	1·0 liter
pH	3·80 ± 0·15

Bleach GP 462

Water	600·0 ml
Potassium ferricyanide	40·0 grams
Potassium bromide	30·0 grams
Sodium acetate ·3 H$_2$O	5·0 grams
Acetic acid (glacial)	5·0 ml
Sodium bisulfate	6·0 grams
E.D.T.A. Na$_4$	10·0 grams
Water to	1·0 liter
pH	4·10 ± 0·20

205

Stabilizing Bath GP 692

Water	250·0 ml
Formalin (40% sol.)	12·5 ml
Wetting agent	1·8 ml
Water to	1·0 liter
pH	7·60 ± 0·30

3M (FERRANIA) COLOR

Ferrania-color is a three-color subtractive color process introduced in Italy in 1952. When it was introduced it consisted of two elements that could be used singly or together: a coupler-incorporated, three-color negative and a coupler-incorporated, three-color print film. Although the process was not used for motion picture production in the United States it was used in Europe to produce several pictures. One of the first pictures photographed in this process and distributed in the United States was the IFE production *Aida*. This film was praised for its color quality by *Film Daily* and *Independent Film Journal*. In 1956 an Italian production *The Queen of Babylon* was released in the U.S. by Twentieth Century-Fox.[18] The process, however, did not become popular in the United States.

In 1964 the Minnesota Mining and Manufacturing Co. purchased control of Ferrania and began to distribute their photographic products in the United States. These first efforts were limited to black and white films and a Ferrania-color Print Film whose recommended process was not compatible with other existing color processes. For this reason its introduction was unsuccessful.

Ferrania Type HS Color Release Positive

A color release positive film balanced for printing with 3000°K filtered tungsten illumination. Either additive or subtractive printing could be used. This film had three layers sensitized respectively to Blue, Red, and Green light. Antihalation protection was furnished by a dye backing on the film base which dissolved during processing. Incorporated in each layer were dye-forming couplers which reacted with the developing agent during processing to form color images complementary to the negative from which they were printed. Through a separate developer application a silver plus dye optical sound track was produced. Introduced in 1968 this film received limited acceptance because it required a separate process incompatible with other existing color processes.

Several changes were made in both the film and process and in 1970 a new improved compatible print film was introduced.

The compatible color print films manufactured under the name of 3M Color Positive are multilayered color films which consist of three light-sensitive emulsions coated on a single support. The bottom blue-sensitive emulsion contains a colorless dye coupler which reacts during development to produce a yellow dye. The middle red-sensitive emulsion contains a colorless dye coupler which reacts during development to produce a cyan dye.

206

The top green-sensitive emulsion contains a colorless dye coupler which reacts during development to produce a magenta dye. The reverse side of the support is coated with an antihalation layer consisting of an alkali removable resin containing carbon black. The antihalation layer is removed during processing.

PROCESSING SPECIFICATIONS FOR FERRANIA COLOR POSITIVE TYPE HS

	Sol.	Time	Temp.
Color Developer	R.C. 125	9–12 min.	65°
Spray Rinse	—	10–20 sec.	68°–75°
Stop-Fix	F. 8	4 min.	
Wash	—	4 min.	68°–75°
Bleach	VC 225	8 min.	
Wash	—	2 min.	68°–75°
Sound Track Re-Development		10–20 sec.	
Wash	—	2 min.	68°–75°
Fix	F.C. 200S	4 min.	
Wash	—	10 min.	68°–75°
Dry	—	15–20 min.	

Color Developer R.C. 125

Solution A
Water	200·0 ml
Hydroxylamine hydrochloride	2·80 grams
Diethyl-p-phenylenediamine sulfate	1·0 gram
Water to	500·0 ml

Solution B
Water	200·0 ml
Calgon (sodium heximataphosphate)	2·0 grams
Sodium carbonate (monohydrate)	79·60 grams
Sodium sulfite (anhydrous)	2·50 grams
Potassium bromide	1·20 grams
Sodium hydroxide	2·0 grams
Water to	500·0 ml

Pour Solution A into Solution B and filter before using. pH after mixing $11·00 + 0·2 - 0·1$.

Stop Fixer F. 8
Water	800·0 ml
Sodium thiosulfate (crystal)	250·0 grams
Sodium sulfite (anhydrous)	20·0 grams
Acetic acid (glacial)	15·0 ml

Boric acid (crystal)	10·0 grams
Potassium alum	15·0 grams
Water to	1·0 liter
pH	$4·3 \pm 0·1$

Bleach VC 225

Water	800·0 ml
Potassium bromide	20·0 grams
Potassium dichromate	5·0 grams
Potassium alum	40·0 grams
Sodium acetate (crystal)	2·5 grams
Acetic acid (glacial)	15·0 ml
Water to	1·0 liter
pH	$3·10 \pm 0·10$

Fixer F.C. 200S

Water	800·0 ml
Sodium thiosulfate (crystal)	200·0 grams
Sodium sulfite	10·0 grams
Water to	1·0 liter
pH	$8·2 \pm 0·5$

Sound Track Developer

The development of the sound track is achieved as with other color positive films; the developer normally used should prove entirely satisfactory.

3M Color Positive, Type 650[19]

A color positive film balanced for printing with filtered tungsten illumination. Introduced for sale in the United States in 1970 its improved characteristics include better sharpness through the use of thinner emulsions, better sound reproduction capability and improvements in physical characteristics.

3M Color Positive, Type 651

A color positive film balanced for printing with filtered tungsten illumination. Introduced in 1974 to replace Type 650 its improved characteristics include better color reproduction and saturation.

The films employed in the 3M color system can be processed in conventional type continuous processing machines with minor modifications for all of the steps required. The 3M

Company has published the following recommended times and formulas for processing 3M color positive film. These recommendations are identical to and can be used interchangeably with those made for the Kodak ECP-1 process.

PROCESSING 3M COLOR POSITIVE FILM

Times and temperatures given below are intended as a guide and should be adjusted by trial evaluation to individual needs. Replenishment rates should also be standardized by conventional analytical and sensitometric analysis.

TIME AND TEMPERATURE TABLE

	75°F	80°F
Pre-Bath	10–20 sec.	10–20 sec.
Wash	10–20 sec.	10–20 sec.
Color Development	8 min.	5 min. 20 sec.
Wash	10–20 sec.	10–20 sec.
Stop-Fixing	2 min.	1 min.
Wash	1 min.	40 sec.
Bleach	6 min.	4 min.
Wash	2 min.	1 min.
Sound-Track Re-Development	10–20 sec.	10–20 sec.
Wash	10–30 sec.	10–30 sec.
Fixing	2 min.	2 min.
Wash	6 min.	5 min.
Stabilizing Bath	10 sec.	10 sec.
Drying	—	—

FORMULAS

Pre-Bath

Water	800·0 ml
Borax ($Na_2B_4O_7 \cdot 10H_2O$)	20·0 grams
Sodium sulfate (desiccated)	100·0 grams
Sodium hydroxide (flake)	1·0 gram
Water to	1·0 liter
pH at 70°F	9·30 ± 0·10
pH at 80°F	9·26 ± 0·10

Color Developer

Water	800·0 ml
Sodium hexametaphosphate or Calgon	2·0 gram
Sodium sulfite (desiccated)	4·0 grams

Color developing agent*	3·0 grams
Sodium carbonate (monohydrated)	20·0 grams
Potassium bromide	2·0 grams
or Sodium bromide	1·7 grams
Water to	1·0 liter
pH at 70°F	10·65 ± 0·05
pH at 80°F	10·59 ± 0·05

*Para-phenylene diamine type color developing agent such as (CD-2).

Stop-Fixing Bath

Water	600·0 ml
Sodium thiosulfate (pentahydrate)	240·0 grams
Sodium sulfite (desiccated)	15·0 grams
Acetic acid (glacial)	13·4 ml
Boric acid (anhydrous)	7·5 grams
Potassium alum (dodecahydrated)	15·0 grams
Water to	1·0 liter
pH at 70°F	4·25 ± 0·25
pH at 80°F	4·25 ± 0·25

Bleach

Water	800·0 ml
Potassium bromide (anhydrous)	20·0 grams
or Sodium bromide	17·0 grams
Potassium dichromate (bichromate) (anhydrous)	5·0 grams
Potassium alum (dodecahydrated)	40·0 grams
Water to	1·0 liter
pH at 70°F or 80°F	3·10 ± 0·20

Adjust to proper pH with 2·5 N Sodium hydroxide or 7 N Sulfuric acid.

Sound-Track Developer

Solution A

Water	250·0 ml
Sound coating aid*	2·0 grams

Sift the coating aid slowly into the water with continuous agitation. If undissolved particles remain, allow the solution to stand 40–60 min. Additional stirring should produce a homogeneous mixture.

Add:
Hexylene glycol	10·0 ml

*Gantrez AN4651 (GAF Corp.).

210

Solution B

Place in a 150 ml beaker

Water	600·0 ml
Sodium hydroxide (flake)	80·0 grams
Sodium sulfite (desiccated)	60·0 grams

Cool to room temperature and add:

Hydroquinone	60·0 grams

Add solution A to B with stirring. Then add:

Ethylenediamine (98% by weight)	13·0 ml
Water to	1·0 liter

Fixing Bath

Same formula as the Stop-Fixing Bath

Stabilizing Bath

Formalin	10 ml to 20 ml
Kodak Photo-Flo 600 solution (concentrate)	2·0 ml
Water to	1·0 liter

REFERENCES

[1] MIURA, YOSHIO AND HARA, MAKOTO, "The Fujicolor Positive Film Type 8818 (35 mm) and Type 8828 (16 mm and 16/8 mm)." *Journal of the Society of Motion Picture and Television Engineers,* Oct. 1967, pp. 1006–1007.

[2] *Fuji Film Data Book: Fuji Motion Picture Films.* Fuji Photo Film Co., Ltd., Tokyo, Japan, 1970.
Fuji Film Processing Manual: Fujicolor Negative Film Type 8516. Fuji Photo Film Co., Ltd., Tokyo, Japan, 1971.
Fuji Film Processing Manual: Fujicolor Positive Film 35 mm Type 8819, 16 mm Type 8829. Fuji Photo Film Co., Ltd., Tokyo, Japan, 1972.

[3] *Fuji Film Processing Manual: Fujicolor Reversal TV Film RT-100 16 mm Type 8424.* Fuji Photo Film Co., Ltd., Tokyo, Japan, 1972.

[4] KOSHOFER, G., "30 Years of Modern Color Photography 1935–1965," *The British Journal of Photography,* Sept. 1966, pp. 828.

[5] VANDEPITTE. Cable from Antwerp, August 1974.

[6] "Gevaert Motion Picture Films for Professional Use." Mortsel, Belgium: Motion Picture Film Department, Gevaert Co., 1963, p. 9.

[7] CORNWELL-CLYNE, ADRIAN, *Colour Cinematography.* London: Chapman Hall, Ltd., 1951, pp. 743–749.

[8] "Elements of Color in Professional Motion Pictures," *Society of Motion Picture and Television Engineers,* New York: 1957, pp. 25–37.

[9] MERUSSEN, L. A., "The Gevacolor Positive Film Type 953," *Journal of the Society of Motion Picture and Television Engineers,* Jan., 1964, pp. 18–21.

[10] VERBRUGGHE, R. G. L., "A New Color Print Filmstock," *Journal of the Society of Motion Picture and Television Engineers,* Jan., 1968, pp. 29–33.

[11] EYNARD, R. A., "Gevachrome Original Films for a Sharp and Brilliant Television Image." *Presented at 106th Technical Conference of the Society of Motion Picture and Television Engineers,* Los Angeles, Sept., 1969.

[12] VERGRUGGHE, R. G. L., "A Sharp Reversal Color Print Film," *Journal of the Society of Motion Picture and Television Engineers,* Dec., 1967, pp. 1198–1201.

[13] HUYBRECHTS, R. J. H. AND VERBRUGGHE, R. G. L., "Type 903—An Improved Gevachrome Print Film." *Presented at 110th Technical Conference of the Society of Motion Picture and Television Engineers,* Montreal, Oct., 1971.

[14] HUYBRECHTS, R. J. H. AND VERBRUGGHE, R. G. L., "Gevachrome II: A New Color-Reversal System for Film Productions and News Gathering." *Presented at 116th Technical Conference of the Society of Motion Picture and Television Engineers*, Toronto, Nov., 1974.

[15] "Gevachrome II Processing Method for Gevachrome Camera Films—Types 700, 710 and 720 and Gevachrome Print Film—Type 780," Mortsel, Belgium: Motion Picture Film Department, Agfa-Gevaert, 1974.

[16] "Processing Motion Picture Films," Mortsel, Belgium. Motion Picture Film Department, Agfa-Gevaert, 1964.

[17] VERSLUYS, E. Correspondence from Mortsel, Belgium, April, 1974.

[18] LIMBACHER, J. L., *Four Aspects of the Film*, New York: Brussel and Brussel, 1968, pp. 64–65.

[19] FRANCHI, L. AND BONELLI, P., "A New Color Positive Film (3M Type 650)." *Presented at 108th Technical Conference of the Society of Motion Picture and Television Engineers*, New York, Sept., 1970.

X REHALOGENATION PROCESSES

Because the three processes described next do not properly fit into any of the broad categories discussed previously, they have been set apart into a separate subcategory, "Subtractive Processes involving Rehalogenation." Rehalogenation is the practice whereby silver halide is reformed from silver by the treating of an emulsion with an aqueous solution of an oxidizing agent and with the appropriate halide ion, the oxidizing of the metallic silver to silver ion not affecting substantially the dyes formed by color-forming development, and the halide ion reacting with silver to form the desired silver halide.

In two of the following processes films that are essentially single layer black and white color-blind emulsions were used to produce three-color release prints, but in the first to be described, Gaspar Color, multi-layer film was employed in a dye-bleach process.

GASPAR COLOR

Gaspar Color was a subtractive color process for making motion picture release prints invented in 1930 by Dr Bela Gaspar. In 1934 Gaspar Color, Ltd., was formed in England and the process was introduced for commercial use. Special multilayer film for the process was manufactured by Gevaert of Belgium.[1] According to Cornwell-Clyne, who was technical supervisor of the laboratory, "a large number of very beautiful release prints were made."

During World War II Gaspar moved his base of operation from Brussels to the United States. In 1941 the Hollywood Color Film Company announced that the Gaspar Color process was available in its Burbank laboratory. Both two- and three-color prints were offered in 16 mm or 35 mm.[2] When film could no longer be obtained from Belgium because of the German occupation, Gaspar entered into an agreement with the Ansco Division of General Aniline and Film Corporation, Binghamton, New York, for the manufacture of Gaspar Color print film.[3]

The first use of the Gaspar Color process in the United States was for George Pal's "Puppetoons." There is no record of its ever having been used for feature production.[4]

Although the Gaspar Color process was capable of producing a very acceptable color release print, it failed to achieve commercial success in Hollywood. In the opinion of the writer, this was due to lack of sufficient capital and manufacturing facilities to exploit the possibilities of Gaspar's inventions: this, plus the need to match the already satisfactory quality standard set by the Technicolor process.

Since the Gaspar Color process was a release print process and not a complete system of photography and printing, several different systems could be employed to obtain the original photography. Any color photographic process that could produce a set of color separation positives could be used. The essential point was that two or three black and white color separation positives made on a step registration printer were required in order to make the release prints.

Both types of Gaspar Color print film had emulsion coated on the back side of the support. The two-color Gaspar Color print film had a normal reversal-type silver emulsion plus a cyan-blue dye on one side and normal reversal-type silver emulsion plus a mixture of red and yellow dyes on the other side (Fig. 62a). The three-color Gaspar Color print film had a blue sensitive emulsion plus a magenta dye coated on top of a red sensitive emulsion plus a yellow dye on one side of the support and a blue sensitive emulsion plus a cyan-blue dye on the other side (Fig. 62b).[5]

Fig. 62 Gaspar color. a. Two-color Print Film. 1. Normal reversal type silver emulsion plus a cyan-blue dye. 2. Film base. 3. Normal reversal type silver emulsion plus a mixture of red and yellow dyes. b. Three-color Print Film. 1. Blue sensitive emulsion plus a magenta dye. 2. Red sensitive emulsion plus a yellow dye. 3. Film base. 4. Blue sensitive emulsion plus a cyan dye.

Each layer was printed independently in the following manner:

1. *Two-color.* Both sides printed simultaneously on a special printer with two light sources, the three films passing through the gate at the same time. The blue separation positive was printed onto the emulsion containing the red dye at the same time the red separation positive was printed onto the emulsion containing the cyan blue dye.

2. *Three-color.* Two passes through the printer were necessary to expose the three-color print film. On the first pass three films went through the gate at the same time. The green

214

separation positive was printed with a blue filter onto the emulsion containing the magenta dye; at the same time the red separation positive was printed with a blue filter onto the emulsion containing the cyan dye. On the second pass the blue separation positive was printed with a red filter onto the emulsion containing the yellow dye.

If a special printer having a light source on both sides of the gate was not available the films could be printed on any conventional step registration printer. Two passes were required for the two-color film and three passes were required for the three-color film.

After printing the film was developed in a black and white developer to produce a high contrast negative silver image. This was followed by a wash, a fix and a wash. Next it passed into a dye bleach where the dyes in the emulsions were destroyed in proportion to the presence of the developed silver. Once again the film was washed, then bleached. The function of the second bleach was to convert the metallic silver formed by development into silver chloride so that it could be removed by the final fix. In order to prevent the silver in the sound track area from also being removed by the final fix, the sound track area was striped with developer by means of a wheel applicator prior to fixing. The final fix removed all the remaining silver halide in the picture area leaving a pure dye image and a silver sound track. This was followed by a final wash and the film was dried and ready for projection using normal projection equipment.[6]

Developer

Metol	1·0 gram
Sodium sulfite	24·0 grams
Hydroquinone	7·25 grams
Sodium carbonate	15·0 grams
Potassium bromide	0·1 gram
Water to	1·0 liter

Fix

1st Fix 9 min.
2nd Fix 6 min.

Sodium thiosulfate	300·0 grams
Sodium metabisulfite	0·7 gram
Water to	1·0 liter

Dye Bleach—11 min.

Thiocarbamide	70·0 grams
Potassium chrome alum	50·0 grams
Hydroquinone	1·0 gram
Sulfuric acid (conc.)	5·0 ml
Water to	1·0 liter

Silver Bleach—5¼ min.

Copper sulfate	100·0 grams
Sodium chloride	100·0 grams
Hydrochloric acid (conc.)	2·5 ml
Water to	1·0 liter

Sound Track Redeveloper—1 min.

Metol	25·0 grams
Sodium sulfite (anhydrous)	300·0 grams
Hydroquinone	75·0 grams
Sodium hydroxide (40% sol.)	125·0 ml
"Nekal"	25·0 ml
Dextrin	500·0 grams
Water to	1·0 liter

POLACOLOR

The Polacolor process as a system for motion picture release printing was announced in 1947 by the Polaroid Corporation of Cambridge, Massachusetts. In this process conventional black and white film was used to produce three color subtractive color prints.[7]

Paramount Pictures used Polacolor to release several cartoons of the Screen Song and Popeye series, also one Noveltoon.[8] Although successful for this purpose, the process was not extended to feature productions. The location of the laboratory far from the motion picture production centers and its limited capacity were not favorable for feature picture release. In 1949 the Polaroid Corporation was faced with the alternative of investing enough additional money to relocate the laboratory and set up for large scale automatic production or to abandon the process. The decision was to discontinue the process and concentrate on the Polaroid process for amateur still photography.[9]

A description of the processing steps and formulas is given in USP 2471574 issued to W. H. Ryan and V. K. Walworth and assigned to the Polaroid Corporation. To produce prints by the Polacolor process it was necessary to begin with three separation negatives, red, green and blue. From the red separation negative a print was made on normal black and white release film such as Eastman Fine Grain Release Positive, Type 5302. This print was developed in a cyan dye-forming developer which forms a silver image and a cyan dye image in the exposed portion of the emulsion layer of the film. Development was stopped by immersion in a stop bath for one minute. The film was then washed for three minutes and given a controlled flash by exposure to a fifteen watt incandescent bulb located approximately two inches from the film, which was moved past the bulb at the rate of thirty feet per minute. Rehalogenation was accomplished by treatment for three minutes in a solution which reformed silver halide in any exposed portion of the film. Following this treatment the emulsion layer contained silver halide throughout and the component image formed of cyan dye, the silver halide being substantially uniformly sensitive and developable only upon exposure to light. The film was washed to remove any residual traces of rehalogenating composition in-

216

cluding oxidizing agent and any soluble reaction products of the rehalogenating treatment, and then dried. The print was then ready for exposure from the green separation which was printed in register with the previously developed cyan image. After printing the film was developed for three and one-half minutes in a magenta dye forming color developer, then immersed in a stop bath for one minute. The emulsion layer then contained light-sensitive halide, the cyan component image, the magenta component image, and the developed silver image. After washing for three minutes the remaining silver was reconverted to light-sensitive silver halide by immersion for three minutes in the rehalogenating solution. The film was then washed and dried and the blue separation negative was printed in register with the dye images obtained from the red and green separation negatives. The exposure from the blue separation negative was developed in a yellow dye forming developer for four minutes. Following the yellow development, the emulsion layer contained light-sensitive silver halide, the cyan component image, the magenta component image and the yellow component image, also developed silver. Development was stopped by immersion for one minute in the stop bath. This was followed by a three minute wash and a three minute immersion in the rehalogenating bath. The effect of this final treatment in the rehalogenating bath is to convert the silver to silver halide so that the emulsion contains light-sensitive silver halide throughout along with the cyan, magenta and yellow dye components which together form a multicolor image. Subsequent treatment with a conventional fixing bath followed by washing and drying removed the remaining silver halide and left the multicolor dye images.

Formulas for processing steps outlined above were as follows:[10]

Cyan Color Developer

Sodium carbonate	25·0 grams
Sodium sulfite	1·0 gram
p-diethyl amino aniline monohydrochloride	0·6 gram
Potassium bromide	0·4 gram
2, 4-dichlor 1-naphthol	1·0 gram
Acetone	100·0 ml
Water to	1·0 liter

Stop Bath

Sodium carbonate (desiccated)	2·2 grams
Paraformaldehyde	5·0 grams
Water to	1·0 liter

Rehalogenating Bath

Potassium bromide	200·0 grams
Cupric chloride	35·0 grams
Water to	1·0 liter

Magenta Color Developer

Sodium carbonate (desiccated)	12·5 grams
Sodium sulfite	0·6 gram
p-diethyl amino aniline monohydrochloride	0·4 gram
Potassium bromide	0·25 gram
p-nitrophenylacetonitrile	0·25 gram
Acetone	25·0 ml
Water to	1·0 liter

Yellow Color Developer

Sodium carbonate	50·0 grams
Sodium sulfite	5·0 grams
p-diethyl amino aniline monohydrochloride	3·0 grams
Potassium bromide	2·0 grams
Ethylacetoacetate	20·0 ml
Acetone	80·0 ml
Water to	1·0 liter

PANACOLOR

The Panacolor Process was a three-color subtractive color process for making motion picture release prints. Panacolor, Inc., was formed June 10, 1957, for the purpose of developing and applying a color process invented and patented by Michele P. L. Martinez.[11] During the period 1957 to 1962 the process was improved and techniques for its application on a commercial basis were developed. Printing speed was increased and color reproduction was improved. Also a processing laboratory capable of producing 160 million feet of release prints per year was constructed.[12]

On June 27, 1962 a press preview of the process was held at the Screen Directors Guild building in Hollywood. The material used for the demonstration consisted of miscellaneous test footage plus a production reel of the MGM feature picture, *The Horizontal Lieutenant.* The following day the *Hollywood Reporter* announced that MGM had ordered fifty prints of *The Horizontal Lieutenant* from Panacolor; the remaining prints were to be made on Eastman Color Print Film by the MGM laboratory.[13] Other feature pictures that used the Panacolor print process were *The Castilians, Pyro, Samson and Ulysses, Secret Seven,* and *Mother Goose a Go Go.*

In order to make release prints using the Panacolor process it was necessary to start with three color-separation negatives. If a system that produced three separation negatives was employed for the original photography the prints could be made directly from the original negatives. If, however, one of the multilayered integral tripacks was used for the original photography additional steps were necessary before the prints could be made. It was necessary to prepare three separation-master positives and three separation-negatives, or a

218

color intermediate positive and three separation-negatives, if the original was a color negative. Color separation negatives could be made directly from the original if it was a reversal color film.

Release prints made by the Panacolor process were made on conventional black and white film which was developed in a series of dye coupling developers.[14]

The red separation negative was printed first on a continuous contact printer equipped with a full fitting sprocket. A silver plus a cyan dye image was produced by development with a developer which contained a cyan dye-forming coupler. This was followed by a wash, then the film was treated with an oxidizing bath which converted the metallic silver formed by development back to a light-sensitive silver salt. Then the film was washed and dried. Next the green separation negative was printed in register with the previously developed cyan image. A silver plus a magenta dye image was produced from this printing by development with a developer which contained a magenta dye-forming coupler. This was followed by a wash, then the film was treated with an oxidizing bath which converted the metallic silver formed by the magenta development back to a light-sensitive silver salt. Then the film was washed and dried. For the final picture printing the blue separation negative was printed in register with the previously developed cyan and magenta images. This was followed by sound track printing. A silver plus a yellow dye image in both the picture and the sound track area was produced from this printing by development with a developer which contained a yellow dye-forming coupler. Next the film was washed and only the picture area was treated with an oxidizing bath which converted the metallic silver formed by the yellow development into silver salt. Following this treatment the film was washed and fixed with a conventional fixing bath, washed and dried.[15]

Cyan Developer

Calgon	1·0 gram
Potassium bromide	4·80 grams
Sodium hydroxide	9·50 grams
Sodium bicarbonate	30·0 grams
2·4 Dichlor-alpha-napthol	5·0 grams
CF 80	5·0 grams
Starch	45·0 grams
Water to	1·0 liter
pH at 75°F	9·76

Magenta Developer

Calgon	1·0 gram
Potassium bromide	4·20 grams
Sodium carbonate	25·0 grams
Sodium hydroxide	8·43 grams
1-(2, 4, 6-Trichloropheny)-3- nitroanilino-2-pyrazoline-5-one	3·0 grams

CF 80	4·0 grams
Starch	42·0 grams
Water to	1·0 liter
pH at 75°F	10·80

Yellow Developer

Calgon	1·0 gram
Potassium bromide	3·50 grams
Sodium hydroxide Y 50	to adjust pH
S-5 developer (Dicolamine)	7·0 grams
Phenidone A	0·125 grams
Starch	39·50 grams
Water to	1·0 liter
pH at75°F	13·20

Bleach

Water	800·0 ml
Potassium ferricyanide	100·0 grams
Potassium bromide	100·0 grams
Water to	1·0 liter

Instead of using the immersion or spray technique for the treatment of the film with the developing and bleach solutions, the Panacolor process used a wheel applicator to coat the film with thixotropic solutions. These thick solutions were mixed in special tanks with counter-rotating agitators and pumped to the coating stations where the correct amount of material was metered to an applicator of special design.[16] Temperature was maintained plus or minus $\frac{1}{2}°$. Relative humidity was maintained at plus or minus $2\frac{1}{2}$% at $97\frac{1}{2}$%.

The three separation negatives were threaded on loop racks, one for each color printer and one for the sound track printer. The prospectus for Panacolor, Inc., stated that they were printed simultaneously, indicating that the print film passes through all four printers in a single pass. The printers pictured were modified Bell and Howell Model D printers; therefore, it appears that the print film passed through the first printer, was processed and dried, passed through the second printer, was processed and dried, passed through the third and fourth printers, was processed and dried, all in one continuous strand, at a speed of 240 feet per minute.[17]

Formulas for the processing steps outlined above were as follows:[18]

REFERENCES

[1] CORNWELL-CLYNE, ADRIAN, *Colour Cinematography* (London: Chapman and Hall, Ltd., 1951), p. 419.
[2] WYCKOFF, A., "Gaspar Color Comes to Hollywood," *American Cinematographer*, November, 1941, p. 510.
[3] Discussion with W. Hunter, formerly with Motion Picture Division of General Aniline and Film Corporation.
[4] WYCKOFF, A., "Gaspar Color Comes to Hollywood," *loc. cit.*, p. 511.
[5] *Ibid.*

[6] CORNWELL-CLYNE, ADRIAN, *op. cit.*, pp. 424–425.

[7] FROST, G. E. AND OPPENHEIM, S. CHESTERFIELD, "Technical History of Professional Color Motion Pictures" (The Patent, Trademark and Copyright Foundation, George Washington University, Washington, D.C., 1960), p. 40.

[8] LIMBACHER, J. L., "A Historical Study of the Color Motion Picture," Dearborn, Michigan, 1963, p. 19.

[9] FROST, G. E. AND OPPENHEIM, S. CHESTERFIELD, *op. cit.*, p. 4.

[10] USP 2471574.

[11] Prospectus: Panacolor, Inc., Federhill, Stonehill & Co., June 6, 1961.

[12] 1961 Annual Report: Panacolor, Inc., New York, May 4, 1962.

[13] *Hollywood Reporter*, June 27, 1962.

[14] Prospectus: Panacolor, Inc., Federman, Stonehill & Co., June 6, 1961.

[15] *Ibid.*

[16] 1961 Annual Report: Panacolor, Inc., New York, May 4, 1962.

[17] Personal interview with G. F. Rackett.

[18] USP 3372028.
 USP Application 81893 and 81894 filed Jan. 10, 1961; 81751 and 81752 filed Jan. 10, 1961.

XI CONCLUSION

In the preceding sections of this study the author has attempted to describe the technical characteristics of the many color motion picture processes developed in the United States during the period 1900–1975. The extent to which each process is described is dependent on the source material which was available. In some cases a process was announced in a press release and never heard of again. In describing many of the lesser known processes the interpretation of patent literature has been heavily relied on as source material; also, the state of the art at the time of the patent issued. Originally it had been proposed that the written material would be supplemented with personal interview. This, however, in most cases did not prove to be practical. It soon became evident that most of the people interviewed failed to remember technical details concerning processes that they had not worked with for over twenty years.

Although there were a multitude of patents granted during the period studied, the processes they covered can be divided into a relatively small group, each one within the group having a great deal of similarity to the others in the group. The classification of additive color processes can be broken down into two sub-classes.

1. Optical, mechanical and shared area systems.
2. Lenticular film supports and associated filters.

The classification of subtractive color processes can be broken down into four sub-classes:

1. Optical, mechanical and shared area systems.
2. Those employing bipack negative and double coated positive films.
3. Monopacks
 a. Those employing non-coupler incorporated multilayered film.
 b. Those employing coupler incorporated multilayered film.
4. Rehalagenation systems employing single layer film.

In general, the additive processes were not successful commercially or those that did achieve success retained it only for a short time. This was due to many factors, the three most significant ones being:

1. The need for more light in projection.

222

2. The need for special projection devices.
3. The need for special camera devices.

The subtractive processes have, on the other hand, been relatively successful. Even the two-color processes were moderately successful commercially. Although they were inferior to the three-color additive systems from the standpoint of color fidelity, their ease of operation kept them available commercially until they developed into or were replaced by three-color subtractive processes. Systems which employed standard camera and projection equipment have in general been the most successful.

With the exception of Technicolor, the laboratory has not been a significant factor in the choice of a color process. Laboratories have shown willingness and a great degree of flexibility in adapting to relatively complicated processes and processing procedures. Changes in equipment and/or technique that have resulted in improved screen quality have been accepted readily. This has caused an increase in overall quality, a reduction in the cost of release prints, and a highly competitive situation among the laboratories. It has also resulted in a certain degree of standardization and the elimination of some processes. For the present, Eastman Color Negative has emerged as virtually the standard for 35 mm color cinematography in the United States. It has the advantage of high quality and uniformity, and is adaptable to use with all of the existing release print systems. This position was being challenged in 1974 by the introduction of an improved Fuji color negative film.

In the release print area Technicolor imbibition prints attended a high degree of success and for many years were the standard of the industry. The decision by the Technicolor management to discontinue the process in the United States in 1974 was a difficult one. Several factors were involved: changes in the patterns of print ordering, tighter production schedules, rising costs for both labor and materials, the need to replace outdated and worn out equipment and increasing competition in price and service from the laboratories offering the various multilayered print films. Technological advances by the Eastman Kodak Co. in the United States, the Agfa-Gevaert Co. in Belgium, the Fuji Film Co. in Japan and the Ferrania Co. in Italy made it possible for the producer to obtain release prints of good technical quality on a variety of films. He was now able to shop in a competitive market and make the best deal he could.

At the present time the Eastman Color films and processes are the most popular in the United States, replacing the imbibition process in Technicolor's new Hollywood laboratory. The other multilayered films have however become increasingly more important in the production of release prints for American made motion pictures. In the period 1965–1975 several hundred million feet of these films were printed and processed.

The future of color motion picture processes seem to be committed to the use of multilayered films. This type of color system has progressed to the point where color has become almost as easy for the cinematographer to handle as black and white photography. The oversize, cumbersome, complicated mechanical devices used for the pioneer color motion picture processes have been replaced by the conventional motion picture cameras used for black and white cinematography. Film speeds have increased considerably, and with this increase has come a reduction in set lighting levels and a more dramatic and interesting use of lighting.

Color quality and uniformity have improved substantially. Two-color processes are a thing of the past in American theaters and the three-color processes are producing "natural color" which is a much truer reproduction of the actual colors of the scene.

Today color is so easy to handle that the average amateur can obtain better color pictures by pointing a camera and pushing a button than the professional could obtain forty years ago at any expense of money or effort.

DEFINITIONS OF TERMS

Absorption Band (*of a color filter*) – A dark zone in a spectrum resulting from the failure of a color-filter to transmit light of wavelengths corresponding to the band.

Acid Dyes – Dyes in which the color resides in the negative ion (anion). Commonly, salts of colorless inorganic bases with colored or potentially colored organic acids.

Additive Mixture – See Additive Synthesis.

Additive Primaries – Red, green and blue.

Additive Process – A process for reproducing objects in natural colors by means of the principle of additive synthesis. Usually, black and white positives, printed from negatives taken through the primary color filters, are projected or viewed in register by means of light beams of the primary colors.

Additive Synthesis – The formation of a color by mixing light of two or more other colors. Any color may be formed by mixing light of three primary colors in the proper proportions. Some colors may be formed by mixing light of two other colors.

Analytical Densities – The composition of the image is expressed as amounts of component absorbers (that is, cyan, magenta and yellow dye deposits).

Angstrom Unit – A unit of length generally used for specifying the wavelength of radiation, especially light and radiant energy of wavelengths shorter than light. Numerically equal to 0·0000001 mm (10^{-7} mm). The unit more frequently used in colorimetrics is the millimicron.

Aniline Dyes – A term broadly applied to synthetic dyes derived from aniline or other coal-tar products.

Arbitrary Three-Filter Densities – An arbitrary kind of integral color density in which the color response functions employed are those which the particular filters or photocells, etc., happen to give. Densities of this type are satisfactory for comparison of identical or nearly identical images within a particular color system.

Artificial Daylight – Light (visible radiation) having the same (or nearly the same) spectral composition as direct solar radiation plus skylight—in practice produced by selectively absorbing some components of the light emitted by artificial sources.

Banded Tricolor Filter – See Tricolor Filter.

Basic Dyes – Dyes in which the color resides in the positive ion (cation). Commonly, salts of colored organic bases with colorless acids.

Beam Splitter – An optical system so arranged as to reflect or transmit two or more portions of a light beam along different optical axes. Such a device is frequently used in the production of color separation negatives.

Bichromated Gelatin – Gelatin sensitized to light by the incorporation of a soluble bichromate, usually ammonium or potassium bichromate.

Bipack – A unit consisting of two superimposed films or plates sensitive to different portions of the spectrum, and intended to be exposed one through the other.

Biprism – A prism having a principal section which is a triangle with a very obtuse angle and two equal acute angles, sometimes used as a beam splitter.

Black – Incapable of reflecting light in an amount which will produce a visible light response.

Black Body – (1) A body which when heated radiates ideally according to fundamental physical laws (i.e., Wien radiation law), relating energy, frequency, and absolute temperature. The properties of incandescent tungsten or carbon approximate those of a black body. (2) A body which absorbs all light incident upon it.

Bleach – *v.t.* To remove the color by chemical means; in photography, to remove, by chemical action (usually oxidation), the silver of an image. An image thus treated may be restored by suitable means generally leaving the gelatin film toned and/or tanned. *n.* A chemical reagent used for bleaching.

Bleeding of Color – The diffusing of dye away from a dye-image; most noticeable where dark areas adjoin light areas in a picture.

Brightness – The light (luminous power) per unit area, per unit solid angle, emitted from a surface in a given direction; the candle-power per unit area.

Chemical Toning – The process of converting the silver of a photographic image into a colored substance, or replacing it by a colored substance through the use of chemical reagents which are not dyes.

Chromatic Aberration – A defect of a lens resulting in a difference in focal length for light of different colors.

Chromaticity – The quality of colors that embraces hue and saturation but excludes brilliance.

Colloidal Dyes – Dyes the particles of which are submicroscopic in size, but larger than molecules or ions.

Color – (1) The general name for all sensations (other than those related to spatial distribution) arising from the activity of the eye and its attached nervous system. Examples of color are the sensations red, yellow, blue, black, white, grey, etc. (2) More loosely, as above but excluding the black, white, and grey sensations.

Color Balance – The adjustment of the intensities of printing or viewing colors (of a color picture) so as to reproduce properly the scale of greys, flesh tones and other important colors.

Color Blindness – An ocular defect resulting in failure of the eye to distinguish between chromatic colors. In total color blindness all colors appear as greys; the more usual partial color blindness (dichromation) is marked by inability to distinguish between certain pairs, as, for instance, red and green.

Color Contrast – See Contrast, Color.

Color Developer – A substance or mixture of substances capable of reducing silver halides with the simultaneous production of an insoluble colored oxidation product in the regions of the silver deposit.

Color Filter – See Filter.

Colorimetric Purity – The ratio of the luminosity of the dominant wavelength to the total luminosity of the color being measured.

Color Mixture Curves – See Color Sensation Curves.

Color Negative – A negative record of the brightness and color values of the original object.

Color Photography – A process in which an attempt is made to reproduce objects in their natural colors by photographic means.

Color Positive – A positive photographic (print) record of color values.

Color Saturation – See Saturation, Color.

Color Screen – (1) A color filter. (2) A surface bearing a mosaic, either regular or irregular, of minute, juxtaposed, transparent elements of the primary colors; used in a screen-plate or screen-film process of color photography.

Color Sensation Curves (*excitation curves*) – Curves based upon the response of the normal human eye, showing the relative excitations of the three elementary sensations, according to the Young–Helmholtz theory of color vision.

Color Sensitivity, Photographic – The sensitivity of a photographic material to light of various portions of the spectrum.

Color Separation – The obtaining of separate photographic records of the relative intensities of the primary colors in a subject in such a manner that a photograph in natural colors can be produced therefrom.

Color Specification – A description of a color made

in such a way that the color sensation may be duplicated. This may be done either with the aid of a color analyzer or by the use of certain visual color matching devices, such as colorimeters or color comparators.

Color Temperature (of a source) – The temperature (expressed on the absolute scale) at which a black body radiator will visually match the color of the source.

Color Transparency – A color photograph upon a glass or film support to be viewed or projected by transmitted light, as distinguished from a color photograph on paper or other opaque white support to be viewed by reflected light.

Complementary After-Image – A sensation caused by ocular fatigue characterized by the persistence of an image of the color complementary to that of the original stimulus.

Complementary Colors – Two colors of light, which, when added together in proper proportions, produce the sensation of white or grey. Also, two colors of dye or pigment, which, when superimposed in proper concentrations, produce a grey.

Cones – One of the two chief light sensitive elements of the retina, frequently regarded as the seat of color vision. See Rods.

Cone Vision – Cones are one of the light sensitive elements in the retina of the eye. They are responsible for vision under higher illumination levels, can perceive colors, and are capable of rendering good definition.

Continuous Spectrum – A spectrum, or section of a spectrum, in which radiations of all wavelengths are present; opposed to line spectra, or band spectra.

Contrast, Color – The ratio of the intensities of the sensations caused by two colors. Sometimes the logarithm of this ratio.

Coupler – An organic compound which reacts with an oxidized form of the developer to form a dye. Couplers have been successfully incorporated in emulsion layers and also in developing solutions.

Daylight – Total radiation from the sky and sun. For standardization of spectral quality, measurements are made at noon. The quality of daylight matches approximately that of a black body at 6500°K.

Density – A measure of the light stopping power of material. It is expressed as the logarithm of the opacity, which in turn is the reciprocal of the transmission. $D = \log_{10}0$ or $D = \log_{10}1/T$.

Desensitization – Treatment of a photographic material, as with a solution of a suitable dye, to reduce its sensitivity to subsequent light exposure without destroying the developability of a previous exposure.

Developed Color Images – Colored photographic images produced by direct development.

Dichroic – Pertaining to the property of certain crystals of showing different colors when viewed in different directions by transmitted light; or pertaining to the property of some solutions of varying color with layer thickness or concentration.

Differential Hardening (of gelatin) – The production of an image in gelatin in a manner such that the hardness is proportional to the original silver density of the image; or, in other cases, to the amount of light which has fallen upon a specially treated gelatin coating.

Diffuse Densities – (1) The incident light is nearly collimated; the receiver accepts all transmitted light falling normally upon the sample, or (2) the incident light is diffuse, and only the normal component of the transmitted light is evaluated.

Discontinuous Spectra Radiators – Light sources such as neon, sodium vapor, mercury arcs and fluorescent lamps which emit radiation whose energy is concentrated at a few wavelengths with little energy in between.

Dominant Wavelength – In a system of monochromatic colorimetry, the wavelength the hue of which matches the hue of the color being measured.

Double Coated Film – Film having a sensitive emulsion on both sides of the base, the emulsions or the base often being impregnated with a dye which prevents the penetration of actinic light to the opposite emulsion when exposing either one of them.

Double-Image Prism – A prism so designed that with a lens it will form two images of an object; a beam splitter.

Du-Pac – See Bipack.

227

Duplitized Positive – See Double Coated Film.

Dye Density – (1) The logarithm to the base 10 of the visual opacity of an area in a finished dye image. (2) The density of a single component of a two- or three-color print as measured by light of the complementary color.

Dye Mordanting – Broadly, the process of fixing a dye to a substance for which it has no affinity by means of a second substance which has an affinity for both the dye and the first substance. More especially, in color photography, the treatment of a silver image so as to replace it in whole or part with a substance having an affinity for dyes.

Dye Toning – The process of affixing a dye to a silver image or of replacing a silver image by a dye image through the action of mordants.

Elementary Colors – See Primary Colors.

Elements (of a screen-plate or lenticular color film) – The individual filter particles of a color screen, or the minute lenses of a lenticular film.

Embossing – *v.t.* The process of impressing minute lens elements upon a film base to produce a lenticular color film. *n.* The lens elements collectively.

Emulsion – Improperly but universally used in photography to describe the silver halide suspended in gelatin. Truly, fine droplets of one liquid dispersed in a second liquid in which it is insoluble.

Equality of Brightness (of colors) – The state in which two colors have equal visual luminosity.

Equivalent Neutral Densities – The assumed components are usually the dye deposits of the color process; the amount of dyes expressed is the luminous density of the grey image that could be formed by adding to the single dye deposit under consideration sufficient quantities of other dyes of the color process.

Equivalent Neutral Printing Densities – The assumed components are usually the dye deposits of the color process; the amount of dye is expressed as the printing density of the image that could be formed by adding to the single dye deposit under consideration sufficient quantities of the other dyes of the color process to form an image with red, green and blue printing densities all equal.

Etch – To dissolve portions of a surface not protected by a resist, as in making a half-tone plate on copper or zinc; also, to remove differentially hardened gelatin from an image.

E.I. (exposure index) – A number associated with the sensitivity and latitude of the emulsion, its development, its intended field of use, and the spectral quality of the light which illuminates the subject. At the present time there is no American Standard covering the measurement of the speed of motion picture camera films. The Exposure Index is a guide number given to a film by the manufacturer to assist the user in obtaining correct exposure of a particular type of film.

Filter – A light transmitting material (or liquid solution in a cell) characterized by its selective absorption of light of certain wavelengths. A so-called "neutral grey" filter absorbs light of all wavelengths to which the eye is sensitive to approximately the same extent and so appears without hue.

Filter Factor (filter ratio) – The ratio of the exposure required to produce a given photographic effect when a filter is used to that required without the filter. Many considerations such as color-sensitivity of the emulsion, quality of radiation, and time of development influence the filter factor.

Filter Overlap – The spectral region in which two or more filters transmit light effectively.

Fringe – A defect in a color picture resulting from lack of registration of the component images. A fringe may be caused by parallax, error in printing registration, or by movement in the object which has taken place between the exposure of color separation negatives.

Fundamental Colors – See Primary Colors.

Gamma – The slope of the straight line part of the curve obtained when density is plotted versus the logarithm of the exposure.

Gelatin Filter – A filter in which gelatin is used as the vehicle for the absorbing material.

Grey Key Image – An image of neutral color occasionally printed in register with the images in tricolor inks or dyes. In the imbibition process, the grey key image is sometimes developed on the printing material by the ordinary photographic method.

Half Silvered Mirror – See Mirror, Semi-transparent.

Halide – A halogen with one excess electron giving a negative charge.

Halogens – Family of four elements consisting of fluorine, chlorine, bromine, and iodine.

Hue – That attribute of certain colors in respect of which they differ characteristically from the grey of the same brilliance, and which permits them to be classed as reddish, yellowish, greenish, or bluish.

Hue Sensibility – The sensibility of the eye to differences of hue.

Hue Shift Mask – One which could affect the R.G. and B. differently and is made to actually change the hues of some colors compared to the hue obtained without masking. A hue shift mask corrects for unwanted absorption of one dye only.

Hypersensitization – The treatment of an unexposed photographic material by immersion in a solution, such as ammonia, to increase its sensitivity, principally to longer wavelengths.

Imbibition – A process for producing a dye image by mechanical printing. A dyed relief or differentially tanned matrix of some substance such as gelatin is brought into intimate contact with a moist absorbing layer such as gelatin, the dye diffusing from the matrix to the absorbing layer.

Imbibition Matrix – A coating of gelatin or other colloid upon a support having an image capable of being dyed with water-soluble dye. See Imbibition.

Interference Colors – Colors resulting from the destruction of the light of certain wavelengths, and the augmentation of the light of others in a composite beam by interference. Colors of thin films and polarization colors of doubly refracting crystals in the polarscope are examples of interference colors.

Lake – A pigment formed by the combination of an organic dye with a metallic compound or another dye with which it forms an insoluble precipitate.

Laking – See Lake.

Latent Image – As used in photography: An invisible image resulting from the exposure of a light sensitive material to light. This latent image is transformed into a visible silver image by action of the developer.

Lenticulation – Minute optical elements having the form of cylindrical or spherical lenses embossed into the support side of photographic film. They serve in the process of analysis and synthesis of images in an additive color process. See Keller Dorian Process.

Leuco-Base – A white or slightly colored substance which, upon oxidation, sometimes accompanied by reaction with an acid or base, yields a more highly colored dye.

Light – Radiant energy, like heat waves, radio waves, X-Rays, etc., that can be perceived by the human eye. The band of wavelengths that can be seen by the eye lies between 400 mu and 700 mu in the electromagnetic spectrum.

Light Restraining Dye – A dye used for impregnating a light sensitive emulsion to prevent the deep penetration of light during exposure.

Light Splitter – See Beam Splitter.

Line Screen Process – A color-screen process in which the screen is formed by a regular pattern of ruled lines.

Luminous Flux – The flow of radiant energy evaluated in terms of the sensitivity of the eye. The unit of luminous flux is the lumen. A lumen is the visual interpretation of the flux from a standard candle flowing in a steradian.

Luminous Intensity – The visual intensity of a source. The unit is the candle. It is equal to a lumen/steradian. The intensity of a source is constant with respect to distance, but usually not with direction. A tungsten lamp viewed from the direction of the base has no intensity at all.

Luminous Units – The psychophysical units corresponding to the physical units listed above. The psychophysical terms are referred to as luminous intensity, luminous flux, luminous energy. Instead of speaking of luminous irradiance, the term is illuminance. Luminance is used instead of luminous radiance. Luminance is the adopted term for what used to be called brightness, the latter word now being reserved for the psychological sensation only.

Mask – An auxiliary image used with an original picture to modify characteristics of the original for reproduction purposes.

Masking – (1) As applied to photography: A technique in making color reproductions either to fully correct or minimize the reproduction deficiencies resulting from high photographic contrast and/or optical characteristics of the dye used in subtractive sensation only. (2) A technique of color printing by means of masks designed to reduce color degradation by compensating for imperfect transmission characteristics of the dye in the original photograph.

Matrix – A coating of gelatin or other colloid upon a support having an image capable of being dyed with water-soluble dyes. See Imbibition.

Maxwell Experiment – The first demonstration of the principle of additive synthesis with color separation negatives. Clerk Maxwell and Thomas Sutton in 1861 produced a set of four plates and projected them in register before an audience.

Maxwell Primaries – The colors red, green, and blue-violet used by Maxwell to demonstrate the application of the Young–Helmholtz theory to color photography.

Micron – A unit of length equal to 0·001 mm (10^{-3} mm). Used frequently to designate the wavelength of radiant energy in the infra-red region.

Millimicron – A unit of length equal to 0·000001 mm (10^{-6} mm). This is the unit usually used in colorimetrics in expressing the wavelength of radiant energy.

Minus Color – The color which is complementary to the color that is named; for example, minus red is a color complementary to red.

Mirror, Semi-transparent – A mirror uniformly coated with reflecting material in such a manner that part of the light incident upon it is reflected, the other part passing through the surface. A type of beam splitter.

Moire Effect – A "watered" pattern produced when two or more screens bearing a system of fine regular lines or similar pattern are superimposed nearly but not exactly in register.

Monochrome – A picture executed in a single color.

Mordanting – See Dye Mordanting.

Mosaic Screen Plate – A color screen plate.

Motion Fringe – A fringe of color occurring at the edge of images when the color separation negatives are taken at different instants.

Multilayered Interference Filter – A filter comprised of very thin layers of alternate high and low refractive index materials deposited on glass. The transmission depends on the refractive indices, the layer thickness and the number of layers.

Neutral Color – Grey; achromatic; possessing no hue.

Neutral Filter – See Filter.

Neutral Wedge – A wedge composed of a neutral (grey) absorbent material.

Opacity – The ratio of the incident light to the emergent light.

Orthochromatic – (1) Characterizing the equivalence between the photographic effect of various colors upon a photographic material and the physiological effect upon the eye. (2) By usage, characterizing a photographic material sensitive to all colors except red.

Panchromatic – Characterizing a photographic material sensitive to all colors of the visible spectrum.

Parallax – The apparent displacement of an object as seen from two different points.

Primary Colors – Three colors, which, when mixed in the proper proportions, can be used to produce all other colors. The three colors most commonly used are red, green, and blue-violet.

Prismatic Spectrum – A spectrum formed by a prism.

Quality (*color*) – Chromaticity.

Quality of Radiation – An expression which refers to the spectral composition of the radiation. In both photography and in the viewing of colored pictures the quality of the radiation used is important.

Ratio Diaphragm Cap – A mask placed over a banded tricolor filter shaped to permit a predetermined ratio of the different colors of light to pass through a filter for lenticulated film color photography.

Refraction – The bending or deviating of a light ray in going from one density medium into another;

such as from air into glass. If the light ray strikes the medium at some angle other than perpendicular, one side of the ray will strike the denser medium sooner than the other and will, therefore, be slowed down while the other side continues at the same velocity momentarily. This uneven pull on the ray changes its direction. If the ray goes from a less dense into a more dense medium, it will be bent toward the normal-perpendicular. If it goes from a more dense to a less dense medium, it will be bent away from the normal.

Register – *v.t.* To cause to correspond exactly; to adjust two or more images to correspond with each other. Such correspondence may be required either in printing or in projection. *n.* A state of correspondence.

Rehalogenation – The practice whereby silver halide is reformed from silver by the treating of an emulsion layer with an aqueous solution of an oxidizing agent and with the appropriate halide ion; the oxidizing of the metallic silver to silver ion substantially without affecting the dyes formed by color forming development and the halide ion reacting with silver ion to form the desired silver halide.

Relative Brightness Mask – A mask affecting all three layers equally, resulting in a change in brightness of some colors compared to others without effecting a change in hue.

Relief Process – Any color process in which relief images are produced, for the purpose of matrix printing.

Resist – A coating used to protect certain portions of a surface upon which an image or design is to be produced by etching, dyeing, or other chemical or physical treatment.

Rods – One of the two chief light sensitive elements of the retina. See Cones.

Rod Vision – One of the two light sensitive elements in the retina of the human eye in which the nerve impulses are generated. The rods are extremely sensitive to dim light, and are responsible for vision at low brightness levels. Rods are insensitive to color and are not capable of good definition.

Saturation, Color – The degree of freedom of a color from admixture with white.

Saturation Sensibility – The sensibility of the eye to saturation.

Sensitometric Exposure – A graduated series of exposures, usually in logarithmic steps, on a single strip of film. This type of exposure is made on a precision instrument in which exposure is varied by varying the intensity of the illumination or the time of the exposure.

Sensitizers – Materials, usually dyes, used to increase the sensitivity of photographic emulsions to light of various wavelengths.

Separation, Color – See Color Separation.

Shoulder – The part of the curve representing the highlight portions of the original subject in a photographic negative or the shadow in a positive. Equal log exposure increases show decreasing density differences.

Spectral Composition (of radiation) – The specification of the relative energy at different wavelengths of radiation emitted by a source, or reflected or transmitted by a material; usually shown graphically as a spectral distribution curve.

Spectral Distribution Curve – See Spectral Composition.

Spectral Energy Curve – See Spectral Distribution Curve.

Spectral Sensitivity – The sensitivity of a light sensitive material (or instrument, such as a photoelectric cell) to radiation of various wavelengths.

Spectral Transmission (of a filter) – The extent to which a filter will transmit radiation of different wavelengths. Shown graphically as transmission, opacity, or density plotted against wavelength.

Spectrogram – A photograph of a spectrum. See Wedge Spectrogram.

Spectrophotometer – A spectroscope with a photometric attachment used to determine the relative intensity of two spectra or spectral regions.

Spectrophotometry – A method for specifying the spectral reflection, absorption or transmission characteristics of objects in terms of the fundamental physical units. It is the measurement relative to a standard of the transmission or reflection of a material at the various wavelengths of the spectrum. The result of the measurement is a physical specification of the material independent of the spectral characteristics of the source which irradiates it or the receiver.

Spectrophotometric Curve – A curve showing the transmission or reflectance of an object at each wavelength. The ordinate of the curve can be either in transmission or reflectance, or in density or reflection density.

Spectroscope – An instrument for forming a spectrum and measuring wavelengths in various regions throughout the spectrum.

Spectrum – An image of a source formed by light or other radiant energy through the medium of an optical device which refracts or diffracts the radiation of different wavelengths to different degrees. Throughout the visible spectrum of a continuous light source the spectrum appears as a number of juxtaposed areas of color varying from red to violet, e.g. the rainbow.

Stereoscopic – Applied to vision, the ability to perceive depth and thus solidity as a characteristic of objects. This visual effect is produced by the separation of the observer's eyes, each giving a different point of view of the object. In photography it is produced by taking two pictures from slightly different viewpoints and viewing them separately, one with each eye.

Subtractive Primaries – The three printing colors used in a three-color subtractive process; usually named magenta (minus green), blue-green or cyan (minus red), and yellow (minus blue).

Subtractive Process – A process of reproducing objects in natural colors using a restricted number of primary component colors in which the composite image is produced by passing a single beam of white light successively through two or more layers of colored images, each of which absorbs one region of the spectrum which is passed by the other layers.

Tanning Developers – Solutions which cause hardening, or which render insoluble the gelatin of an emulsion in proportion to the amount of latent image converted into silver.

Three-Color Process – Any process, either additive or subtractive, for producing photographs using three primary colors.

Tintometer – An instrument for estimating or specifying color by comparison with a graded series of standard colors.

Toe – The part of the curve representing the shadow portions of the original subject in a photographic negative or the highlights of the subject in a positive. Equal log exposure increases produce increasing density differences.

Toning – See Chemical Toning, Dye Toning.

Transfer Process – A process in which an image, usually dyed or pigmented, is transferred from one surface to another.

Transmission – The ratio of the light transmitted by the body to the incident light.

Trichromatic Process – See Three-Color Process.

Tricolor Filter – (1) A composite filter containing areas of three primary colors. (2) A single filter of one of three primaries.

Tripack Process – A process of exposing three films (or plates) simultaneously, in which the films are arranged as a pack so that the outer films (or interposed filters) transmit certain portions of the light to expose the following layers. See Bipack.

Two-Color Process – Any process, either additive or subtractive, for producing photographs using two colors.

Unwanted Absorption – The absorption of light by a subtractive primary in regions of the spectrum other than that considered its primary absorption.

Visibility – of radiation. The ratio of the luminous flux (lumens) to the corresponding energy flux (watts).

Visibility Curve – A graphical representation of the relation between visibility (expressed relatively) and wavelength. This curve has a maximum in the green at 555 mu.

Visible Spectrum – That portion of a spectrum of radiant energy having wavelengths from approximately 400 to 700 millimicrons.

Wedge – An optical device composed of absorbing material in which the transmission varies progressively from point to point. Such a device may cause a variation in either hue or intensity, or both.

Wedge Filter – See Wedge.

Wedge Spectrogram – A spectrogram produced by photographing a spectrum through a neutral wedge (sometimes an optical wedge), placed

usually over the slit of the spectrograph. Such a spectrogram shows graphically the effective photographic sensitivity vs. wavelength for the photographic material and light source used.

White Light – Radiant energy that has a wavelength-intensity distribution such that it evokes a neutral grey (hueless) sensation in the average normal eye.

White Object – An object of a color such that it reflects all wavelengths of the visible spectrum equally; an object which if illuminated by white light will appear without hue to the average normal eye.

Wratten Filters – A widely used commercial brand of color-filters.

Young–Helmholtz Theory (*of color vision*) – An explanation of phenomena of color vision assuming three separate elements in the normal eye, each stimulated by a different section of the visible spectrum.

Note: Although the above definitions were obtained from several sources, one primary source was:

Color Committee of the Society of Motion Picture Engineers, "A Glossary of Color Photography," *Journal of the Society of Motion Picture Engineers*, May, 1935, pp. 432–449.

BIBLIOGRAPHY

CORNWELL-CLYNE, ADRIAN. *Colour Cinematography*. London: Chapman and Hall, Ltd., 1951.

DUNN, CARLTON E. *Natural Color Processes*. Boston: American Photographic Publishing Company, 1936.

EVANS, R. M. *An Introduction to Color*. New York: John Wiley and Sons, Inc., 1948.

——, HANSON, W. T. AND BREWER, W. L. *Principles of Color Photography*. New York: John Wiley and Sons, Inc., 1953.

FORSYTHE, W. E. AND ADAMS, E. Q. "The Nature and Measurement of Light," *1001 Ways to Improve Your Photographs*. New York: National Educational Alliance, Inc., pp. 240–246.

FRIEDMAN, J. S. *History of Color Photography*. Boston: American Photographic Publishing Company, 1944. London: (Rev. Ed.) Focal Library, 1968.

FULTON, A. R. *Motion Pictures: The Development of an Art from Silent Films to the Age of Television*. Norman: University of Oklahoma Press, 1960.

GLAFKIDES, PIERRE. *Photographic Chemistry*. Vol. II. London: Fountain Press, 1960.

GREGORY, C. C. *Motion Picture Photography*. New York: Falk Publishing Company, Inc., 1927.

HAYNE, D. (ed.). *The Autobiography of Cecil B. De Mille*. Englewood Cliffs, N.J.: Prentice-Hall, Inc., 1959.

LIMBACHER, J. L. *Four Aspects of the Film*. New York: Brussel and Brussel, 1968.

MILLER, T. H. AND BRUMMITT, WYATT. *This is Photography*. New York: Garden City Publishing Co., Inc., 1945.

NEBLETTE, C. B. *Photography: Its Principles and Practices*. New York: D. Van Nostrand Co., Inc., 1947.

RAMSAYE, TERRY. *A Million and One Nights*. New York: Simon and Schuster, 1926.

ROSE, J. J. *American Cinematographer Handbook and Reference Guide*. Los Angeles: Southland Press, 1950.

Society of Motion Picture and Television Engineers. *Elements of Color in Professional Motion Pictures*. New York: Society of Motion Picture and Television Engineers, 1957.

SPENCER, D. A. *Colour Photography in Practice*. London: Pitman and Sons, Ltd., 1938. Revised Edition Focal Press, 1975.

——. *Progress in Photography, 1940–1950*. London: Focal Press, 1950.

Tinting and Toning of Eastman Positive Motion Picture Film. Rochester, N.Y.: Eastman Kodak Co., 1927.

WALL, E. J. *History of Three Color Photography*. Boston: American Photographic Publishing Company, 1925. London: (Rev. Ed.) Focal Library, 1969.

——. *Practical Color Photography*. Boston: American Photographic Publishing Company, 1928.

Appendix

Program for Kinemacolor command performance 1911.

EASTMAN KODAK COMPANY
ROCHESTER, N.Y.

October 2nd, 1911.

Charles Urban, Esq.,

London, England,

My dear Mr. Urban:-

In conversation with one of our Directors who has just returned from abroad, one of the proprietors of a large department store here in Rochester, he told me that one of the most satisfactory entertainments he had ever attended was one at your Scala Theatre, where he spent with some of his family about three hours one afternoon. He was so enthusiastic about it I thought you would like to know it. I am delighted that you are having such success with the color pictures. The Coronation pictures have lately been shown here in Rochester and I have heard many flattering comments on them. I myself was out of town and missed seeing them.

With kind regards, I am,

Yours very truly,

Letter to Charles Urban from George Eastman.

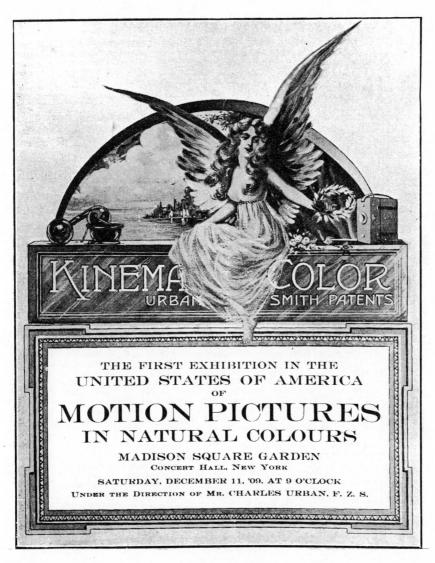

Kinemacolor program.

KINEMACOLOR

For a proper realization of the astounding advance made by "Kinemacolor" in the art of the camera, it must be clearly emphasized that the colours obtained are due to the agency of LIGHT only. No painting, hand-work, stencil-work or similar devices are used. The colours are, as it were, lying latent in the photographic picture and are brought into visibility at the moment of exhibition. It is true that by the older methods coloured moving pictures could be obtained, and are still obtained, but only by the costly process of employing numerous girls to laboriously paint the pictures—a process often taking weeks in the case of long subjects. Even by this expensive and slow process only certain classes of subjects are capable of being dealt with.

By the Kinemacolor process, the colors of nature are photographically recorded simultaneously with the taking of the picture· the completed picture in all its glowing richness of colour can be exhibited within a few hours and duplicates can be issued with the same celerity that we are accustomed to with black and white subjects

In working out the process, one of the most difficult problems was that of making the photographic film sufficiently sensitive to red light. As everyone is aware, the photographic film known to commerce is not sensitive to red rays, and only very slightly to yellow and green ones. For that reason a red light is used in dark rooms to watch the development of negatives by. The making for a colour-sensitive film necessitated exhaustive experiments covering a period of nearly three years, but finally a product was obtained which in ordinary sunlight is sensitive to colour waves from the brightest of violets to the darkest of reds.

In further working out the invention, Messrs. Urban and Smith kept steadily in view one most important point, namely; that any process to be really valuable must be readily adaptable to existing things. As a consequence of this determination, Kinemacolor can be exhibited in conjunction with black and white pictures in any motion picture theatre in the world. The same machine with a trifling addition answers both purposes, and first one kind of picture and then another (black and white or color) can be exhibited as the nature of the programme demands.

A full description of the process would necessitate a scientific disquisition of a lengthy character, and would be scarcely in place on the present occasion. A full exposition was given by Mr. Charles Urban, F.Z.S., and Mr. G. Albert Smith, F. R. A. S., to a large audience of scientist and photographic experts at the invitation of the Royal Society of Arts, London, and was fully reported in the *Journal* of that Society, December 11th, 1908, and this report may be consulted by those desirous of approaching the subject in its scientific aspect. For the present it is sufficient to say that when the Kinemacolor camera is at work a pair of carefully selected light-filters sift the colour waves of the scene and permit

CONTINUED ON FOURTH PAGE

Kinemacolor program.

242

"KINEMACOLOR"

PRODUCED UNDER THE DIRECTION OF
MR. CHARLES URBAN, F. Z. S.

MR. G. ALBERT SMITH, F.R.A.S., ENGLAND,
WILL BRIEFLY DESCRIBE THE NEW ART.

PROGRAMME

SELECTED FROM THE FOLLOWING SERIES FOR THE PURPOSE OF
DEMONSTRATING THE WIDE SCOPE OF KINEMATOGRAPHY
TO WHICH "KINEMACOLOR" IS APPLICABLE

1. OUR FLORAL FRIENDS (10 Studies)

2. NATURAL COLOUR PORTRAITURE (12 Studies)
 Dealing with details of Costumes and Flesh tints.

3. THE S.S. "GEORGE WASHINGTON"
 leaving Southampton for New York.

4. SCENES ON THE RIVIERA, South Coast of France, including
 Views of Cannes, Nice and Monte Carlo.

5. CARNIVAL AND BATTLE OF FLOWERS, Nice.

6. WAVES AND SPRAY, Waterfall and Mountains (French Alps).

7. THE NEW SULTAN OF TURKEY
 going to the Semelik, Constantinople.

Kinemacolor program.

"KINEMACOLOR"

8. LIFE ON THE RIVER THAMES,
 from the Tower of London to Henley.

9. "OUR FARMYARD FRIENDS"
 Luncheon on Straw, Among the Sheep, Feeding a Lamb,
 Donkey and Carrot, the Parrot, Mesmerized Rooster, Rabbits,
 Cattle, Horses, Cat at Toilet, Kitten and Parrot, etc.

10. BRITISH RACES AND MILITARY
 The King's Derby, Royal Ascot, the Soldiers' Pet, Band of the
 Cameron Highlanders, Sentry at Aldershot, March of Gordon
 Highlanders, etc.

11. THEIR MAJESTIES, THE KING AND QUEEN OF ENGLAND
 driving through London.

12. SCENES ON GALATA BRIDGE, CONSTANTINOPLE.

13. MOTOR BOAT AND YACHT RACING, England.

14. GERMAN UHLANS AND INFANTRY, Berlin.

15. WEST POINT CADETS.

16. VIEWS OF POTOMAC FALLS (note Rainbow) AND THE
 HOME OF GEORGE WASHINGTON. Mt. Vernon.

17. THE HARVEST—Ploughing, Reaping, Loading Crops. off to the
 Barn, Threshing, Relaxation after Labour.

18. REVIEW OF THE BRITISH NAVY, at Spithead, England.

19. LONDON ZOOLOGICAL GARDENS
 Showing Pavilion and Flower Vase, Camels, Polar Bears,
 Buffalo, Tigers, Swans, Hippopotami, Zebra, Brown Bear.
 Leopards, Flamingoes, Elephants, Giraffes, Macaws, etc.

20. "OLD GLORY," showing 2000 Children forming the Stars and
 Stripes on the steps of Albany Capitol during the Hudson-
 Fulton Celebration.

A NOTICEABLE FEATURE OF "KINEMACOLOR" IS ITS
MARVELOUS STEREOSCOPIC EFFECT

Kinemacolor program.

them to be recorded separately and in due proportions. When the film bearing these colour records is subsequently run through a motion picture machine fitted with somewhat similar filters, the colour waves are set in motion again, and as the proportion of coloured light then served out to the observers are the same as at the outset, the original scene is reconstructed, as it were, to the eye.

It must be repeated that the *rationale* of the process is not easy to set forth in simple terms so that those unacquainted with the phenomena of light and colour can immediately understand the scientific principles involved. Those who really wish to do so will readily acquaint themselves with the science of the subject by an excursion into the fascinating realms of physics where such things are dealt with.

The main point in connection with the above is that for the *practical working* of Kinemacolor no *scientific knowledge whatever is necessary.* Any photographer who understands his business can readily *take* motion pictures in natural colours, and any man who knows enough about projecting machines to obtain his license from city authorities can be taught in ten minutes how to exhibit Kinemacolor pictures in conjunction with his ordinary programme.

It has been pointed out in an American print by a critic, who, by the way, had never seen the results, that "THE MAIN PRINCIPLES OF THE URBAN-SMITH PROCESS WERE KNOWN TO THE SCIENTIFIC WORLD BEFORE EITHER MR. URBAN OR MR. SMITH TOOK UP THE MATTER!" Exactly! Messrs. Urban and Smith admit the fact and take special pride in it. Their invention *is* based upon the solid foundation of established scientific truths. If it were based upon some fantastic notion not in accordance with the principles of pure science there would be little hope for its future. It is just *because* Kinemacolor is based upon the solid rock of scientific fact that distinguished scientists all over Europe have been enthusiastic in its praise and have predicted a brilliant future for the young art, which has been born to the world for the entertainment and instruction of the people.

Messrs Urban and Smith's only claim is that with the expenditure of much time and money they are the *first* to take up these sound scientific principles and materialize them into practical, everyday results,and it is for that reason that the Patent offices of every civilized country in the world have granted Letters Patent for the process.

Kinemacolor is a young art and at present it is being withheld except to three of the world's great cities, and because of its youth the inventors claim some indulgence for the shortcomings incidental to all new things. But it is hoped that the present exhibition, to which Mr. Urban has the honour to invite you, will convince you that a new era has dawned for the moving picture industry; that a new power has been placed in the hands of those whose business or interest it is to make records of the world's happenings; and that the enjoyment of the vast majority of mankind who cannot attend these happenings but who delight in seeing them pictorially reproduced will be greatly increased by

KINEMACOLOR

Kinemacolor program.

KINEMACOLOR
URBAN-SMITH PATENTS

THE ONLY PROCESS IN EXISTENCE SHOWING MOTION PICTURES IN THE ACTUAL TONES, TINTS AND HUES OF NATURE

"THE GREATEST ADVANCE IN THE HISTORY OF KINEMATOGRAPHY."—*Vide, European Press.*

KINEMACOLOR RESULTS ARE REPRODUCED BY MEANS OF ONE LENS, ONE FILM AND THE STANDARD PROJECTOR (WITH SLIGHT ADDITIONS TO THE MACHINE)

"KINEMACOLOR IS REVOLUTIONIZING KINEMATOGRAPHY."
—*Vide, London Press.*

ADDRESS ALL COMMUNICATIONS TO CHARLES URBAN
URBANORA HOUSE, WARDOUR ST. W., LONDON, ENG.

Kinemacolor program.

246

BI-PACK CAMERA INSTRUCTIONS

As noted above, in Chapter VI, the use of bipack film in a standard 35 mm motion picture camera requires slight modification of the camera.

Mitchell NC[1]
1. Move the lenses toward film plane a distance of 0·0045 in., then use normal calibration for focus. Camera with standard instead of "slip-ring" lens mounts would have to be either eye-focused or recalibrated.
2. Adjusting lenses will necessitate "shimming" the ground glass back 0·0045 in.
3. Remove "stripper" shoe at back of main sprocket and replace with "cutaway" shoe.
4. Lock off clutch.
5. Substitute either four-roller pressure plate or a solid pressure plate for the usual two-roller pressure plate. In the four-roller plate the top roller is straight while the other three rollers are crowned 0·003 in. The four-roller pressure plate is patented by Cinecolor Corporation and license for use must be obtained from them. The solid plate is crowned 0·003 in. and is of polished chrome. Pressure can be obtained with a solid screw or by the use of a spring twice the tension of the normal spring. In practice use is generally made of the solid screw for the four-roller plate, being careful to avoid "runouts".

Bell and Howell Standard (Unit I movement)[2]
A. Tools—Make sure that you have available the two wrenches which are delivered as standard equipment with each camera.

1. General utility wrench.
2. Front and rear ball bearing cone wrench.

Also prepare two strips of film about 6 inches long, cutting out the film perforations over a length of approximately 3 inches.
B. Withdraw the "Unit I" intermittent mechanism and, using the general utility wrench, loosen the lock nut at the rear of the camera, turning it slightly counter-clockwise.
C. The cam setting rim is then loosened and can be set at will. If it is found that it is difficult to loosen it use the wrench. Do not force the turning of the ring and if it still offers resistance with the use of the wrench, merely tap the lock nut with the heel of the palm of the hand to jar it loose.
Note that two reference dots are engraved on the rim of the cam setting ring which are to coincide with the edge of the casting and which by their positioning set the cam so that it will bring the film mechanism register leaves, and therefore the film emulsion or emulsions, to the focal plane with exacting precision.
D. When the two dots are brought to coincide with the lower edge of the casting, the intermittent film mechanism is set to bring the first emulsion at the lens focal plane for bipack (double film) operation. When the two reference dots are brought to coincide with the lower edge of the casting the intermittent film mechanism is set to bring the film emulsion at the focal plane for "single film" operation.
E. After setting the cam ring at its proper position, lock the lock knob at the rear of the camera, using the general utility wrench, turning it clockwise.
F. You are ready now to insert in the camera the film intermittent mechanism. See to it that it is pushed fully home and it can be easily locked in place with the provided locking latches.
It is now possible to use the camera for either single film or double film work according to the setting of the camera in and out register leaves cam.
G. The rear register leaf is equipped with five rubber buttons which can be pushed forward to protrude from

the inner face of the back leaf or retracted to be flush with this leaf surface by a combination of leaves and suitable spring.

In one position of the levers the rubber buttons are flush with the inner active face of the back register leaf and are in position for "single film" operation.

In the other position of the levers the rubber buttons protrude from the inner active face of the back register leaf and are in position for "double film" operation.

H. Although the setting of the camera cam is very easy and accurate, if the above instructions are followed, it is good practice to check the film tension after the final adjustment of the rubber buttons is made. If the buttons are set for single film operation take one single piece of film cut as described in A and insert it in the "Unit I" film intermittent mechanism as the film would be threaded for photographing operation.

The fact that the portions of the film where the perforations are, are cut away ensures that there will be no interference from either the pilot or the driving pins.

Using the small crank supplied as standard equipment with the camera at the rear single frame shaft make sure that the register leaves are in such a position that they bring the film to the lens focal plane (photographic position).

Without disturbing this positioning take hold of the film strip and move it up and down in the film channel.

The film must be free to move without effort but a slight resistance (film tension) must be felt. Experience, easily acquired, will tell when proper tension is applied.

I. If the buttons are set for double film operation make the same film tension test, using however both strips of film instead of only one. Tension resistance must be felt in either the single or double film test.

J. The double compartment double set film magazines used for double film operation are threaded so that the loops of the front film are one perforation longer than those of the back film. .

The driving and take-up sprocket film guides and the sprocket teeth are so designed and constructed that they take adequate care of either single or double film.

K. For single film, the camera is threaded in the regular way using the standard film magazines.

For double film, the coupled "bipack" magazines are used and the film is threaded as described in J. The film magazines coupled for bipack work can be disassembled into two single units for individual use with single film. The lower magazine is equipped with a special adapter and when used as a single magazine the opening on top of the casting must be closed with the special cover plate supplied and a longer fastening rod is to be used to attach the magazine to the camera.

L. From the above it is quite evident that when using the interchangeable "Unit I" film mechanism for double films the lens focal plane of the camera is pushed back an amount sufficient to compensate for the extra thickness of the front film.

Since the ground glass at the focusing aperture is precisely set for the focal plane of the emulsion of the single film, compensation must be devised for setting the lens so that it will properly focus at the displaced focal plane. To this effect an index marking is engraved on the lens holder indentified with the reference letter B (bipack).

Focus visually the object through the regular ground glass and before operating the camera rotate the lens mount so that the distance marking found by visual observation is switched to the B reference marking engraved in the lens mount. For extremely close-up work such as titles it is suggested that a photographic check of the "B" marking be made, and additional reference points be determined according to the particular requirements of the operations.

The above instructions are very easily followed and all operations require only a few seconds if performed in their sequence and with normal care.

REFERENCES

[1] Boyle, J. W. and Berg, B. "Studio Production with Two-Color Bi-Pack Motion Picture Film," *Journal of the Society of Motion Picture Engineers,* February, 1947, p. 112.

[2] Cornwell-Clyne, Adrian, *Colour Cinematography* (London: Chapman and Hall, Ltd., 1951), pp. 574–578.

INSTRUCTIONS FOR CAMERAMEN
FOX
NATURE COLOR PICTURES
For Cameramen

THE photography of Fox Nature Color Pictures requires that two frames of motion picture negatives be exposed at the same time through two lenses on the same camera, one having in front of it a piece of gelatine passing green light only and the other being covered with a similar piece passing only red light.

In order to do this a standard type of camera has been taken and changed so that it will pull the film down two frames at a time. This has required a special pulldown mechanism which will be seen to have a longer stroke, and a special gate so curved that the film remains somewhat longer in position on the pulldown claws.

The camera is driven by motor which may be synchronized with a motor driving a sound camera. This motor revolves at the normal speed and if the camera is cranked by hand it is cranked the same as standard cameras. Since, however, the film is being pulled down two frames at a time rather than one it is necessary to carefully adjust the lengths of the loops so that the film does not touch either at the bottom or the top at any part of the stroke.

If it does touch there is danger that the film will move slightly before the positioning pins enter the perforations and so damage the film. The pressure of the spring on the pressure pad should be somewhat greater than in black and white cameras and once it is set must be left alone. This increase in pressure is necessary because the pad rests on two frames of the film rather than on one.

It must also be remembered that the film runs out of the magazine twice as fast as regular film so that with a one thousand foot roll it is only possible to photograph a scene which would normally run five hundred feet. The actual speed of the film is 180 ft. per minute as against 90 ft. per minute for standard.

This difference in speed is on account of the fact that two frames at a time are exposed, and so does not affect the actual exposure of each frame. The time of exposure for any frame, in other words is exactly the same as for black and white pictures using the same shutter opening.

The film used for all work will be Eastman Panchromatic Type 2 HYPERSENSITIZED which has been kept at least 120 hours since hypersensitizing.

The lenses for the camera are furnished in pairs mounted in the same lens block one above the other and already matched in focus. Focussing for a shot is done by turning the outer rim of the lens block, which moves the pair of lenses back and forth as in a single lens. Focussing must be done by tape.

The focussing scale on the lenses is marked in feet but since it may become displaced it is necessary for each cameraman to test the lens for focus when he receives the camera and to check it frequently. If found to be wrong the camera must be returned at once to the color laboratory for adjustment.

To check the focus it is suggested that a chart having fine lines or any regular test chart, be placed ten or fifteen feet from the camera and well lighted. Several shots of this should be made with the focus set at slightly different distances above and below the actual distance—one-eighth inch steps on the ring would be very good. *If the filters are not in place in front of the lenses when these tests are made the results will be worthless.* The filters to be used for testing will be discussed in a later paragraph.

Hypersensitized film not less than five days old must be used for these tests. This film will keep about 10 days at room temperature and about 30 days if kept on ice.

Definition should be determined from the image made through the green filter. Under no conditions should the relative focus of the two lenses be changed. A high precision compound microscope with an apochromat objective is required in matching the two. If there is any doubt whether the lenses are still matched consult the laboratory.

Great care must be taken in color photography to see that all lenses are as clean as is possible. Lens paper should be used. Care must also be taken to see that the lens is well shaded from direct light and the lens hood used.

In color photography lens flare and dirt on lenses gives a *colored* effect on the screen especially noticeable in the shadows as a color veil which cannot be eliminated in the laboratory and which is very unpleasant on the screen.

Instructions for cameramen Fox Nature Color 1929.
Page 2

With each camera a pair of cemented prisms known as a beam splitter is supplied. These must be kept as clean as is possible and are extremely delicate. Since the prisms are cemented together with a balsam which has a relatively low melting temperature the beam splitters must be protected from heat as well as moisture as far as is possible. If bubbles appear or if the prisms become separated the beam splitter must be returned to the laboratory for repair. Their use on the camera will be explained in a later paragraph.

Each lens system is made up of two identical lenses mounted so that their optical axis are separated by the distance on centers of two frames and have their axis as nearly as possible parallel to each other and at right angles to the plane of the film. A 40mm. and a 50mm. pair of lenses are supplied working at f/2.8. It is expected that in the near future other focal lengths will be available.

If two pictures are taken with a single lens camera from slightly different positions the pair of pictures will not be identical due to the different angle of view. If the distance between the lenses is very small compared to the distance to the subject, say ¾″ lens separation and 25 feet to the subject, then this difference in the two pictures is not visible even when the two pictures are placed over one another.

If two pictures are taken of subjects close to the camera and the two are placed over each other a sort of fringe is seen around the subjects caused by the difference in the two pictures. This fringe is called parallax and appears on the screen in this process as a colored border around subjects.

In order to be able to take close-ups it is therefore necessary to have some means of photographing the subject *as though the pair of lenses were one single lens.* The beam splitter which is supplied with each camera does this, and works as follows: The beam splitter mount is pushed onto the two pins in the lens mount until the spring clips hold it fast. Care must be taken to see that it is pushed in as far as it will go.

When correctly set, the window is directly in front of the lower lens and the mount is rigid. The light which would enter the lower lens then enters the beam splitter and is partly reflected in

Instructions for cameramen Fox Nature Color 1929.
Page 3

251

such a way that about half the light passes through the upper lens and is focussed on the film. The other half of the light passes through the lower lens and is also focussed on the film. In this way all the light from the subject enters the camera from one point of view and the two pictures show no parallax. The upper lens, of course, is covered so that no light reaches it except through the beam splitter. Since less than half as much light reaches the film through each lens as without the beam splitter at least twice as much light has to be used on the set.

For all sets in which there is no object *closer* than twenty feet the beam splitter need not be used. *For all objects closer than twenty feet the beam splitter must be used.* The beam splitter furnished with each camera is the only one which can be used with that particular camera. If any difficulty is encountered the color laboratory should be consulted.

Slight differences between the cameras are corrected in the laboratory on the projection printers. This work is done by eye with the help of a microscope and requires that an object be examined on the outside edges of the frame which is very sharp on the negative.

To assist in this work and make possible the printing of scenes in which at the start no object appears in the plane of focus of the lens it is necessary that at the start of every scene two cards about a foot and a half square and having painted on them large H marks with sharp edges be photographed. One of these must be placed on each side of the set so that they come near the edges of the frame in the negative and at the distance from the camera at which the main action is to take place. This will also be the distance of sharpest focus of the lens.

Two sets of pairs of color filters are supplied with each camera. The *color* of all these pairs is the same but the *ratio* of the amounts of light passed is different in each pair. This has been done by placing a series of neutral densities over the red filters of one set and over the green filters of the other set.

It is necessary for correct color rendering in this process that a white card in the set give the same density in the negative through each filter. In other words the exposures of the two frames must be so balanced that a white object records the same

Instructions for cameramen Fox Nature Color 1929.
Page 4

in both. Since one exposure (the one through the red filter) is made by red light and the other by green it will be seen at once that any variation in the color sensitivity of the film will require a change in the ratio of the exposures.

Different types of light sources, such as white flame arcs and daylight, for example, will also require different ratios, due to the actual difference in color of the sources themselves.

For every emulsion as received by the laboratory the ratio necessary for any condition under which the film will be used will be determined and the information supplied to the camerman at the time he receives the film.

Thus a cameraman is about to shoot a scene lighted entirely by white flame carbon arcs. He looks at the card supplied with the film with which his magazine is loaded and finds that for white flame carbon arcs filter number, say, G1 is to be used. He places filter number G1 in position in front of his lenses and makes his shot. It is only necessary to check the filter whenever either the lighting or the emulsion number of the film is changed.

Filters must be kept free from dirt and must not be touched by the fingers. They should be returned to the laboratory frequently and new ones obtained. They must not be used when buckled.

So far little has been said of the steps in the process beyond the taking of the negative. It will be much easier to understand the discussion that follows if we briefly go over the whole process. No attempt will be made to explain the theory, we will simply state the different steps and note the requirements that they place on camera work.

As stated, the original negative is first exposed, two frames at a time, through red and green filters. The green filter passes all greens and some orange, and the red passes all reds except very deep ones, and also some orange. No blue light is passed by either filter. It is, therefore, possible to record on the negative any color except pure blue, which will record as though it were black. Light blues, since they reflect considerable green, will however, record as green. This will be discussed presently in more detail.

A good negative for color work appears to the eye to be about the same as a satisfactory black and white negative, but care must

Instructions for cameramen Fox Nature Color 1929.
Page 5

be taken to see that it is not at all heavy. Contrary to all present practice if there is any doubt the negative should be somewhat *under* exposed. It is expected in the near future that instruments will be available which will aid in determining exactly the amount of light required at any time, but for the present, detail should *just show in the shadows on the negative and no more*. A heavier negative than this will not only be very difficult to handle in the laboratory but will tend to make all the whites in the final picture green.

It is interesting to note here just how much light will need to be used on the sets. Since the lenses now furnished both work at f/2.8 we will compare the amount of light necessary with that for black and white work at the same aperture, assuming that the reader is familiar with black and white work. Due to the fact that the filters each pass only a small part of the total range of colors to which the film is sensitive, approximately eight times as much white light must be used on the set as for work without the filters.

In cases where the beam splitter is used, twice as much light again is necessary, or sixteen times as much. Where so much light has to be used in the shadows the problem of balancing the lighting becomes a rather difficult one and it will be found a great help to view the scene through a quite heavy neutral density, or a somewhat lighter one may be placed over the finder and the scene viewed through the camera lens with the green filter in place.

All Fox Nature Color Picture negatives will be given exactly the same amount of development regardless of exposures, subject matter, or lighting and it is therefore necessary that the cameraman use correct methods on the set. Since negatives will be developed in borax developer it is a good idea to develop any test strips that are run for any reason, in a similar developer. The formula for borax developer recommended by the Eastman Kodak Co. is suitable and *must be used fresh*. A used borax developer acts very differently.

From this negative a positive is printed which is known as a master positive. This must have extremely low contrast compared to ordinary prints and is very sensitive to variations in

Instructions for cameramen Fox Nature Color 1929.
Page 6

exposure, extent of development, etc. For this reason very carefully standardized methods are used in the laboratory for handling it and it will not be possible to control the contrast of the original negative by varying the master positive contrast.

The original set *must* be lighted flat. A contrasty color picture is hard to watch on the screen for any length of time and more improvement can be made in a picture by skillful handling of flat lighting than by any sort of contrast effect. It is a safe rule to remember that a fully lighted set in colors has more contrast when seen on the screen than one in which hard lighting has been attempted.

From this very low contrast master postive the final color prints are made by projection at the same time of each pair of frames on opposite sides of double coated film. They are exactly registered by microscope by means of several precision prisms and lenses.

After printing and passing through several steps this film is then dyed with red dye on one side and with green dye on the other. It is interesting to note that the frame which was exposed through the green filter is dyed *red* and the frame which was exposed through the red filter is dyed *green*. This dye printing process of itself gives extremely high contrast which it is not possible to control and has a relatively short latitude.

That is, the range of intensities of light in the original set which it will record is rather short. A range of light intensities in the set of 1 to 60 is about all that can be handled. This, of course, is the reason why flat lighting and low contrast master positives are a necessary part of the process. Examples of all the steps of the process are included with this booklet.

While we are on the subject of lighting it might be well to point out a few things learned by experience in this work. A spotlight in a set, if there is anyone moving in and out of it, is very noticeable in the finished picture, not so much because of the change in intensity of the lighting on the person but because such a change causes a noticeable color change in the reproduction of the flesh tones.

Back lighting should be used very carefully since very bright highlights, such as catch lights in the hair, will have a tendency

to come out distinctly green and so may entirely destroy the effect intended.

If any soft focus effects are attempted it·is necessary that the cards which are photographed at the head of every scene for the laboratory to use for registering, be photographed *sharply*. If diffusion disks are used these may be removed for the shot.

Mercury lights, since they give no red light, are impossible to use for color work. General lighting must be restricted to white flame carbon arcs, including sun arcs, or daylight.

The effect of the filters is always to change the lighting to the same standard conditions (approximately those given by ordinary home lighting), and it is for this reason that the unaided eye is probably the best judge of the color and light balance of a set. This will be considered further.

Colored lighting, of course, can be used and will give the effect of colored lighting if sufficiently bright and the laboratory has been notified. If the laboratory is not notified of the effect intended the result may be very different.

Very beautiful effects may be obtained in this process by the careful and skillful handling of the lights, just as in black and white work. The above notes have merely been intended to assist the beginner in getting acquainted with the peculiarities of the process at the start.

There are certain limitations, of course, to the process as regards what colors may be reproduced. While it is a good idea to understand these limitations, the safest rule to use in designing sets, costumes, etc., is to make the subject appear under Mazda lighting as it is desired to have the finished color picture appear on the screen, remembering only that blues will record as either black or green, depending on whether they are dark or light.

Almost no other definite statement can be made as to the color to expect from an original, due to the fact that a color as seen by the eye is very much affected by the color of its surroundings, and so may appear very different even though actually the same.

Again, anything which experience has taught the observer is of a definite color, will very strongly tend to appear that color to him on the screen. In this way bananas and lemons appear a

very satisfactory yellow on the screen although they actually may be, and usually are, pink. An object which the audience knows is gold will also appear yellow.

On account of these facts the only sure way of determining the color which a given object will appear on the screen is to make a test picture; this is especially true of fabrics.

With the above in mind a few general statements on the colors to be expected may be of interest. In the first place, as already noted, since no blue light passes the camera filters there are no blues in the final color picture.

The green dye which is used is slightly blue-green and under certain conditions of color contrast will appear quite blue on the screen. A dark blue in the original, such as blue serge, will usually photograph as black or a very dark green. Light blues will photograph light green since they reflect considerable green. Blue eyes will usually appear blue, but large areas of blue sky will be quite noticeably green and this may be rather objectionable in some cases.

Yellows, in general, unless greenish yellow in the original, will record as light pink. Some shades of light yellow, especially canary yellow, will record as white or grey. Blonde hair records naturally. A dark green, such as grass, unless fully lighted usually appears too dark. In the studio it is possible that light blue or blue-green grass would record more naturally. Reds generally reproduce satisfactorily except the very pure reds, which come out lighter than the original.

Makeup should be used which will make the person appear as the director desires the final picture to look, when the person is seen under regular tungsten light such as is used in lighting homes. Special makeup can, of course, be used to create any desired effect but will appear on the screen approximately the way it looks to the eye under, say, a forty watt tungsten light. Any blue in the makeup must be avoided.

Some control of the color rendering of a scene is possible in the laboratory and is necessary in order to offset slight errors in handling or in camera work, although large errors cannot be corrected.

Instructions for cameramen Fox Nature Color 1929.
Page 9

Since the laboratory will not know what the colors of the original set were, or what were the intentions of the director in the scene (he may desire flesh tones to appear dark and so use dark makeup for instance) it will be necessary to photograph at the head of every scene a standard color chart made up from Windsor and Newton's Permanent Oil Colors. More definite information as to the colors to use and the way in which they should be prepared may be obtained from the laboratory.

This color chart should contain at least one patch of pure flat white and should be so held that it faces about half way between the principal light direction of the set and the camera. For this purpose we consider the principal light of the picture to be in the direction in which the strongest front lighting in the set comes. If the color chart were a mirror, the above instructions would mean that it would be so held that the principal light was reflected into the camera lens. This color chart may be photographed at the same time as the registration cards but must be taken under exactly the same conditions of lighting as are to be used for photographing the scene.

If colored lights or any special color effects are to be used the laboratory must be notified exactly what effect it is desired to produce as these cannot be handled in the regular manner.

Before photographing a scene the following points must be carefully checked:

1. The set must be lighted by sun arcs and broadsides with white flame carbons, or by daylight.

2. The loops in the camera must not touch either at the top or bottom at any part of the stroke.

3. The spring pressure on the pressure plate must be somewhat greater than for black and white.

4. The lenses and the beam splitter surfaces must be as clean as it is possible to get them using clean lens paper.

5. The proper filters as given on the card supplied with the film must be in position in front of the lens so that with the lens in the shooting position the red filter is above the green.

Instructions for cameramen Fox Nature Color 1929.
Page 10

6. Focus must be set by actual tape measurement to the distance at which the principal action is to take place.

7. The beam splitter must be used on all sets in which there is any object closer than twenty-five feet.

8. At the distance set on the lens two cards with H marks must be placed so that one appears on each side of the movietone frame in the negative.

9. At the same distance a color chart obtained from the color laboratory must also be taken. This chart and the above cards may, of course, be taken at the same time, but the lighting must be exactly the same as is to be used for the scene.

10. If any diffusion is to be used in the scene the above two shots must be made without the diffusion screens.

11. The film used must be Eastman Panchromatic Type 2 HYPERSENSITIZED and must be at least 120 hours old. It must be kept on ice whenever possible but should be kept at room temperature for a few hours before using to prevent the formation of moisture spots.

12. If any special effects are attempted a note to the laboratory must accompany the film stating exactly the effect intended. This includes shots intended to show a night scene.

NOTES OF INSTRUCTION ON HANDLING
OF TECHNICOLOR CAMERAS

THREADING CAMERA

The path of film through the Technicolor two-color camera is shown in Figure 63.

Notice that the film on a Technicolor camera feeds from the back compartment of the magazine and takes up in the front compartment which is the reverse of the practice used in a black-and-white Bell & Howell camera.

The film should feed from the left or forward side of the feed magazine so that the film runs down to the throat of the magazine in a straight line.

To prepare the camera for threading:

1. See that the small pressure rolls on top and bottom of constant feed sprocket (3) are in the released position, that is back and clear of the sprocket.
2. Turn the intermittent sprocket (1) forward (in operating direction) until it has just finished one of its forward impulses. Stop here. This automatically leaves the shuttle (2) in the down position with a clear path for the film below the "fixed pins" or "register pins" which are mounted on the aperture plate at the bottom of the prism bracket. The shuttle is down but on the point of moving up toward the aperture plate and register pins on the next forward impulse of the camera.
3. Retract the intermittent sprocket (1) out of the shuttle "2" by drawing out the locking pin (4) and swinging it and the sprocket housing up and to the right.
4. See that the confining latch on the outside edge of the shuttle is unfastened and the path through the shuttle therefore clear. The latch is opened by pressing it toward the front of the camera compressing the light spring and then swinging the latch down and clear of the film path.

To thread the camera:

Draw a loop out of the magazine approximately 8 or 10 inches long. Set the magazine on the camera and lock it in place being careful to feed the two sides of the film loops on either side of the block (5) as shown in the sketch, the film going to the left of guide roller (6), and threaded to the right of punch and punch guards (7).

Then grasping the lower end of the film loop, thread it into the shuttle (2), sliding the film into the straight line clear space between the shuttle and stripper plate. The best way to do this is to hold the film with the left hand below and to the left of the shuttle and the right hand just above and to the right of the shuttle and by drawing the back edge of the film tight in this manner, it will slide easily into position and against the back surface of the shuttle plate. See that a perforated pin hole on the front edge of the film is two sprocket holes above the top end of the shuttle, as shown in Figure 64. This method of threading insures a very careful selecting of perforated sprocket holes.

Holding the film in this position, then snap the intermittent sprocket (1) up into the shuttle by manipulating the lock pin (4) swinging it down to the left until it clicks into place.

A gentle tug on the film along its length will assure you that the film seats down properly on the sprocket teeth if it has not already done so. Be sure that the small perforated pin hole on the edge of the film is still in its proper relation to the end of the shuttle. If it is not, swing the sprocket down out of shuttle again and thread properly.

Next, close the latch on the shuttle.

Then thread the top section of the film on into the continuous feed sprocket (3) under the guide rollers as shown, and lock the rollers into place. When making this threadup, also slip the film *between* the automatic

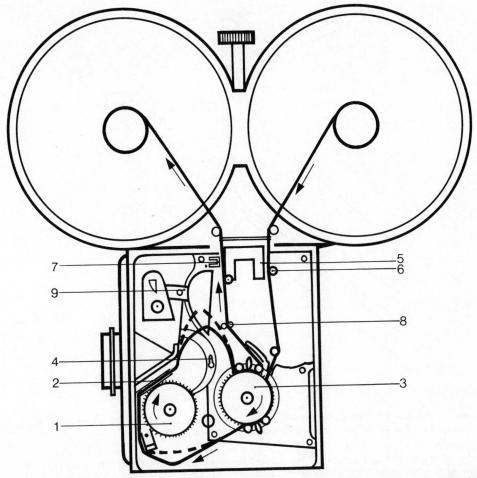

Fig. 63 Technicolor two-color camera film path. 1. Intermittent sprocket. 2. Shuttle. 3. Constant feed sprocket. 4. Locking pin. 5. Block. 6. Guide roller. 7. Punch and punch guards. 8. Automatic stop rollers. 9. Boss.

stop rollers (8) as shown. The length of the top loop when the camera is threaded as described above should be the "long" position indicated by the dotted line. The loop should be so that the top of its arc is about parallel to the center line of the boss (9).

Next proceed to thread the lower loop of the film into the bottom side of the feed sprocket (3), locking the guide rollers in the proper manner. This loop should be in the "short" or dotted line position. This should be gauged to clear the guard sector under sprocket (1) sufficiently to that the film is not drawn tight in the loop. Check this loop by revolving the intermittent sprocket, by use of the stop crank, through one quarter of its revolution. The bottom loop should just clear the bottom surface of the camera when it is in the "long" position. Any readjustment of loop lengths should be made by shifting the film one or two sprocket holes as desired on the feed sprocket (3).

Next take up any slack film that may be between the magazine and the feed sprocket into the magazine. Slip the take-up belt on the magazine, being sure that it and the film is snug and under tension on the "feed on" side. Finally put the brake on the feed side of the magazine. Before closing up the camera, check the threadup by

261

Fig. 64. Location of perforation pin hole.

turning it over slowly with the stop crank several times, checking the loop lengths, the seating of the film on the stationary pins, and the proper path of the film through the various rollers.

Caution

If for any reason the film is damaged in threadup and film torn from between the sprocket holes by the register pins, it is imperative that the prism bracket be taken out of the camera and a proper inspection made to be sure that there are no film chips in the aperture on the prism surfaces or in the shuttle clearance spaces.

Miscellaneous notes on cameras:

Camera buckles

Buckles may be caused in Technicolor cameras from any one of several causes.

1. Poor perforations, chipped or ragged perforations that catch on pins or sprocket teeth and cause a buckle or tear.
2. Improper setting of camera intermittent sprocket or prism bracket or aperture plate causing a lack of alignment of film through these parts, resulting in so-called "camera punching" and in severe cases, buckles.
3. Dirt or foreign material in the shuttle, cramping the film and resulting in a buckle.
4. Improper feed or take-up.
5. Quick camera starts.
6. Pick-up of emulsion on shuttle.

1. *Poor perforations*

Several years ago, a great deal of our camera trouble, both punching and buckling, was caused by this defect. Dull perforator punches would give us ragged and torn perforation edges causing rapid pile-up of chips and dirt

262

and an eventual cramping of the film and finally a buckle. Fortunately, the extreme care and testing of the perforating operation has now practically eliminated this source of trouble.

On several occasions, we have also had damaged holes caused by the feed or take-up sprockets of a perforator. If these are not in proper alignment or if tensions are improperly set, the edges of the perforations are damaged and turned up, making it impossible for the film to feed through the shuttle. This trouble also has largely cleared up due to present day care in perforation inspection.

Note that this perforation damage can also be caused in the camera itself. Damaged, jagged or rough teeth on either the continuous feed or the intermittent sprocket, or lack of alignment of the pressure rolls on the feed sprocket can cause this sprocket hole damage.

2. *Improper setting of camera sprocket-prism bracket-aperture plate*

Severe lack of alignment of any of these parts will cause buckling generally preceded by sprocket hole "punching". Improper settings would be:

Intermittent sprocket pulling the film too far in relation to the register pins.
Intermittent sprocket not pulling the film far enough.
Intermittent sprocket not in same lateral plane as the register pins.
Excessive shake on intermittent sprocket when in the locked position of the star wheel, whether due to wear of some of the parts or due to the sprocket eccentric loosening up.
Improper alignment and squareness of the bracket and aperture plate, sometimes caused by dirt on the back face of the bracket.

Most often, these improper settings will result only in camera punching, but also at times punching sets up a vibration and sway of the film loops sufficient to cause excessive twists of the film in the shuttle and finally a buckle.

3. *Dirt or foreign material in the shuttle*

The clearances in our camera shuttle on the film path are not large. It is very easy for a foreign particle of hard emulsion or even a wood or metal chip to be carried on the film into the shuttle, cramping the film and causing a break. Cleanliness inside the camera and the film magazines is one good aid to preventing this difficulty. It is well never to let the end of a roll of film pass through the camera shuttle as there is apt to be chips of wood or dirt here and also a perforation may be torn near the extreme end as the film passes through the mechanism.

(Note: Whenever an end does run through the shuttle by accident, the prism bracket must be removed and inspected for film chips and dirt.)

4. *Improper feed or take-up*

Our magazines are used with a brake operating on the feed side of the magazine to prevent a coasting of the roll of film on camera stops. The roll of film is so large and heavy that it will always coast when the camera stops, if a brake is not used, resulting in a loop of loose film piling into the feed magazine. Invariably, when the camera is started again this loop snaps and breaks the film. This sort of a buckle is a clean break and generally causes no damage inside the camera, as it simply acts like an end of film passing through.

A buckle from improper take-up is generally quite serious. If the take-up belt slips, or if the roll of film has taken up unevenly causing a drag on the edges of the roll, then the film fails to pass into the take-up side of the magazine, looping down and catching around the feed sprocket as well as jamming in the shuttle.

The new automatic stop rolls now in use in the cameras aid considerably in overcoming this trouble. Generally, the instant the film runs out of its proper path due to poor take-up, these automatic stop rolls contact and stop the camera.

5. *Quick camera starts*

We have frequently had buckles caused by quick camera starts when working at a taking speed of 24 pictures per second. When a camera is properly set in every way it probably will not buckle on a quick start but any one of several adjustments that may be out would allow a break to occur under such a violent strain.

On sound pictures at speed 24 pictures per second we have adopted the practice of using from 7 to 9 feet of film to bring the camera up to full speed slowly and gradually—no jumps.

6. *Pick-up of emulsion on shuttle*

This has been one of the most frequent causes of camera punching and in severe cases, camera buckling. At our present photographic speed of 24 pictures per second, the amount of emulsion which is rubbed off the film and which gathers on certain points of the shuttle is very harmful. This emulsion gathers and cakes up in two or three definite positions on the shuttle and after becoming of a certain size and thickness presents an amount of

friction to the film sufficient to cramp it in the shuttle and cause trouble. We have found it necessary to remove the shuttle from the camera (when operating at speed 24) at the end of every roll of negative to properly clean the shuttle. Unfortunately, this pile-up varies from one emulsion of negative to another. Constant care against corrosion of the shuttle and proper polishing of this member are great aids in avoiding pile-up trouble.

WHAT TO DO

Before the use of the automatic camera stops, camera buckles were of a most serious nature. They are still a severe strain on the camera mechanism though probably there is less film jammed and piled up in the camera with the use of the automatic stop.

Generally after a buckle, it will be found that the film break has occurred in the shuttle on the stationary pins with a resulting piling up and jam of film and torn particles in and around the shuttle and pins and on the lower prism surface. Also, there will often be several layers of film wound up tightly around the continuous feed sprocket under the guide or pressure rollers.

On some occasions, there will be so much film wound and jammed around the feed sprocket that the camera cannot be "turned over," neither can the pressure rolls be backed off. The only remedy here is to cut away the film with a sharp knife, cutting in 2 or 3 positions on the circumference of the sprocket, thus relieving the tension and breaking the film up into small sections so that it can be drawn from the sprocket. In using a knife *never cut down toward the sprocket*; insert the knife under the layers of film and cut away from the circumference of the sprocket. Sprockets have been ruined by gouging them with a knife blade, as the metal is relatively soft. After removing the film from the feed sprocket, examine the feed sprocket pressure rolls to check the clearance between them and the sprocket. They may have been jammed out of true, and if so need bending back. The proper clearance for these rollers is approximately two thicknesses of film raw stock.

Next remove the prism bracket and shuttle from the camera for inspection. Remove all film chips and sections from the shuttle and aperture plate. Be sure there are no small film particles jammed down at the base of the register pins nor in the clearance holes for the pins that are in the shuttle. Be sure there are no chips or particles hidden in under the edges of the prism and aperture plate.

Now check the intermittent sprocket vernier to be sure that it has not slipped out of position. Every camera should be marked with the proper vernier setting so that this can be checked instantly when the occasion demands it.

Also check the star wheel on the eccentric sprocket shaft for play. This eccentric bearing may have loosened and need tightening.

Returning the bracket into the camera then check the depth that the intermittent sprocket enters into the shuttle. Under a severe buckle this may have shifted.

Be sure the sprocket teeth have not been damaged.

Finally, check the pressures all over the shuttle between the aperture plate and shuttle in the manner recommended by the mechanical dept.

Check the clearance between the shuttle or pressure plate and stripper. It should measure 0·014 in. to 0·015 in.

Whenever conditions permit, a camera should be returned to the mechanical department for checking after a buckle.

264

TECHNICOLOR THREE-COLOR EQUIPMENT

E. M. Thayer
Frank Schreiner

APPROVED ROUTINE PRACTICE

MECHANICAL SERVICING OF THREE-COLOR CAMERAS

Originator:
A. E. Carlson

1. Inspect camera generally for any indication of damage, abuse or wear.
2. Remove motor; crank camera by hand to test for smoothness and tightness.
3. Position front door dial, release and open front door. (Arrow at mark)
4. Position claw pins for removing aperture plates. (Out position)
5. Position register pins for clearance. (Out position)
6. Remove pressure plates.
7. Remove aperture plate angle brace screws from L.H. aperture plate, using special slot grip screwdriver.
8. Release R.H. aperture plate post screws (2) with screwdriver 1/32 in × 1/4 in × 6 in.
9. Remove R.H. aperture plate with angle brace attached.
10. Release both L.H. aperture plate post screws.
11. Remove L.H. aperture plate, *pulling down film lubricating pad while removing.*
12. Remove dust cover, clean magazine pad, clean and replace cover.
13. Blow film chips and lint out of camera with bellows or rubber tube air gun. Filtered compressed air is normally used in the shop.
14. Clean inside of camera with lintless cloth. If necessary, dampen with cleaning solvent.
15. Wipe clean with chamois.
16. Clean film sprocket rollers; drop oil in oil cups and test for easy rolling action.
17. Clean film sprockets with chamois; check for burrs and wear.
18. Do not move register adjustments.
19. Clean movements with show card brush ＃ 6 dipped in cleaning solvent; remove any excess solvent with a lintless cloth.
20. Polish aperture plates, using ＃ 3 and ＃ 4 polishing paper wrapped on special wooden block. ＃ 4 is generally sufficient. Sharp corners may be chamfered slightly, but only slightly, and polished.
21. Clean aperture plates with cleaning solvent. Dry thoroughly.
22. Remove hinged film lubricating pad of bipack movement when necessary to clean.
23. Oil film lubricating pads, and check for proper clearance of bipack, inspect condition of felts.
24. Check and clean bipack separating pin.
25. Check film track on register pin guide plate. Do not polish unless necessary, and then be very careful that polishing powder does not get on pins or movement.
26. Check register pin guide bushing for emulsion chips. Also, inspect register pins. Register pins must not be arbitrarily polished as this will destroy accuracy of register.
27. Replace aperture plates (L.H.M. first), making sure that contact surfaces are clean, and that there is oil on aperture plate posts.
28. Tighten both screws holding each aperture plate.
29. Tighten screws holding angle brace to L.H.M. plate.
30. Clean solid pressure plates with cleaning solvent. Wipe dry with chamois.
31. Check solid pressure plate face for scratches. Polish, if necessary. Roller pressure plates may be rinsed several times in cleaning solvent, blowing out each time with filtered air and checking smoothness of operation of the rollers. Oil bearings sparingly, wiping off excess oil. Rollers should show no signs of catching.

32. Replace pressure plates and check operation of springs—1 lb. Check pressure plate seating with film of current use.
33. Remove and inspect knife edge for burrs, wear and parallelism; clean and oil prism mount base, and replace knife edge with "*front*" toward shutter.
34. Oil moving parts of movements, upper pedestal bearing, and oil cup on pedestal.
35. Oil upper bipack loop guide roller.
36. Clean side door fittings with cleaning solvent, and wipe with oiled cloth.
37. Oil door latches.
38. Oil front door lock.
39. Clean and oil master lens mount. Check position of brass ball container. (Balls at edge of master mount.) Special wrench is used to change ball race position.
40. Clean outside of camera box with cleaning solvent.
41. Clean dovetail on bottom of camera with cloth dampened with cleaning solvent. Brush on a light film of oil.
42. Clean and oil rear release knobs for film sprocket rollers.
43. Oil both motor lock nuts.
44. Oil magazine sheave bearing. Remove and clean inside, if necessary.
45. Inspect motor gear pair, and coat with graphite grease.
46. Put one drop of oil in each motor bearing oil hole, if necessary.
47. Check motor for operation and electrical continuity, and replace.
48. Oil switch lever and test operation.
49. Oil magazine hold down screw.
50. Clean and oil selsyn motor dovetail.
51. Oil matte box dovetail.
52. Oil auxiliary finder dovetail.
53. *Clean contact faces of front door and breech lock.*
54. Close front door and synchronize shutter. Check for gear wear.
55. Check master lens guide pin.
56. Never change Index position on Master Mount unless instructed.
57. Check stripper plates.
58. Check focusing finder eyepiece for free action of diaphragm.
59. Check camera level.
60. Check camera wiring by buzzing out camera switch. Check for burnt contacts in switch.
61. Check tachometers for correct reading.
62. Check bloop lights and wiring when used.
63. Check general operation of camera.
64. Replace magazine driving belt when needed.
65. Check mechanical condition of camera case contents, fill oil can, etc. Blow out case.
66. Check lens stop mechanisms and Matte Box mechanical condition.
67. Check prism mount; remove rust and coat mount with *light* film of oil. Do not get oil on glass or near prism base.
68. Check spare parts on hand for replacements.
69. Check universal finder units for wear and proper mechanical operation. Oil, if necessary.

NOTE: Standard Oil "Spot Remover" has been found satisfactory as a cleaning solvent. Standard Oil, "Handy Oil" has been found safe to use for a lubricant. The graphite grease used on gears is Dixon's #3 Cup Grease. No other grease has, as yet, been found to withstand the heavy tooth pressure. It does, however, seem to harden on standing. Cameras, if not used, should be run every month. An expensive overhaul can otherwise become necessary.

To Assistants
and Loaders

October 27, 1938
By A. E. Carlson

RECOMMENDED STANDARD PROCEDURE FOR SPECIAL EFFECT
NEGATIVE REQUIRING MULTIPLE EXPOSURE

First Exposure:

When photographing scenes that are to be held for further exposure, such as glass shots, matte shots, etc., each negative record is to be notched prior to the exposure of such scenes, if any other material precedes it on the roll. Take up three to four feet into the magazine, and resynchronize the film. The sync. marks should be accurately enough placed to that the film may be rethreaded in sync. and in frame for subsequent exposure. Take care that the register pins are in and the claws out when the marks are made. Following this, do not remove the film from the track for inspection or cleaning without re-marking.

If more than one special effects scene or take of the same scene is photographed, find out from the Special Effects Department whether the scenes are to be broken down for separate loading before re-exposure. In such cases, or if there is any question, notch and resync. At the tail end of each section of negative; which is to be separated by notches from other succeeding sections in that group; and at the tail end of the last section of the group; the negative should be resynchronized as above, three feet before notching, as well as following the notch. This tail end mark then always will be available as a check as in case of confusion of the other sync. marks. This tail end sync. is unnecessary on tests to be sent through the laboratory, being included only on "held" footage.

Each time the negative is sync. punched, the counter reading to the frame should be marked in pencil on the emulsion near the punch mark, so that it may be seen in the magazine throat. This noted counter reading may then be compared with the log sheet and magazine card data when rethreading.

It is important that an accurate log be kept of each scene so that ample information will be available at the time of second exposure. The counter reading should be recorded to the frame for each sync. mark, and to the nearest foot for each notch.

Please record carefully all camera stops, the footage allowed for each test, and the purpose of the test; i.e. whether it is for lineup, pilot, or some other reason. Record also any remarks requested by the customer's special effects department regarding counter footage of good action, etc. The log sheets should be marked plainly "HOLD FOR DOUBLE EXPOSURE."

Record on the magazine card all notches and directions for disposal of each part of the group, particularly noting which sections are to be rewound and held until called for by the customer for subsequent exposure.

It is usually not necessary to slate a scene which is to be held for double exposure, unless it is a sound-recorded scene and a clapper is necessary. The customer's Special Effects Department procedure should govern this. The scene number should, however, be noted on the log sheet, and can then be put on at the time of the second exposure. If practicable, a slate should be included on any tests to be sent through the laboratory. Record on the log sheets whether or not slates are included in any case.

If the matte used on the first exposure is of such a size that the area of the first exposure will predominate in the finished scene, then secure a pilot test on the first exposure in the standard manner. If the second exposure will predominate in area, secure a pilot on the second exposure. If the area of the two exposures is approximately equal, secure pilots on both on coincident footage. In any case, allow footage for such tests on the first exposure, and note such footage on the log sheets.

Loaders' Instructions:

Negative groups should be broken down as indicated on the log sheets and magazine cards. Can the portions to be held, marking on the card whether or not it has been rewound ready for loading. Mark the usual information as to group, emulsion, etc., plus the *counter footage* of the head and tail ends, and of head end and tail end sync. marks.

When called for for re-exposure, load the film into a magazine and make out a card for it as usual. Use the reverse side of the magazine identification card, which has provisions for the information required, such as counter footage of head and tail ends, sync. mark footage reading, etc.

When loading, pull sync. marks down to magazine throat so that they show on the stick.

Second Exposure:

Thread the camera as usual, taking care to have the sync. marks at the bottom of both the green and bi-pack plates simultaneously, while the register pins are in and the claws out. Set the footage counter to the number indicated on the copy of the original log sheet. From here, procedure in lining up, removing hand tests, etc. follows the requirements of the customer's method.

Any time the camera is to be unthreaded, or negative broken down which is to be held for exposure later, new sync. marks should be made, in each case allowing at least three feet ahead of the marks to rethread the magazine and camera. These marks should be recorded in the log and magazine cards.

At completion of a scene or tests, if any negative remaining in the feed side of the magazine is to be held, clear five feet and make new sync. marks for rethreading. Unthread the camera, and three feet *ahead* of the new sync. marks, notch the film for breaking. Pull the sync. marks into the *feed* side of the magazine, leaving the notches exposed on the stick.

Follow usual form in making out log sheets, with these special notes:

Under remarks, note type of light on the first exposure and all subsequent exposures. Ordinarily it will be assumed that the lighting used on the first exposure will indicate the developing technique to be used on the completed scene.

In the lighting column, note camera speed, as this is usually less than normal. Also check type of light used.

As hand tests torn off for development usually occupy the first part of the film, the first entry may include the whole group of tests torn off. Mark plainly that this film has been removed, and indicate the new start and sync. footage.

The second and subsequent entries indicate disposal of each group of footage in the usual manner, indicating position of pilots, etc. Following these, copy the scene description, lens, stop, focus and light of the original exposure off the copy of the original log sheet, which copy is in the producer's matte department or accompanying the negative. Footage, etc., may be omitted from this entry, as they are indicated in the log of second exposure.

Make separate entries on the reverse side of the standard magazine identification card for each section of negative. Instead of "ft. exp." and "end", the new sync. and "ft. exp." is entered, as shots are made entirely to counts and the length of the end is misleading when given in feet instead of the counter reading at the end of the roll. Any notches occurring in the roll should be noted as usual. The disposal of all of the film in both the takeup and feed side of the magazine should be entered on the magazine card or a separate card may be used to convey this information to the loader.

It is suggested that the assistant keep, on a separate sheet, his own log of each hand test, sync. footage, lens stops, etc., as he goes along. This information is not necessary to the camera department and need not be turned in. However, if, for example, a test from the scene is sent through the laboratory and the remainder held to await the result of the test, it is necessary to know the stop, light levels, etc., used for guidance in photographing subsequent tests or the scene itself.

Records:

After log sheets are turned in, copies should be made in the office for the use of the operators making the second exposure. A special rubber stamp, "Copied by——", is to be used on the copy to identify it as such and the initials of the person making the copy are to appear in the space provided. These copies will be held in the Equipment Department until the second exposure work is started by the studio (unless previously called for), when they will be issued to the assistant assigned to this work.

AEC

268

To Assistants
and Loaders

October 27, 1938
By A. E. Carlson

IDENTIFICATION OF NEGATIVE HELD FOR SUBSEQUENT EXPOSURE

Exposed negative held for subsequent exposure is to be identified by the loaders on the cans and on the magazine cards when loaded by the counter footage at the head end and the counter footage at the tail end of the section so loaded. This counter footage should identify each notched section of each group. For instance, a group may be synced at 6 feet at the start and may be notched at 300 feet. A second section may be notched at 500 feet and a third section may run to the end of the roll. In this case the first section should be identified as to length as follows:

Group *xxx* 6 ft. to 300 ft.

The second section should be identified as—

Group *xxx* 300 ft. to 500 ft.

The third section should be identified as—

Group *xxx* 500 ft. to counter footage at end of group.

This identification should remain constant even though some of this footage is subsequently removed for tests, as the amount removed for tests is accounted for by log sheets. Technicians and Assistant Cameramen receive these groups so identified and should forward this identification on log sheets for second or other exposures, so that this identification may remain constant throughout the use of this section of the group. This information should be placed on the log sheets in the space marked "LENGTH".

These instructions are in addition to those issued under the heading, "RECOMMENDED STANDARD PROCEDURE FOR SPECIAL EFFECT NEGATIVE REQUIRING MULTIPLE EXPOSURE".

AEC

SUBJECT INDEX

270

271

273

INDEX OF PROPER NAMES